1000 YEARS OF
JOYS AND SORROWS

YARKHOTO

It's almost as if a caravan is wending its way through town
A clamor of voices mingling with the tinkle of camel bells
The markets bustling as before
An incessant flow of carts and horses

But no—the splendid palace
Has lapsed into ruin
Of a thousand years of joys and sorrows
Not a trace can be found

You who are living, live the best life you can
Don't count on the earth to preserve memory

—AI QING, 1980

1000 YEARS OF JOYS AND SORROWS

A MEMOIR

AI WEIWEI

TRANSLATED BY Allan H. Barr

CROWN
NEW YORK

Published in the United States by Crown,
an imprint of Random House, a division of
Penguin Random House LLC, New York.

CROWN and the Crown colophon are registered
trademarks of Penguin Random House LLC.

Simultaneously published in hardcover in Great Britain by Bodley Head,
an imprint of Vintage, a division of Penguin Random House Ltd., London, in 2021.

Art credits appear on p. 375.

LIBRARY OF CONGRESS CATALOGING-IN-PUBLICATION DATA
Names: Ai, Weiwei, author. | Barr, Allan Hepburn, translator.
Title: 1000 years of joys and sorrows / Ai Weiwei; translated by Allan H. Barr.
Other titles: One thousand years of joys and sorrows
Description: New York: Crown, [2021]
Identifiers: LCCN 2021028838 (print) | LCCN 2021028839 (ebook) |
ISBN 9780553419467 (hardcover) | ISBN 9780553419474 (ebook) |
ISBN 9780593240694 (international edition)
Subjects: LCSH: Ai, Weiwei. | Expatriate artists—Great Britain—Biography. |
Artists—China—Biography. | Dissenters, Artistic—China—Biography.
Classification: LCC N7349.A5 A2 2021 (print) | LCC N7349.A5 (ebook) |
DDC 709.2 [B]—dc23
LC record available at lccn.loc.gov/2021028838
LC ebook record available at lccn.loc.gov/2021028839

Printed in the United States of America on acid-free paper

crownpublishing.com

2 4 6 8 9 7 5 3 1

FIRST EDITION

Book design by Barbara M. Bachman

Translation by Allan H. Barr

THIS BOOK IS DEDICATED TO

MY PARENTS AND MY SON.

———

CONTENTS

1000 YEARS OF
JOYS AND SORROWS

Pellucid Night

Boisterous laughter erupts along the path
A bunch of boozers stumble out of the sleeping village
Clatter their way toward the sleeping fields
On this night, this pellucid night

—LINES FROM "PELLUCID NIGHT,"
WRITTEN BY MY FATHER IN A
SHANGHAI PRISON IN 1932

I WAS BORN IN 1957, EIGHT YEARS AFTER THE FOUNDING OF the "New China." My father was forty-seven. When I was growing up, my father rarely talked about the past, because everything was shrouded in the thick fog of the dominant political narrative, and any inquiry into fact ran the risk of provoking a backlash too awful to contemplate. In satisfying the demands of the new order, the Chinese people suffered a withering of spiritual life and lost the ability to tell things as they had truly occurred.

It was half a century before I began to reflect on this. On April 3, 2011, as I was about to fly out of Beijing's Capital Airport, a swarm of plainclothes police descended on me, and for the next eighty-one days I disappeared into a black hole. During my confinement I began to reflect on the past: I thought of my father, in particular, and tried to imagine what life had been like for him behind the bars of a Nationalist prison eighty years earlier. I realized I knew very little about

his ordeal, and I had never taken an active interest in his experiences. In the era in which I grew up, ideological indoctrination exposed us to an intense, invasive light that made our memories vanish like shadows. Memories were a burden, and it was best to be done with them; soon people lost not only the will but the power to remember. When yesterday, today, and tomorrow merge into an indistinguishable blur, memory—apart from being potentially dangerous—has very little meaning at all.

Many of my earliest memories are fractured. When I was a young boy, the world to me was a split screen. On one side, U.S. imperialists strutted around in tuxedos and top hats, walking sticks in hand, trailed by their running dogs: the British, French, Germans, Italians, and Japanese, along with the Kuomintang reactionaries entrenched on Taiwan. On the other side stood Mao Zedong and the sunflowers flanking him—that's to say: the peoples of Asia, Africa, and Latin America, seeking independence and liberation from colonialism and imperialism; it was we who represented the light and the future. In propaganda pictures, the Vietnamese leader, "Grandpa" Ho Chi Minh, was accompanied by fearless young Vietnamese in bamboo hats, their guns trained on the U.S. warplanes in the sky above. Every day we were treated to heroic stories of their victories over the Yankee bandits. An unbridgeable gulf existed between the two sides.

In that information-deprived era, personal choice was like floating duckweed, rootless and insubstantial. Denied the nourishment of individual interests and attachments, memory, wrung out to dry, ruptured and crumbled: "The proletariat has to liberate all of humanity before it can liberate itself," the saying went. After all the convulsions that China had experienced, genuine emotions and personal memory were reduced to tiny scraps and easily replaced by the discourse of struggle and continuous revolution.

The good thing is that my father was a writer. In poetry he recorded feelings that had lodged deep in his heart, even if those little streams of honesty and candor had no natural outlet on those many occasions when political floods carried all before them. Today, all I

can do is pick up the scattered fragments left after the storm and try to piece together a picture, however incomplete it may be.

The year I was born, Mao Zedong unleashed a political storm—the Anti-Rightist Campaign, designed to purge "rightist" intellectuals who had criticized the government. The whirlpool that swallowed up my father upended my life too, leaving a mark on me that I carry to this day. As a leading "rightist" among Chinese writers, my father was exiled and forced to undergo "reform through labor," bringing to an abrupt end the relatively comfortable life that he had enjoyed after the establishment of the new regime in 1949. Expelled at first to the icy wilderness of the far northeast, we were later transferred to the town of Shihezi, at the foot of Xinjiang's Tian Shan mountain range. Like a little boat finding refuge in a typhoon, we sheltered there until the political winds shifted direction again.

Then, in 1967, Mao's "Cultural Revolution" entered a new stage, and my father, now seen as a purveyor of bourgeois literature and art, was once again placed on the blacklist of ideological targets, along with other Trotskyists, apostates, and anti-party elements. I was about to turn ten, and the events that followed have stayed with me always.

IN MAY OF THAT YEAR, one of the leading revolutionary radicals in Shihezi visited us in our home. My father had been living too cushy a life, he said, and now they were going to send him to a remote paramilitary production unit for "remolding."

Father offered no response.

"Are you looking to us to give you a farewell party?" the man sneered.

Not long after that, a "Liberation" truck pulled up outside the front door of our house. We loaded it with a few simple items of furniture and a pile of coal, and tossed our bedrolls on top—we didn't have much else to take. It began to drizzle as Father took a seat in the

front cabin; my stepbrother, Gao Jian, and I clambered onto the back of the truck and squatted under the canvas. The place we were going was on the edge of the Gurbantünggüt Desert; it was known locally as "Little Siberia."

Rather than go with us, my mother decided to take my little brother, Ai Dan, back to Beijing. After ten years in exile, she was no longer young, and she couldn't stomach the prospect of living in even more primitive conditions. Shihezi was the farthest she was willing to go. There was no way to keep the family together. I did not beg Mother to go with us, nor did I plead with her to leave my little brother behind. I held my tongue, neither saying goodbye nor asking if she was coming back. I don't remember how long it took for them to disappear from view as we drove off. As far as I was concerned, staying was no different from leaving: either way, it was not our decision to make.

The truck shook violently as it lurched along a seemingly endless dirt road riven with potholes and gullies, and I had to hold tight to the frame to avoid being tossed in the air. A mat beside us was picked up by a gust of wind and within seconds it swirled away, disappearing into the cloud of dust thrown up in our wake.

After several bone-shaking hours, the truck finally ground to a halt at the edge of the desert. We had arrived at our destination: Xinjiang Military District Production and Construction Corps, Agricultural Division 8, Regiment 23, Branch 3, Company 2. It was one of many such units established in China's border regions in the 1950s, with two goals in mind. In times of peace, Production and Construction Corps workers would develop land for cultivation and engage in agricultural production, boosting the nation's economy. If war broke out with one of China's neighbors, or if there was unrest among the ethnic minority population, the workers would take up their military role and assist in national defense efforts. As we were to learn first-hand, such units sometimes had an additional function—the housing of offenders banished from their native homes elsewhere in China.

It was dusk, and the sound of a flute came wafting over from a

row of low-standing cottages; several young workers were standing outside, watching us curiously. We were assigned a room that had a double bed but nothing else. My father and I moved in the small table and four stools that we had brought from Shihezi. The floor was tamped earth and the walls were mud brick with wheat stalks sticking out. I made a simple oil lamp by pouring kerosene into an empty medicine bottle, poking a hole in the bottle cap, and threading a scrap of shoelace through it.

MY FATHER REQUIRED LITTLE in life apart from time to read and write. And he had few responsibilities. It was my mother who had always handled the housework, and she had never expected us to lend a hand. But now it was just my father, Gao Jian, and me, and our living arrangements aroused the curiosity of the other workers, rough-and-ready "military farm warriors" who were blunt in their inquiries. "Is that your grandpa?" they would ask me, or "Do you miss your mom?" In time I learned how to look after things myself.

I tried to build us a stove, so that we could get heat and boil water. But the stove leaked smoke from everywhere except the chimney, and tending it made my eyes smart and left me choking, until I realized that air had to flow freely into the chamber. Then there were the other daily chores, like fetching water from the well, picking up meals from the canteen, feeding the stove with firewood, and shoveling away the cinders. Someone had to do these things, and more often than not that someone was me.

For us, the past was something severed from our new existence—
the two had nothing in common, apart from the sun rising and set-
ting. Our life now seemed like an open-ended course in wilderness
survival training, if we were lucky enough to survive. The produc-
tion corps company faced north, toward a desert the size of Switzer-
land. The first time I saw it, I was so excited that I raced across the
barren sand until I was out of breath. Then I lay down flat on the
ground and gazed up at the endless blue sky. But the excitement soon
wore off. Under the sun's intense glare, there were no shadows on the
desert floor, a salt plain so white it looked as though it were covered
in a thick carpet of snow. Whenever a gust of hot wind blasted past,
camel thorn bushes would roll this way and that, and grains of sand
stung my face, stabbing my skin like needles.

The workers came from widely varied backgrounds, with myste-
rious, incommunicable pasts that this border region had helped to put
behind them. Forgotten by the communities of which they were once
part, they lived only in the here and now. Many were members of the
stigmatized "Five Black Categories"—landlords, rich peasants, coun-
terrevolutionaries, bad elements, and rightists. Or they were, like me,
children of Black Category members. Some were former soldiers,
and others were young people unwanted by their native cities or refu-
gees from impoverished areas in the Chinese hinterland. Here, at
least, they could avoid starvation by cultivating wasteland and grow-
ing enough crops to feed themselves.

My father was initially assigned to the forestry management team.
In order to isolate him and limit his corrupting influence, they or-
dered him to trim trees on his own, sending him off with a pair of
shears and a small saw. The farm's elms and Russian olives had never
been trimmed since they were planted, and they now grew so hap-
hazardly they looked more like shrubs than trees. Their trunks had
been gnawed and nibbled by sheep, and side branches sprouted every-
where. But Father soon took to his new job, because he was fond of
trees and happy to keep his distance from the crowd.

Meanwhile, I went off in the morning to classes conducted by the

school's sole teacher in its single classroom, along with six or seven other second and third graders. The company offered no education for older children, so my brother Gao Jian, who was five years my senior, attended secondary school at another production corps unit, where he lived as a boarder.

When school got out, I would take a thermos and walk a long, long way to meet my father. From a distance I would watch him circle a tree, trimming branches here and there, then retreat a few steps to check whether the two sides were balanced. When he finally became aware of my approach, it would take him a few seconds to relax. On one occasion, I remember, he mopped his brow as he gulped down the water I had brought, then handed me a branch of elm wood that he had sawed off. He had made a point of rubbing away its burls and blemishes, and it was as smooth and glossy as an ancient scepter.

In the center of the company headquarters stood an auditorium, its facade embellished with a five-cornered star, whose bright red had faded to a pale rust color. Here in the production corps, the auditorium held the same status as an ancestral shrine did in the old days. This kind of hall was now found all over China, in factories and communes, in government organizations, schools, and army units. Above the stage hung a portrait of Mao, with Marx and Engels on his left and Lenin and Stalin to his right, all facing the center of the hall, their eyes fixed on the far distance.

No matter how exhausting the day's labor might have been, every evening the company would hold a meeting after dinner. Beneath the stark light of a mercury-vapor lamp, 240 workers and their families would spread their stools across the floor and listen as the political instructor gave an ideological report, analyzing political develop-

ments on the national level. In this era when "politics" invaded all aspects of life, at the dawn of each day one had to request Chairman Mao's instructions before beginning work or study, and at the end of the day a similar ritual was conducted, that of reporting to the Chairman on the progress of one's work or study that day. The political instructor needed to provide guidance in carrying out the party line, in implementing party policies and executing the decisions and directives of the higher authorities, and in studying Marxism-Leninism and Mao Zedong Thought. After that, the commander would assess the day's work and line up the following day's assignments.

Typically, those who fell into the Five Black Categories would be called to the front of the stage, where they would have to bow their heads penitently toward the audience below. Even if my father was clearly present, the presiding official would yell, "Is the big rightist Ai Qing here?" To add "big" in front of "rightist" was standard practice when referring to my father, given his reputation and impact as a writer. On one occasion, he was even denounced as a "bourgeois novelist"—an odd title, since it was his poetry that had made him famous. But the audience actually had no interest in who he was or what he had done in life. Everything said at the meeting was seen as standard procedure and perfectly reasonable, for the revolution needed to have enemies—without them, people would feel a deep unease.

When summoned, Father would rise from his stool, thread his way through the crowd, and take his place on the stage; his hair would flop down over his forehead as he bowed low in acknowledgment of his crimes. For a moment, the audience would quiet down, before resuming its customary insouciance, the children running wild as the men shared crude jokes and the women breastfed their babies, or knitted, or cracked sunflower seeds between their teeth while they gossiped.

If the authority on the stage said, "Now we'll let the big rightist Ai Qing leave," Father would promptly exit the hall. He would never know in advance if he would be dismissed. It all came down to

whether or not there was a "Latest Directive" from Chairman Mao to share with the audience. If there was, people like Father were not allowed to be present.

In the early years of the Cultural Revolution, almost every day—or every night—there were directives from Chairman Mao to transmit. The company's copy clerk would write them down word by word and line by line as they were read out over the telephone, before they were shared publicly at the nightly meetings. These messages served a function similar to Donald Trump's late-night tweets while in office. They were the direct communication of a leader's thoughts to his devoted followers, enhancing the sanctity of his authority. In the Chinese case, these pronouncements went even further, requiring total compliance. No sooner were they announced than a cacophony of gongs and drums would celebrate the imparting of Mao's wisdom, and the listeners would be injected with new energy. Here, and across the country, such scenes were enacted day after day, and it was years before the issuing of Latest Directives was discontinued.

The Cultural Revolution, we were told, was "a deeper, broader new stage in the development of the socialist revolution," which was "a revolution that touches people to their very souls." The goal was to "dislodge the power holders who are taking the capitalist road, critique the bourgeois reactionary academic 'authorities,' critique the ideology of the bourgeoisie and of all exploiting classes, and reform education, culture, and everything in the superstructure that does not conform to the socialist economic base, in order to consolidate and develop the socialist system." When I was growing up, everyday life was saturated with this kind of overblown language, and though its meaning was hard to grasp, it seemed to have hypnotic, or narcotic, properties. Everyone was possessed by it.

The auditorium also doubled as a dining hall. At mealtimes every day, my father was required to stand at the entrance, banging on an old enamel washbowl, announcing to all that he was a rightist and a criminal. He soon became a familiar sight, and the workers would walk past him without a second thought, forming a long line at the

kitchen hatch. There they had to hand in their dish and food coupons and recite a quotation by Chairman Mao before the cook would ladle out a portion of food. The cook would recite a quotation at the same time, affirming his commitment to the revolution. Our life was a stage, with everyone automatically playing their appointed roles: Father's failure to appear at his usual spot at the entrance to the hall might indicate some greater misfortune was under way, and people would get anxious.

In this era of dreary routine and material scarcity, the kitchen served as the focus of people's imagination, even if little changed from one day to the next. Each morning the cook would mix cornmeal with warm water and place the dough into a meter-square cage drawer, then stack five such drawers inside an iron pot and steam them for thirty minutes. When the lid was lifted off, the whole kitchen would fill with steam, and the cook would carve up the corn bread vertically and horizontally, each square piece weighing two hundred grams. To show his impartiality, he would weigh the blocks publicly. This same corn bread would be served from the first day of the year to the last, except on May 1 (International Workers' Day) and October 1 (National Day), when the corn bread would acquire a thin red layer, made up of sugar and possibly jujubes. If someone was lucky enough to find a jujube in their corn bread, this would always stir some excitement. The company had large expanses of cornfields, but we never once had fresh cornmeal to eat, only "war-relief grain" that had been in storage for goodness knows how long: it scraped your throat roughly as you swallowed, and reeked of mold and gasoline.

Each one of us—Father, Gao Jian, and I—received an allowance of just 15 yuan a month, which at the time equaled a little over five dollars. So our combined income came to only 45 yuan a month, whereas a regular worker's pay was 38.92 yuan. Father smoked a cheap brand of cigarettes that cost five fen a pack and gave off an acrid smell, like singed wool; often a cigarette would stop burning after just a couple of puffs. Thanks to these cigarettes, Father's military padded jacket acquired several more holes. Matches were classified as "combat

readiness materials," and each family was allocated a single box per month. Often we would run out of matches, and to start a fire in the stove I would have to borrow a light from the neighbors.

To save money, my father switched to smoking the tobacco that the company itself grew. We would use old receipts to roll little paper cylinders, into which we would pour crumbled tobacco leaves until they were stuffed full. Every evening I would help Father roll some twenty cigarettes and then store them neatly in a blue-and-white china jar that had somehow managed to escape destruction during the Red Guard raids on our former home. The handle and lid were pure silver, and on the body of the jar were painted a little bridge over a stream and a page boy with a zither, next to a rocky outcrop, low-hanging weeping willows, and a thatched cottage, its wood-framed window half open. The jar brightened even the dimmest corner with the luster of its white porcelain and cobalt blue.

As night fell and an impenetrable darkness descended on the wheat fields outside, the insects kept up a constant drone. Father and I would sit on either side of our little table, the oil lamp casting our shadows—one big, one small—on the wall behind us. My mind was often as bare as the room itself, empty of imagination and empty of memories, and my father and I were like strangers, with nothing to say to each other. I would often simply stare into the lamp's jumping flame.

Sometimes, however, just when I was about to nod off, Father would begin to rummage through his memories and reminisce about his past. Gradually, I would be transported to the places he had been, meeting the men and women he had known, and gaining some understanding of his loves and his marriages. As he talked, it was as though I wasn't there. His storytelling seemed to have no purpose beyond making sure his stream of memories did not dry up. In Little Siberia, isolation forged a closeness between us, and material deprivation brought with it a different kind of plenty, shaping the outline of my life to come.

Hearts Are Burning

MY FATHER'S BIRTH WAS A DIFFICULT ONE. DURING HER pregnancy, my grandmother had a strange dream, in which her baby was stranded on a little island in the middle of a churning sea. This was an ill omen, family and friends agreed, and my grandmother, then just twenty and still observing Buddhist practices—she later converted to Catholicism—burned incense and prayed for good fortune every day, but anxiety lingered. The labor lasted two days and two nights, and she was tested to the limits of her endurance. But finally, from behind the silk curtains of a red-lacquer, gold-tinted canopy bed, there emerged an infant's piercing wail.

Grandfather already had a name in mind, selected not only to reflect the boy's place in the generational sequence but to uphold the family's moral standing and social prestige. Like a mother-of-pearl detail embossed on a lacquer vessel, the name would be inserted with scrupulous care into the lineage genealogy and would come to shape the future of its owner in unseen ways. Father's name was Haicheng, hǎi (海) meaning "sea" and chéng (澄) meaning "clear."

Father was born on the seventeenth day of the second moon in the second year of the Xuantong reign (March 27, 1910). According to

the traditional Chinese calendar, this day coincided with the spring equinox, when day and night are of equal length and all of nature is enjoying revival.

In the eyes of country folk, children born in that year "came out riding the dragon's tail." And indeed, within eighteen months, three hundred miles away in the city of Wuchang, progressive elements in the military staged a coup, launching the 1911 Revolution. Soon China's southern provinces were seceding from the Qing empire, one after another. In 1912, the Qing dynasty officially came to an end, and with it two thousand years of feudal autocracy.

In the eyes of the superstitious, an arduous birth was an inauspicious sign. Twelve days later, when Grandmother was well enough to receive visitors, Grandfather called in a fortune-teller, as was customary in such cases. The visitor first inquired about the precise time of the child's birth, and then asked the year, month, day, and hour of his parents' births. Then he began to take readings from the large compass he had brought with him.

After a long and suspenseful process of data collection, the fortune-teller presented a shocking prognosis: the newborn child was "at odds" with his parents' fate, and if they raised him at home he would "be the death of his parents." They understood this to mean that the baby should be cared for by someone outside the family. The joy of welcoming their firstborn was replaced by a feeling of dread that the child was a harbinger of family misfortune. Even if the boy survived into adulthood, the fortune-teller said, it would be best if he

never called them "Father" and "Mother," but rather "Uncle" and "Aunt."

The fortune-teller's gravity and apprehension affected my grandparents deeply. His reading of the situation seemed as solid and unassailable as the household effects surrounding them, and his grim forecast was carved onto my father's destiny like a birthmark.

My father was of course oblivious to the fortune-teller's visit. Off to one side, unaware of his miserable fate, he lay comfortably in a bamboo cradle, wrapped tightly inside a comforter embroidered with the words TEN THOUSAND JOYS, with only a lump on his head to show for the struggle of his prolonged birth.

My father was born into a landowning family in the village of Fantianjiang, in the northeast corner of what was then Jinhua prefecture, part of the coastal province of Zhejiang. My grandparents died long before I was born, but from the two portrait photos that survive, it seems there was a close resemblance between the two of them. If not for my grandfather's beard, husband and wife would look almost indistinguishable, both with round faces, high foreheads, hair combed back, and prominent eyes that curved down slightly in the corners. Dressed neatly, they wear kind expressions.

In his village of a hundred or so households, my grandfather, Jiang Zhongzun, was known as a man of culture. He named his den "Aspiring to Improvement Studio," and in it hung scrolls of his own handsome calligraphy that testified to his commitment to self-cultivation. In the reception room hung a wooden plaque carved with the words BLISS RESIDES IN FAMILY BONDS, which summed up his outlook more generally.

Grandfather owned a soy sauce shop and a general store that sold imported goods, and in addition to managing these businesses, he spent a good deal of time following current events and reading new books. He subscribed to *Shen bao,* a Chinese-language newspaper founded by a Londoner based in Shanghai. If a villager wanted to know what was going on in the world—the state of play in China's war with Japan, for instance—he could get some idea just by scanning

Grandfather's face. He also enjoyed poring over his world atlas, avidly followed new developments in weather forecasting, and read Thomas Huxley's *Evolution and Ethics*.

In the village he was considered a reformist and was among the first to cut off his queue, the long braid that signified Han Chinese submission to Manchu authority during the Qing period. He allowed the women in the family to unbind their feet and sent his two daughters to study at a Christian school founded by Stella Relyea, an American missionary affiliated with the American Baptist Foreign Mission Society, which at that time already had a quarter of a million adherents in China. Grandfather was also a member of the International Savings Society, a French bank in Shanghai. At that time, to deposit one's savings in a bank was viewed as a very bold move.

My grandmother, Lou Xianchou, came from a prominent family in neighboring Yiwu County. After Father, she gave birth to seven more children, three of whom died young, so Father ended up having two brothers and two sisters. Grandmother was warmhearted and generous and would often treat the hired help to a handful of melon seeds or peanuts. High school students who lived close by would regularly drop in to read the family's newspapers and magazines and chat with her. Although she could not read or write, she could recite some Tang poems and folk ditties and had a whimsical sense of humor.

In 1910, the year my father was born, my grandfather had just turned twenty-one. The Qing dynasty was nearing the end of its 266-year rule, while in Russia the fall of the czars and the advent of the Soviet regime were just seven years away. It was the year that Tolstoy and Mark Twain died, the year that Edison invented talkies in faraway New Jersey. In Xiangtan, in Hunan, seventeen-year-old Mao Zedong was still in school; his first wife, selected for him by his parents in an arranged marriage, died a month before my father was born. But Fantianjiang, like so many other Chinese villages, slumbered on, unremarkable and anonymous.

Not long after the fortune-teller's prediction, a baby girl was born

to a peasant family in Fantianjiang but then, at least according to one report, was immediately drowned by her mother, who deemed it more advantageous to serve as the wet nurse of the Jiang family's newborn son than to raise a daughter of limited long-term value. That sounds heartless, I know, but things like that did happen then—and are not unheard of today.

The baby girl's mother had been born to a family named Cao that lived in the nearby village of Dayehe (a name that translates to Big-Leaf Lotus). She had come to Fantianjiang as the child bride for a distant and impoverished member of Grandfather's extended family. Nobody in Fantianjiang bothered to learn her real name; they simply called her Big-Leaf Lotus, after her village. Then thirty-two years old, Big-Leaf Lotus began to nurse my father with her breast milk, thus supplementing her family income to support her hard-drinking husband and their five children. The locals considered her fortunate to have this opportunity.

Big-Leaf's home was just a short walk from the Jiang house. It consisted of two low-ceilinged rooms, their walls blackened by kitchen smoke, with a wooden bed in one corner and a rickety square table not far away. Cracks between the roof tiles revealed thin slices of sky, and outside the door a stone slab provided seating for Big-Leaf as she fed her suckling child.

This tiny cottage was where my father spent his days and nights, except for the New Year and other major festivals, when my grandparents brought him home for a few days.

The Jiang family compound had a main house with five rooms and two side buildings, each consisting of a two-story layout built of wood, with beams, eaves, and windows carved with auspicious designs and historical scenes. The courtyard, pleasant and tranquil whatever the weather, was laid with dark stone pavers, and orchids and asparagus fern grew in a stone bowl next to the rainwater catchment. Grandfather's compound and adjacent buildings were built in the same style and with the same materials. No two buildings were identical, but they were all tightly linked, like a woven brocade whose

every warp and woof were imbued with Confucian teachings. Their design employed creativity and painstaking skill to showcase the traditional order that had been carried on from one generation to another over many centuries.

Back at Big-Leaf Lotus's house, my father would eat sweet rice cakes, cured pork, and crisp buns stuffed with mustard greens, which he loved. Then he would sit on her lap in front of the fire and she would tell him stories. She was utterly devoted to him, and every time he called her, she would put down whatever she was doing and hold him in her arms, gently pressing her sun-beaten face against his pale one. Big-Leaf Lotus filled his early childhood with loving warmth.

Jinhua, the biggest town in the area, lay in a basin, with hills on all sides, bisected by two rivers that eventually merged and flowed northward. Fantianjiang lay twenty-five miles to the northeast of Jinhua, on the edge of Yiwu County. North of the village stood the mountain of Twin Peaks, which shone a warm color under the right sunlight. A spring gushed from underneath briar-shrouded boulders, while farther down, the clay soil, red with iron oxides, supported a variety of plants, including bamboo, camphor, fir, and walnut. Camellias, azaleas, pomegranates, and osmanthus also dotted the landscape.

Two ancient camphor trees stood on a rise just before you entered the village. It would have taken several people to link their arms

around one of their enormous trunks, and over the centuries their spreading branches had woven a broad canopy of leaves. One of the trees had a hollow in it big enough for children to play inside, and a niche in which an image of the Buddha had been installed. The villagers called this tree "the Old Lady," and would go there to seek blessings for their children.

My father was slow to start speaking and didn't really get going until he was three; some of the villagers at first thought him an idiot. At four he reached the age for schooling, so Grandfather brought him back from Big-Leaf Lotus's home and he began to live with his parents. In 1915, when he turned five, a privately funded primary school opened in the village, offering an art class conducted by a teacher skilled in painting and handicrafts. This triggered Father's interest in making things with his hands. Out of wood, he fashioned a miniature house with doors and windows that could be opened, and he put together a magic lantern as beguiling as a kaleidoscope. One winter day, when his mother gave him a brazier to warm his hands, he picked it up and swung it from side to side, making the charcoal hiss and pop, to the surprise and delight of his younger siblings. Seeing how absorbed Father became in making objects, Grandfather would say mockingly, "How about I send you off to the workhouse for the poor?" In those days, handicrafts were accorded little respect.

Grandfather found other reasons to be dissatisfied with his eldest son. Once, a sparrow deposited droppings right on top of Grandfather's head. Considering this bad luck, he gave Father a wooden bowl and told him to fetch a special herbal tea from the neighbors to "purge misfortune." Father made no move toward the door, feeling the errand was beneath his dignity. Angered by this act of defiance, Grandfather grabbed the bowl and clamped it down on top of my father's head so hard that its rim scratched his scalp and drew blood.

His aunt (the wife of Grandfather's older brother) was shocked, took him aside, and fried him a couple of eggs as a consolation. "If he beats you again," she said, "I'll fry you another egg, how about that?" Father nodded his approval. Later he wrote a note that read, "Dad

beat me—what a brute!" Grandfather found the note inside a drawer, and after that he never beat his son again.

Father's childhood was never very happy, and as time went on his relations with his parents only grew more strained. Once Father said to his little sister, "After Mom and Dad die, I'll take you to Hangzhou"— the provincial capital of Zhejiang, more than ninety miles away. Grandmother overheard this and summoned him to the hall. She took two strings of coins from the money chest and hung them around his neck, saying, "If you want to leave, then leave right now—no need to wait till we're dead." Father stood there silently as she scolded. By then, he was already carrying a secret around inside him: one day he would go far, far away; he would see much more of the world than the villagers had and would visit places they had never even dreamed of.

SOON AFTER THE END of the First World War, in the spring of 1919, the Allied powers convened a conference at the Palace of Versailles, near Paris, to decide the peace terms, and China took part as one of the victors. But the Paris Peace Conference paid no heed to the Chinese delegates' demand for territorial integrity, instead awarding Germany's colonial holdings in Qingdao and Shandong to Japan. When the news reached China, it sparked nationwide protests.

On May 4, some three thousand students from Beijing's universities gathered in protest in front of Tiananmen, the imposing gate that marked the southern entrance to the Forbidden City, demanding the defense of national sovereignty and the ouster of Chinese officials accused of collaborating with the Japanese. This surge of nationalist sentiment, which became known as the May Fourth Movement, soon spread across the nation. At the same time, China's intellectuals, convinced that drastic cultural change was needed if their country was to shed its backwardness and avoid further humiliations, began to agitate for "Mr. Democracy" and "Mr. Science" (the "Mr." prefix convey-

ing deference to a teacher) and to criticize Confucianism and the traditional moral order that had underpinned imperial rule. Crying "Down with the Kong Family Shop!" (a derogatory reference to Confucian ideology), they called on young people to wake up to China's crisis, extolling freedom, progress, and science. These ideas were already influencing local education in Jinhua, and Father's elementary school textbooks now imparted the rudiments of democracy and science.

Inspired by the Russian Revolution, a number of Chinese intellectuals, led by Chen Duxiu and Li Dazhao, began to promote Marxism-Leninism. In June 1921, Lenin sent a Comintern delegate operating under the pseudonym of Maring to Shanghai to preside over the first congress of the Chinese Communist Party. Preparations for the meeting were made in an atmosphere of fear and tension, and to avoid the prying eyes of the Kuomintang government the venue was switched to a boat on the South Lake in Jiaxing, a town sixty miles away.

In the party's program appeared, for the first time, concepts like "working class," "class struggle," "dictatorship of the proletariat," "elimination of the system of capitalist ownership," and "coalition with the Third International." Perhaps because Chinese equivalents of these terms had not been devised, the congress documents were printed in Russian. In addition to Maring (a Dutch Communist whose real name was Hendricus Sneevliet), one other foreign delegate attended: a Soviet citizen, "Nikolsky," whose true identity would remain a mystery for almost half a century, until with the help of Gorbachev a Russian archive revealed that his name was Vladimir Abramovich Neiman-Nikolsky. On Stalin's orders, he was shot in 1938 on a charge of spying. Thus did the Chinese Communist Party begin its long and checkered history.

In 1925, at the age of fifteen, my father was admitted as a boarder to Jinhua's Seventh High School, located in a former Taiping prince's mansion, an imposing edifice with a lofty central hall. It was a boys' school, and most of the pupils were the sons of well-off gentry from the surrounding villages. Under the influence of progressive trends

that were sweeping the country, Father identified with Western democratic and republican values and admired the so-called New Literature, a form of writing based on the spoken vernacular. Once, in an examination, the class was asked to write an essay in the classical language and Father defiantly wrote one in the vernacular instead, entitled "Every Era Has Its Own Literature." His teacher was not impressed. "Half-baked ideas!" he scoffed. Even today, my father's naive advocacy of a literature that is true to its age can make little headway in China.

While Father was away at school, Big-Leaf Lotus died at the age of forty-six. Her five sons wept bitterly, and even her husband, prone to curse and beat her whenever he drank too much, shed some tears. She had lived her life in poverty, and on leaving this world all she got was a flimsy coffin. But her early death meant that she no longer needed to fret about what would happen when her husband died, or worry because her eldest son had become a bandit, or grieve for her second son, killed in a battle, or wonder how her third, fourth, and fifth sons were going to eke out a living. In a poem Father wrote years later to commemorate her life of struggle and hardship, he imagined his foster mother dreaming of attending his wedding and being greeted warmly as "Mother-in-Law" by his lovely bride, in wistful recognition of the critical role she played in his early years.

At school, Father was now all the more enthralled with art. In math class, on the pretext of needing to use the toilet, he would run off and draw from nature, slipping back into the classroom only when class was about to finish. When he came home for the summer holidays, Grandfather asked him to keep an eye on the rice fields, but he would take his siblings to sketch at a Buddhist temple half a mile away instead. The temple had been built in early medieval times, with ancient cypresses in the courtyard that reached up high toward the sky. Inside the main hall stood a statue of a big-bellied Maitreya beneath a couplet that read, "Big Belly can accommodate all that cannot be accommodated / Laughing Mouth laughs at all who are laughable." In keeping with the rebellious spirit of the time, Father

nonchalantly took a pee next to the Buddha, to show his disdain for religion.

IN MAY 1925, as Father was preparing for his middle school exams, thousands of students in Shanghai poured into the streets to protest the mistreatment of Chinese workers by Japanese businesses. Armed police were dispatched to arrest the protesters, and on the afternoon of May 30, when students and residents demonstrated and demanded the release of those arrested, British constables opened fire. More than twenty people were injured or killed. After the massacre, there were nationwide strikes and boycotts pressing the government to abolish the colonial outposts established in China by foreign powers. From the mid-nineteenth century on, Western nations had created areas in China's outposts that were governed by foreigners, in violation of China's sovereignty. In enclaves such as the Shanghai International Settlement and Shanghai's French Concession, such administrations controlled civil affairs, tax collection, judiciary, law enforcement, education, transportation, postal and telecommunication services, public works and utilities, and sanitation, and they even stationed troops—operating, in effect, as a state within a state.

In Jinhua, Father's high school launched a movement to show solidarity with the demonstrators in Shanghai. Students marched through the streets of the town, brandishing flags, shouting anti-Japanese slogans, and urging workers to strike and merchants to close their stores. They smashed shop signs and window displays, ransacked warehouses in a search for imported goods, and set fire to stacks of British and Japanese products on the riverbank. Inspired by this revolutionary fervor, Father was determined to go to Guangzhou and enroll in the Republic of China Military Academy. When Grandfather learned that his eldest son wanted to abandon his studies, he was so furious he refused to speak to him. Given Grandfather's strong opposition to the idea, Father had to give it up.

In 1927, the uneasy alliance that had formed between the Nationalists and the Communists ended abruptly. On April 12 of that year, after Nationalist forces reached Shanghai, Chiang Kai-shek, their commander in chief, issued orders to arrest and kill Communists, whose success in mobilizing workers he saw as a threat to his authority. The effects of the clampdown were soon felt in provincial towns like Jinhua. One morning the school principal told all the students to assemble in the playing field. Ostensibly it was to hear an address, but actually the school authorities wanted to have free run of the dormitories so they could search for banned items. Father slipped away and climbed through the back window of his dorm room, where he extracted a pamphlet he had been reading—Plekhanov's *Materialist Conception of History*—and managed to dump it in a drainage ditch before he could be caught. This mimeographed pamphlet had inspired him to study Marxism, a worldview that would leave a heavy imprint on his life.

In the fall of 1928, after graduating from high school, Father was admitted to the painting department of Hangzhou's newly established National Art Academy. Its inaugural class comprised some eighty students, and most of its instructors had received art training abroad. In art school, Father found a refuge from political turmoil.

Hangzhou was celebrated for the beauty of its nearby West Lake, and whenever he had the chance Father would pack his equipment into a knapsack and head out to do some painting. By the lakeside woods or among the surrounding hills and fields, he would painstakingly record scenes that caught his eye, in the subdued gray tones that he favored. He was a diligent student, with a country boy's love of nature. Socially he maintained an awkward reserve, but he felt a deep sympathy for the poor and the suffering. Peddlers, boatmen, and cart pullers, as well as the impoverished owners of thatched cottages and their grimy-faced children, were all regular subjects of his art.

The West Lake's misty mornings and ever-shifting moods left Father with a vague sensation of loneliness and melancholy, and he never truly felt settled in Hangzhou. His life took a new direction

when one of his pictures caught the attention of Lin Fengmian, the then twenty-eight-year-old principal of the art academy, who had spent several years in France in the early 1920s. "You won't learn anything here," Lin told my father. "You ought to study abroad."

The study-abroad trend had begun with the Self-Strengthening Movement (1861–1895), when the Qing government, beset by both internal and external threats, sought to develop Western-style industries, communications, and financial services. Officials realized that sending students to the West to study could play a crucial role in gaining a mastery of Western science and technology. In the wake of the First World War, France was in urgent need of labor and began to accept Chinese students to work-study programs. Some of them— most notably, Zhou Enlai and Deng Xiaoping—would go on to become prominent figures in the Chinese Communist Party. Inspired by a faith in Communism, Chinese youth began to search in Europe, the fountainhead of Marxism, for new ideas and new theories that might remedy China's ills.

Lin Fengmian's advice made a deep impression on Father. But if he was to study abroad, he had to persuade Grandfather. When he went home for the winter holidays, he brought one of his teachers with him to help make his case. "If he goes abroad," the teacher said, "he can make a lot of money when he comes back."

Grandfather was skeptical, but he finally gave in. He pried up a floorboard and lifted out a large pot full of silver dollars. A silver dollar had considerable value in China at the time: it could buy you sixteen pounds of rice, six pounds of pork, six feet of cloth, or in some places even a small plot of land. With a grave expression and trembling hands, Grandfather counted out eight hundred of these coins— sufficient funds to cover the cost of my father's boat ticket and living expenses for the first few months in France—at the same time enjoining him to be sure to come back at the end of his time abroad. "Don't enjoy yourself so much that you forget your home."

On the day he left, the morning sun spilled across the stone pavers as Grandfather accompanied Father to the edge of the village. Father

soon banished from his mind the high hopes that Grandfather had invested in him: his thoughts were focused on the road ahead, and he couldn't wait to put distance between himself and those tired fields and the barren little village, to begin his solitary wanderings, roaming free.

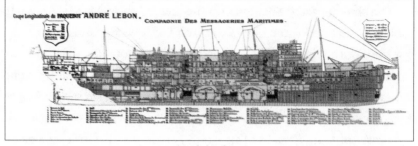

André Lebon

AT THE SHANGHAI WATERFRONT, thick ropes secured the French packet steamer *André Lebon* to the black iron bollards in Shiliupu Docks. The ship's olive-green prow rose high out of the water, and steam billowed from its two brick-red funnels, obscuring the banks and Western businesses that lined the riverbank. The steamer measured 528 feet from bow to stern, bigger than a small village and almost too long to see from one end to the other. A constant clamor rose from vendors hawking their wares, from rickshaw pullers, barefoot stevedores, porters shouldering heavy steamer trunks, and travelers of all descriptions lugging their personal effects.

With a population of three million, Shanghai in the late 1920s was almost as large as London, New York, Tokyo, or Berlin. The Shiliupu (District 16) Dock, built in the 1860s during Shanghai's early days as a treaty port, was now the most bustling and frenetic place in the city. The Chinese laborers who were packed off to Europe during the First World War and the young people who went there to study in the postwar years all set off on their journeys from here.

Father was one of hundreds of passengers who made their way up the gangplank and onto the *André Lebon*. Once he found a berth in third class, he set down his luggage and art supplies, feeling like a rice

weevil packed inside the vessel's cavernous hold. His cabin was narrow and crowded, the bunks packed close together. Soon the engines began to roar, and heat from the engine room, mixed with the smell of cargo, filled the corridor with a rich aroma. The ship's horn echoed as Father watched the wharf gradually disappear into the distance.

The ship departed Shanghai on the afternoon of March 9, 1929. It took two days and three nights to reach Hong Kong, and after crossing the South China Sea it stopped in Saigon for four days to load cargo. In the bill of lading that was part of the navigational log kept by Captain Auguste le Flahec, the cargo included 20,220 sacks of rice, 2,958 sacks of flour, 3,941 crates of rubber, 562 sacks of coffee beans, 1,951 cases of tea, 477 sacks of tin ore, 899 bales of silk fabric, 408 bales of raw silk, 470 sacks of peppercorns, 300 sacks of gallnuts, and other miscellaneous produce, for a total weight of 3,121 tons. As he watched the derricks depositing the wealth of the colonial ports into the ship's hold, Father felt an agitation inside, one that would never fully subside during his time abroad.

By March 27 the ship had traveled as far as Maliku Atoll, off the southern tip of India. Father, buried in his French grammar, completely forgot it was his birthday. Four days later, they reached the port of Aden, and from there it was on to Djibouti, on the Horn of Africa. After a leisurely passage up the Red Sea, they traversed the Suez Canal and my father got his first glimpse of the Mediterranean. The last, stormy leg of the voyage delivered them, via Sicily, to Marseille, on April 12, 1929, a Friday. There my father boarded a train to Lyon, and from there it was a simple journey to Paris.

PARIS IN THE 1920S impressed visitors with its bustle of cars and trams and expanding Métro network. To a young Chinese student like Father, it must have been eye-opening to observe the freedoms enjoyed by Parisian women, who were able—without eliciting much

comment—to smoke in public, cut their hair short, dress daringly, and participate in sports. Ernest Hemingway would famously recall Paris in the 1920s as a "moveable feast," but George Orwell's description of life in a Paris slum paints a less glamorous picture: "It was a very narrow street—a ravine of tall, leprous houses, lurching towards one another in queer attitudes, as though they had all been frozen in the act of collapse. All the houses were hotels and packed to the tiles with lodgers, mostly Poles, Arabs and Italians. At the foot of the hotels were tiny *bistros*, where you could be drunk for the equivalent of a shilling. On Saturday nights about a third of the male population of the quarter was drunk." My father would have recognized the Paris that Hemingway and Orwell depicted, but his own memories took a different form.

Initially, to keep their housing costs low, Father and a couple of friends chose not to live in central Paris at all. Instead they found lodgings in Fontenay-aux-Roses, six miles southwest of the city center but connected to Paris by a tram service. There, Father moved into the home of a Frenchman named Grimm, a rough-and-ready fellow who drank heavily and gave Father his first job, in a bicycle accessory shop. Later he moved into a lodging house, the Hôtel de Lisbonne, on the rue de Vaugirard in the Sixth Arrondissement. His room was tiny and had a noisy pipe running through it, but the rent was cheap. The Portuguese landlady was a kind old soul who did not make a fuss if he fell behind with his payments.

Father eagerly explored museums and galleries, and every afternoon went to sketch models at the "Atelier Libre" in Montparnasse, where the low admission fee attracted aspiring artists like him. He was skilled at capturing movement with simple lines. He loved the colors and lyricism of Marc Chagall's figures and landscapes and was entranced by the daring innovations of the Impressionist painters.

One happy outcome of this immersion in the French art scene was that one of his own pictures was selected for a spring exhibition at the celebrated, trendsetting Salon des Indépendants. It was a small

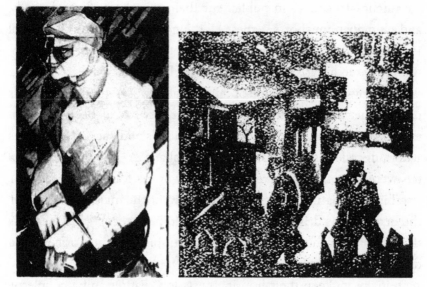

Works by Ai Qing, 1929

oil painting of an unemployed laborer, inspired less by his political leanings than by his feelings as an outsider. But its acceptance into the show bolstered his sense of self.

One single black-and-white photograph survives as a visual record of my father's stay in Paris. Four young men cluster together in a meadow; among them, standing to the left of an easel, is my father, his hair combed back, brush and palette in hand, very much the young Asian artist. His body looks all the slighter under his large head, and his eyes are fixed directly on the camera in a concentrated and confident gaze.

Within a few months, Father had spent all his money. Grandfather sent him two more installments, but after that he refused to dispense any more handouts, so Father had to start working part-time to make ends meet. Every morning, in a workshop run by an American named Douglass, he would decorate cigarette boxes, writing customers' names on each one. In a single morning Father could paint twenty cigarette boxes and earn twenty francs. In this way he made six hun-

dred francs a month, and after spending fifty francs on rent and ten or so each day on meals, he would use the remainder to buy books and art supplies and cover his daily expenses. Within a few months of the stock market crash of 1929, however, the workshop was forced to close.

During the First World War, France had recruited some thirty thousand Chinese "coolies" to support the war effort. As one French general recalled, they were "good soldiers," stoically enduring even the fiercest bombardments. When the war ended, some stayed on in France, and thus a Chinatown neighborhood had developed in Paris, with a number of restaurants run by people from Wenzhou, a coastal town not far from Jinhua. Chinese expatriates, no matter their place of origin or how many years they had spent in France, were all united in their craving for Chinese food and made regular visits to these eateries.

One day Father was eating in a Chinese restaurant when he noticed, in the corner opposite, another young Asian man, with a thin, pinched face and unruly hair. Father's curiosity was aroused when the other diner lingered long after finishing his meal, throwing glances regularly at the clock and at the street outside. Father realized he must be short of money, so he went over and paid his bill and the two of them left the restaurant together. Thus began a lifelong friendship.

The young man's name was Li Youran. Like Father a native of Zhejiang, and four years his senior, he was studying philosophy at the university and was a good deal more politically engaged. A member of the Chinese Communist Party branch in Europe, he had published essays in *Chi guang* (*Red Light*), a progressive journal that Zhou Enlai had launched ten years earlier.

Li accompanied Father back to the Hôtel de Lisbonne and found that his tiny room contained little more than some picture albums, poetry collections, and a jumble of painting materials. He was moved that Father had paid for his meal despite his own dismal living situation, and was impressed by Father's dedication to his art. From that

day on, the two shared their earnings, and if necessary would borrow from a third party to help each other out. Father introduced Li Youran to art, while Li encouraged Father to read more philosophy and literature. Father was not interested in getting a university education, but he was willing to let Li Youran take him to listen to some public lectures, where he would often amuse himself by sketching the bald-headed speaker.

ALMOST FIFTY YEARS LATER, when the Cultural Revolution had just come to an end and we were finally able to return to Beijing, I at last got to meet this old friend of my father's. Li Youran was about to turn seventy, and he tottered a little, his slender frame bundled up inside a blue jacket.

In the intervening decades they had both suffered through one political campaign after another, and it was a miracle that they were still alive. When Father and Li Youran saw each other once more, their excitement was palpable. With humorous gusto they recalled the past, exchanging inquiries about where so-and-so had ended up and what their situation was now. It was clear they saw themselves in each other's eyes, like two pieces of a broken stone fitting together seamlessly. With grins on their faces they clasped hands and embraced while their stories spilled out in heavy southern accents. Memory was like a rope they could clutch as they made their way forward, or use to haul themselves back to days that had passed.

That day I walked Li Youran back to the bus stop. Outside the Xidan shopping mall, the wind was so strong we had to push against it in order not to be blown away. Speaking loudly over the wind's roar, Li Youran recalled how he and my father, stomachs empty, would roam through the boulevards and squares of Paris, whistling tunes and kicking pebbles as they went. As he spoke, I could almost hear the sound of those pebbles as they skipped across the street.

——

AS A FOREIGNER IN PARIS, Father felt isolated and his desire for knowledge deepened. He would spend hours browsing the bookstalls that lined the Seine, and if he had a little cash on hand he would buy a book and bury himself in it. This period of intensive reading prompted him to think more about the world, and painting often gave way to reflection. At times, the machinery of the modern city and the clamorous street life helped to alleviate his loneliness. Paris reshaped his aesthetics, prompting him to learn and absorb a new culture, and when he painted he began to daub his canvases with brighter colors.

Father took French lessons from a young Polish woman who had graduated from the University of Warsaw and was now pursuing an advanced degree in psychology. Three times a week, at seven in the evening, she would come to his lodgings for conversational practice. She was delighted to see volumes of poetry on Father's desk, and they had long talks about the Russian poets Yesenin and Mayakovsky. It was the first time in Father's life that he had a soul-to-soul exchange with a member of the opposite sex.

At dusk one day, Father paced back and forth in the shady lane next to the university library where his Polish friend studied. They had arranged to meet at the entrance when the library closed, and he had arrived early. He often felt that he was waiting for something to happen, and this was just such a time. One by one the lights inside were extinguished, and then the young Polish woman emerged. She greeted him cheerfully and they began to stroll side by side. For the first time, Father was aware of how self-conscious he felt being her escort, and he forced himself to keep a certain distance from her as they walked.

Not long after, her mother came to take her back to Poland. When he visited her to say goodbye, his young friend asked questions she had not asked before. How big was his family? Were he and his sisters close? How long would it take to get to China?

"Thirty-five days" was his answer.

"Oh, that's so far away!" She looked away in dismay and her eyes welled up with tears.

As he was leaving, Father presented her with a book, with an inscription on the flyleaf: "When you pick up this volume, you will remember a young man from the Orient."

DURING HIS TIME IN Paris, Father seldom felt an urge to rest; some nights he could hardly sleep at all. A nineteen-year-old from a foreign land, he found his life completely disconnected from his recollections of the past. Excitement and anxiety, ambition and insecurity made his head burst with ideas and emotions, and as thoughts came to him he would jot them down in his sketchbook, no matter how early or how late the hour. To allow his brain some temporary rest, he would resort to going up and down the stairs or pacing the boulevards among the teeming crowds. For solace he turned increasingly to literature, and to poetry in particular. He admired prose works by Russian authors, including Gogol's "The Overcoat," Turgenev's *Smoke,* and Dostoevsky's *Poor Folk,* but was drawn especially to the poetry of Blok, Mayakovsky, Yesenin, and Pushkin.

For Father, poetry came to acquire a lofty, almost holy status. He identified strongly with a devotion to the creative, expressive life articulated by Apollinaire (whose line "I had a flute then, which I would not have given away even for a French marshal's cane" he liked to quote) and Mayakovsky (who had detailed his needs as "a pen, a pencil, a typewriter, a telephone, an outfit for your visits to the dosshouse, a bicycle"). When he first heard news of the Russian poet's suicide in 1930, he fell into a funk, as though he had lost a dear friend.

Father had a special fondness for the socially engaged poetry of the Belgian author Émile Verhaeren, and later in life he would carefully translate into Chinese a selection of his poetry under the title *Yuanye yu chengshi* (Field and town). To him, Verhaeren possessed

both a modern, clear-eyed rationality and emotions that were stronger and more complex than one could find in any earlier writer. Of Verhaeren he would say, "He alerted his readers to the rampant growth of cities in the capitalist world and the spectacle of so many villages on the verge of extinction."

In his own writing, Father searched for a language that would capture social realities and emotional feelings. "I feel sick every time I find myself making use of some conventional expression," he wrote. "It disgusts me when a poet trades in hackneyed phrases." Inspired by the experiments of the French Surrealists, he filled his sketchbook with fleeting sensations, in the style of André Breton's "psychic automatism."

Under Li Youran's tutelage, Father began to get some exposure to revolutionary Soviet films, screened in the so-called Lenin Hall, in a working-class district of Paris. And one evening he and Li Youran went to 61 rue Saint-Jacques, in the Latin Quarter, and attended a meeting of young progressives from East Asia. Afterward, he wrote his earliest poem, "Gathering."

> *A cluster here, a cluster there, we sit in clouds of smoke*
> *A clamor swirling around the tables*
> *Voices both high and low*
> *Mild, passionate, explosive views*
> *Burning faces bobbing under the lamplight*
> *Snatches of French, Japanese, Annamese, Chinese*
> *Simmering in all four corners of the hall*
> *Unkempt, bespectacled, puffing on cigarettes*
> *Perusing letters, reading the papers*
> *Deep in thought, frustrated, excited, silent*
> *Ruddy lips in constant motion*
> *Words spilling forth like sparks*
> *Every gaunt and struggling face*
> *Every straight or bending body*
> *Paints a sad, dark shadow.*

They shout and yell and rage
Their hearts burning
Their blood churning
They come from the East
Japan, Annam, China
Loving freedom, hating war
In a fury over these things
In anguish over them
Working up a sweat
Tears in their eyes
Hands clenched in a fist
Pounding the table
Yelling
Screaming
The windows tightly closed
Hemmed in by the darkness outside
As the rain drips dolefully on the windows
Inside is full of warmth
The warmth flowing over every face
Warmth surging into every heart
Everyone breathing the same air
Every heart burning with the same fire
Burning, burning
In this dead Paris
In this dead night
61 rue Saint-Jacques is alive
Our hearts are burning.

Within ten days of writing this poem, Father set off on the journey home.

—

Snow Falls on China's Land

Unless a grain of wheat falls into the earth and dies,
it remains alone; but if it dies, it bears much fruit.

—AI QING, "THE DEATH OF
A NAZARENE," 1933, QUOTING
JOHN 12:24

IN LITTLE SIBERIA, FATHER SOMETIMES WOULD TALK OF HIS time in Paris, especially during the long, cold winter, when potatoes and onions were all we had in the kitchen cellar. To me, Paris seemed like an impossible other world.

But in the summer, green beans and cucumbers hung from the trellis, and there were carrots and ruddy tomatoes and jumbo-size gourds. The vegetables and fruit grown by members of the Five Black Categories were both good-looking and delicious. These fresh crops brought color to our drab lives, and as children we eagerly joined the harvest.

The sandy soil and desert climate also favored the growth of large watermelons, which the grower would share with us children, splitting each fruit into two not with a knife but with a firm slap. Then my playmates and I would plunge our hands into the bright red pulp, scoop out huge mouthfuls, and gulp them down. Watching us gorge

ourselves, the grower would remind us not to swallow the seeds: what we spat out would serve to grow the next year's feast.

The company owned some four hundred sheep, but never once were we served lamb. Except in spring, when their wool was shorn, we had to keep our hands off them, and the meat all went to the state. But one day the sheep found their way into a field of alfalfa, a rotation crop used to improve the alkaline soil, and nobody was able to drive them out. If you did manage to drag one away, another would scamper right back in to resume munching on the tender leaves. The shepherd, a mute, was so desperate he was jumping up and down in anguish. The sheep just kept on gobbling down the alfalfa, to the point that they collapsed on the ground and couldn't get up again because their bellies were so bloated. As the sun went down, their gray eyes straining, the sheep died slowly, one by one. Given the paranoid atmosphere at the time, this disaster was seen not as a random mishap but as a grave political incident.

But for us, there was upside. At the cost of only two mao, I procured a sheep's heart, liver, lungs, guts, stomach, and head, which were all unceremoniously dumped into my bucket, creating a steaming hot, rank-smelling potpourri. I washed the body parts, first turning the guts inside out and dumping what was inside—an astonishing amount—and rinsing them until clean. I then soaked them in salt water and scrubbed until all the smell was gone, and finally tossed them into boiling water. I washed the lungs by pouring water down into the cavity through the air passage, while slapping the lobes until they swelled up as though about to explode, at which point a muddy fluid oozed out. I kept on doing that until the water ran clear. What I remember most clearly was the rare joy on my father's face when I brought the boiled innards to the table along with a heaping plate of sheep's head.

However dismal his days, meals had a way of stirring my father's enthusiasm. He carried with him happy memories of childhood treats, but when in prison or in exile the quest for food mingled with the sour taste of humiliation.

IN PARIS, A CAFÉ not far from Father's lodgings sold a kind of cus-
tard brioche known as a *chinois*. It bothered him that a pastry he had
never eaten in China was called a "Chinese," and he found it irksome
when at breakfast he heard customers saying, "Give me a few *chinois*."
Once, when in conversation with a friend, somebody shouted at him,
"Chinois, you can't speak that lingo here. In France, we speak French."
Another time, when Father was painting *en plein air* on the outskirts
of town, a tipsy Frenchman staggered over, threw a glance at his can-
vas, and cried in derision, "Hey, Chinois! Your country's a mess, and
here you are painting away!" The Frenchman's casual scorn crystal-
lized the indignities he had suffered in this alien land, and an urge to
go home seized him suddenly and forcibly.

The political situation in China had shifted while my father was
abroad. The Chinese Communists had mounted a series of insurgen-
cies against the Nationalist government, temporarily establishing
control over various parts of south China. In the Great Depression
that followed the stock market crash of 1929, unemployment in Japan
rose to 2.5 million, and the Japanese militarist government saw Chi-
na's resource-rich northeast as an economic lifeline.

By September 18, 1931, Japanese troops occupied the city of
Shenyang, the old Manchu capital, and in the months that followed

they brought all three of China's northeastern provinces under their control. As relations between China and Japan deteriorated, the French government, eager to protect its own interests in China and Indochina, adopted a passive stance to the Japanese aggression. By January 28, 1932, when Japanese amphibious troops launched an attack on the Chinese garrison in Shanghai, Father had left for Marseille and boarded a steamship heading back to China.

Father would look back on those three years in Paris as the best in his life—never again would he experience such freedom and leisure. No longer was he a boy from the boondocks, painting landscapes on the banks of the West Lake—he was now a young man, with an independent mind and the confidence to express himself. The intellectual nourishment and idealistic notions he acquired in France would help him chart a course through the tumultuous years ahead.

Grandfather must have been sorely disappointed when Father returned to Fantianjiang in 1932 with neither a diploma nor any other evidence of achievement in hand. Other relatives eyed him curiously, not sure what to make of him. He stayed in his father's house most of the time, glumly browsing the books that filled the bookcases. Occasionally he would regale his younger siblings with stories about life in France, or busy himself making Go pieces with bits of strawboard and teaching them how to play the game. To him the village seemed like a stagnant pond, and whatever was happening in the outside world failed to stir even the slightest ripple. Home felt more foreign to him than ever.

In May 1932, Father left once more for Shanghai. In the early decades of the twentieth century, Britain, France, and other countries had established foreign concessions there, and with these concessions came Western banks, newspapers, and missionary-run universities, along with other trappings of modern civilization: a racecourse, cinemas, automobiles, streetlamps, department stores, fire stations, and flush toilets, not to mention bars, dance halls, nightclubs, and even beauty contests. At the time, Shanghai was the fastest-growing city in

East Asia, and with its multitude of colleges, bookstores, and publishers, it attracted many educated young people like my father.

In Shanghai, Father made a new friend named Jiang Feng, a young man his age from a working-class family, short in stature but with a strong and tenacious character. Jiang Feng was an introspective type with an artistic bent who had taken part in various union activities and made woodblock prints that portrayed workers on strike.

My father lived with several other young artists at 4 Fengyu Lane, a noisy communal space in a small two-story building on rue Porte de l'Ouest. Through Jiang Feng he was introduced to the League of Left-Wing Artists, and soon they established the Spring Earth Painting Club as a base for the league's activities. Father drafted its manifesto, which read in part, "Like other forms of culture, art grows and evolves along with the tides of the era, and so modern art must inevitably follow a new road and serve a new society. Art needs to constantly advance, fulfilling its role in educating and organizing the masses." Father was beginning to align himself with a revolutionary agenda, one that valued culture as a vehicle for grounding theory and ideology in visible forms of expression.

On July 12, 1932, while the Spring Earth Painting Club was hosting a class in Esperanto—the constructed language then popular in progressive circles—detectives from the French Concession police force suddenly descended on the venue. When they entered, Father was sitting on a shabby old sofa. A policeman turned to him and asked, in stiff French, "Are you a Communist?"

"What do you mean, 'Communist'?" my father replied innocently. He was not a party member at the time, although—unbeknownst to him—plenty of his friends were.

"Don't waste your time on him!" the inspector barked. He then threw open a wooden trunk and pulled out a poster that depicted Chiang Kai-shek, the Chinese head of state, sprawling on the ground and licking a pair of army boots that symbolized Japanese imperialism.

"What's this?" the inspector asked.

"It's a protest against imperialism!" my father answered in French. "Surely France allows such things? Don't Henri Barbusse and Romain Rolland oppose imperialism?"

Another poster pictured a crowd of workers marching out of a factory in protest, brandishing red flags. "So what's this then?" the inspector cried triumphantly, slapping my father in the face. He, Jiang Feng, and ten others were taken into custody. In Father's lodgings they seized the *Collected Works of Lenin,* copies of the French Communist newspaper *L'Humanité,* and some books he had brought back from France.

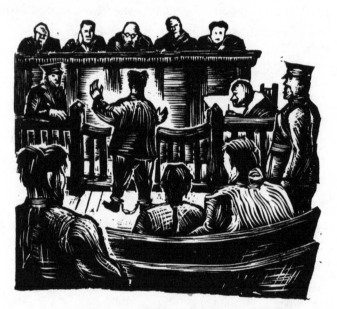

The Trial, 1936. Woodblock print by Jiang Feng of
Ai Qing in court

On the grounds that he had violated China's laws by "causing a public disturbance through Communist Party activities," Father was referred for prosecution by the Jiangsu Provincial High Court, and the case was filed that very day. The evidence consisted of items from Father's room and the League of Left-Wing Artists' records, including its constitution, its list of members, and the minutes of its meetings, as well as posters and other promotional materials. The court established

to its satisfaction that the Spring Earth Painting Club was an organ of the League of Left-Wing Artists, bent on "damaging the republic," a vague charge much like the political crime of "inciting the subversion of state power," of which I would be accused in the following century.

In the courtroom, the elderly presiding judge sat in the middle, with one judge on either side. Asked whether he was "a Communist Party leader," Father answered in the negative. When asked his occupation, he said "sketch artist." The presiding judge wasn't sure what he meant by this and glanced at his colleagues, who were equally perplexed.

Three days after Father's arrest, my aunt Jiang Xihua rushed back from Shanghai to Jinhua to get funds from Grandfather so that the family could hire a defense attorney. But by the time she returned, the court case was already in its final stage and the judge was about to announce the verdict. When Father was told he had been sentenced to a six-year prison term, he could not help laughing. It had never occurred to him that he would have to spend the next few years in jail. Of the people arrested with him, he was given the heaviest sentence, perhaps because of his defiant attitude.

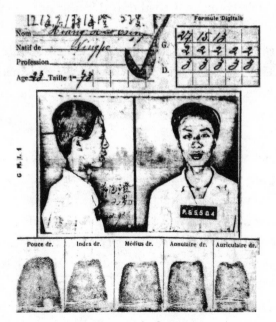

Prison record of Ai Qing

The prison in Shanghai's Second Zone, located at 285 rue Massenet, was known as Massenet Prison. It held some three thousand inmates, including many political activists. Father shared a cell with twenty other prisoners. At night, only half of them could fit onto the communal bed and the rest had to sleep on the concrete floor. The waste bucket was emptied only once a day, and the cell stank of urine and feces. Before long Father came down with a debilitating fever and was diagnosed with tuberculosis. He was transferred to a quarantined "sick bay," but medicine was in short supply and his condition continued to worsen. Luckily, his friend Li Youran, now back from France, managed to smuggle medication into the jail and bribe a prison doctor to give him proper treatment.

On the night of January 14, 1933, as a heavy snow began to fall, Father sat beneath his barred window and thought of his native village. He remembered Big-Leaf Lotus, who had given him so much warmth and love. Unable to sleep, he wrote a long, deeply affectionate poem in colloquial Chinese, recalling his wet nurse and other penniless country women who had equally difficult lives; in his own suffering, he felt connected to them. (Having only ever heard his nurse's name and never seen it written down, he rendered it in his poem as "Dayanhe," realizing only later that it should have been "Dayehe.") The poem's first reader was an inmate in shackles, facing a death sentence. In his soft, lilting Suzhou dialect, the man read the poem line by line, and it brought him to tears.

> Dayanhe, seeing the snow today makes me think of you:
> Your grassy grave now weighed down with snow
> The dead weeds on the roof of your derelict house
> The little garden plot that had to be mortgaged off
> The stone bench by the doorway all covered with moss
> Dayanhe, seeing the snow today makes me think of you.
> Dayanhe, today your suckling is in prison
> Writing a song of praise for you
> For your purple soul beneath the yellow earth

For your open arms with which you hugged me
For your lips that kissed me
For your kindly, sunbaked face
For your breasts that fed me
For your sons, my brothers,
For all the wet nurses in this great land
Who are like Dayanhe, and their sons
For my Dayanhe who loved me as she loved her own.

("DAYANHE, MY WET NURSE," 1933)

So as to conceal his authorship of the poem, Father used the pen name Ai Qing (艾青). He had always hated Chiang Kai-shek (蔣介石), whose surname he shared, for betraying the revolutionary cause, and so he crossed out the phonetic component of the character that was his surname, creating a new name for himself, Ai (艾). Ai is the Chinese name for mugwort, which in the Chinese poetic tradition has associations with both "breaking off" and "beauty." This name, adopted on impulse, would end up accompanying him for the rest of his life.

On many sleepless nights, as lines came into his head, Father would hastily write them down on a crude straw-paper notebook by the faint light of the streetlamp outside. When daylight came, he would often find he'd written one line on top of another.

From Li Youran, Father learned that his poem "Gathering" had just come out in the journal of the League of Left-Wing Writers, *Beidou* (Big dipper)—it was his maiden publication. Li Youran also brought news that he'd received a letter from Father's Polish friend, who'd heard of his imprisonment. She asked, "Why does painting a few pictures get you locked up in China? Is there any way to help him?" After that, he received no further news of her. Given the fate of so many Polish Jews under the German occupation in the years that followed, it is not surprising that all his later efforts to make contact with her proved fruitless.

After Father had served a third of his term, he was transferred to

the Jiangsu Self-Examination Institute, in Suzhou, a reformatory for left-wing radicals, and in October 1935 he was released on parole, having spent three years and two months behind bars. His lonely time in prison, when men around him were facing the threat of death and he himself had been gravely ill, had strengthened his will and honed his literary ambitions. The twenty-odd poems that he wrote during his confinement were striking evidence of his talent.

During my father's incarceration, Grandfather was driven to such despair that he would often spend the whole night in tears. But Father's tribulations in jail failed to soften his beliefs, and he was all the more determined not to back down.

While he was in prison, his parents had found a wife for him to marry. Father was unenthusiastic, arguing that his criminal record disqualified him from contemplating marriage at the time. But the family would not take no for an answer, and his brother-in-law, hearing his excuses, suggested, "You and she can surely be friends at least, can't you?"

The bride-to-be, a distant relation named Zhang Zhuru, hailed from Shangxi township, in Yiwu County. Her mother had one day said to Grandmother, "Your eldest son is not yet engaged. How about you take your pick of our two daughters—they're both available." Grandmother judged Zhuru, the younger daughter, to be the better match, and arranged for the betrothal accordingly.

Zhang Zhuru was not quite sixteen. Fine-featured and mild-mannered, she felt certain that Father had not deserved to go to jail. She recalled later her earliest impression of him: "While in prison, Jiang Haicheng had copied out some of his poems for me, and he sent me a picture he'd drawn. It was a black-and-white sketch done on a little piece of paper—even smaller than an index card—and enchanting in its fine detail."

Traditional marriages were designed "to honor the ancestors above and generate posterity below" and were settled in a time-honored process described by the Confucian philosopher Mencius as

"arranged by parents and negotiated by the matchmaker." In keeping with custom, the bride was delivered to the groom's house in a sedan chair, amid raucous music and merriment. Bowing in unison to heaven and earth, my father and his young bride certified their solemn union.

Despite this concession to marriage, Father's attitude to the family continued to disappoint his father. One of Grandfather's teachers, who had taught the classics for many years, came up to him in the street once and said sardonically, "I hear your son has made a name for himself through poetry." The villagers were prone to ironic commentary, joking that *dúshūle* ("studied books") sounded a lot like *dōushūle* ("lost everything"). Grandfather shared that skeptical attitude toward his son's budding reputation, asking Father, "Does that stuff you wrote count as poetry?"

In the villagers' eyes, only pentasyllabic or heptasyllabic rhyming verse in classical Chinese deserved to be called poetry. Father offered no answer to Grandfather's question; those traditional prejudices could not easily be overturned in just a few words. In Father's view, poets needed to free themselves from formal constraints, using vibrant, colloquial language rather than following the contrived, effete literary fashions that had long held sway.

Grandfather gradually grew to detest Father's way of treating the family home as though it were just a roadside inn on some grand journey he was making, and he grieved that his son set so little store by the estate that his progenitors had labored so hard to build. He felt, too, that Father exerted a negative influence over his younger siblings.

He warned Father that there was no bourgeoisie in China and insisted that he had never oppressed his underlings, so even if someday there was a revolution, why would he become its target? Then he would smile benignly and open his account book, with its meticulous record of the loans on which he was being paid interest. As he flicked the beads of the abacus, he would murmur to his son that he needed to show more concern for his brothers' and sisters' futures.

In his poem "My Father," Father would later say of Grandfather:

> *Through timidity he kept his sights low*
> *And in the most tumultuous age*
> *Led the most commonplace life*
> *Like countless Chinese landlords*
> *Insipid, old-school, stingy, complacent.*

Grandfather had wanted his son to study economics and law, to be a businessman or an official. As my father saw it, Grandfather had no appetite for real change and preferred to look on from the sidelines: "Unable to drum up enthusiasm for 'progress' / he greeted with indifference the prospect of 'revolution,'" content to lie back on his bamboo couch with his rice wine and water pipe, a volume of Qing ghost stories in hand.

Father was determined to leave Fantianjiang, and after much effort he finally secured a position teaching Chinese at a women's teacher training school in Changzhou, midway between Shanghai and Nanjing. On the day of his departure, despite having only a thin coat to ward off the February cold, he felt energized by the prospect of earning a steady income of forty-five yuan a month.

Grandfather was not impressed that his son was about to become a schoolteacher. In the family business, when the shop assistant collected payment from a customer, he would bark out an acknowledgment and toss the coins into the cashbox so casually that small change sometimes fell on the floor. "If you were to put those bits of loose change together," Grandfather said, "it would add up to more than what you're going to make."

AS A TEACHER, FATHER selected his own instructional materials rather than follow a set curriculum. He encouraged his students' self-expression, editing their submissions to the school magazine and

writing a foreword to the inaugural issue. "Every student has her own voice," he wrote. "Like an underground spring, one day it will burst forth and flow unceasingly toward the sea." But at the end of the first term, the school rescinded his appointment, on the grounds that he had conducted radical propaganda in the classroom. His students lamented his departure, and to thank their talented but impoverished young teacher they pooled their money and bought him a watch.

Li Youran was at this point working as a teacher and librarian in Suzhou, translating Romain Rolland on the side. He persuaded Father to move to Shanghai—offering to underwrite his living expenses if necessary—in the hope that he could concentrate on his poetry. Li Youran understood better than anyone Father's devotion to his craft and his passion for language.

Father and his now pregnant wife moved into an attic room in Zhabei, a working-class suburb of Shanghai. It was here that he published, at his own expense, his first collection of poetry, *Dayanhe*, a slim booklet containing nine poems, for which he designed the cover art: a sketch in light green of a young man with a clenched fist and a hammer.

Father was writing tirelessly then, his mind active and rich. He felt the future calling him, urging him on, and through writing his goals came into clearer focus. If he were to ever doubt his ability to write, he told himself, life would no longer be worth living.

Dayanhe soon attracted the attention of the critic Hu Feng, a leader of the League of Left-Wing Writers and a friend of the celebrated writer Lu Xun. "I would like to introduce a poet," Hu Feng wrote. "He writes under the name of Ai Qing. Every one of his works springs from his rich emotions. His language is neither too bland nor too noisy, and certainly has none of that paper-flower, paper-leaf ornamentation. His poems, accessible and at the same time full of animation, give expression to the feelings of his that have been stirred by real experience and present vignettes warmed by his engagement with life."

Between the early spring and summer of 1937, on the eve of Ja-

pan's invasion of China, a number of Father's poems (including "Sun-shine," "A Dialogue with Coal," "Spring," "Laughter," and "Dawn") were published in *Gongzuo yu xuexi congkan* (Collected writings on work and study), edited by Hu Feng and Mao Dun, earning favorable reviews from left-wing critics.

Father, now more mature and more alert to political developments, sensed that war was on the way. His confidence in his work went hand in hand with a faith in China's revival. But still, it was impossible to make a living just by writing poetry. In July 1937, his wife was about to give birth, and Father, although normally indifferent to money matters, felt pressure to earn a steady income. He accepted a teaching position in Hangzhou, at Huilan Middle School. On July 6, on board the train from Shanghai to Hangzhou, he sat reading the newspaper, occasionally gazing out the window at the fields, and wrote "Reborn Land," his prediction for the future:

> *Our great land that was dead*
> *Now under the bright sky*
> *Is born again.*
> *Hardship is just a memory;*
> *In its warm chest*
> *There will flow anew*
> *The blood of warriors.*

His forecast was vindicated the very next day. On July 7, 1937, Japanese forces bombarded the county seat of Wanping, near Beijing, in an episode known in modern history as the Marco Polo Bridge Incident. This day marked the beginning of Japan's wholesale invasion of China, and of China's war of resistance. On this same day, Ai Qing and Zhang Zhuru's daughter was born. They gave her the name Seventh Moon.

Within a month, the Chinese forces in north China had been out-gunned and forced to retreat, and both Beijing and Tianjin had fallen to the Japanese. When Japan opened a second front near Shanghai,

close to a million men were drawn into battle. Three months later, the Chinese army abandoned its positions, and it was only a matter of time before Nanjing, the nation's capital, fell to the invaders. Facing outright defeat, the Nationalist government announced it was moving its capital to Chongqing, in the meantime stationing a portion of its government personnel in Wuhan.

When Father first arrived in Hangzhou, the war in the south had yet to begin, but he already felt oppressed and uneasy. The West Lake was unchanged, hazy and indistinct. It seemed to him that the locals were drifting through life, still clinging to an illusory notion of leisure. The onset of war had failed to shock Hangzhou; while the fate of the nation hung in the balance, people simply continued with their routines. "I cannot pretend to love Hangzhou," Father would soon confess. "Like so many cities in China, it is crammed with narrow-minded, selfish residents, along with complacent and vulgar office workers, low-level officials accustomed to currying favor, and cultural types who make a hobby of hyping things up. They commonly think of themselves as living in unparalleled happiness, as though lounging in their mother's lap." He would write these words at the end of the year, when news came to him that Hangzhou had fallen, after he and his family had escaped to Wuhan.

As the autumn of 1937 advanced, Hangzhou was surrounded on three sides by the Japanese. The Zhejiang provincial government evacuated to Jinhua, farther out of harm's way. By October, many Hangzhou residents had fled the city, and Father's pupils stopped coming to class, so he and his family left for Jinhua and took refuge at his family home. The following month, he managed to borrow enough money to buy train tickets for himself, Zhang Zhuru, their four-month-old daughter, and the older of his two sisters, Jiang Xihua, and they joined the exodus of people heading for safer areas in China's interior.

When they arrived at Jinhua Railway Station at eight o'clock in the morning, wounded soldiers, freshly evacuated from the battlefield, lay strewn along the platform. One of the soldiers, a faint gray light

shining in his eyes, told Father that hospitals in the area were no longer taking in casualties. Some had covered themselves with straw for warmth, while others threw straw in a heap and set fire to it to warm their hands. Civilians were camping out in any available space, curled up inside dirty bedrolls. The fighting had disrupted the normal train schedule, and in the confusion it was unclear whether rail services would even continue. Ticket sales had been halted, and if a train came in everyone simply piled in, whether they had tickets or not.

Father and his family managed to squeeze their way onto a train bound for Nanchang and improvise some seating on top of bundles and suitcases in the corridor. The carriage was completely dark, and quiet, apart from one or two children's sobs and their mothers' soothing lullabies. Father's thoughts unrolled with the rhythm of the turning wheels. Despite all the difficulties, he felt confident about the journey. The vastness of the land on either side, dimly visible by the light of the locomotive's headlight, gave him joy and pride in being Chinese, and the darkness of the night brought him an almost religious feeling of exultation. After stopping at Nanchang, the train continued on to Wuhan. It was the depths of winter, and the sprawling riverside city was swollen with a huge tide of Chinese government and army personnel who had evacuated from Nanjing, along with countless refugees from Shanghai and other cities in the lower Yangtze valley.

Father and his family found a temporary home in the reception office of an art school. On December 13, he bought a newspaper from a paperboy in the street; the headline read, "Nanjing, Capital of the Republic of China, Falls." In the weeks that followed, Nanjing, three hundred miles east of Wuhan, would suffer a brutal slaughter at the hands of the Japanese.

"War has come," Father wrote. "And through the people's endurance, amid the poet's prayers, the day will come when we can break our chains. At this moment an author must reflect deeply on the following issue: How do we make our voices truly representative of the Chinese people? Our voices must treat this war as an event linked in-

separably with the living needs and revolutionary goals of the entire nation." This piece, entitled "We Must Fight Until Freedom Is Ours," served as Ai Qing's pledge to his compatriots, articulating a firm purpose during the harrowing years of the Japanese occupation.

It was then that he wrote "Snow Falls on China's Land," which reads in part:

> *China's roads*
> *Are so steep and so muddy*
> *China's pain and disaster*
> *Is as broad and endless as this snowy night*
> *Snow falls on China's land*
> *The cold locks it in.*

As he finished this poem, it truly did begin to snow, and when he gazed up at the sky, he felt it was nature's response, that the swirling snow answered his long-held wish to fuse reality with art. To him the message was clear: only those tenacious enough to withstand the winds of war would be able to make it through to the end.

———

Toward the Sun

"SNOW FALLS ON CHINA'S LAND" WAS RIVEN THROUGH with a love of life and love of the land. My father wrote it when he was young and optimistic and brimming with confidence in China's future. Thirty years later, when I lived with him in Little Siberia, nobody would have cared if he was reduced to his last feeble breaths. And if he had died then, his death would have been deemed of no consequence.

Our lives in Little Siberia were miserable in many ways, but children will find entertainment where they can, no matter the circumstances. In Xinjiang's northern latitude, summer days are long, and in the early afternoon, when the grown-ups were napping, my friends and I had the freedom to go on adventures. We would go out to the fields to dig up rats' nests, unearthing a labyrinth of little storehouses and collecting enough seeds to fill a sack. Or we would scavenge for treasure on the warehouse roof: standing on a classmate's shoulders, I would stretch a hand into a hollow and grope around for birds' eggs, whose tangy contents we'd pour down our throats.

One afternoon, while playing hide-and-seek, we looked through a crack in the locked warehouse door and saw two feet dangling in the

air, and at the same time smelled the reek of insecticide: a middle-aged man was hanging from the rafters. Some said he had hanged himself, and others said he had been strung up after dying from a beating. The cause of such a death, the responsibility for such a death—these were not issues that would warrant an investigation. If someone died while in custody, it was written off as "committing suicide for fear of punishment" and "separating oneself from the people." It saved the cost of an executioner's bullet.

In the autumn of 1968, so as to draw a clear line with the "big rightist," the company leadership had us move once more—this time into a *dìwōzǐ*, a disused dugout. Such dugouts had been the primitive homes of early pioneers in this part of Xinjiang. Ours took the form of a square hole dug into the ground, with a crude roof formed of tamarisk branches and rice stalks, sealed with several layers of grassy mud. The dugout had long been abandoned, and the steps on the ramp leading down to the entrance had collapsed.

When we descended into our new home for the first time and pushed open the wooden door, it gave a grating creak, and a musty smell emerged from the cool, dark space. No sooner had Father entered than I heard a thump and he sank to his knees in pain: he had hit his forehead on a protruding joist and drawn blood. There was no way to raise the roof, so all we could do was dig the floor a shovel's length deeper so that he could stand up straight.

Our "bed" was a raised platform made with earth left behind from the excavation, which we covered with a layer of wheat stalks. Gao Jian and I built a stove and a flue and hollowed out an alcove for an oil lamp. Brushing away the saltpeter that had accumulated on the walls, we pasted on some sheets of old newspaper as wallpaper. Above the bed we hung an old cotton sheet, to catch sand shaken loose when pigs scampered around above our heads. A square hole in the roof served as a meager skylight, and this we covered with a plastic sheet. Once, we were startled when a piglet's rear end suddenly poked through the hole. After a struggle it managed to clamber out and away.

Our glass lamp chimney was quickly stained by the sooty kerosene smoke, and at dusk every day I would make a point of rubbing it clean. I would cover one end with my hand and blow into the other, then use a chopstick to push a piece of cotton inside and rub it back and forth. But when we woke in the morning, the chimney would be filthy again and our nostrils would be black with smoke.

That year the company was stricken with an infestation of rats, attributed by the local leadership to a Soviet conspiracy. Lurking behind the wallpaper, our rats were constantly busy, gnawing on paste, making nests, and raising litters, and at night we'd hear them trimming their teeth at all hours. I experimented with a variety of rat-catching techniques, the simplest of which was to dig a hole in the corner and put a half-filled bowl of water in it. The next morning, I'd find a handful of little gray bodies floating on the surface. If I dropped a grain of cereal on the floor and raised my foot just above it, within seconds a rat would appear underneath my shoe. To give them their due, those rats were really quite cute.

We also had lice. After sucking blood, lice turn black, and they pop when you pinch them hard. In the seams of my clothes they would lay many tiny, transparent eggs. The good thing was that we had very few clothes, so we could toss them all in a single bucket and soak them in boiling water, not caring that our shirts and pants all ended up dyed blue. The only way to eradicate the lice was to lift up the mattress and sprinkle hexachlorobenzene (C_6Cl_6) crystals, a fungicide, which we called "six-six." The smell was so strong, it kept me awake all night.

Making us live underground punished my father, and it also served

the needs of the political struggle. Reactionaries like us were in a separate category from the revolutionary masses, and our living conditions had to reflect that. Every time we were ostracized and rejected, my perspective on society shifted accordingly. The estrangement and hostility that we encountered from the people around us instilled in me a clear awareness of who I was, and it shaped my judgment about how social positions are defined. Although in most situations I found myself on the defensive, over time my passive stance gradually evolved into one where I held the initiative. Father and I also gained a greater sense of security, finding comfort in exclusion from a community so complicit in our mistreatment.

THIRTY YEARS EARLIER, as the Japanese closed in on Hangzhou, my father had written to his critic friend Hu Feng to share his fears that the war might take his life before he had the chance to express himself fully in his poetry. By the end of 1937, over a month had gone by since Father and his young family had arrived in Wuhan, and although they were safe enough for the time being, he was no nearer to fulfilling his ambitions as a writer. Every day was filled with struggle, and he had still not found a paying job. Zhang Zhuru had been counting on him to be the breadwinner and never imagined that things would be so difficult. This was her first trip away from Jinhua and her first experience as a mother. Their young child's constant crying added to her anxiety; money worries and the danger of Wuhan's encirclement by Japan kept her on the verge of panic.

Ai Qing was far from the only intellectual displaced and living hand to mouth in the wake of the Japanese invasion. In late 1937, at the suggestion of Hu Feng, a number of writers and artists were recruited to teach at the newly founded National Revolution University, in the northern town of Linfen, and Father decided to join them. On January 27, 1938, he, along with his wife and child, his friend Li Youran, and others, set off on a grueling journey. Waiting for them at the plat-

form in Hankou Station was a long line of carriages so encased in metal sheeting, they looked like a string of iron boxes designed to carry soldiers and ammunition to the front line. Once they were all aboard, the metal doors were closed and locked from the outside by a railroad policeman. There were only two windows in the whole carriage, one at each end, and no toilets at all, and the air was stifling. If the passengers wanted to answer the call of nature, they had to wait until the train stopped at a station and the door was opened. Father, his wife, and their seventh-month-old daughter had to sit on the damp floor for days as the train slowly made its way through contested territory, where the threat of danger was constant.

When Father peered out one of the tiny windows, under a frigid sky he saw an endless expanse of yellow earth but few signs of life, just occasional clumps of refugees and wounded soldiers, fire-charred tile-roofed houses, and abandoned villages. It was the first time he had crossed the Yangtze and entered the rugged terrain of north China. He took out his notebook and sketched people making their way through the distant fields, travelers waiting at a ferry crossing, dawns and dusks in the frozen northlands. These desolate scenes evoked his sympathy for the working people struggling to survive in this unforgiving environment.

On the morning of February 6, in a bitterly cold wind, Father and family got off the train and plodded into the old town of Linfen. In the days that followed, he would teach art classes at the university, although food remained in short supply, and school meals consisted of little but carrots and coarse steamed buns. The water was the same muddy color as the buns. He was able to teach his classes for only twenty days before the town fell to the Japanese and the family was on the move once more, this time seeking refuge in Xi'an.

There, together with other artists and authors, Ai Qing set up an Anti-Japan Arts Troupe. But once, when he was leading his team in a show in a nearby county town, one of the team members was murdered, and he came to suspect that the group had been infiltrated by a Nationalist spy. He decided to return to Wuhan, where he would be

able to contribute to the work of a new umbrella organization, the All-China Resistance Association of Writers and Artists.

It was in Wuhan, in April 1938, that Ai Qing completed "Toward the Sun," a lyric poem—more than four hundred lines long—inspired by his four-month stay in north China, where he had witnessed both China's miseries and its people's stubborn vitality. It soon became a staple at poetry readings; as evening fell, students would read it aloud around a bonfire, the light illuminating their faces, and the poem's passion and confidence would warm their hearts.

> I speed onward
> Always riding wheels of ardor
> The sun above my head
> Its powerful rays
> Scorching my body
> Heartened by its heat
> I hoarsely sing:
> "Now, my heart
> Is split open by a hand of flame
> The stale old soul
> Discarded on the riverbank . . ."
> Now
> Toward what I see and hear
> I feel a love and concern as never before
> Wishing even to die in this bright moment
> We love this day
> Not because we
> Cannot see our difficulties
> Not because we
> Cannot see hunger and death
> We love this day
> Because this day has brought us
> Tidings of a bright tomorrow.

("TOWARD THE SUN," 1938)

Ai Qing imagined his country entering a creative age that would welcome a poet capable of giving expression to this special moment in Chinese history. As he put it, "The poet who belongs to this great, unique era must commit to it uncomplainingly, enduring hardship as readily as missionaries who risk persecution, immersing his sincere heart in the emotions and dreams of the thousands."

While in Wuhan, he received a letter from an army officer, accompanied by a horrific photograph of a row of human skins hanging from trees at the entrance to a village, skins that Japanese troops had flayed from Chinese bodies, seven male and one female. This grisly image would inspire Father to write one of his many socially engaged poems, as would the sight of a wretched old beggar woman kowtowing to pedestrians in downtown Wuhan. Unlike some of his fellow poets, who sought to avoid war-related topics in their work, Ai Qing now confronted reality more keenly and more urgently than ever before. And he continued to write with a steady rhythm that was ideal for recitation.

The campaign to defend Wuhan lasted four months, but in the end the Nationalist Kuomintang (KMT) forces were forced to retreat once more, and Father had to find yet another place to shelter. In late July 1938, he traveled with his wife and daughter to Hengshan, in central Hunan. In this quiet old county town he was able to write steadily every day, making good progress on a book-length theoretical study entitled *Shi lun* (On poetry) that he saw as one of his most important achievements, a formulation of a new aesthetic that would meet the demands of a new era.

A poet, he argued, is different from somebody who simply writes poetry. A poet is loyal to his own experience and does not write about things outside his own understanding, whereas somebody who writes poetry simply puts together sentences, whose words he arranges in separate lines. Without fresh colors, without luster, without images, he asked, where is a poem's artistic life?

"Poetry today ought to be a bold experiment in the democratic spirit," he declared, "and the future of poetry is inseparable from the

future of democratic politics. A constitution matters even more to poets than to others, because only when the right to expression is guaranteed can one give voice to the hopes of people at large, and only then is progress possible. To suppress the voices of the people is the cruelest form of violence." Eighty years later, his faith in poetry as freedom's ambassador has yet to find vindication in China.

In August 1938, Ai Qing learned that the Hengshan school where he had been planning to teach lacked funds to pay his salary. All he could do was write to friends in different parts of the country, asking them to let him know of any teaching vacancies. One day, finally, an answer came through: a friend promised to get something lined up if he came to Guilin, in the southern province of Guangxi. The area had historically been something of a backwater, but during the war years it had become a gathering place for writers and artists. So, in October 1938, Father moved to Guilin with his wife and daughter. They lived in a small, spartan room with an earthen floor, one wall made of wood and three of brick. Given the shortage of space, they had to put their cooking stove in the hallway.

Father's job was to create and edit a literary supplement for the *Guangxi Daily*, which paid him a monthly salary of several dozen yuan, sufficient to cover rent and grocery expenses. He counted himself lucky, for many writers who had taken refuge in Guilin had no job, and there were plenty whose survival depended on meager author's fees or handouts from friends. His supplement ran to ten thousand characters in each issue, but half of that was given over to advertisements, and the contents were haphazard. "This supplement has ended up as a public toilet!" he fumed. He was writer and editor, and proofreader as well, and day after day he busied himself securing contributors and coordinating with the printer. To relieve the exhaustion that came with working late, night after night, he took up chain-smoking.

In November 1938, Japanese planes commenced bombing raids on Guilin. Many civilians died in these attacks, and more than ten thousand were left homeless. The house where Father and his family lived

was damaged, and bomb splinters fell just a few yards away. Early in the morning, as the sky was just beginning to brighten and most people were still sleeping soundly, a thinly clad Ai Qing burst into a friend's room and began to recite a just completed poem:

> *If I were a bird*
> *I would sing hoarsely*
> *Of this storm-buffeted land*
> *This river forever surging with our grief and outrage*
> *This furious wind that never stops blowing*
> *And the warm dawn that comes from the woods*
> *And then I would die,*
> *Letting even my feathers rot in the earth.*
>
> *Why do I so often have tears in my eyes?*
> *Because I love this land so deeply.*
> ("I LOVE THIS LAND," 1938)

This period was the most productive phase of my father's career as a poet, and his work was circulated widely. By scrimping and saving, he managed to fund the publication of his collection *The North*, which was distributed in both mimeographed and handwritten copies. A melancholy note ran through these poems, a bitter, desolate depiction of life in the midst of turmoil and hardship, but beneath the surface readers could feel an ardent, fighting spirit.

IN APRIL 1939, ZHANG ZHURU, pregnant with their second child, returned to Jinhua with the intention of giving birth in the comfort of home. In her absence, my father was drawn to a young woman journalist named Gao Hao, who had read one of his poems at a poetry reading. Father found he had much in common with her, and soon he fell in love. He promptly wrote to Zhang Zhuru, proposing

divorce. Shocked, she told him she would return to Guilin as soon as possible. Gao Hao, for her part, turned down Father's offer, and she later married someone else.

Although rigorous and exacting in his art, Father could be impractical and erratic when it came to romance. Emotionally deprived as a child and forced to fall back on his own devices in a hazardous, vagabond life, he was prone to fantasies and unrealistic expectations, imagining love to offer an exalted freedom from mundane concerns. In the wake of his failed pursuit of Gao Hao, he fell ill and sank into a deep despondency.

One evening in June 1939, when his wife had yet to return, a former student named Wei Ying reappeared in his life. Ai Qing had been her idol when she was in middle school, and now she had come to Guilin expressly to see him. When Father, still demoralized after the collapse of his love affair, answered a knock on the door, he was astonished to find her standing there. She offered a way out of his despair, and soon moved in with him. By the time Zhang Zhuru returned from Jinhua with their daughter, Seventh Moon, there was little chance of repairing their marriage.

In September 1939, when the principal of a school in Xinning, across the provincial border in rural Hunan, invited Ai Qing to teach classes there, he accepted the offer and took Wei Ying along with him. They lived there in a simple earthen-brick house at the foot of a hill, not far from the Fuyi River, with chile peppers and tobacco leaves drying beneath the eaves and a pile of squash by the door. Their little room, just twenty by twenty feet, was furnished with a wood-framed bed, desk, and stool. In the evenings he would light a kerosene lamp, prepare for the next day's class, and correct homework. With this return to the countryside, he wrote many poems on rural themes, often striking a note of sadness that conveyed the insecurities of a farmer's life of unceasing toil. His observations sharpened his sense of social inequality and strengthened his conviction that land should be redistributed.

In early October of that year, as Zhang Zhuru was en route to Xin-

ning with Seventh Moon and another couple, she gave birth to a baby
boy. After recuperating in Xinning for a month, she agreed to divorce,
entrusted the newborn to my father's care, and left for Jinhua with
their daughter. Like other progressive men of his generation, my fa-
ther had never felt fully invested in the marriage arranged by his par-
ents. Such a marriage was a relic of the feudal tradition, and what he
really aspired to was the free love he saw as the Western standard and
the emerging norm in China. Within a few weeks, at twenty-nine, he
had married seventeen-year-old Wei Ying.

My father was a lively, unconstrained teacher, and the classroom
would often erupt in laughter at his stories and jokes. But teaching
had only a faint connection with creative writing, and inwardly he
simply hungered to write. For him, writing was as important as life
itself.

One day, Wei Ying received a letter from a classmate living in the
territory controlled by the New Fourth Army, the Communist Party's
most substantial military unit during the war with Japan. The letter
painted a vivid picture of intense but inspiring army service and in-
vited Wei Ying to come join her classmate. To this idealistic young
woman, a humdrum existence in the backwater of Xinning was not
nearly as attractive as the appeal of a new life in the Communist-held
zone. Although she would not carry through with the idea at this
time, an ambition to serve the cause would stay with her.

It was not just Wei Ying who was now eager to be somewhere
else—Ai Qing, too, was also ready for a change. From Chongqing,
China's wartime capital, he had received a job offer from Tao Xing-
zhi, the principal of Yucai School, famous for catering specifically to
the needs of war orphans and other displaced children. The opportu-
nity was too good to pass up. So he packed up his books and poetry
manuscripts, and he and Wei Ying, with baby in tow, boarded a boat
that would take them north.

But almost immediately they had to return to Xinning. On the
boat, the baby refused to feed and cried constantly, and Father had no

option but to engage a wet nurse to look after the child in her own home. In time, the wet nurse, believing her pay to be too meager, passed the child on to a teacher and his wife. Still later, the boy's foster parents, alarmed by the fighting in Hunan, took him to Guilin, but, with food and medicine in short supply during the war, the little boy fell ill and died. I can only imagine how Father grieved after learning of his son's death. He loved his children, with an instinct common to all parents; without this instinct, he once said, humanity would have no future.

Ai Qing and Wei Ying set off a second time, just the two of them, boarding a boat that would take them to Shaoyang, the first stop on a long and difficult journey to China's wartime capital. But by now their marriage was already showing signs of strain. It rankled Wei Ying that Zhang Zhuru had left the infant with them, and in their hearts a fissure had quietly formed.

MORE THAN TWO YEARS had passed since the Japanese began their occupation of eastern China, and a complex situation had now emerged, with the Japanese controlling east China, including coastal areas and the lower reaches of the Yangtze valley, the Nationalist government in control of the southwest and parts of the northwest, and the Communists active in scattered areas of the country, with a particular strength in northwest China. After the early period of collaboration between the Nationalists and the Communists ended in a bloody purge in 1927, the Communist Party had managed to establish so-called soviets (self-governing Communist mini-states) in remote areas such as southern Jiangxi and western Fujian. But in October 1933, the Nationalist government encircled the Communists' base area in Jiangxi Province, and the following autumn, the worker-peasant Red Army began to evacuate. After a yearlong cross-country retreat that became known as the Long March, the remnants of the

Communists regrouped in northern Shaanxi Province, in China's im-
poverished northwest. By that time, Mao Zedong had established
himself as the leading figure in the Communist Party.

In December 1936, two key military commanders of the National-
ist armies placed Chiang Kai-shek under house arrest and pressured
him to abandon efforts to suppress the Communists and instead join
with them in resisting Japan. This so-called Xi'an Incident brought
about a second period of cooperation between the two parties. In
1939, Chongqing not only served as the temporary home of the Na-
tionalist government but also housed a delegation from the Chinese
Communist Party.

In May 1940, after many setbacks en route, my father and Wei Ying
were finally able to board a Yangtze steamer for Chongqing. Their
money spent, they had to sleep on the deck as the boat passed through
the mist-wreathed Three Gorges. By the time they reached Chong-
qing, on June 3, 1940, they had been traveling for more than a month.

Ai Qing, now penniless, appealed to the arts federation for help,
and accommodation was found for him and Wei Ying in the north
wing of the federation's headquarters, overlooking the Jialing River.
A week later, they witnessed one of the many bombing raids suffered
by China's wartime capital during the war with Japan. Shrapnel punc-
tured the walls and ceiling of their room, showering the floor with
debris, and Father had to get down on his knees to search among
broken tiles and shards of glass for the books, letters, and manuscripts
that meant so much to him.

At the same time, on the other side of the world, war had come to
Western Europe. Between April and June 1940, German forces in-
vaded Denmark, Norway, the Low Countries, and France, and on
June 14 they entered the French capital. Ai Qing wrote "Requiem for
Paris" the following day:

> *The tricolor flag is lowered*
> *And fluttering in its place*
> *On the Place de la Concorde*

By the bank of the Seine
Is a blood-red flag with a black swastika
The grand mansion collapses
And with it the lintel on which was carved

"Liberty, Equality, Fraternity."

For him, the fall of Paris—a precious spiritual home—was a crushing loss.

By late June 1940, Father was teaching literature at Yucai School, in a rural hamlet a safe distance from Chongqing. He felt a sense of relief to be back in a tranquil mountain village. He could arrange his life according to his own wishes, waking early and getting some writing done before breakfast. Sometimes a squadron of Japanese warplanes would appear in the sky in the afternoons, and at the sound of their engines overhead, he would throw a jacket over his shoulders and run outside to count them. He soon learned that there were twenty-seven planes in the standard Japanese bombing formation.

IN THE SUMMER OF 1940, my grandfather died in the hospital in Jinhua, at the age of fifty-three, and my grandmother wrote to my father and asked him to come home and assist with the funeral. According to local custom, only those who died in their own beds could be judged to have died a proper death, and since my grandfather had breathed his last breath away from home, it was considered unseemly to bring his body into the village. So his coffin was temporarily stored outside, and the family asked monks to come and recite sutras for seven days, to help the soul of the deceased make its passage to the other world. Soon it was the harvest season, the hottest time of the year, and my grandfather's corpse began to decompose; such a foul odor emerged from the coffin that the villagers were forced to make a detour to avoid it. It rained heavily before the inter-

ment, and rainwater seeped into the coffin, causing an evil-smelling liquid to flow out through the cracks.

SHORTLY AFTER GRANDFATHER'S DEATH, Japanese forces raided the villages around Jinhua and many of the locals fled into the hills. One resident, however—a landlord's son—recklessly fired off a gun in the marauders' direction, and the Japanese retaliated by burning the entire village. My grandmother sat among the tiles of her ruined house and wept for three days and three nights, and soon she died, too.

Father did not go back home to take charge of his parents' funerals. A poem he wrote in Yan'an explained his reasoning:

> Last spring he wrote me several letters
> Begging me to return
> He had important things to say to me
> Things regarding land and property:
> But I defied his wishes
> And made no effort to go home
> I feared that the duty the family gave me
> Would ruin my young life.
> My father now
> Is lying quietly in the earth
> I have not raised a soul flag for him
> Nor have I donned mourning garb
> Instead I'm on the move, singing my hoarse song
> In the war of liberation, amid the beacon fires
> Refusing to bury myself
> I callously defied my mother's wishes
> Grateful for the encouragement the war has given me
> I head in the opposite direction from home
> Because ever since I learned

There is a greater ideal in the world
What I need to be loyal to is not my home
But a sacred faith
That belongs to ten thousand people.

ON THE MORNING OF September 25, 1940, Zhou Enlai, the chief of-
ficer of the Eighth Route Army liaison office in Chongqing, which
served as the Chinese Communist Party's administrative arm, visited
Yucai School. In an address to teachers and students, he offered an
analysis of current affairs, raising spirits with an upbeat prediction of
how the war with Japan would play out. Zhou greeted my father
warmly and made a point of welcoming him to join the growing
numbers of left-wing intellectuals in the Communist stronghold of
Yan'an: "If friends such as Mr. Ai Qing go to Yan'an, they will be able
to write without distraction, with no need to worry about basic ne-
cessities." These blandishments could not fail to have some impact on
Father, who dreamed of being able to fully devote himself to writing.

Since his release from prison in 1935, he had traversed a dozen
provinces, traveled enormous distances, and worked at more than ten
different jobs. He looked forward to ending his destitute, nomadic
life. But despite all the difficulties, he had published more than two
hundred poems and essays and three books of poetry, fulfilling his
vow to write with the same indomitable stubbornness that a soldier
would need to fight a battle.

After the South Anhui Incident of January 1941, in which the Com-
munist New Fourth Army was badly mauled by Kuomintang forces,
relations between the two parties deteriorated. If forced to make a
choice between the KMT under Chiang Kai-shek and the Communist
base areas, many progressive intellectuals chose the latter. There was
an element of blind hope in this choice, but appealing concepts such
as "progress" and "liberation" were potent antidotes to despair.
Within the Communist Party, Mao Zedong issued a call to "absorb

intellectuals on a large scale." "The policy of winning support from intellectuals is a major precondition for the revolution's victory," he stated, and "the pen must unite with the gun." These positive-sounding declarations obscured a more complex reality: as a young man, Mao had tried unsuccessfully to get a job at Peking University Library, likely fueling the prejudice against academics that we can see in his later words and deeds.

As people increasingly questioned the legitimacy of the Kuomintang regime, the image of the Communist Party was shifting from agent of disorder to upholder of national interests. Yan'an was touted as a paradise of equality, freedom, and democracy, a model of a democratic China. Basic needs were met by a military supply system based on egalitarianism, and the Communists, rejecting the Confucian ethical code and traditional elite values, were promoting gender equality and popular culture.

Yan'an had particular appeal for young, idealistic intellectuals, and Wei Ying was a case in point. Although now eight months pregnant, she announced one evening that she was not prepared to wait any longer: even if it meant giving birth en route, she wanted to leave for Yan'an right away. In the Communist mecca, she believed, the baby could be left in a nursery while she dedicated herself to a full-time job. The two of them said nothing more that night, but when Wei Ying woke the next morning, Father, looking up from the book he was reading, said to her simply, "Do as you like."

The Communist Party had developed plans to help some important cultural figures in Chongqing evacuate with their partners to safer havens such as Hong Kong, Yan'an, and Guilin. One foggy morning, Wei Ying was informed that transport was available to take her to Yan'an along with other women, a number of whom were, like her, mothers-to-be. "Take care on the trip," Zhou Enlai urged. "It won't be long before we see each other again." Wei Ying gave birth soon after arriving in Yan'an. In the wake of the delivery, she was so weak that she had to leave the baby with neighbors, and by the time she had recovered strength, the baby had died.

Back in Chongqing, many of Father's friends had already left. He noticed KMT secret agents following him in the streets, and to remain in Nationalist territory seemed increasingly dangerous. In China, no matter what choice you make when you come to a crossroads in life, it is hard to avoid becoming politics' plaything, and life in Yan'an would prove to bring its own hazards.

Zhou Enlai, eager to see Father join the Communist cause, furnished him with a thousand yuan in travel expenses and advised him to stick to the main roads. Zhou told him that if by chance he was detained, he should send a telegram to Guo Moruo, a poet and historian who was well connected in both Communist and Nationalist circles. A former student of Father's who had official connections prepared documents that identified him as a high-level government consultant, and four others traveling with him were also given false identities. To fully look the part of a gentleman of importance, he wore a fur coat with an otter-skin collar; the others professed to be either family members, secretaries, or bodyguards. They took a long-distance bus that delivered them, late one afternoon, to Yaoxian, in central Shaanxi, where people were waiting in a long line to enter the town before the gates closed. Sentries inspected them in groups of four and five before giving clearance to enter. In the month it took to complete the journey, Father and the others had to negotiate forty-seven KMT checkpoints, and if their cover had been blown at any one of them, they would have faced immediate arrest. When at last Yan'an's iconic hilltop pagoda came into view, the weary travelers broke out in a gleeful rendition of *L'Internationale*, the revolutionary ballad dating back to the days of the Paris Commune.

IN THE TREELESS TERRAIN of northern Shaanxi, caves are the most common form of human habitation. Carved into hillsides, they provide insulation from the rugged climate; one such cave was assigned to Father and Wei Ying. To signal the arrival of such a celebrated

poet, Zhang Wentian, the general secretary of the Chinese Communist Party, and Kai Feng, the propaganda chief, soon paid a courtesy call. Zhang Wentian, spectacles perched on his nose, impressed Father with his scholarly manner. The two men welcomed him and inquired about his needs, and closed by asking him to choose between one of two cultural organizations for his work affiliation: either the Lu Xun Academy of Arts or the Yan'an branch of the All-China Resistance Association of Writers and Artists. He selected the second of the two, which was more familiar to him and was led by a well-known female writer, Ding Ling.

A new page in Ai Qing's life was now beginning. He had left the world of individual expression behind, and his days of unshackled writing were about to end.

The Pagoda Hill, Yan'an

—

The New Epoch

T HANKS TO FATHER'S METICULOUS PRUNING, AFTER SEVERAL months the woods around our production unit in Little Siberia looked much better, and even attracted approving glances from other workers. The leadership realized belatedly that it had been a mistake to allow a "rightist" to beautify the environment, as the task had not turned out to be as much of a punishment as intended. So, in order to make Father's life more miserable, now he was made to clean the latrines. This was the most grueling and unpleasant form of labor, for the property had a total of thirteen communal toilets, whose facilities consisted mainly of a row of squatting stations above a cesspit.

For his new job Father acquired a new set of tools: a flat-tip spade, a long-handled iron scoop, and a steel drill rod a little thicker than a man's thumb. This last item played a vital role in the winter months, when the feces would freeze into icy pillars.

Before he began to apply himself to each latrine, Father would always light a cigarette and size up the work, as though admiring a Rodin sculpture. The nicotine rush would bolster his courage in addressing the task ahead.

Latrines

In winter, when Father set to work with his drill rod, it might have
looked as though his tool was only throwing up slivers of ice, spatter-
ing his face and clothes. But ultimately his perseverance would be re-
warded: continual plunging would carve a deep gouge at the foot of
the pillar, toppling the tower of shit. Then he could move on to the
last step: breaking up the frozen feces into manageable pieces and
shifting them out of the latrine one by one. In summer his work rou-
tine took a different form: first he would separate the liquid from the
solid waste, ladling the urine scoop by scoop into a hole in the ground,
then cover the feces with sand and slaked lime, so it would attract
fewer flies and mosquitoes.

It was an era without toilet paper, so people used a range of
substitutes—everything from cornstalks and cotton bolls to wadding
from the fraying sleeves of padded jackets and empty cigarette packs.
(Protruding wall corners, prized for their ass-wiping properties, also
enjoyed intensive use.) Newspapers, on the other hand, were never to
be seen, for the simple reason that every page would have Mao's name
and a few quotations of his printed on it, and if you wiped your ass
with a piece of the paper, there would be no safe place to get rid of it.
If discovered, such an act of sacrilege would be reported and the in-
criminating evidence put on display, proof of another grave "counter-
revolutionary incident." No one was prepared to risk this.

After clearing the pits, Father would use the square shovel to straighten the corners of the latrine and lay down an even layer of fresh soil. By the time he made his final inspection, the toilet might still be a disagreeable place, but it had been tidied up and looked clean and proper. Now he could make his departure, shovel over his shoulder and scoop in hand, and head off toward the next latrine.

During our five years in Little Siberia, Father did not rest one single day. He knew better than anyone that if he were ever to take time off, the next day he would have to do twice as much work. Even in the coldest winter weather, when the temperature dropped to minus twenty-two degrees Fahrenheit, Father's clothes would be so soaked with sweat after his exertions that every evening he had to hang them up to dry.

Father accepted his lot stoically. As he put it, earlier in life he'd had no idea who cleaned toilets for him, and so it wasn't unreasonable to expect him now to do cleaning for others. It was an outlook that reflected his tolerance, generosity of spirit, and commitment to equity. Although he loathed superstition, intimidation, and cruelty in any form, while never abandoning the principles of honesty and decency, he was able to adapt to circumstances. I have to admit I lack that level of forbearance.

IN YAN'AN TWENTY-SIX YEARS earlier, Father lived in a different kind of isolation. The town is encircled by three mountains—Fenghuang, Baota, and Qingliang—with three interlocking canyons stretching west, east, and south. No matter which mountain path he took from his cave, it was a long walk to the headquarters of the Resistance Association of Writers and Artists, and unless there was some special need, he seldom left home. Couriers would bring him mail and collect his letters. Paper was in short supply, so Father would fashion envelopes out of old newspapers and stick a strip of paper on top with the name and address.

In 1941, a relatively relaxed atmosphere still prevailed in Yan'an's cultural circles, and although the supply of material goods was meager, intellectuals—particularly those of Ai Qing's status—were accorded certain privileges. Father was issued an Eighth Route Army uniform and a cotton-padded jacket for use in the winter, and every month he received a small stipend. Food, medicine, and boiled water were free. Meals were brought to Father in his cave by a soldier from the "Central Kitchen," and after he finished, the same soldier would take his bowl back. In April 1942, Father and Wei Ying had another child, the first of four who would survive, a daughter named Ai Qingming. Wife and child were not included in the food allowance and ate their meals in the communal canteen instead.

In July 1941, Zhou Yang, the dean of the Lu Xun Academy of Arts, had published an essay entitled "Informal Remarks on Literature and Life," in which he complained that a number of authors in Yan'an "were proving incapable of writing anything much." This provoked Ai Qing and four other writers to jointly sign a letter rejecting this accusation, intensifying the latent rift between party ideologues like Zhou Yang and more liberal intellectuals.

A few days later, at dusk on August 11, 1941, Mao Zedong, not yet party chairman but already the dominant political figure in the CCP

leadership, paid a visit to the authors of the protest letter. As he made his way down the slope toward Father's cave, he signaled to his body-guard to go no farther, then continued alone to greet Father. At this, his first encounter with Mao, Ai Qing found him to be thoughtful, composed, and widely read, quoting with ease from a variety of sources. Afterward, Mao invited him and his neighbors to go down the mountain and have dinner at his quarters, a meal that included bacon, salted fish, and eggs. Mao listened attentively and took notes, laughing and cracking the occasional joke.

But the unpleasantness stirred up by Zhou Yang's "Informal Re-marks" had begun to puncture some of Ai Qing's illusions about Yan'an. Until that point, he had not fully understood how the CCP operated. The May Fourth spirit embraced democracy, freedom, in-dependence, and equality, but these values were bound to be at odds with the ideological unity, centralized leadership, and collectivism de-manded by the Communist Party.

In December 1941, Ai Qing channeled his ambivalence into a poem entitled, simply, "Epoch."

> *I stand beneath low-hanging eaves*
> *Gazing in awe at the bare mountains*
> *And the endless sky*
> *In the end I feel a miracle is happening*
> *I see something glittering with light*
> *Like the sun it lifts my heart.*
>
> *Pounding wildly, my heart keeps chasing it*
> *Like a bridegroom hastening to a wedding*
> *Though I know that what it brings is not festive good cheer*
> *Nor the merriment of a vaudeville show*
> *But a sight more cruel than a thousand abattoirs*
> *Still I rush toward it*
> *With all the eagerness a life can muster.*

"Epoch" is the most striking work that he wrote during the Yan'an period. The poem affirms a new epoch promised by the fledgling Communist state, but it is darkened by a grim undertow:

> No one could suffer more than me
> I am loyal to the epoch and commit my life to it, but I am silent
> Against my will, like a captive
> Wordless on my way to execution.

He could already sense that loyalty to his epoch—service to the emerging power, in other words—would exact a fateful cost, but it seemed that there was no alternative:

> I love it more than anything else I have loved
> For its arrival, I am willing to hand over my life
> Relinquishing everything, from body to soul
> Before it I appear so insignificant
> I'm even willing to lie faceup on the ground
> And let its feet, like a horse's hooves, stamp upon my chest.

The poem captures with uncanny prescience the intersection of dramatic change and personal calamity that would accompany the revolution sweeping across China in the 1940s. But Father could not foresee just how quickly members of the Yan'an cultural community would themselves be trapped in treacherous political currents.

Out of a disappointment with the Nationalist government, left-wing intellectuals had flocked to Yan'an, but once there, they realized that the Communist Party was not immune to corruption and arbitrary, autocratic tactics, and discontent began to build. In March 1942, Ding Ling, Yan'an's most prominent female author, published an essay, entitled "Thoughts on March 8 (Women's Day)," that drew attention to the inequities and the "silent oppression" facing women in this supposedly progressive community.

Ai Qing had been concerned for some time about the criticism to

which authors were subjected. When Ding Ling invited him to share his views, he promptly obliged, writing a pithy essay called "Understand Writers, Respect Writers," in which he staunchly defended the right of authors to express themselves as they saw fit, noting tartly, "A writer is not a skylark, nor is she a singsong girl whose job it is to warble tunes to entertain her patron." For Father, freedom of expression was the precondition for any meaningful literary work. "Apart from the freedom to write," he continued, "authors demand no other privilege. Only when artistic creation is endowed with a free and independent spirit can it give impetus to the mission of social reform."

Other authors, still more outspoken, targeted the increasing trends toward bureaucratic complacency, factionalism, and a cult of personality. On March 17, 1942, Wang Shiwei completed an essay entitled "Wild Lilies," exposing the dark shadows in Yan'an society: the disillusionment of the intellectuals, their concerns about the hierarchical system and the privileges that the top leaders enjoyed. His reference to "some rather healthy 'big shots' who receive unnecessary and unreasonable perks" struck a nerve. After Mao read Wang's essay in *Jiefang ribao* (Liberation daily), he banged his hand on his desk and asked acerbically, "Who's in charge here, Karl Marx or Wang Shiwei?"

He demanded that the editors admit their fault in allowing such a work to be published and pledge to avoid any such error in the future. As Mao saw it, criticism of the party was no less damaging to the cause than a military defeat, and would serve to weaken morale and even compromise the party's legitimacy.

In early April 1942, an orderly delivered a letter to Father from Mao: "There's something I want to talk to you about. Please come over if you're free." When they met, Mao began with a stab at humor: "I like to play the patriarch." Then he went on. "There are a lot of problems now in Yan'an literary and art circles. People are not happy with a lot of the essays that have been published. Some look as though they could have been dropped from Japanese planes, and others belong in a Nationalist newspaper."

Mao asked Ai Qing's opinion about what should be done. My fa-

ther had not given much thought to this, and suggested off the top of his head, "How about we hold a meeting, and you come out and give a talk?"

"If I talk, will people listen?"

"I will, at least," he answered.

Two days later, he got another letter from Mao: "Regarding the cultural policy issues that we talked about, please collect for me all the critical commentaries and share with me any insights you have." For emphasis, he had drawn three little circles under the word "critical." Ai Qing did not understand what was meant by "critical commentaries," so he did not try to collect them; instead he wrote down his own views and sent them to Mao.

In his essay, writing from an author's perspective, he examined the relationship between the creative arts and politics, and considered the questions of what to write and how to write. In the struggle to improve people's lives, Ai Qing argued, literature and art share the same goals as politics, but literature and art are not an appendage to politics—they are not a gramophone or a loudspeaker for politics. Literature and art's integration with politics finds expression in their truthfulness: the more truthful the works, the closer their alignment with the progressive political direction of their era.

A few days later, Mao wrote back in response, "Thank you for your letter and your essay. I am keen to discuss them with you. The river is high, so I'll send a horse to pick you up." In April, Mao's living quarters were still chilly, and the party leader wore an old padded jacket, its sleeves so worn that the strands of padding were exposed. "We read your piece," Mao told him, "and we'd like to share our reactions." Ai Qing's essay had been reviewed by Mao's colleagues in the leadership, and Mao himself had comments written down on several sheets of paper. The floor was uneven and the wooden table a bit wobbly, so Mao went outside and came back with a piece of tile to slip under one of the table legs. Then he expounded his views, which were not entirely in line with my father's.

On May 2, the Yan'an Forum on Literature and Art began. During

the preceding days, Zhou Yang had drawn up a list of participants, and Mao had sent out an invitation to more than a hundred writers and artists. After lunch, on the appointed day, people gathered in the large conference room of the party headquarters in Yangjialing. Twenty-odd stools had been placed around a long table, on which a white tablecloth had been laid, with two other rows of stools next to the north wall. A wooden armchair, rather than a stool, occupied a central position by the table—clearly designed for the presiding officer. Mao arrived promptly at 1:30 P.M. and walked around the room, shaking hands with everyone.

"It seems there aren't many chairs," Mao remarked as he opened the proceedings. "There just aren't enough of them. In the future we need to provide a few more armchairs." In saying this, he was referring obliquely to the comments that had been made about power and privilege in Yan'an. It was not a comment on the need for seats so much as a sardonic dismissal of some people's complaints about unfairness.

"To defeat the enemy," Mao went on, "we must rely primarily on the army with guns. But this army alone is not enough; we must also have a cultural army. The first of these armies is led by Commander-in-Chief Zhu, the second by Commander-in-Chief Lu." By Zhu he meant Zhu De, head of the Communist armed forces, and by Lu he meant Lu Xun, who had died in Shanghai some years earlier but remained a symbol of left-wing activism. The audience laughed appreciatively. Many of them had not realized until now how much importance Mao attached to the role of literature and art. Until the forum, intellectuals had commonly assumed that culture and revolution advanced in parallel and had equal status; the goal of this meeting was to make patently clear that literature and art had to serve the party, just as soldiers had to obey the orders of their superiors.

Following the first plenary session on May 2, further sessions were held on May 16 and 23, when Mao made his closing remarks. No real consensus emerged among the speakers; writers presented their opinions and argued their cases. Father and Ding Ling both spoke up

at various junctures. For much of the time, Mao sat there expression-
less and did not intervene even when radical views were expressed.

On the last day of the forum, all 109 attendees posed outside the
conference room for a group portrait. Just as the photographer was
about to close the shutter, a dog ran into the shot. Mao stood up to
shoo it away, shouting, "Kang Sheng, get your dog under control!"
Everybody laughed. In Yan'an, Kang Sheng was in charge of counter-
espionage and the capture of "running dogs."

Years later, as a small boy, I studied the wide-format, black-and-
white photograph taken that day. Mao sits in the middle of the front
row, Ding Ling four seats to his left. Father stands on the far right,
next to Zhou Yang. Like a painting of the Last Supper, the photo-
graph struck a note of poignancy and mystery, and it felt very remote
and foreign to me.

After dinner, a hanging lamp was rigged up in the courtyard and
everyone moved outside to hear Mao's closing speech. "*Āiyā*, this is
not easy to do," Mao could be heard muttering as he looked over his
notes. But once he began to deliver his speech, his heavy Hunanese
accent held everyone's attention. "The problem of whom to serve,"
Mao said, "is fundamental; it is a question of principle. All our litera-
ture and art are for the masses, and in the first place for the workers,
peasants, and soldiers." "The masses" was one of his favorite con-
cepts, and what he really meant when he used that term was the rank-
and-file population, subject to the will and direction of the party.

Mao's speech at the Yan'an Forum on Literature and Art ended up
reshaping Chinese intellectuals' understanding of their mission. He
devoted particular attention to issues of a writer's target audience
and the attitude they should bring to their work, explicitly demanding
that they cater to the needs of workers, peasants, and soldiers rather
than elite readers. The May Fourth Movement had seen intellectuals
as the core of society: they were to shoulder the responsibility for
enlightenment and social critique. Mao, on the other hand, believed
that intellectuals, rather than seeking to make the people more like
them, should make themselves more like the people; they should

abandon social critique and devote more time to self-criticism. The forum had a far more wide-ranging significance than many of the participants had expected, generating a programmatic document that would dictate the fate of Chinese culture for decades to come. With it, the function of intellectuals was fundamentally altered, and novelists, poets, and artists were now all lumped together under the omnibus label "literature and art workers."

From then on, Ai Qing and his fellow writers found that alternative pathways were closed off to them. An opportunity to exercise their free will might possibly appear after the war with Japan was won, or perhaps it would remain forever out of reach. For now, all arguments had been replaced—suppressed—by the party's voice and the party line, and their aspirations were reduced to an empty farce.

Given the constant threat of political interference, only through opportunism could they win a little living space—and stale mediocrity would be the only outcome. The Chinese Communist Party and left-wing intellectuals were like two celestial bodies in the solar system: as they orbited, they might at certain moments travel in parallel, but each moved on its own plane, and they inevitably went their separate ways. In the years that followed, intellectuals would face increasing pressure to conform, leading ultimately to the Anti-Rightist Campaign in 1957, which marked the end of intellectuals as a force in society. From that time on, Chinese intellectuals were confined to a marginal position, and they have been there ever since.

SOON AFTER THE FORUM ENDED, Father wrote a letter to Mao expressing a concern that his creative inspiration was withering. He proposed to go down to remote, impoverished villages so that he could spend more time with ordinary working people and find material for his poetry. While commending him for this initiative, Mao cautioned him against going, on the grounds that the Japanese still posed a threat in many areas. He recommended instead that Father

stay in Yan'an and study, suggesting he familiarize himself with Marxist-Leninist historical materialism and class relations in the countryside. Ai Qing needed to have a sound grasp of these issues, he emphasized, if he was to gain a clear understanding of China's realities and the path ahead.

One sunny day, Mao Zedong stopped by Father's home and, eyeing the vegetables and flowers growing outside the cave, noted that disagreements between writers and political leaders were not unusual: Lenin, for example, had not always seen eye to eye with Gorky. To make progress and achieve victory, he said, it was sometimes necessary to regulate thinking within the ranks, but nobody would be sacrificed.

Before long, however, an increasingly harsh "Rectification Movement" rendered up its first victims. It sought to impose a high level of ideological unity and compliance by employing self-scrutiny and mutual surveillance—coercive methods that would become standard practice within the party.

The CCP's intelligence services made it known that within the party "spies were as common as hempseeds" and asked that party members rescue those people who "consciously or unconsciously" were serving the enemy. Personal histories were scrutinized for the slightest traces of suspicious activity, and almost everyone faced grueling questioning; people were held in isolation, threatened, or tortured, forced to criticize themselves and denounce others. Out of the thirty thousand functionaries and students in Yan'an, at least half were accused of being spies.

Under the pressure to conform, everyone sank into an ideological swamp of "criticism" and "self-criticism." My father repeatedly wrote self-critiques, and when controls on thought and expression rose to the level of threatening his very survival, he, like others, wrote an essay denouncing Wang Shiwei, the author of "Wild Lilies," taking a public stand that went against his inner convictions.

Situations such as this occurred in Yan'an in the 1940s, occurred in China after 1949, and still occur in the present day. Ideological cleans-

ing, I would note, exists not only under totalitarian regimes—it is present also, in a different form, in liberal Western democracies. Under the influence of politically correct extremism, individual thought and expression are too often curbed and too often replaced by empty political slogans. It is not hard to find examples today of people saying and doing things they don't believe in, simply to fall in line with the prevailing narrative and make a superficial public statement.

After my father's death, at my prompting, my mother asked the China Writers Association to make my father's confidential dossier available for our inspection. Such dossiers contain confidential materials about an individual's political thought; they include both the individual's own statements and accusations made by others, along with the party organization's own assessments. But I failed in my efforts to examine the official record: my mother's request was turned down, and she was told to forget the idea altogether. Without having access to the full record, it is irresponsible to make a judgment about the conduct of others, and when the object of evaluation is no longer alive, and unable to defend and explain himself, objectivity inevitably perishes. When we cannot hear from my father on this period of his life, any evaluation I might make of his conduct in Yan'an can only be subjective.

IN JUNE 1942, WANG SHIWEI was labeled a member of a so-called Five Member Anti-Party Clique, expelled from the Communist Party, and imprisoned on a charge of being a counterrevolutionary Trotskyist spy. He would be executed in 1947.

One afternoon, the party secretary of the Resistance Association came to see Ai Qing. After a little idle chitchat, he suddenly looked intently at my father and asked him why he had been released early from the Suzhou reformatory in 1935. He also told Father he needed to explain to the party organization his involvement with the *Guangxi Daily* newspaper in 1938. Father sat there speechless for quite some

time, shocked that he was now under scrutiny. Realizing that he must be under suspicion of having collaborated with the Nationalists, he was unsure what this meant for his future. As he left, the party secretary looked at him dourly and said that everyone had to face the music and there was no getting out of it.

The atmosphere surrounding the investigations became increasingly tense, with writers confined to the Central Party School for "rectification" and "rescue." Every day they would be forced to study specified texts and works by Mao, questioned continually, and forced to write self-criticisms. Ai Qing was allowed to return home only once a week, and as soon as he got home he would lie down, his face ashen. When ordered to write "confessional" materials, he would pace back and forth in the cave, in an agony of indecision. Some of his colleagues found the pressure too much to bear and resorted to suicide. For them, putting an end to life was the only way of bringing the humiliation to a halt.

I have limited insight into these painful experiences in Father's life, as he would mention them only obliquely, knowing there was no chance of redress, and I never pressed him. It was not until I myself became a target of the regime's hostility that I came gradually to appreciate what he must have gone through. During questioning, when I avoided expressing my full opinion on one issue or another, I was relying on my instinct to steer clear of danger areas.

It is said that Ai Qing was cleared of suspicion only after Zhou Enlai returned to Yan'an from KMT territory. In time, by responding positively to Mao's call to serve the workers, peasants, and soldiers, he won the confidence of the party establishment and, in March 1945, was admitted into the Communist Party as a full-fledged member.

IN APRIL 1945, THE Rectification Movement finally came to an end and the Seventh Congress of the CCP was held in Yan'an—the first party congress in which Mao Zedong presented the key political re-

port. Above the chair's platform hung a huge portrait of Mao with the slogan "Advance Victoriously Under the Banner of Mao Zedong," signaling that the Chinese revolutionary camp had cast aside Soviet Bolshevik dogma and was charting its own path. Mao's leadership of the party was emphasized throughout. Liu Shaoqi and Zhou Enlai joined the other attendees in praising him, shouting "Long live Comrade Mao Zedong!" Mao's name appeared 130 times in the party's report, and he was hailed as "the talented and creative Marxist" and "the greatest revolutionary, politician, theoretician, and scientist in Chinese history." Embroidered flags honoring him covered every wall of the auditorium.

That year, Ai Qing's lack of productivity was criticized, compounding his own doubts about his role. He was reassigned to the Lu Xun Academy of Arts as the chair of the literature department. Every day, in the academy's courtyard, he lectured about poetry, his students sitting in a circle on campstools, resting their notebooks on their knees. In his lectures he would present a critical reading of some of his favorite authors: Whitman, Pushkin, Yesenin, Verhaeren.

The evening of August 15, 1945, at first seemed just like any other summer evening. But then from the foot of the hill came burst after burst of firecrackers, and people started running up the slope shouting, "Japan has surrendered!" Cave residents leapt with joy and raced off to tell their friends. A victory procession formed, and a long line of pine-oil torches flowed through the valley like a river, turning the dark Yan'an night into day. It was a moment the Chinese people had been awaiting all too long.

At 8:15 A.M. on August 6, an American bomber had dropped the atomic bomb "Little Boy" into the sky above Hiroshima. It detonated 44.4 seconds later, killing 66,000 people, a third of the city's population. Three days later, "Fat Man" was dropped on Nagasaki, and within a week Emperor Hirohito had announced his country's surrender on the radio. In China, the war had lasted eight years, killing almost twenty million Chinese.

Meanwhile, Mao was growing more confident that his side would

"Little Boy," "Fat Man"

emerge triumphant against Chiang Kai-shek. His soldiers had only millet and rifles, he noted, but history went on to validate his prediction that their millet and rifles would prove more powerful than Chiang's airplanes and tanks. As he put it, "Although the Chinese people still face many difficulties and will long suffer hardships from the joint attacks of U.S. imperialism and Chinese reactionaries, the day will come when these reactionaries are defeated and we will be victorious. The reason is simply this: the reactionaries represent reaction, we represent progress."

On June 26, 1946, full-blown civil war broke out. Chiang Kai-shek launched an assault on the liberated areas, aiming to overpower them within three to six months. Kuomintang forces had a total of 4.3 million men, with a well-equipped army, navy, and air force. The CCP forces comprised only 1.2 million army personnel, with no navy or air force. The KMT held 76 percent of the country's territory, controlling the major cities and most of the railroads, industry, and human and material resources. The liberated areas amounted to only 24 percent of the

territory. But in the first year of conflict, the CCP armies managed to destroy 1.12 million of the KMT forces, shattering their offensive.

In the competition for the hearts and minds of the Chinese people, land reform secured a solid base of popular support for the Communists. In the areas controlled by the CCP, the land and property of landlords and rich peasants were confiscated and distributed to the poor. In September 1947, the CCP approved new laws on land reform, abolishing the "feudal land system" and dictating that land was to be owned by those who tilled it. The property rights of lineage halls, temples, monasteries, schools, and organizations were to be annulled, and all debts incurred in villages before land reform were canceled. Land was to be comprehensively redistributed, with reallocations from those with more or richer land to those with less or poorer land.

Historically, social change in China has always involved land, and the twentieth-century Chinese revolution was in essence a peasant revolution. In 1949, 80 percent of the population were peasants, and the peasants became the revolution's greatest strength. Land reform eliminated the local gentry class that had existed since the earliest days of the imperial era.

IN SEPTEMBER 1945, Ai Qing said goodbye to Yan'an, his home of more than four years. The Lu Xun Academy of Arts was being split up into three sections: one remained in Yan'an, one moved to the northeast, and one was sent to north China. Ai Qing was appointed team leader for the third of these groups, which had fifty-six members. After a forty-nine-day trek through bitter cold, Ai Qing led his group into Zhangjiakou, a city in a strategic location northwest of Beijing. Wei Ying followed in a separate detachment of family members, along with their daughter and a newborn son, Ai Duanwu.

It was the first time in years that Father had been in a city, and standing in downtown Zhangjiakou, which weeks earlier had been under Japanese control, he felt a surge of pride. "When we think now

of this as *our* city," he wrote, "the people's city, a city liberated by the people after an arduous struggle, and now the people can live here free of imperialist abuse and warlord humiliation, breathing freely, living freely, singing freely, what happiness this is!" He needed to throw himself into the new reality.

Father's family continued to grow. In November 1947, Wei Ying gave birth to Ai Guigui (now best known as Ai Xuan), their third child. But Ai Qing, wrapped up in the revolutionary cause, had little time to attend to his family. During the land reform campaign, he was immersed in administrative work, and his creative activity fell by the wayside. He would wake up in the morning to find his mind had become dry and shriveled.

In July 1947, the Communist armies were on the offensive. Then, from September 1948 to January 1949, in three key battles of the civil war—in the northeast, in central China, and in the Beijing-Tianjin area—the Kuomintang lost more than one and a half million men. In the autumn of 1948, a Communist field army inflicted a series of stinging defeats on Nationalist forces, driving them to surrender and bringing all of northeast China under Communist control. Many of its crack forces were decimated, and Kuomintang authority gradually collapsed, leading to victory for the Communist Party.

Father proceeded as quickly as possible toward Beijing, where he assumed leadership of what was then the National Art School in Beiping (later the Central Academy of Fine Arts). There he was responsible for sorting out property and deciding which instructors to keep. Wei Ying, who had been assigned to a position in the provincial administration, stayed with the children in rural Hebei for the time being, moving to Beijing later.

In April 1949, Ai Qing and his old friend Jiang Feng, accompanied by Li Keran, a professor at the art school, visited the celebrated ink painter Qi Baishi, who taught at the National Art School in Beiping. Qi, then in his mid-eighties, had lived the first forty-odd years of his life as a subject of the Qing dynasty, and with his traditional long, dark gown and flowing white beard, he still looked the part. His eyes

glinting, he warily studied the unfamiliar visitors in their army uni-
forms and institutional armbands. To dispel Qi's unease, Ai Qing hur-
ried to explain that he had admired his paintings since he was eighteen.

"Where did you see my paintings?" Qi asked.

"At West Lake Art School—some leaves from one of your albums
were hanging in my classroom."

"Who was the principal?"

"Lin Fengmian."

Qi nodded, visibly pleased. "He likes my work, I know."

In the center of the old-fashioned studio stood a large rosewood
table, on which lay Qi's tools of the trade: a brush, ink, paper, and
inkstone. Qi Baishi painted something for each of his guests—for Ai
Qing, a four-foot-long scroll of shrimp swimming around, accompa-
nied by two little fish.

There was quite a debate about whether to keep Qi Baishi on the
school's payroll, with some people grousing that he came in just once
a month, doing a single demonstration each time. Father saw things
differently. "When the Japanese and then the Kuomintang were in
charge, Qi Baishi managed to keep himself alive. Are we going to let
him die of hunger now that we're here?" He had a genuine liking for
Qi, and took to calling on him regularly.

On July 2, 1949, a congress of national workers in literature and art
was convened in Zhongnanhai, the compound next to the Forbidden
City that now housed the offices of the top CCP leadership. That
evening Mao gave his first speech in Beijing, to a large group of writ-
ers and artists. In welcome remarks that were largely devoid of real
content, he said, "The people need you as writers and artists, and as
organizers of literary and artistic work. You are doing good things for
the revolution and for the people. Because you are needed, we have
good reason to welcome you."

In the four years since Father had last seen him, Mao had put on
some weight, and the "you" and "we" in his speech announced a clear
change from his practice in the Yan'an era, when he just said "we."
The newly formed associations managing literature, drama, film,

music, and art marked the institutionalization of the party's control over the creative arts. There was no going back to an era of free expression.

Ai Qing was appointed chair of a committee tasked with examining designs for a new national flag, national seal, and national anthem. In September 1949, he selected thirty-eight draft flag designs from among the many submissions and collected them together in a file for the entire congress to review and discuss. In the end, a red flag with five yellow stars was chosen as the national flag. Red symbolized revolution, one large star symbolized the Chinese Communist Party, and four smaller ones represented workers, peasants, and two kinds of bourgeoisie—the "urban petty bourgeoisie" and the "national bourgeoisie."

At three o'clock in the afternoon of October 1, Mao Zedong, chairman of the Central People's Government, and Zhu De, commander in chief of China's armed forces, climbed the ancient Tiananmen gate as exultant crowds gathered in the old streets and open spaces below. Mao wore a stiff new suit specially made for the occasion, cut in the Zhongshan style made famous by Sun Yat-sen, father of the Republic of China. Festive red ribbons were pinned to his chest and to the chests of all the other dignitaries. Mao announced in his Hunanese drawl, "Comrades, today the People's Republic of China and the Central People's Government are established!" Cannons were fired and martial music swirled as, at the press of a button, the red flag with its five yellow stars slowly rose to the top of the pole.

But it would not be long before those who designed the symbols of the new republic, including my father, would be held up to public scorn.

The Gardener's Dream

EIGHTEEN YEARS LATER, OUR ENCAMPMENT ON THE EDGE of the desert was always in an uproar on the days when workers from multiple paramilitary units joined forces to ensure an impressive turnout at large-scale denunciation meetings. At these events, individuals believed to have violated the principles of Mao Zedong Thought or defied Mao's wishes were publicly condemned, criticized, humiliated, and even physically abused, in a form of struggle tantamount to mob violence. The Cultural Revolution, launched in Beijing, had quickly spread across the whole nation, everywhere stirring boorish, vengeful crowds. Like dry kindling, they were just waiting for a spark to light their fire.

On such days, Father would have to walk several miles to the performance venue, where he would join the other "ox demons and snake spirits" from far and wide, who all stood in a row in front of the stage, facing the revolutionary masses already primed to voice their righteous indignation. Sometimes, public denunciations of miscreants would be paired with the announcement of verdicts regarding "active counterrevolutionaries," who would be immedi-

ately dragged off to the execution ground, where their deaths would be observed with ghoulish fascination by spectators of all ages. Once the denunciation meeting was over, the audience, still in high spirits, would sing revolutionary anthems as they walked back slowly to their sleeping quarters under the bright moonlight.

In the early stage of the Cultural Revolution, the stated goal was to "smash the four olds"—old ideas, old culture, old customs, old habits—and replace them all with Mao Zedong Thought. Ever since the establishment of the People's Republic of China, political movements had grown ever more fierce, but the Cultural Revolution was hailed as being "without precedent in history," an event that would touch the soul of every person alive. The denunciation meetings were just the start of the myriad humiliations to which Father and others like him were subjected.

As 1967 drew to a close, radical activists designed a tall dunce cap for Father to wear when he was paraded through the streets. It made him look a bit like a traditional official in a Beijing opera, with earflaps that swung back and forth as he walked. The hat was too big for him and would tumble off his head when he was in motion, so he had to keep it in place with his hand, which only made it more difficult to "hang his head in admission of guilt." Behind him, Red Guards— young militants who made it their mission to combat any and all perceived enemies of Mao Zedong Thought—would repeatedly poke him in the back with a red-tasseled spear to make him bend lower.

At the denunciation meetings, the Five Black Category elements would all be made to wear black, and Father would sometimes need to borrow someone else's black jacket—even if it was a very tight fit—in order to play his part properly. One night I was alone in our dugout, huddled in the corner with my pillow and quilt, waiting for Father to come back after one of these events. When he finally entered, he was entirely black from head to toe. In a faint voice he explained: At the rally, someone had charged the stage and spat in his face, then shoved his head down and dumped a pot of ink all over him. He'd had nothing to drink all day and was so utterly exhausted,

he just sat down and said nothing more. It was days before he could get all the ink stains off his face.

Since Father's vision was deteriorating, he had started to use a magnifying glass for reading. Once, before a sentencing rally, a security officer burst in, grabbed the magnifying glass, and then climbed a ladder up onto the roof of the auditorium, where, peering through the glass, he scanned the horizon for any sign of hostile activity, such as a pending attack by some rival militant faction. That image of a man trying to use a magnifying glass as a telescope has always stayed in my mind as an example of the ignorance and folly of the Cultural Revolution years.

Through a combination of overwork and poor nutrition, Father developed a hernia. The pain in his groin grew unbearable, and he often dripped with sweat. One day I returned home from school to find him lying in bed. He called me over and gave me a little piece of paper torn from a newspaper, on which he had written two names unfamiliar to me, both surnamed Jiang. He said he wasn't sure he was going to survive, and if he were to die, I was to go and see his two younger brothers in Jinhua. They would look after me. His voice was low and weak, but he seemed calm and collected. I was eleven by then, and did not panic. We had become so accustomed to difficulties that it was second nature to me to take things as they came. And fortunately, he did not die. Four years later, he finally got permission to go to the hospital in Shihezi so that the hernia could be repaired.

But my own situation had also become more fraught. During one lunch break, a classmate and I went to the stables to have a look at the horses as they munched on straw and frisked around. One of the horses particularly impressed me: big and tall, it seemed even more handsome than a Tang dynasty tricolor ceramic horse. I was on friendly terms with the coachman, who would often toss me a bunch of vegetables if he was hauling a load of produce and saw me tramping along the road with a basket of firewood on my back.

Somebody reported to the teacher that I had gone to the stable, and there was hell to pay. Since I was the son of a Five Black Category

element, a visit to the stable might mean that I was engaged in sabo-tage. As I stood on the playground and the teacher delivered her tongue-lashing, I saw my father passing by with his shovel and scoop on his shoulders and felt all the more miserable, fearing I had made things worse for him. But when I got home, he did not reproach me at all—he may well have been preoccupied with some worry of his own.

All told, my father and I spent fourteen months together, just the two of us, in Little Siberia. Often he would prod me to write to my mother, and each time I would tell her much the same thing—either "The water here is very sweet—the sweetest in the world" or "Here we have the most delicious watermelons in the world." Unaccus-tomed to expressing emotions to my parents, I fell back on trite pro-motional clichés.

And then, one day, Mother arrived, along with my little brother, Ai Dan. They had taken a bus bound for the oil town of Karamay and had gotten off in Shawan County, and from there taken another bus toward the oil fields, getting off at a stop about a mile from the farm. The driver told her that to get where they wanted to go, they needed to cross the wheat fields toward a hazy patch of green.

Off the bus at last, Ai Dan dashed on ahead like a happy rabbit, while Mother followed behind. She saw someone standing in the dis-tance, and when she could make out that it was Ai Qing, she said, "That's Dad."

Standing with shovel in hand, Father said, "You two look like you've come down from heaven."

"Where do we live?" Ai Dan asked.

"Come along, I'll show you," Father said.

"*Where?*" Ai Dan said. "That's no house!"

"That's our home, all right," Father said. "A dugout is not so bad—warm in winter and cool in summer."

I felt as though a miracle had appeared in front of me: Mother, lovely as always, was standing there, hand in hand with my little brother, both of them all spick-and-span. It was then I realized just

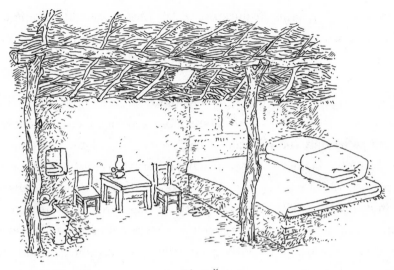

Dìwōzǐ

how much I had been missing her. From that moment on, everything would be different: in our underground home there was now laughter and warmth, and we were no longer lonesome and morose. Mother was a good cook, and now we could eat her noodles. The color soon returned to Father's face. Life continued to be hard, but we never talked of what we had been through during the time we'd been apart, because we were so relieved to be together.

That year I put childhood behind me. I would team up with other kids to forage in the desert for firewood, which we'd carry back home on our backs and store away for the winter. Every time I would collect more than I could really carry—so much that I couldn't stand up straight—and once I started walking, I had to keep shuffling my way forward, step-by-step. But as time went on, my back and my legs grew strong, and I could walk a long way. Occasionally I would spot a wolf lurking in the distance. If I was moving, it would move with me, and if I stopped it would stop, a gleam in its eye, likely waiting for me to keel over.

Before very long, a neat stack of firewood had formed outside our tiny home, with even dimensions and straight edges that would fully match some artworks I would encounter later in life. Our neighbors

were quietly envious. At dusk every day, Mother would wait by the door, and when she saw me trudging slowly home with a heavy load on my back, the look of approval on her face would always make me forget the hardship of the journey.

Once we acquired a bicycle, I would take Ai Dan to collect firewood. At the time I was still quite short and, like a circus monkey, could pedal only the top half of each revolution of the wheels. But the bike could take us farther into the desert to harvest bigger pieces of wood, which we'd tie securely on top of the rear rack, in a pile so high it towered above my head. With Ai Dan perching on the crossbar, it took all my strength to keep the bike straight as we rode. Once, as we were crossing a dry riverbed, storm clouds quickly gathered, resulting in a downpour. With a mighty gust of wind propelling us from behind, our bicycle careened down the slope, bouncing wildly, and threw us on the ground.

But rain like that was a rare event, and most often there was not a cloud in sight. After baking in the sun, the water in our canteen would be almost too hot to drink. If we came across a little pool of rainwater with animal footprints around the edge, I would use an army-issue cap to scoop up a little water and filter out the impurities before we gulped it down.

Every spring, I suffered from diarrhea and had to get out of bed— and out of the dugout—several times a night. I would squat there in the stillness, the vault of heaven hanging low and the sky full of stars, and I no longer felt afraid. I self-medicated, swallowing antibiotics by the handful. I also got hold of a copy of *The Rural Barefoot Doctor's Handbook* and some acupuncture needles and began to practice acupuncture on myself, collecting herbs and decocting traditional Chinese remedies for good measure. The doctor in the company clinic, Dr. Yan, had me work as his acupuncture assistant, and the patients said they felt no pain as I inserted the needles. Being an educated man and a part-time poet, Dr. Yan took the opportunity to ask Father for tips on how to improve his writing. One of his lyrical efforts began

with this fine couplet: "Platoon leader twisted his ankle when pulling a cart / it was all red and swollen and the pain hit hard."

In spare moments, Father found time to read about Roman history, his source material a French reference book he'd managed to acquire. He enjoyed telling me tales of grisly murders and palace intrigues. And I began to read myself: an old edition of the classic *Romance of the Three Kingdoms* and a recent novel about land reform in the Chinese countryside. A dog-eared copy of Mark Twain's *Life on the Mississippi* gave me my first taste of true reading pleasure. But Father restricted my reading, on the grounds that poring over this kind of heavy tome in poor light would be bad for my eyes. He had another reason, too: he didn't want me to get too immersed in the world of books, because he knew the dangers that could lead to.

One morning in November 1972, the dogs all started barking madly, excited by a truck that had driven up and stopped outside. Unbeknownst to us, the production corps leadership had arranged for us to return to Shihezi. As we gathered up our few belongings, a cluster of neighbors stood in front of our underground home, as startled by our departure as they had been by our arrival. "You're leaving sooner than I expected," the hunchbacked director told my father.

Nobody could give us a clear accounting of who had decided to send us back to Shihezi, or what had prompted this move. As happens so often, the things you most wanted to know were precisely the things you would not be allowed to know, in an impenetrable, illogical puzzle. We had grown used to the life here and had been fully prepared to carry on indefinitely: "Let's just imagine this has always been our home," my father would say. But now we were going to leave, and amid all the changes the only thing we could be sure of was the unpredictability of what was to come.

I was fifteen by then. I had not the slightest idea what was going to happen next, sensing only that things would sort themselves out somehow, just as a leaf tossed about by the wind will eventually fall to the ground. But when it will fall and where it will fall are not some-

thing the leaf can decide. The morning we left, before getting in the truck I squatted down outside the dugout and brushed my teeth with toothpaste for the first time in my life—a gesture of farewell to Little Siberia and a recognition that a different kind of life was about to commence. As the truck began to move, I took a last look at the home we had made those past five years, our warm, safe little dugout. We left Father's tools laid out neatly in a line by the door, the blade of his square shovel now half worn away.

FOR SO MUCH OF his life, my father had led an itinerant existence, and in the spring of 1950 he moved houses yet again. Having been assigned editorial duties at *People's Literature,* the premier publication of the newly formed China Federation of Literary and Art Circles (CFLAC), he took up residence in new quarters at 21 East Zongbu Alley in Beijing. In this narrow street, a couple of miles east of the Forbidden City, the CFLAC occupied a compound that dated back to the Ming dynasty (1368–1644), when it housed a government agency. A number of acclaimed authors now lived here, and my father occupied a suite of rooms in an imposing two-story building, erected on a tall marble foundation and topped by green ceramic tiles. He lived on the upper floor, the largest room serving as his study and living room, with two bedrooms adjacent. A staff member was responsible for cooking, supplying hot water, and running errands. Wei Ying, now working for the *Workers' Daily* newspaper, devoted herself to her new job as a reporter and was often away for days on end.

In leisure moments, my father liked to go to Liulichang, the antique market southwest of Tiananmen that had been operating since the Qing dynasty. In those early days, the rich physical culture that had accumulated over the long course of centuries was still on view

everywhere, and Ai Qing was intrigued by all those echoes of the past. In the shops there were all kinds of treasures: bronzes and jades, paintings and calligraphy scrolls, classical furniture, the four treasures of the scholar's studio—paper, brushes, ink, and inkstone. My father would browse happily for hours, occasionally picking out something that he particularly fancied. His appreciation of traditional crafts would, in turn, come to have an impact on me, and forty years later this same street would become one of my regular haunts.

In July 1950, as a member of a Chinese delegation charged with propaganda work, Ai Qing left China for the Soviet Union, where he would spend four months on an extensive tour that included Moscow, Georgia, Azerbaijan, and Siberia. During this time, he found himself in the close company of a former student of his who was now an interpreter for the group. Together in a foreign land day after day, they became romantically involved. Gossip about their relationship quickly made its way back to Beijing, deepening the rift that had developed between Ai Qing and Wei Ying during their Yan'an years. She and my father were often at loggerheads, and by now they had been living apart for some time.

When Wei Ying found out about Father's affair, she wrote a letter of complaint to the Central Organization Department, quoting him as saying, "I'm not afraid of anything. Even if I end up expelled from the party, that's no big deal." He responded by filing for divorce in April 1951. Although a Beijing court approved his suit, Wei Ying successfully appealed the judgment and a long dispute ensued, leading in 1953 to my father's being placed on probation by the Communist Party for "political negativity and repeated errors in relations between the sexes." It would not be until May 1955 that the divorce was finally ratified.

MAO ZEDONG, ALTHOUGH NOW undisputed leader of all mainland China, was quick to perceive potential dangers. In the early 1950s, he

launched one campaign after another in order to consolidate and enhance the position of the new government. At the outset, Mao's regime had confiscated all privately owned land in the countryside and redistributed it among the hundreds of millions of rural workers, thus gaining their trust and support. However, once land reform had eliminated the landlord class and enabled the appropriation of its wealth, the Communist Party reversed course, reclaiming the land and collectivizing it instead.

Next the party conducted a "thought reform" campaign targeted at the academic community. In 1949 there were more than two million intellectuals in China, and soon they were joined by a significant number of overseas Chinese who, inspired by the prospect of progressive change in China, returned to their native country to support reconstruction efforts. The majority of intellectuals came from landowning or upper-middle-class families, and the party set out to reform their worldviews, demanding that they study the basics of Marxism-Leninism and critique their own bourgeois habits of thought.

In November 1949, a prominent aesthetics scholar named Zhu Guangqian had published a self-criticism in *People's Daily*, and soon such luminaries as the sociologist Fei Xiaotong and the philosopher Feng Youlan were doing the same, vowing to "reform their thinking in accordance with Marxism-Leninism and the needs of the new society." *Wenyi bao*, an influential magazine, published self-criticisms by more than thirty authors. This campaign differed from the Yan'an Rectification Movement in that now Mao explicitly called on intellectuals to "remold their ideology." "Criticism meetings" and "struggle meetings" were held, with the aim of undermining the independence of intellectuals while bringing them under ideological authority. Their allegiance to spiritual freedom and free expression was steadily being whittled away.

In an article in *People's Daily*, Ai Qing was singled out for criticism. "Among some of our editorial staff," the author wrote, "tensions have developed between the individual's creative work and his editorial du-

ties, and some have failed to prioritize the latter. This is particularly the case with Ai Qing, who during his term as deputy editor of *People's Literature* showed an inadequate sense of mission. On many occasions, in fact, he displayed a liberal attitude and abdicated his leadership responsibilities." Publicly chastised in this way, Father sank into a deep despondency. At a loss to know what to do, he found consolation only in drinking sessions with friends and in the appreciation of poetry and painting. He even toyed with the idea of going back to making art.

IN JULY 1954, WHEN THE Chilean poet Pablo Neruda turned fifty, he made a point of inviting Ai Qing to attend his birthday celebrations in Chile. The two men had first met in August 1951, when Neruda came to Beijing to award the Stalin Peace Prize to Song Qingling, the widow of Sun Yat-sen, and Father was given the job of entertaining him. Neruda, Ai Qing's senior by six years, had published his first collection of poetry at the age of nineteen and had joined the Chilean Communist Party after the Second World War.

During Neruda's visit in 1951, Father had showed him around sights like the Summer Palace and the Western Hills, and in the course of a week the two men had become fast friends. Neruda was charmed by Father and touched by his work; later he would recall Ai Qing as "the prince of Chinese poets."

In Chinese, Neruda's name was rendered Nieluda—聂鲁达—and Ai Qing, playing on the etymology of the first of these characters, teased his guest, saying, "The first character in your Chinese name is made up of three 'ears.' But you have only two ears. What happened to the third one?"

Neruda clapped a hand over his broad forehead. "It's right here. I use it to listen to the future."

In 1954, China had yet to establish diplomatic relations with most countries outside the Communist bloc, making travel difficult, so it

took Father eight days to get to Santiago. When he arrived, kites were flying in the blue skies above the Chilean capital, and he sketched a Chinese-style kite in his notebook: a long centipede with little spinning pinwheels at each of its joints. The drawing so captured Neruda's imagination that he vowed to fly such a kite on his next visit to China.

With his grass-green wool jacket, Neruda looked like a retired soldier, his forehead bald and shiny, gazing out at the world with the innocent curiosity of an overgrown boy. For Father, it was a delightfully relaxed visit, and on the beach beside Isla Negra, Neruda's house on the Pacific coast, he collected shells of all different colors. He saw them as gifts from the ocean and gave them pride of place on his desk after his return to Beijing. Neruda would tell his friends that Ai Qing was the only poet left over from the age of Qu Yuan, China's earliest known lyric poet. As a symbol of respect, he presented Father with an oxhorn cup inlaid with a silver duck's bill.

BY THE MID-1950S, HU FENG, the first literary critic to recognize Ai Qing's talent, had been under a cloud for quite some time. He had been accused by *People's Daily* in 1952 of having "an individualist orientation characteristic of the bourgeoisie and the petty bourgeoisie." In July 1954, Hu Feng firmly rejected such criticisms in his "Report on the Practice and State of Art and Literature in Recent Years," which became known as "the Three-Hundred-Thousand-Word Letter."

Hu Feng was known as a man of integrity who prized his independence and stubbornly resisted any kind of coercion, and this latest defiance of authority now led to his purge. Mao retaliated by instructing *People's Daily* to publish "Materials Regarding the Hu Feng Anti-Party Clique," for which he personally wrote an introductory note. In the summer of 1955, Hu Feng was arrested, and soon he was sentenced to a fourteen-year prison term.

The accusations against the "Hu Feng Anti-Party Clique" implicated several hundred authors, all of whom were suspended from their jobs during the investigation; many were formally charged and imprisoned. But that was far from the end of it. In August 1955, accusations were leveled against another anti-party clique, supposedly led in part by Ding Ling. Ever since Yan'an days, Zhou Yang had seen Ai Qing as an ally of Ding Ling's. Now, as deputy minister of propaganda and deputy minister of culture, he accused her of trying to expand her clique by roping others in—an allusion to her ties with Ai Qing.

Ai Qing had always resented Zhou Yang's dictatorial ways, and he bristled at the wild accusations leveled at Ding Ling and the party's intolerance of divergent views, which were reminiscent of the excesses of the Yan'an Rectification Movement. The Writers Association was made up of two groups of people, he protested: the first group was always being criticized, and the second group was always doling out the criticism. Ai Qing's remarks confirmed the establishment's view of the poet as arrogant and aloof and contemptuous of the party organization.

DURING THE ONSLAUGHT AGAINST Hu Feng, party documents had to be delivered to key personnel at all hours of the day and night. The Writers Association assigned such work to a number of junior staff members who lived on the first floor of the Writers Association housing. One of them, a young woman named Gao Ying, would become my mother.

Gao Ying was born in 1933 in Huangxian, Shandong Province, but when she was young her family moved to Jiamusi, in Heilongjiang, up near the border with the Soviet Union. It was there that she witnessed the aftermath of Japan's surrender in August 1945, when the Japanese occupiers hastily evacuated, leaving furniture, housewares,

and clothes behind. The Japanese laid mines as they pulled out, and for weeks the town was rocked by explosions as the mines were detonated.

After the Communist forces established control of the northeast, Gao Ying, by then a skilled young singer and dancer, joined a performance troupe entertaining the troops in Shenyang. Later, with the support of her mother, who sent her off with three gold rings sewn inside the hem of her jacket, she attended a teacher training school, and in 1949 she was recruited by an arts troupe.

At seventeen, Gao Ying had married a man eleven years her senior, another Shandong native. He had gained party approval for the match, and without really thinking what she was doing, she accepted his proposal and moved out of her dormitory room and into the apartment they had been allocated. Only later did Gao Ying learn that her husband already had another wife.

In 1955, Gao Ying and her husband were transferred to Beijing; by that time, they had two children. She brought her older child, Lingling, with her, leaving her son, Gao Jian, with family in Shandong.

A staff member in the personnel section of the Writers Association had recently undergone surgery, and another had just given birth, so Gao Ying was brought in as a replacement. One Saturday evening, she was working late in the office when a middle-aged man came down the stairs.

"Comrade Ai Qing, where are you off to?" one of her co-workers called.

He was on his way to view a foreign film, he told her. One of Ai Qing's tasks as a member of the film review board was to clear foreign films for public screening.

"Do you want to go, too?" he asked. "If you do, I can take you."

"Gao Ying," the young colleague said, "there's not much work for us today. How about we both go?"

Gao Ying was then just twenty-two, lively and forthright. Father found her very attractive, and she was charmed by his lack of affectation.

Every Sunday after this, Father would make a date with Gao Ying, but they had to be cautious. Both had yet to finalize their divorces, and their romance would be seen as confirmation of liberal, individualist tendencies. Downtown, there was a danger they would run into someone they knew, so most often they would arrange to meet in a quiet park in the southeast corner of the city. Father would first go to a shop near Chongwenmen that catered to foreigners, where he could buy Western food unavailable elsewhere, like croissants, which Gao Ying loved.

MEANWHILE, AI QING WAS under increasing scrutiny from his peers. The poems he had written after Liberation did not inspire readers nearly as much as his earlier pieces. His recent poetry lacked ardor, and this absence was linked to a lack of engagement with politics. It was said that his writer's block stemmed from a problem of attitude: he might have rejected the old society, but his enthusiasm for the new one was lacking. On the face of it, the criticisms appeared to reflect the views of Ai Qing's fellow poets, but in reality they were the standard party tactic of fomenting suspicion and fear in order to weaken the bonds between writers.

In the face of so much censure, Ai Qing had little choice but to adopt a repentant attitude: "As a poet, I feel ashamed," he confessed. "As a poet of the New China, I feel all the more ashamed. I have failed to write appealing works." But he saw no way forward.

In 1956, however, a thaw set in—though only briefly. In a major speech, Premier Zhou Enlai stated that the vast majority of Chinese intellectuals were state workers and were serving socialism, as they were already a part of the working class. Never before had a top leader indicated that intellectuals had such a secure position; in the past they had always been seen as elements of the bourgeoisie.

In April 1956, Mao gave another, equally encouraging signal. He argued for the coexistence of different academic approaches and pro-

posed to "let a hundred flowers bloom, let a hundred schools of thought contend." He recalled how in early China, before the country's unification under the first emperor, all kinds of ideas could be freely discussed, and the same was needed now.

This kind of talk boosted Ai Qing's spirits, and during the summer of 1956 he wrote several fables, reengaging with ideas that had prompted his Yan'an essay "Understand Writers, Respect Writers," fourteen years earlier. "The Gardener's Dream," for instance, tells a story about a man who grows only roses in his garden. He dreams that a great variety of flowers—the peony, water lily, morning glory, and orchid, among others—rush to introduce themselves and plead their cases, begging not to be overlooked: "Flowers have a will of their own, and blooming is their right." And in "The Cicada's Song," a cicada sings the same old deafening and monotonous tune over and over again from morning to night, no matter what changes take place around it. In this piece, Ai Qing did little to disguise his scorn for the narrow range of acceptable topics and forms in the literature of the New China.

AI QING'S ROMANCE WITH Gao Ying proceeded apace, at the same time attracting unwelcome attention from the party organization. After Gao Ying's husband filed a complaint that Ai Qing had wrecked their marriage, the Writers Association pressed her to confess her er-

rors and tried to restrict her movements and deny her contact with him. At the same time, in light of "the gravity of his errors and his incorrect attitude to his errors," the party sentenced Ai Qing to probation, its stiffest penalty short of expulsion.

My parents persevered, however, and in the end the authorities grudgingly accepted their status as a couple. Since both were now divorced, Ai Qing and Gao Ying were able at last to pick up their marriage certificate and begin a new life together. My father, now forty-six, and my mother, twenty-three, along with her two children, moved into a traditional courtyard house that he had purchased with his publishing royalties. He decorated the courtyard with a variety of plants—flowers, cacti, and some exotic specimens such as a potted lotus whose blossoms opened at midday and closed again a few hours later. In a photograph taken at the time, the newlyweds sit together contentedly, the wife resting her head on her husband's, their steady gazes expressing confidence and contentment. They were blissfully unaware that another political storm would soon shatter the calm.

ON APRIL 30, 1957, Mao Zedong convened representatives of China's non-Communist constituencies for a forum, urging them to speak freely: "Say everything you know, and say it all without holding back; there is no offense in expressing your views, and listeners will profit from your advice; if we have made mistakes we will correct them, and if we haven't made mistakes we will make sure to avoid them." These senior figures took him at his word, and suggested—in tactful language—that the one-party state was creating divisions in society. Mao remarked that this atmosphere of critical debate ought to continue; otherwise, bureaucratism would never be solved. Soon the CCP Central Committee issued a directive that called on people outside the party to "express opinions" and encouraged the masses to present criticisms of the party and the government, in order to help the Communist Party rectify itself.

In April 1957, my parents spent several weeks in Shanghai, staying in the Peace Hotel, next to the waterfront. Father had an ambitious project in mind: he wanted to tell the story of Shanghai since the May Fourth Movement, in the form of a long historical poem that would trace the rise and fall of imperialism and colonialism. But one day, at his room in the Peace Hotel, he received a telegram from the Writers Association, summoning him back to Beijing to take part in the latest rectification movement. He and my mother, then heavily pregnant, bought train tickets and set off for home. On the eve of the May 1 International Workers' Day holiday, as the train trundled slowly into Beijing Station, the couple could see fireworks bursting in the sky above Tiananmen Square.

They returned to their house to find the housekeeper already preparing clothes for the newborn. The due date was fast approaching, and Ai Qing was keen to see the baby delivered at home, where he could keep his wife company and see this unplanned addition to the household enter the world. On May 18, 1957, at two o'clock in the afternoon, the baby was delivered. When the midwife cut the umbilical cord that was wrapped around my neck, a spurt of blood hit the whitewashed ceiling—"like a spray of cherry blossom," my father remarked.

My father opened a standard dictionary, *Cihai* (Ocean of words), to a random page, closed his eyes, and stabbed his finger down. When he looked, his finger was resting on the character *wèi* (未), which means "not yet." "Let's call him Weiwei," he said.

Soon after my birth, my parents entered the most difficult stage in their lives, and they were later prone to remark that I was the start of their misfortunes. Actually, of course, it was not my father's tragedy alone: hundreds of thousands of intellectuals would fall victim to the onslaught. Not long after urging that a hundred flowers should bloom and a hundred schools of thought contend, Mao drastically shifted his attitude. In an essay entitled "The Situation Is Changing," which started to circulate within the party on June 12, 1957, he used the term "rightist" to describe the party's critics. As he saw it, these admirers of

bourgeois liberalism were fundamentally opposed to the Communist Party's monopoly on power.

All that talk, then, of encouraging candid discussion turned out to have been a premeditated effort to "tempt the snake out if its den." During the April forum, some had said what was really on their minds, and Mao now concluded that they were seeking power. Increasingly, he defined the threat posed by "rightists" in ominous terms: "The contradiction between bourgeois rightists and the people is an adversarial, irresolvable, live-or-die contradiction." Insecurity and resentment drove Mao to dehumanize his critics in a grotesque fashion: "Now a whole bunch of fish have floated to the surface. Not just any old fish—they look like sharks, they've got sharp teeth, and they like to bite people."

At this inopportune moment, in July 1957, Neruda made his second—and final—visit to China. Despite the clouds gathering over him, Father was given clearance to accompany the poet on his travels in southwest and central China. Ai Qing flew to Kunming to greet Neruda and his wife, Matilde, along with the Brazilian author Jorge Amado and his wife, Zélia, and together they toured Yunnan, the Yangtze Gorges, and the city of Wuhan.

In his memoirs, Neruda would later recall, "In Kunming, the first Chinese city across the border, our old friend, the poet Ai Qing, was waiting for us. His broad dark features, his large eyes brimming with mischief and kindness, his quick intelligence, were once more a promise of pleasure during this long journey."

"Like Ho Chi Minh," Neruda went on, "Ai Qing belonged to the old Oriental stock of poets conditioned by colonialist oppression in the Orient and a hard life in Paris. Coming from prisons in their native land, these poets, whose voices were natural and lyrical, became needy students or waiters in restaurants abroad. They never lost confidence in the Revolution. Very gentle in their poetry but iron-jawed in politics, they had come home in time to carry out their destinies."

In China, however, human destinies often are shaped by larger political forces, not by an individual's choices. According to Neruda, Ai

Qing and other Chinese friends "had never said a word about being under investigation, nor had they mentioned that their futures hung by a thread," and Neruda was horrified to learn, on his return to Beijing, that Ai Qing had become a target of attack. Father did not appear among the crowd of well-wishers on the day of Neruda's departure. It would be twenty years before he was seen again in Beijing cultural circles.

THE ANTI-RIGHTIST CAMPAIGN WAS conducted all across the country. At the Writers Association, it began with the vilification of Ding Ling. One speaker after another denounced her as an "anti-party element" or accused her of "capitulating to the enemy" or "craving independence from the party." Colleagues who not long before had been shaking hands and chatting happily with her were now showing a different face altogether, in a chilling example of how quickly people could change their stand.

Ai Qing, however, stood up for Ding Ling. "How can you be so heartless?" he protested. "It's wrong to bad-mouth a comrade like this, as though she were a despicable criminal. Sectarian attacks are unacceptable." These words not only failed to help Ding Ling; they ended up bringing disaster down upon Ai Qing's head. Father had stirred up a hornet's nest, and now he was assailed on all sides.

From early June through early August 1957, the Writers Association held twelve meetings, with more than two hundred party and nonparty authors in attendance, to expose the alleged anti-party clique led by Ding Ling. On its front page, *People's Daily* published an article celebrating this triumph and claiming that Ai Qing and a number of his closest associates from the Yan'an days were in cahoots with her. Ai Qing was identified as someone who had long been active in various "anti-party cliques"—"Ding Ling's accessory, Li Youran's friend, Jiang Feng's crony, Wu Zuguang's bosom pal." Wu Zuguang was a well-known playwright; he, Ai Qing, and these other

friends would soon all be labeled rightists and banished from the capital.

Autumn was coming, and Father would sit at his desk in solitude, his eyes dull, saying nothing the whole day. Gao Ying would make a point of waiting in the alley when the postman delivered the newspaper so she could tear out any article that mentioned Ai Qing and throw it in the trash.

In December 1957, the party leaders at the Writers Association made the decision to expel Father from the Communist Party and relieve him of all his posts. When he learned the news, he was devastated.

Late one night, Gao Ying was sound asleep with me in her arms when a series of loud bangs woke her up. She rushed into the kitchen to find Father pounding his head against the wall in despair. She hugged him tightly as warm blood ran down his face. In that terrible era, political life was one's primary life; without it, there was no point in living.

After Ai Qing was branded a rightist, other writers avoided him like the plague. His only form of outside contact would come when he went to Zhongshan Park and played a game or two of chess with another idle visitor, someone unaware of his pariah status.

Among the Russian poets Ai Qing loved, Yesenin and Mayakovsky had both ended their suffering by suicide. One of Father's early writings speculated about the possibility of dying without hope, disconsolately, with constant regret that death had come not in the heat of battle but in a secluded, lonely corner. That kind of thought must have come into his mind countless times during this period.

By the end of 1957, Ai Qing's career was already in tatters, but for critics eager to burnish their revolutionary credentials, there was still more to say about his unpardonable errors. The following spring, an article by a young literary critic, Yao Wenyuan, took the attack on him one step further, detecting a bourgeois tendency to Ai Qing's work at all stages of his career. Many intellectuals had arrived in Yan'an with bourgeois notions of democracy, Yao acknowledged, but

most had gradually accepted proletarian ideology. Ai Qing, on the other hand, had clung stubbornly to reactionary ideals and had never overcome his fear of the proletarian-led revolution. It was only a matter of time before he was unmasked. "Ai Qing's era has thus come to an end, loathed by the masses," Yao Wenyuan concluded. "He started out a proponent of bourgeois democracy and finished up an enemy of socialism; now he has run out of road."

In the years that followed, Yao would write dozens of articles that championed Maoist orthodoxy and questioned the loyalty of Chinese intellectuals, endearing himself to Mao and ultimately securing a position in the Politburo. Only after Mao's death, in 1976, was he punished for his role in the Cultural Revolution: as one of the notorious "Gang of Four," Yao would spend twenty years in prison.

In Mao's view, to simply label Ai Qing and other such offenders "rightists" was not enough: they also had to receive physical punishment commensurate with their grave offenses. That is why 550,000 intellectuals would now be subjected to "reform through labor." Twenty years later, when they finally received "rehabilitation," only 100,000 would still be alive. By then, dissidence was all but dead.

From Far Northeast to Far Northwest

THE YEAR 1958 OPENED WITH NEW ATTACKS ON AI QING and his fellow authors. On January 26, 1958, *Wenyi bao*, the influential literary journal, asked aggressively, "What is it that needs renewed criticism?" It offered its own answer: "Wang Shiwei's 'Wild Lilies,' Ding Ling's 'Thoughts on March 8, Women's Day,' Ai Qing's 'Understand Writers, Respect Writers,' and other such essays." The article went on:

> What is noteworthy about these authors is that, while adopting a revolutionary tone, they are peddling a counterrevolutionary message. Those with a keen sense of smell will of course be able to sniff them out, but others may be misled. People abroad who know the names of Ding Ling and Ai Qing may want to get a sense of what this is all about. And so we are reprinting in full this bunch of essays. Our appreciation to Ding Ling, Wang Shiwei, and the others for their efforts: poisonous weeds have now become good fertilizer, teaching our great people how our enemies operate.

Ai Qing was shocked to find that a case that he thought had been put to rest sixteen years ago was now being revived. Several months earlier, at a meeting of the Communist Youth League branch of the Writers Association, the presiding officer had asked everyone to "assist" Gao Ying in drawing a clear line between herself and Ai Qing and to expose his anti-party stance. Gao Ying, however, resisted the pressure they put on her. "I'm not aware of Ai Qing having any anti-party issues," she said, "and I am not going to divorce him. If Ai Qing is considered so retrograde, then there's no way I can be progressive. And so, to purify the Youth League organization, I am announcing my withdrawal from the Youth League."

This threw the conference room into turmoil. Gao Ying rushed out of the room and out of the compound, and jumped into a rickshaw parked outside. "Let's go!" she cried to the startled driver. When she got home she told Father, "From now on, wherever you go, I go with you."

In the Anti-Rightist Campaign, political pressures forced countless couples apart, but my parents stuck together. At that time they had three children at home with them: Gao Ying's children from her first marriage, Lingling and Gao Jian, and me. My first birthday was coming up, but we were about to leave our cozy home—and it would be two decades before we returned.

FATHER HAD FIRST MET General Wang Zhen in 1943, during his time in Yan'an. After my father moved to Beijing, the two men moved in different circles and seldom met, but on Ai Qing's return from Chile, Wang Zhen had invited him over to his house for a meal. During their conversation, the general had brought out his dog-eared copy of the *Selected Poems of Ai Qing,* the pages of which were densely marked up, with little circles underneath lines he particularly admired. On the title page he had written a message to his children: "One circle: you

need to know these lines well. Two circles: you need to learn by heart."

In the early spring of 1958, when rightists like Ai Qing were facing expulsion from the capital, Wang Zhen, now minister of state farms and land reclamation, invited him over to his home once more. He did not beat about the bush. "Lao Ai," he said, addressing Father in familiar fashion, "you're no anti-party, anti-socialist element. You are on the side of truth, I know. It's time you distanced yourself from the cultural world and joined us instead."

Wang Zhen picked up a stick and walked over to the large map of China hanging on his wall. Heilongjiang was in the top right-hand corner of the map, and Wang pointed at a tiny dot in the far northeast, a forestry station called Nanheng Woods. "Lao Ai," he said, "this is where you're going."

Like other rightists, my father was being exiled to one of the nation's least hospitable regions for "thought remolding." But Wang Zhen had made sure that he would be sent to the "Great Northern Wilderness," the area then under his jurisdiction, where he could keep a protective eye on him. The Great Northern Wilderness was the northernmost part of China, its northern and eastern edges just a stone's throw from the Soviet Union. Ever since the 1650s, during the reign of the first Qing emperor, this part of the country had had a grim reputation as a dumping ground for people accused of insubordination or sedition.

Before leaving Beijing, my mother paid a visit to a grocery store that catered to foreign residents and purchased a case of imported American milk powder. There was no milk to be had in the Great Northern Wilderness, and later my mother credited this infant formula with strengthening my little body for the challenges of exile.

We traveled north on a train earmarked for use by the military, on which we were the only civilians. To avoid attention, before boarding the train Father told Lingling, "If anyone asks what your dad does, tell them I'm in agriculture."

When we eventually reached Mishan, Wang Zhen was there to greet us. The little county town was crammed full with tens of thousands of soldiers returning to civilian life. Wang Zhen, like the wartime commander he had once been, stepped onto the roof of a truck and began to shout directions to the farmers-to-be, urging them to open up virgin land and till the soil in the Great Northern Wilderness, in keeping with the Yan'an spirit. "There's a poet named Ai Qing," he told them, "who is going with you—how about you welcome him?"

"Welcome!" they roared.

"Today we are going to advance into the Great Northern Wilderness. If we have no transportation, what do we do?"

"March!" was the answer.

In Mishan, one could gaze across Lake Khanka at the Soviet Union, on the eastern bank; Vladivostok was not far away. We were allotted empty rooms in a vacant school. When Mother learned that the previous occupants had had a child who died of measles there, she was scared I might pick up the infection. "I'd rather we slept in the street!" she cried. So we moved to a different place and spent the night there instead.

My mother's ancestral home was in Shandong, the home province of Confucius, and like many Shandong natives she had a traditional outlook on family affairs. Deferential to her parents and devoted to her children, she was forthright and capable. Though conservative in expressing her emotions, she loved Father, but in that era the word "love" was never associated with personal feelings, for love could be extended only to the state, the party, and its leader.

Our final destination was State Farm 852. Deep in the mountains, it had until recently been virgin forest. Ai Qing was the only rightist to be sent there. Another 1,417 rightists—authors, painters, actors, musicians, and engineers among them—were sent to two other logging camps in the same general area. They composed just the tiniest fraction of the half million rightists now scattered to all four quarters of the land.

The Communist Party secretary of State Farm 852, who had once

served as Wang Zhen's security officer, treated us with courtesy and consideration. Five freestanding log cabins had been built for the camp managers—one in the middle and four others spaced evenly around it. We were assigned a cabin on the southeast corner that had originally been designated for Wang Zhen's use. It had been put together with lengths of pine, the gaps between the log planks stuffed with sawdust to keep out the cold. Birch trees stood outside, starkly white.

My father was given the honorary title of deputy camp leader, a position without authority or any specific duties. Being a man of letters, he had no experience in forest management or timber extraction, so Wang Zhen suggested he simply be given a chance to mix with the ordinary workers and "experience life," thereby gathering material for his writing. He made himself useful by helping build cabins and installing *kàng*, the heatable brick beds that were standard fixtures in this bitterly cold climate. During the day he was in charge of writing announcements on the blackboard, and in the evenings he would hold up a lantern for those doing heavy work.

In April the trees in the forest had yet to turn green, and Father would take us children out to look for birds. Shafts of sunlight projected down through the branches, illuminating fallen trunks and drifts of leaves amid the stillness and gloom. On the approach of night, the wind would pick up, roaring menacingly as it gusted through the valley. Father would tell us then, consolingly, that the forest was the wind's home: every night, after its busy labors, the wind needed to come home, just as we did. In his eyes, the wind was the mountain's oldest citizen, and I was its youngest.

The state farm had a tiny general store, but its door was padlocked for months on end because it had so little to sell. Survival here depended on one's own efforts. My parents thought to clear a little plot and plant some vegetables, but just digging up the tangle of tree roots coiled beneath the soil left my father's hands covered with sores and blisters.

One day, deep in the forest, we came upon a newborn sika deer.

We brought it back to camp and fed it baby formula. For a while it romped happily as my playmate, until one day, tragically, it stumbled into a well and drowned. Later, the camp acquired a single large reindeer, built an enclosure for it, and put Father in charge of it. Eventually, it managed to knock down part of the fence and make its escape, to my father's secret delight.

In the silence of the forest, life was simple and austere. Once summer came, the mountains were carpeted with "golden needles"— yellow wildflowers that we picked and dried and happily ate. Once, when I was only just barely old enough to speak, I tugged Father's hand and led him into the woods. In a hollow at the foot of a tree I had found a monkey head mushroom, and I was excited to show him.

In the autumn of 1958, when the railway was extended east as far as Hulin, all the railroad ties for the project were made from our timber. My mother had been tending the plant nursery and growing vegetables, but to support the railroad construction, she was drafted into the logging workforce. Trees were harvested with a big saw pulled back and forth by two people; every time a tree was toppled, it would hit the ground with an enormous thump that echoed across the mountain. By the end of the day my mother would be soaked in sweat, only to be chilled by the wind as she left the trees' shelter. That winter, Mother caught a cold, and the cough that followed persisted for more than two months. The blood vessels in her eyes burst with all her coughing, and her eyes turned red. Without access to medicine, she was left with chronic asthma.

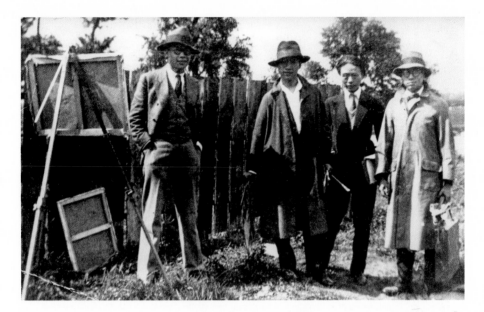

Ai Qing in the outskirts of Paris, France, September 1930.
LEFT TO RIGHT: *Tang Yihe, Wu Zuoren, Ai Qing, and Zhou Gui.*

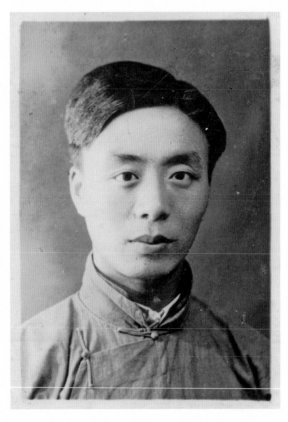

Ai Qing in Changzhou, Jiangsu Province, China, 1936, where he taught Chinese at the Wujin Normal School for Women.

Pablo Neruda and Ai Qing on a boat in Wuhan, China, July 1957.

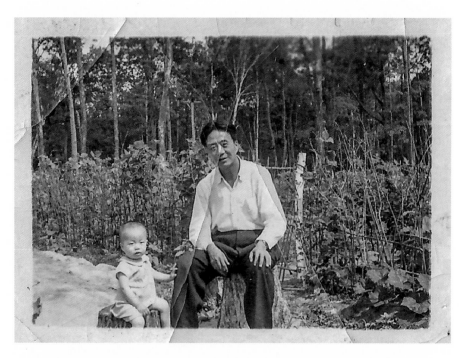

Ai Weiwei and Ai Qing at the 852 Farm, Heilongjiang Province, China, 1958.

Ai Weiwei at the 852 Farm,
Heilongjiang Province, China, 1958.

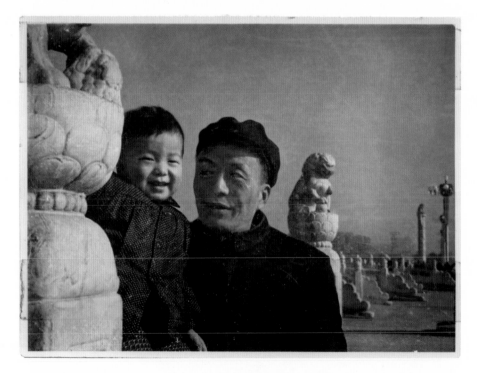

Ai Weiwei with Ai Qing at Tiananmen Square, Beijing, China, November 1959.

Gao Ying and Ai Weiwei in Shihezi, Xinjiang Province, China, 1962.

Ai Qing and Ai Weiwei at home in Dongcheng District, Beijing, 1980.

Ai Qing in Beijing after being released from the rehabilitation camp in 1980.

Ai Weiwei on the Lower East Side, New York, 1985.

*Ai Dan and Ai Weiwei
in front of the Pyramid
Club, New York, 1987.*

Ai Weiwei standing behind To Be Looked At (from the Other Side)
by Marcel Duchamp, Museum of Modern Art, New York, 1987.

*Ai Weiwei
in Times Square,
1987.*

*Allen Ginsberg and
Ai Weiwei on
the Lower East Side,
New York, 1988.*

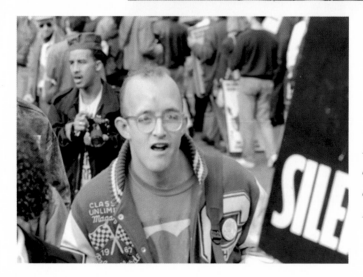

*Keith Haring
at an ACT UP
demonstration in
New York, 1989.*

In the more remote logging sites, the lumberjacks had to dig a hole in the frozen snow and make themselves a temporary shelter, covering the hole with tree limbs and tarps, leaving a gap in the roof for ventilation. They would light a fire to keep them warm in the evening, but it would never last long enough to burn the whole night through, and in the morning it would be so cold that the vapor from the sleepers' breath would rise like a cloud through the hole in the roof. If there was no sign of vapor coming from the hole, it meant that the men inside had died.

When winter came, the mountains were buried in snow for a good six months, and as soon as the snow melted in the spring, there was mud everywhere, and trucks bringing in supplies would be unable to get very far. With grain rations exhausted, we could stave off hunger only by boiling wheat seedlings. My father had lacked calcium in his diet when he was young, had never had very good teeth, and now, unable to break up the coarse seedlings, had no choice but to swallow them whole. This led to his constantly having loose bowels. Soon he was thin as a rake and unable to get out of bed. Weary in body and soul, often after he closed his eyes he had no desire to open them again. But our presence, and my mother's encouragement, helped him stay alive. If it hadn't been for us, my mother later said, the two of them would have bought one-way tickets down to the river, tied themselves together, and jumped into the frigid water clutching a heavy stone. It would have taken just a minute to bring an end to their torments.

In the woods, we were not connected to the electricity grid, so Father offered up his publication royalties to purchase a small generator for the state farm, and after that we had light. When Wang Zhen visited the camp in October 1959, he was shocked to find Ai Qing emaciated and bedridden, and he brought in a doctor to treat him. Not long after that, Father received a letter from the Ministry of State Farms and Land Reclamation that said we could return to Beijing.

Two years earlier, the Soviet Union had launched *Sputnik,* the first-ever artificial Earth satellite. Elated by this breakthrough, the So-

viets laid out a plan to "comprehensively launch the era of Communist construction," with the goal of overtaking the United States within fifteen years. Mao Zedong, similarly, imagined matching Britain's industrial output in ten years and catching up with the United States in the ten years after that. The official formula was to "catch up with Britain and the U.S. in twenty-five years or a bit longer," but this was simply to allow some flexibility—Mao privately thought that twenty years should be enough. The CCP leadership proposed a so-called general line: "to go all out, aim high, and build socialism with more outcomes, faster speed, better quality, and lower cost." The general line, the Great Leap Forward (a push for rapid industrialization, including a mass steel campaign), and the people's communes (intended to collectivize China's rural economy) became "Three Red Flags" raised all across the nation. But these radical policies would bring about the deaths by starvation of tens of millions in the years that followed.

ON OUR RETURN TO the capital, my parents learned that they were being banished to another remote location, this time in extreme northwest China. There, the Xinjiang Production and Construction Corps had been established by Wang Zhen, with orders to "develop and guard the border areas" near the Gurbantünggüt Desert in northern Xinjiang.

It was now late November 1959. In Beijing the weather was getting cold, and Mother had deep misgivings about taking me with them. Like the northeast, Xinjiang had long been seen as a fitting disposal area for undesirables, and during the Qing period it was often selected as a place of exile for those who had offended the imperial court. To get there involved long, arduous travel, and living there meant almost total isolation. Worried that a two-and-a-half-year-old child would be too young to endure the rigors of the journey, my parents entrusted me to the care of my aunt Jiang Xihua, who was now working in Bei-

jing as an art designer. But when they were about to leave, I sat on their suitcases in a desperate effort to prevent their departure. Clutching Mother's legs, I protested that not taking me was tantamount to "wanting to get rid of me." With the car waiting at the curb, she pushed me aside and ran out of the house.

When my parents left for Xinjiang, the railroad extended only as far as the border with Gansu Province and the small town of Xingxingxia, which in the old days had served as a checkpoint for travelers heading west. The next day they took a bus to Weiya, which at that time was so tiny it didn't even appear on maps. There they boarded a bus for a two-day journey to Kumul, where they spent a night, before finally reaching Ürümqi, then locked in snow and ice. Along the full length of the journey through Xinjiang they never saw even the smallest patch of green, only an endless expanse of camel thorn. Sandstorms threatened to shatter the bus windows, and the road conditions were so terrible that Father said it was a miracle his bones were still in their proper places at the end of the trip.

En route, Father had his first glimpses of the Flaming Mountains, the ruddy sandstone hills in the desert east of Ürümqi that seem to burn with an unquenchable fire, and he began to appreciate the austere beauty of the Xinjiang landscape. And although Xinjiang was new to him, he had friends from Yan'an there who would look out for him: Wang Enmao, the first secretary of the Xinjiang Autonomous Region, and Zhang Zhonghan, the deputy commissar of the Xinjiang Production and Construction Corps.

From 1959 to 1961, China was in the grip of a disastrous famine, and tens of millions of people starved to death. Xinjiang, however, was less seriously affected than many other places, and the grain supply was adequate. My parents, concerned that I might not have enough to eat in Beijing, decided to fetch me.

In the summer of 1961, I had just turned four. On our way through Lanzhou, the main city in Gansu Province, we stayed in an inn where the bed was infested with bedbugs. Mother, so punctilious in matters of hygiene, couldn't sleep at all that night.

The railroad tracks now extended from Xingxingxia to Yanhu, and when we got off the train, a gust of wind blew my cap right off my head. Unfazed, I remarked to my father, "The wind here isn't strong at all!" I had already developed a taste for irony.

Quite by chance, as we sat waiting for the long-haul bus, Father happened to meet Vice Premier Xi Zhongxun, who had come to Xinjiang on an inspection tour. Father had gotten to know Xi—father of China's current president, Xi Jinping—during his Yan'an days. They had a brief chat, and Xi told the Xinjiang officials who had come to see him off that it was high time my father's rightist status was reconsidered. In his eyes, Ai Qing was clearly no anti-party element, and he made arrangements for a car to take us all to Ürümqi.

Shihezi lies ninety miles northwest of Ürümqi, on the west bank of the Manas River. In 1949 it had been home to just a few dozen Uighur households, but within ten years it had developed into a town of some 200,000 people. To the north lay the Dzungar Basin, and to the south the Tian Shan mountains. The streets in the new town were so straight they could have been drawn with a ruler. The compound occupied by the administration of the No. 8 Agricultural Production Division was surrounded by a wall, with a guard at the gate. Apart from office buildings, the compound also housed a hundred or more families. Inside the north entrance stood a row of straw-colored Soviet-style bungalows, and the unit on the east end became our new home.

Since we moved houses often during my childhood, and since every move required adjustment and adaptation, home, for me, neither inspired confidence nor conveyed a sense of belonging. A home that cannot be protected and sustained loses its persuasiveness; trust and attachment, when not anchored in memory, also cease to exist.

Towns that followed Soviet notions of urban planning suppressed individual variation in favor of efficiency and uniformity. Shihezi, accordingly, was spacious, with broad poplar groves whose vertical lines formed a neat angle to the horizontal concrete roads they shaded. Built by ex-servicemen, transplants from eastern cities, and economic

refugees from poverty-stricken areas, Shihezi was different from other towns my parents had known, because every one of its bricks, every slab of concrete, was new. Its very lack of history erased the possibility of other realities and highlighted the planners' imagination of the future. Shihezi was inhabited by people with checkered careers, people quite willing to sever connections with their earlier lives and embrace a new beginning, having learned from painful experience that memory and identity were dangerous. The state was a machine that sucked up memory and bleached it white.

The Tian Shan range, to the south, was snow-covered the whole year round, even in the blistering hot summers, and Shihezi owed its lush greenery to the runoff from the mountains. Near our front door, hidden behind a cypress hedge, was a small garden that you entered through a wooden gate over which morning glories sprawled. Inside grew a rich variety of plants. An old, shrunken gardener spent all his time there, bending down to prune branches, loosen earth, clear away weeds, and water the flowers. I never saw anyone talk to him. Rumor had it that he had once been a high-level Kuomintang spy, and I harbored a fanciful notion that secret codes were somehow scattered everywhere in the garden. His home, which seemed to be no bigger than a toolshed, was wreathed in shrubbery and reached by a narrow raised path. I once peeked through the window and glimpsed a twin bed and a desk. The rest of the room appeared untouched. Coated in a layer of dust, it shone with a burnished glow, like eiderdown.

On the surface, at least, Father's situation in Shihezi was not all that bad. There was no work that he had to do, and he was under no particular pressure, but he kept himself busy nonetheless. Up at four or five every morning, he would sit down at his desk to write, by the light of his green-glass lamp. But the poems he sent off to literary magazines would be returned unread, for no editor dared publish his work. Only with Wang Zhen's support did he manage to get a dozen or so pieces published in the internally circulated magazine of the production corps, *Great Leap Forward*, under the pen name Lin Bi,

earning five yuan per poem. Later he began to write a fictionalized account of the Xinjiang pioneer life, *The Desert Retreats*.

As a young boy I would see him every day toiling over the manuscript, every page marked up with revisions, deletions, and insertions. To me, his painstaking devotion to a book that might never get published exerted a mysterious allure, and later in life I would take my cue from him, courting danger by editing underground publications. For him, the act of writing was integral to life, and the will to write could never be destroyed.

Mother handled all the household chores—buying groceries, preparing meals, fetching water. She took care of everything, and the house was always spotless. I often hung around as she did the laundry, admiring her strong arms as she scrubbed our clothes, rinsed them, wrung them out, and hung them to dry on the laundry line outside.

Almost everything in the house was supplied by the government, from armchairs and beds to bookcases, tables, and chairs, even the cup out of which Father drank his tea. Our only items of personal property were the two pieces of luggage we had brought from Beijing. One was a camphor trunk in which Father's paintings were stored. The other was a maroon leather suitcase, its corners protected by bright metal bumpers. The things inside were like a fantasy world to me: artworks from near and far, beautifully decorated ceramics, the oxhorn cup inlaid with silver, an enchanting music box, and—most numerous of all—the conches and cowries that Father had collected from seashores here and there.

One day in the summer of my second year in Shihezi, Father said to me, "Your mom has given birth to a little brother. Let's go visit them." With the afternoon sun on our backs, we walked along the empty streets toward the hospital. In my memory, this was the first time he and I went for a long walk together, just the two of us. On the way we passed a pile of pebbles and I squatted down to pick out ones that interested me, while Father stood off to the side smoking a cigarette, a bag of hard-boiled eggs in his hand.

———

IN DECEMBER 1961, A decision was made to remove the rightist label from a select few among the hundreds of thousands who had run afoul of the 1957 Anti-Rightist Campaign. My father was among the 370 individuals deemed to merit this favor. The news was published in *People's Daily,* and before long the paper forwarded several hundred letters from readers, congratulating my father and wishing him well. But the government's decision did not mark the end of Father's misfortunes, for the Writers Association declined to extend even the slightest leniency to rightist "ringleaders" like him.

Far away, a storm was looming, and soon it would engulf us.

The World Is Yours

The world is yours, as well as ours, but in the last analysis, it is yours. You young people, full of vigor and vitality, are in the bloom of life, like the sun at eight or nine in the morning. Our hope is placed on you. The world belongs to you. China's future belongs to you.

—MAO ZEDONG, REMARKS TO
CHINESE STUDENTS IN MOSCOW,
1957

B Y THE MID-1960S, MAO ZEDONG HAD BECOME CONVINCED that the Soviet Union and its puppet states in Eastern Europe had abandoned the goal of world revolution. Traitors to Marxism-Leninism, Nikita Khrushchev and like-minded leaders were engaged in "revisionism" and a restoration of capitalism. If China was not careful, he believed, the same thing would happen there. Now seventy-three and increasingly fretful about his legacy, Mao believed that the greatest menace lay at the higher echelons of government, among the central leadership. On May 5, 1966, when receiving a delegation from Albania, he said, "My health is not bad, but sooner or later Marx will want me to join him. I am now in the twilight of life, so I need to use the time I have left to put a stop to these efforts at bourgeois restoration."

Mao believed that the forms of struggle used in the past could not solve current problems. He needed a new way, one that would com-

prehensively mobilize the masses from the ground up. The "Cultural Revolution" was his solution. The world could not be put to order without first being thrown into chaos.

On May 16, 1966, at Mao's behest, an expanded meeting of the Politburo approved a document charging that representatives of the bourgeoisie had infiltrated the party, the government, the army, and the various cultural circles. They were a bunch of counterrevolutionary revisionists, just waiting for their chance to seize political power and turn the dictatorship of the proletariat into a dictatorship of the bourgeoisie.

Later that month, a fierce attack on the leadership of Peking University was posted on the campus, in the form of a big-character poster. Since the 1950s, big-character posters—handwritten on one or many large sheets of paper and posted in prominent public locations—had often been used as tools to trigger political campaigns and shape public opinion. Big-character posters were the blogs and the Facebook of the Mao era, the difference being that their views and their language were under strict control, with clear direction and purpose. The attack on the Peking University leadership was part of a larger

effort to unseat Beijing's municipal administration, which Mao saw as reactionary.

In a conversation with his wife, Jiang Qing, Mao Zedong shared his expectations for the Cultural Revolution. Society needed to be thrown into chaos, he said, before it could be properly governed. Every seven or eight years, a movement of this kind would be needed, to draw the "ox demons and snake spirits" out of their dens, in keeping with their class nature. The Cultural Revolution would be a war exercise on a national scale, in which leftists, rightists, and vacillating fence-sitters would all receive their proper due.

July 16, 1966, was a sunny day in Wuhan. Near the newly built Yangtze River Bridge, dressed only in swimming trunks, Mao lowered himself into the river from a motorboat and floated happily downstream for sixty-five minutes. In this staged media event, the showman once again displayed his charisma and stamina. A newsreel of his swim aired throughout the country, and his indomitable spirit of "charging the waves in midcurrent" was meant to spur on the little generals of the revolution.

On Mao's return to Beijing, he issued a truculent statement under the title "Bombard the Headquarters," explicitly targeting the CCP's leadership, and every power holder was soon in the firing line. After that, it was as though a high-pressure hose had been turned on as volatile "revolutionary masses" burst out of every work unit, every school, and every street, fervently organizing "big linkups" that surged throughout the nation, in towns and villages, factories and mines, from the big cities to the distant frontiers.

In the weeks that followed, Mao climbed the steps of Tiananmen eight times, now wearing a green military uniform and accompanied by his "close comrade-in-arms," Lin Biao, one of the few familiar faces left from the old guard (who would later betray him). On August 18, at the first of these rallies, with close to a million Red Guards in the square below, Mao urged the student who put a Red Guard armband on his arm to "be martial," advice that many young radicals would interpret as a signal to be all the more aggressive in their battle

against Mao's enemies. Again and again, Mao would wave a greeting to the mammoth crowds, urging them to dare to think, dare to do, dare to rebel. "Be ready to lose your life, and dare to pull the emperor off his horse," he exhorted them, the emperor in question not being himself, of course, but rather the bureaucratic establishment that Mao saw as his adversary.

On August 23, 1966, Ai Qing's old friend, the author Lao She, and a number of other writers were taken by Red Guards to Beijing's old Temple of Confucius. There they were harangued and beaten viciously. The following morning, Lao She's body was found floating in a lake not far away. On that same day, Li Da, president of Wuhan University, was tortured to death; ten days later, Fu Lei, celebrated translator of Voltaire and Balzac, and his wife, Zhu Meifu, hanged themselves in their house in Shanghai. The red terror had begun.

ONE MORNING IN SHIHEZI, I found that a crowd of people had gathered in the normally quiet street outside our house to read freshly written big-character posters. In them my father's name featured prominently, the two characters of his name crossed out with red ink to highlight his pariah status. I had trouble making any real sense of the generic formulas that littered the posters, lines such as "Tear Off Ai Qing's Spurious Disguise," "Expose Ai Qing's True Counterrevolutionary Colors," and "Dig Out the Hidden Rightist," but clearly this boded ill for my father—and for all of us. The posters even targeted my mother's "bizarre and outrageous clothing," voicing horror at her high-heeled shoes and formfitting dresses.

The authors of these posters were actors and writers, literary types like my parents, and they had been regular guests at our house. Now that the political storm had arrived, they were first to trim their sails to the wind, betraying and slandering people around them, in the hope of enhancing their own position.

Later that summer, as we were having lunch one day, a crowd of

young people, dressed in green military uniforms with Red Guard armbands, stormed into our home. After loudly reciting a litany of Chairman Mao's quotations, they proceeded to "search the house." This was a task they took very seriously, prying up floorboards, flipping through the pages of every single book, gathering up letters and photographs, looking for anything suspicious. In the end they carted off Father's manuscripts, correspondence, and other personal effects, leaving the house a shambles.

My sister was in tears, heartbroken by the loss of beautiful little objects our father had collected, and he tried to console her. "That stuff's not important," he said. "If they want it, let them keep it." To him what mattered were the things he had written. But his long poem about Shanghai and the unpublished pieces he wrote in the Great Northern Wilderness were never recovered.

Father's shelves were packed with literary works, but he had also accumulated a lot of art books. When I was little and not yet able to read the words, I had already begun to enjoy some of these volumes, with their eye-catching covers and illustrations: gilded Virgins, prints of Rembrandt's bronze etchings, buildings and statues from the Classical and Renaissance periods. These all gave wing to my imagination. I remember, too, poetry collections by Whitman, Baudelaire, Mayakovsky, Lorca, and the Turkish poet Nâzim Hikmet. I was fascinated by the Picasso engravings in a volume of Paul Éluard's poetry, and early Chinese revolutionary woodblock prints and traditional window papercuts that Father had acquired in Yan'an. When you turned the pages of the books, they would give off a unique aroma, telling you right away that they were from a different time and place. From an early age, we knew that these books and albums meant the world to Father, for every time he talked about them his face would light up. They helped him forget his worries.

But now, in the current climate, every little fiber of their linen covers posed a danger to us. After several home invasions by the Red Guards, Father decided to burn all his books, and I was his helper. We

stacked the books up next to a bonfire, and one by one I tore out the pages and tossed them into the fire. Like drowning ghosts, they writhed in the heat and were swallowed by flames. At the moment they turned to ash, a strange force took hold of me. From then on, that force would gradually extend its command of my body and mind, until it matured into a form that even the strongest enemy would find intimidating. It was a commitment to reason, to a sense of beauty—these things are unbending, uncompromising, and any effort to suppress them is bound to provoke resistance.

The Anti-Rightist Campaign was targeted at the cultural elite, but the Cultural Revolution set its sights on everyone. Schools closed down to allow students to "engage in revolution," and many teachers, accused of taking the "bourgeois education line," were abused and humiliated, or worse. Adults, busy all day at meetings or struggle sessions, were too distracted to keep an eye on their children, and we were free to play as much as we wanted in the now deserted compound. Hide-and-seek was our favorite game, and once, in search of a good hiding place, I climbed through a window into an empty office. As I crouched down out of sight, I noticed a loose pile of papers on the wooden floor beside me. I was struck dumb by what I saw there: before me lay photographs of my father and family, bundles of letters, and pages and pages written in his familiar hand. These things had been our most prized possessions, and the loss of these few tangible traces of my father's most personal memories would forever impoverish my imaginings of family and society.

———

ONE DAY, WHEN MOTHER came home, she noticed that the wall rack from which we hung our satchels had fallen on the floor. A lightbulb lay on top of Father's desk, and when she picked it up, she found that its coil was intact. "Why remove a perfectly good bulb?" she asked Father, who was sitting there in silence. Suddenly she realized he must have tried to hang himself from the rack, and was now contemplating other forms of suicide. She hugged him tightly, with tears in her eyes. "Ai Qing, don't think that way! What would happen to us if you die? Don't ever try to do that!"

Father glanced down at my little brother, Ai Dan, sleeping soundly and quite unaware of the disaster so narrowly averted. "Gao Ying," he said, "the kids are so young, how could you manage on your own? Don't worry—I'm not brave enough to do it."

In 1967, rivalries intensified between different Red Guard factions. Although all factions were convinced of their undying loyalty to Chairman Mao, their disagreements and mutual hostility developed into armed warfare. On the night of January 25, 1967, conflict erupted in our compound between the "rebel faction," the most radical Red Guard group, and the "royalist faction," a rival outfit that sought to protect the interests of the party organization.

That night, I heard people dashing back and forth on the roof, tiles being crushed underfoot, and a confused hubbub of voices. Loudspeakers blared a deafening cacophony of slogans and threats. The next day we heard cracks of gunfire, as loud and insistent as beans crackling in a stir-fry. Only when darkness came did the gunfire die down, until finally a hushed calm descended on the compound.

The following morning, under a cold sky, some twenty bodies lay strewn across the frozen ground. The dead included a soldier, a pregnant woman, and a classmate of mine named Ma Lu, popular in the neighborhood. A bullet had caught him on his way home from fetching water, and a carrying pole and two buckets lay sprawled next to his crumpled corpse, now stuck tight to a sheet of ice. The soldier's

body was frozen as hard as a rock. Excited by the novelty of the situation, and to show they weren't afraid, the local boys took turns jumping onto the body and off.

Although rumors flew, nobody came out with an explanation for what had happened that terrifying night, and nobody ever took responsibility. Later, absurdly, some claimed that my father had, from behind the scenes, directed the battle, and my mother was accused of conspiring with him.

ONE MORNING, I CAME into the house to find my stepsister Lingling and my stepbrother Gao Jian proudly wearing military uniforms that they'd gotten from who knows where. It seemed very strange to me, not because their clothes didn't fit but because in my mind they were not qualified to dress in such gear, as our father belonged to the so-called Five Black Categories of landlords, rich peasants, counterrevolutionaries, bad elements, and rightists. As one of the ditties of the day went, "Dragons beget dragons, and phoenixes phoenixes. When rats have pups, they're born to live in holes." The theory of a hereditary bloodline was in vogue: the children of Five Black Category elements could never be accepted among the revolutionary elite, any more than a baby rat could become a dragon.

With Lingling and Gao Jian now in their teens, my mother was increasingly concerned about their safety. She persuaded them to go back to Beijing and join their birth father, whose class status as "revolutionary cadre" had so far shielded him from any purge. With the family about to break up, I could sense my father's distress, for he had always treated his stepchildren as if they were his own, to the point that I wasn't even aware that we had different fathers. But Mother didn't want to see their lives ruined just because she was married to my father, and he understood her fears. At this moment of danger, to move them to safety was a wise choice.

Faced with our imminent separation, I felt a deep pain inside, real-

izing we didn't really all belong to a single family: some of us had other options.

I stood stiffly in front of my sister. "Don't go," I murmured.

But Lingling just gave me an odd look—maybe she didn't hear what I said.

After Lingling and Gao Jian's departure, the house was quieter, but we spent every day waiting for the other shoe to drop. Within weeks, Gao Jian returned. Their birth father had been willing to take Lingling into his home, but not her younger brother. To me, as a ten-year-old, this seemed bizarre, and I would continually press my step-brother on why his father did not want him. To Gao Jian, of course, this was the most hurtful question he could be asked, and a punch in the face became his standard response to my inquiries. What I did not understand at the time was that my mother had been awarded cus-tody of Gao Jian, and so her ex-husband was within his rights in de-clining the responsibility of raising their son.

Father seldom talked of the hardships he endured during these days; both then and later in life, with us and with friends, he preferred to keep silent, true to his declaration of a quarter century earlier:

> *No one could suffer more than me*
> *I am loyal to the epoch and commit my life to it, but I am silent*
> *Against my will, like a captive*
> *Wordless on my way to execution.*

Shortly after that, my father and stepbrother and I would be taken—with a few possessions—to the edge of the desert and we would start our lives again in "Little Siberia."

MANY YEARS LATER, on the second day of my detention in April 2011, when I argued that I was entitled to legal protections, my inter-rogator threw me a meaningful look. "Don't you know what Liu

Shaoqi had in his hand that day when the Red Guards burst into his house?" he said. "He was holding a copy of the constitution."

Liu Shaoqi, a veteran revolutionary and a Communist since 1921, had been China's head of state at the start of the Cultural Revolution. Having drafted China's constitution, he took it for granted that the constitution would protect its author. But in 1966, Liu was accused of having taken "the capitalist road," and he ended up a broken man in a makeshift prison. He died of pneumonia in November 1969 and was cremated in secrecy, under an assumed name.

The interrogator raised his voice to make his point. "There is no difference," he said, "between the situation today and the way things were. Today's leaders might well find themselves in Liu's shoes."

He was just calling a spade a spade. What he meant was: Never forget that under a totalitarian system cruelty and absurdity go hand in hand.

Freer Than the Wind

F ROM THE FOUNDING OF THE NEW REGIME TO THE DEATH OF
Mao Zedong, in 1976, China experienced more than fifty politi-
cal campaigns, each more violent than the one before it. The Cultural
Revolution plunged the nation deeply into the realm of fantasy and
delusion.

After the occupation of Prague by Warsaw Pact troops in August
1968, China's relations with the Soviet Union grew all the more tense.
The Soviets stationed a million men on their side of the border with
Xinjiang, and for a while it seemed that war was coming. In anticipa-
tion, my primary school began to emphasize language training, and I
learned how to say in Russian phrases such as "Hand over your gun
and you won't get killed" and "We treat prisoners well."

One evening late in October 1971, a young man appeared at our door.
To Father's astonishment, he pulled out of his pocket a roll of paper—
a confidential "Document from Party Central" reporting that Vice
Chairman Lin Biao, while trying to flee abroad, had perished in a plane
crash in Mongolia. The young man happened to have seen this report
in the farm headquarters, and he decided impulsively that he should
pass it on to "the only person who deserved to read it"—my father.

Headquarters soon discovered that the document was missing, and our visitor was strung up from a rafter for two days and two nights to make him explain his motives. In fact, by the time the report reached the farm leadership, the world outside had already heard the news.

Lin Biao, formerly a top general, had been a founding father of the People's Republic, and during the Cultural Revolution he had played a key role in helping Mao topple his enemies. But a rift had developed between the two men, ultimately leading to the current fiasco. Lin Biao's attempted defection to the Soviet Union dealt a severe blow to Mao's prestige, and after this he seemed a shadow of his former self.

On February 21, 1972, an even more astonishing event took place. Air Force One touched down in Beijing, delivering Richard Nixon for the first visit by an American president to the People's Republic. Nixon's visit signaled a sudden thaw in the decades-old Cold War, overturning all our assumptions and leaving China's population dumbstruck. Seven months later, the premier of Japan arrived in Beijing, and within a few days China and Japan announced the normalization of diplomatic relations. In the wake of these changes, the journalist Edgar Snow, who had introduced Yan'an to the world in his book *Red Star Over China,* made a return visit to China and asked Zhou Enlai if the poet Ai Qing was still living. "Yes, he is," was the reply. "He's experiencing life in Xinjiang."

——

ON OUR RETURN TO Shihezi from Little Siberia, we were housed in
the production corps hotel, a three-story building that stood promi-
nently at an intersection in the center of town. There we were as-
signed two rooms facing each other across a corridor, and our lives
were improved by heating and electric lights. I was now enrolled in
the first year of junior high, at the school in Shihezi that I had at-
tended briefly years earlier. I was appointed student liaison, and a
sketch of mine was hung up in the school hallway and one of my es-
says displayed on the bulletin board.

It was taken for granted that good students like me would join the
Communist Youth League, an organization that had been put in place
partly to recognize and reward positive achievement, and partly to
mold young people's thinking and groom them for future Commu-
nist Party membership. As the Youth League branch secretary put it,
if they did not admit me, they'd have a hard time justifying the re-
cruitment of other, less accomplished students. But my candidacy
proved to be controversial, for some hard-liners questioned my cre-
dentials, noting that my father had been a rightist, and demanded that
I draw a clear line between myself and him. My supporters won out
in the end, however, arguing that I was the kind of boy who, with
proper education, could turn out well. Thus, I was inducted into the
Communist Youth League, my first—and last—co-option by the po-
litical order.

It was at the middle school in Shihezi that I first got to know Zhou
Lin, who would later play an important role in my life. Three years
older than me, Zhou Lin was also from Beijing, and whether it was in
the way she acted or the way she dressed, she was different from the
other girls—more independent, more self-possessed. She would come
to our apartment on weekends and browse our shelves, then tie a big
stack of books and magazines to the back of her bike and cycle off,
returning them all a week later.

———

IN MAY 1972, ZHOU ENLAI was diagnosed with cancer, and from then on his energies flagged. Deng Xiaoping, having sent Mao two letters of self-criticism from the Jiangxi countryside, was allowed to reemerge, and his position as vice premier was reinstated. Other "capitalist roaders," dismissed and abused in the early years of the Cultural Revolution, also began to quietly return to their original posts.

Father had for some time realized he wasn't seeing well, but he had attributed that to the dim light in our dugout. It was only when he got back to Shihezi and consulted an optician that he learned that he had completely lost sight in his right eye. The doctor said that his condition could easily have been treated if he had come a bit sooner. Father just smiled ruefully.

In the summer of 1973, Father's left-eye vision sharply declined, to the point he could hardly read. Given the complexity of his condition, the local doctors did not have confidence that they could fix the problem, and they recommended that Father seek treatment in Beijing. His application had to be approved by successive tiers of the party organization, ending with the party committee of the Xinjiang Military District. Fifteen years after having been exiled, Father was finally given permission (along with Gao Ying and Ai Dan) to proceed to Beijing for medical treatment, while I remained in Shihezi to attend high school.

In Beijing, my parents no longer had a place they could call home, for their house had been taken over by others, and the only option was to stay at the apartment where the younger of my two aunts, Jiang Xining, was now living. Jiang Xining, always a small woman, was now hunched over from years of sweeping the streets and increasingly hard of hearing—one had to speak loudly to be understood. From memories of my early childhood, when she was living in the apartment with her older sister, I still have an image in my mind

of her coming home each day from the Xidan market with a fixed smile on her face, clutching a bunch of greens and a little bag of minced pork.

Father at last had the chance to renew his friendship with Jiang Feng. They had served time together in the Shanghai prison, then met again in Yan'an and arrived in Beijing together in triumph in 1949, only to both be labeled as rightists in 1957. Since that time, they'd had no communication whatsoever, and neither knew whether the other was alive or dead. Jiang Feng, always a quiet man, was now even more taciturn, but through him Father learned the circumstances of several people once close to him: Ding Ling was still in exile in the far northeast, while Zhou Yang had been incarcerated after his fall from grace during the Cultural Revolution.

After consulting a doctor in Beijing, Father managed to fit in a trip to his hometown in Zhejiang. It had been twenty years since his last visit, and though little had changed in the physical landscape, family and friends had aged enormously. He remained under a political cloud, with no prospect of a permanent return to Beijing, and he had no option but to head back to Xinjiang. Jiang Feng made a point of coming to the station to see him off, and the two old comrades bade a tearful farewell.

Propaganda campaigns continued. In a conversation with a foreign visitor in September 1973, Mao Zedong, then about to turn eighty, made a revealing comment, comparing himself to China's first emperor, Qin Shihuang. Qin Shihuang is typically seen in a negative light, as a ruthless despot, but Mao talked of him favorably, reserving his criticisms for Confucius instead. To him, Confucian moderation had little appeal—the concentration of power in the hands of a supreme leader was what mattered. Mao urged the party to study history, to critique Confucius and the Confucian tradition. This initiative, consistent with Mao's long-standing orientation toward ideological struggle, was designed to counteract more pragmatic elements within the Communist Party.

Soon the efforts to critique Confucian thought were combined

with further denunciations of Lin Biao, to create a multipurpose campaign that was even more intensely promoted. Cartoons ridiculing Confucius appeared on the bulletin boards of my middle school, and our teachers, who had only just started feeling good about themselves, now once more had to bow their heads as they walked.

In May 1975, we were in the ninth year of the Cultural Revolution, and for many people this final stage was particularly grim and oppressive. Contrary to Mao's original projections, society had not progressed from great chaos to great order—rather, it was showing more and more signs of stress. The Chinese economy had performed poorly in 1974, and many commodities were in short supply. Mao's wife, Jiang Qing, had teamed up with three other leftists, Zhang Chunqiao, Yao Wenyuan, and Wang Hongwen (in a group later known as the Gang of Four), and was vying for power with Zhou Enlai and Deng Xiaoping.

Over time, Mao came to feel that Deng, while ostensibly following his instructions, was actually contravening them, retaining only the shell of his thought while rejecting the policies of the Cultural Revolution. Late in 1975, Mao spoke out from his sickbed, making it known that he distrusted Deng and labeling his efforts to restore order a "right-deviationist reversal-of-verdicts trend."

It was against this fraught backdrop that my father had been authorized to return to Beijing. There the cataract in his left eye was removed, and afterward he and my mother and Ai Dan managed to stay on in the capital. I joined them there at the start of my winter vacation in early January 1976.

My return to Beijing coincided with the death of Zhou Enlai. For the intellectuals in my father's generation, this was a sad and somber moment. Thirty-six years earlier, Zhou Enlai had arranged for him to go to Yan'an, and in 1944, during the Rectification Movement, it had been Zhou who helped clear him of suspicion. My father felt that Zhou was the most humane of the top party leaders, someone with an understanding and appreciation of intellectuals. Now, with Zhou's death, China's future—and his own future—seemed all the more un-

certain. Grief, anxiety, and apprehension seized everyone in his circle and, indeed, almost everyone in Beijing at this time. On January 11, when Zhou Enlai's body was transported from the hospital where he died to the crematorium at Babaoshan, nine miles west of downtown Beijing, residents turned out in force to bid farewell to their premier. Although Zhou's political opponents—the radicals associated with Jiang Qing—sought to discourage public mourning, news of the impending cremation spread by word of mouth, and as the hearse drove slowly the full length of Chang'an Avenue from east to west, tens of thousands lined the boulevard, weeping and sobbing. My father and I were among the dense crowd of onlookers that afternoon.

Xidan, where we were living then, is just a twenty-minute walk from Tiananmen Square. The Monument to the People's Heroes, the granite obelisk in the middle of the square, became the center of mourning activities in the immediate aftermath of Zhou's death. Every day, I would go there to copy down the poems that people recited, then take them back to my father, who read them with keen interest.

One day, Father and I went to the square together; he wore an old padded jacket and a cotton cap, with a long scarf draped around his neck. On this return to Tiananmen Square, one of my father's eyes was blind and the other was nearly clamped shut in reaction to the bitter cold. He was an old man, with no fixed home and no apparent prospects for improvements in his life. He stood alone under a gray sky, gazing around in grief and loss. The atmosphere in the square was heavy with sadness. The monument stood erect amid a sea of people, the evergreen hedges surrounding it laced with white flowers, as though a heavy snowfall had accumulated. Fourteen years earlier, when Father came to Beijing to fetch me and take me to Xinjiang, we had gone together to Tiananmen Square, and in the picture of him holding me in his arms in front of Tiananmen, we both have smiles on our faces. On this return to the square, after he had endured such protracted ordeals, many emotions must have been churning within him. This was my first experience of a mass gathering.

———

THE FOLLOWING MONTH, Hua Guofeng was appointed acting pre-
mier instead of Deng Xiaoping, clear confirmation that Deng was now
in disfavor. Hua was a quiet, low-key figure, unconnected with the
Gang of Four and with no bonds tying him to Zhou Enlai and Deng
Xiaoping, either. In the power struggle between radicals and moder-
ates, Hua Guofeng held a neutral position, deferring solely to Mao.

The leftist-controlled media discouraged mourning for Zhou
Enlai, but as spring advanced, in many cities in China, people defied
instructions and spontaneously showed their respect. These demon-
strations reached a peak of intensity in Beijing in early April, after I
had returned to Xinjiang. The Monument to the People's Heroes was
practically buried by a mountain of wreaths, and on the April 4 Qing-
ming Festival, when loved ones are traditionally mourned, a million
people swarmed into Tiananmen Square. Many used this moment to
release their pent-up resentment against the radical left, and when the
wreaths were removed overnight in an effort to discourage further
demonstrations, angry civilians attacked police command posts in
the square and burned a police vehicle. On the night of April 5, militia
were brought in to clear the square of protesters; they used clubs to
beat them, and there were many arrests.

Back in Shihezi, I heard on the radio that a "counterrevolutionary
incident" had taken place in Tiananmen Square; Deng Xiaoping was
said to have been behind it. Class enemies, we were told, had made
reactionary speeches, posted reactionary poems and slogans, and dis-
tributed reactionary leaflets, inciting the formation of a counterrevo-
lutionary organization. Having identified strongly with the protesters,
I was outraged that the demonstrations had been so ruthlessly sup-
pressed, and disgusted that the propaganda machine had turned the
truth on its head. I knew that now there would be no space for any
kind of discussion of what had really happened. Thirteen years later,
the Communist Party would take a similar line toward the 1989 de-
mocracy movement. Facing a nonviolent opposition, a totalitarian

regime will not retreat a single step; instead it will always display its essential nature, retaliating with brute force, whatever the cost in human lives and human liberty.

I was now nineteen, and though my ideas were often fuzzy, on one point I was clear: nobody could possibly look forward to a change more than I did. Anything would be better than the current state of affairs. After my high school graduation, in July 1976, I left for Beijing as soon as I could. When my train reached Shijiazhuang, 180 miles southwest of Beijing, passengers on a train coming from the other direction stuck their heads out the window and urged us not to go any farther: there had been a big earthquake in the capital, they said. At that moment I felt a tingle of excitement—I had been hoping for a change, and this was a change, of sorts. But none of us yet realized the catastrophic force of this earthquake, centered in the city of Tangshan, a hundred miles east of Beijing. It had occurred at 3:42 A.M., flattening the industrial city in a few short minutes and extinguishing the lives of more than two hundred thousand people.

When I arrived in Beijing, I found hundreds of people lying out in the open plaza in front of the railroad station, while the telecommunications building on Chang'an Avenue was broadcasting the song "The East Is Red," as though it were just a routine day. Buildings in the capital had sustained minor damage, but there was no wholesale destruction, as happened in Tangshan; it was the frequent aftershocks and rumors of a still stronger earthquake to come that kept everyone on edge and deterred people from moving indoors. That night I camped out at Zhongshan Park, next to the south entrance to the Forbidden City; it was within these precincts that Ming and Qing emperors once made offerings to the gods of soil and grain. A long covered walkway wound past the lotus-covered ponds, and under the ceilings, painted with landscapes and allusions to episodes in history, were benches on either side. That evening, people like me who had nowhere else to go filled every available space on the benches. Aftershocks continued throughout the night, and some people got so jittery they lost their balance and fell into the pond.

In the weeks that followed, fearful of being buried within their homes by another earthquake, millions of Beijing residents lived in the streets instead. At Fuchengmen, next to a gravel heap in a subway construction zone, I was finally reunited with my family. Although the roof of our house had lost only one tile in the tremors, my parents and younger brother were now camping out in a crude shanty put together with metal rods and plastic sheeting. To add to everyone's misery, it was the middle of the rainy season, and almost every day there were heavy downpours, punctuated by thunder and lightning. Ai Dan would stay up much of the night to drain the rainwater that accumulated on the roof of the tent, which was liable to collapse at any moment. Our primitive living conditions reminded Father of the grim days during the war when Chongqing was under Japanese bombardment. Most shops were shut, and we had to depend on makeshift support centers. The only hot food available was wheat cakes, steamed buns, and rice; everywhere you went, there were long queues. Shanties lined the streets, leaving only a narrow gap in the middle for buses and bicycles to squeeze through.

Disaster tests people's endurance, but the real seismic rupture takes place deep in people's hearts—stoic endurance is just what we see from the outside. Starved of reliable news, we had no idea how many people had died in the earthquake, any more than we would have a clear picture of how many died in the Wenchuan earthquake thirty-two years later. But in the case of that second disaster, I got organized and took action to uncover the facts that the authorities wanted to keep hidden, despite the dangers involved. In China, if you try to understand your country, it's enough to put you on a collision course with the law.

In the weeks after the Tangshan earthquake, time stood still, as though we were waiting for something to happen, although we could not say what. We simply sheltered in place, indifferent to right or wrong, impervious to grief or anger, lacking curiosity and kindness.

Around me, people were cautiously passing on reports that so-and-so had been rehabilitated, or that someone or other had now re-

turned to Beijing, and visitors were always eager to discuss these developments. But I felt none of the excitement that so animated my elders, who had experienced calamity for so much of their lives. My life at this point could be described in one word: "dangling." And it was not just me who was dangling; the whole era was—swinging, swaying, in idle, purposeless, uncertain motion. People had nothing better to do; we were all waiting for things to change. In this unusual moment, the entire society was stifled, depressed. Beijing was gray and silent. My father thought I should do what other high school graduates did—go work as a laborer in a rural commune. But I could not imagine putting myself back in a situation where I would be under someone else's thumb.

A LITTLE AFTER THREE O'CLOCK one sultry afternoon, I was cooling off with some friends in the lake at Zizhuyuan (Purple Bamboo Garden) Park, in the northwest suburbs of the city, when we heard an announcement over the loudspeakers that important news was about to be broadcast. We all poked our heads out of the water to listen. Soon the doleful sound of funeral music resounded in all quarters. It was September 9, 1976, and Mao Zedong was dead.

With Mao's passing, just a few months after the deaths of two other top leaders, Zhou Enlai and Zhu De, it was as though the sky had fallen. Sadness was laced with fear for the future and resentment at all that Mao had put us through. What had ended was not a human life so much as a particular understanding of our society. Death took away an era soaked in evil, leaving us only with the habit of clinging ignobly to life.

Within weeks, Zhou Enlai's successor as premier, Hua Guofeng, at the prompting of several retired generals, arrested Jiang Qing and the other members of the Gang of Four. Nobody had expected such a rapid turn of events, particularly when, as Jiang Qing put it, "the Chairman's bones are not even cold." She had underestimated the

boldness of those who orchestrated the coup. According to Hua Guofeng, it was Mao's dying wish that the Gang of Four be purged, and in the same breath Hua announced that the Cultural Revolution was over.

It was around this time that an admirer of Father's poetry offered him the use of a small, single-story residence in the city center, not far from Lu Xun's former home. It was a dark and damp little house with room for only one double bed and one single bed, but it was in a convenient location, and soon there was a constant stream of visitors—former "ox demons and snake spirits" who had now managed to make their way back to the capital.

In this still torpid city, I was at a loose end. There were tens of thousands of people like me, recent high school graduates without a job, recognizable wherever we went and all treated with equally scant respect. In the planned economy that China had then, it was the state that assigned you a job, and there were no other options. Like my father, writers and artists generally were in limbo, no longer political punching bags but still deprived of gainful employment. One of our neighbors, a kindhearted old professor who often came to chat with Father, pushed me to study drawing with him.

Every day I would take a folding stool and easel and go to Zhongshan Park to paint flowers, or spend time at the station sketching people in the waiting room, or go to the zoo to paint lions and elephants, or cycle to places farther away—to the rear hill at the Summer Palace or the ruins of Yuanmingyuan to paint landscapes. Most days I would come home very late. I invested a lot of myself in these pictures, but it wasn't clear to me why, for, apart from me and that elderly professor, nobody else was interested. Although I was unwilling to discover beauty, through painting I could employ an artistic language to achieve a sense of calm. The pleasure gained from this single-minded focus in turn disengaged me from other kinds of connection and gave me a feeling of release. With art I opened up a space that was new to me, an abandoned space infested with weeds, in wild and desolate ruin. Perhaps what I was doing was decadent and self-

indulgent, but it offered the prospect of self-redemption and a path toward detachment and escape.

When a teacher from the Central Academy of Fine Arts went on a trip to the Shandong Peninsula, I tagged along, to get more experience painting from nature. As our fishing boat bobbed up and down on the sea, I saw how the setting sun stained the water blood-red, and how the fishermen's jujube-red skin acquired a purple tint under the bright blue sky. My sketching technique may have been crude, but I drew with great confidence. My view was simply that painting was something I wanted to do, and I had no wish to submit myself to any particular standard; right from the start I refused to let myself be limited by established practices and conventional rules. At the end of the semester, when my teacher gave ratings to his students' pictures, he omitted mine from consideration, viewing me as a student whose work was so oddball as to fall outside any kind of assessment rubric.

IN 1977, WITH THE support of senior figures in the Communist Party, Deng Xiaoping reemerged and his former positions were restored to him. By promoting the idea that practice is the sole criterion for testing truth, Deng provided a theoretical justification for discrediting many of Mao's ideas, thereby weakening Hua Guofeng's position and paving the way for himself to become China's paramount leader in 1978.

During this period of transition, Father returned to his writing with renewed energy and hope. He had written no poetry at all since the start of the Cultural Revolution, but now he would get up at two or three in the morning and try to write for a good three or four hours.

Given his problematic status as a former "big rightist," Ai Qing could not afford—nor could any newspaper afford—to publish poems that might be at all controversial. Accordingly, when on April 30, 1978, a Shanghai newspaper published a work of his for the first time in two

decades, the poem focused on the safest of themes. But it signaled to my father's Chinese readers that Ai Qing was still among the living, after so many years of silence.

In Beijing we still counted as a "black household"—that's to say, residing in the city without official authorization. Wang Zhen, now restored to high position, personally approved the restitution of the house Ai Qing had purchased in the 1950s, but it proved difficult to implement this decision, because several families had taken up residence there and refused to leave. So the Writers Association arranged for my father to temporarily reside at an address in Shijia Alley, a relatively spacious house with six rooms. They installed a telephone—still rare in those days—because he was starting to receive foreign visitors.

With space of his own, Father was able to settle down in his study each day to write. His poem "Fish Fossil," published in *Wenhui bao*, in the now more relaxed political atmosphere of late August, captured the plight of many intellectuals during the Mao era, who for years were denied respect, security, and access to resources essential to their work:

> *You are silent, not even breathing*
> *Fins and gills intact, but unable to move:*
> *You are absolutely still*
> *Never responding to the outside world*
> *Unable to see sky and water*
> *Unable to hear the sound of the surf.*

When intellectuals were sent into exile, their very survival was threatened, and it was all too easy to become a "fish fossil." But, Ai Qing declared, they should never accept such a fate:

> *To go on living, you need to struggle*
> *Advancing through struggle*
> *Even if it kills you*
> *You need to harness all the energy you have.*

In the autumn of 1978, Deng Xiaoping's reformist agenda made progress on several fronts. The verdict on the "counterrevolutionary" incident in Tiananmen Square in April 1976 was reversed, Mao's decision to launch the Cultural Revolution was implicitly repudiated, and—most encouragingly for Ai Qing—the party announced its decision to rehabilitate the victims of the 1957 Anti-Rightist Campaign.

On November 25, at a poetry reading in Beijing's Workers' Stadium (later broadcast by China Central Television), the huge crowd reacted with thunderous applause to a new poem by Ai Qing that celebrated the April 1976 Tiananmen protests and the purge of the Gang of Four. In the poem's final verses, Ai Qing articulated the popular demand for a redress of injustices:

> *All policies must be implemented*
> *All unjust verdicts must be reversed*
> *Even people now in everlasting sleep*
> *Must have their reputations restored!*

He closed with a ringing endorsement of the reformist line:

> *Clear away all obstacles—*
> *Feudal, fascist,*
> *Superstitious, decadent—*
> *Make way for the "Four Modernizations."*

The "Four Modernizations" (in industry, agriculture, defense, and science) were a government priority that had first been articulated by Zhou Enlai and were now central to the new leadership's policy agenda.

As the thaw continued and Father's position became more se-

cure, he grew more optimistic. In December 1978, in his preface to an anthology of his poetry, he conveyed a confident outlook for the future: "I have lived through a momentous, multicolor epoch. Like others of my generation, I have endured all kinds of battles and encountered all kinds of adversaries, in an endlessly shifting landscape. Now the surge of time has swept me to a new harbor, full of sunlight, and in the long blast of the ship's horn my life begins a new voyage."

He also grew bolder, critiquing the cultural policies of the Mao era and pressing for greater artistic freedom. On January 12, 1979, at a forum for writers and artists, he said, "If there is only the freedom to criticize, but no freedom to discuss, who's going to be willing to be creative?" Five days later, at a forum sponsored by the poetry journal *Shikan,* he made a related point. "Without political democracy," he argued, "it's impossible to talk about artistic democracy. You can't expect democracy to be handed to you on a plate—you acquire it through struggle." Why, for so many years, did people not say what they really thought? Because, he noted, truthfulness offended power, and it would bring down terrible punishment, ruining oneself and one's family alike. Now and in the future, poets must speak the truth, raising issues, asking the question why.

Sketch of Gao Ying by Ai Qing, 1978

Finally, in March 1979, Father received the news that he had long awaited: official correction of the verdict that Ai Qing was a rightist. He was fully rehabilitated, with his party membership, political status, and original salary rank all reinstated. Family members, children, and friends implicated through their relationship with him were to be spared any further negative impact.

Before long, strolling in Xiangshan Park, he chanced to meet Zhou Yang, recently released from Qincheng Prison. The former czar of cultural affairs came forward to present an apology: "Comrade Ai Qing, we made a mistake in your case."

To say "we made a mistake" was easy. But so many of the people they had made mistakes about had not survived. Father later expressed his feelings about his reinstatement in this way: "It's not easy to dredge up scattered memories from the bottom of the sea. Corroded by the seawater, many have lost their original luster. For so many years, I was cut off from the world."

But Ai Qing did his best to make up for lost time. Between August 1979 and 1982, he published more than a hundred poems and traveled extensively within China and internationally, receiving wide acclaim. In May 1979, he went on a tour of West Germany, Austria, and Italy—his first overseas trip since 1954. When invited to read a poem at an event in Munich, with a broad smile he pulled some sheets of paper out of his pocket and handed them to his translator. It was a poem about the Berlin Wall:

> *A wall, like a knife*
> *Cuts a city into two*
> *Half to the east*
> *Half to the west*
>
> *How tall is the wall?*
> *How thick?*
> *How long?*
> *No matter how tall how thick how long*

It can never be as tall as thick as long
As the Great Wall of China
It is just a vestige of history
A nation's wound

Nobody likes this kind of wall
Three meters tall is nothing
Fifty centimeters thick is nothing
Forty-five kilometers long is nothing

Even a thousand times taller
A thousand times thicker
And a thousand times longer
How could it block
Clouds and wind, rain and sun?

And how could it block
Birds' wings and the nightingale's song?

And how could it block
Water's flow and currents of air?

And how could it block the ideas
Freer than the wind
Of thousands and millions of people?
Or a resolve even firmer than earth?
Or a desire even longer than time?

("WALL," 1979)

Ten years later, a young man would read this poem aloud at the foot of the Berlin Wall on the day that it fell.

"To be honest," my father would write in 1983, "after experiencing so many years of turmoil and anxiety, I now feel perfectly composed. Many people younger than me have passed away, while I go on living.

If I had died seven or eight years ago, it would have meant as little as if a dog had died. Since the publication of 'Gathering' in 1932, half a century has gone by. My writing career has passed through a long, dank, black tunnel, and often I have felt unsure whether I'd make it out alive, but now at last I have gotten to the other end."

This "other end of the tunnel" marked the end of his personal suffering, but it was far from the end of the regime that had caused that suffering, and the future was more uncertain than ever. After our return to Beijing from Xinjiang, my father's life had changed, and so had mine. Memories made it impossible for me to identify with China's new realities, and ultimately, much like my father before me, I came to feel that the only way out was to leave the country altogether.

Democracy or Dictatorship?

IN AUGUST 1978, I WAS ADMITTED TO THE ANIMATION MAJOR OF the art department at the Beijing Film Academy. With the Mao era gradually consigned to the past, blind obedience and the cult of personality lost their currency. History seemed to have turned a new page, and people reveled in the excitement. So much in China's material and spiritual life had been ruined, but all this destruction seemed to have created opportunities for new things, new ideas, and new people to fill the gaps, and the entering class celebrated its good fortune in finding itself in an era of reform. Our parents might still be under a cloud and our older brothers and sisters might still be toiling in the fields of some remote province, but we surely had a bright future ahead of us.

What I soon learned was that I did not fit in with the new post-Mao order any more than I had fit in with the Maoist order that had shaped—or deformed—my childhood. I felt an aversion to all the norms and premises that others never thought to challenge, and this kept me in an almost permanent state of tension. Many of my classmates came from privileged, establishment backgrounds, and their superior manner reinforced my sense of being an outsider.

In November 1978, a big-character poster, written by someone who identified himself simply as Mechanic No. 0538, appeared on a brick wall next to a construction site near the Xidan intersection in central Beijing. The poster astonished everyone with its boldness, going far beyond the routine denunciations of the Gang of Four and directly criticizing Mao Zedong. For the next four months, this stretch of wall, 10 feet tall and 260 feet long, became the venue for a fledgling movement that denounced autocracy, demanded reforms, and championed democracy and freedom of speech.

One of the movement's brightest lights was Wei Jingsheng, a twenty-nine-year-old electrician turned thinker and writer. His poster, *The Fifth Modernization: Democracy*, put up on the wall on December 5, 1978, presented a sharp-edged critique of the policies pursued by the Communist Party since 1949 and pointedly rejected the message coming from the new party leadership, which Wei characterized as follows: "Take the Four Modernizations as your guiding principle; forge ahead with stability and unity; and bravely serve the revolution like a faithful old ox and you will reach your paradise—the prosperity of Communism and the Four Modernizations." To this orthodox socialist scenario, Wei Jingsheng proposed a radical alternative: "If we want to modernize our economy, sciences, military, and other areas," he argued, "then we must first modernize our people and our society . . . Democracy, freedom, and happiness for all are our sole objectives in carrying out modernization. Without this 'Fifth Modernization,' all other modernizations are nothing but a new lie." Wei Jingsheng put into words many of the thoughts that had been swirling around in my head.

At the end of January 1979, Deng Xiaoping conducted a nine-day visit to the United States—the first time that a top leader of the Communist Party had set foot on American soil. Jimmy Carter arranged for a gala performance at the Kennedy Center, in Washington, D.C., and the final act was two hundred primary school children singing in Chinese the song "I Love Beijing Tiananmen." Deng Xiaoping found

this very touching. He even startled Chinese television viewers by hugging Jimmy Carter in front of the cameras.

But in China, the publication on March 22 of an article in *Beijing Daily* entitled "'Human Rights' Is Not a Proletarian Slogan" was an ominous sign of an impending crackdown. Despite the risks, three days later Wei Jingsheng published in an underground journal an outspoken essay, "Do We Want Democracy, or a New Dictatorship?" Wei could see where things were heading—not toward real political change, but in the direction of continuing ideological controls and the suppression of free speech. Insisting that no political leader deserves unconditional trust, his essay accused Deng Xiaoping himself of dictatorial tendencies. Four days later, in the middle of the night, Wei was detained by a squad of police officers. Other activists were silenced, and the period of intellectual ferment came to an abrupt end.

Thus, while my father was feeling more fulfilled in the wake of his rehabilitation, I was moving in a different direction and becoming increasingly disenchanted. College education, with its pretentious trappings, struck me as fake. I felt untamed blood flowing through my veins: it came from the endless desert, from the white salt plains, from the pitch-black dugout and the helplessness of those long, humiliating years. These memories kept dragging me back to a place I didn't want to go. To expect me now to seek out, in conventional fashion, the contours and colors of visual art, to engage with the storylines and characters in a movie—such assignments failed to engage me.

Coming home from the film academy one evening, beneath a dim streetlamp, I ran into my old Shihezi classmate Zhou Lin, dressed as ever in a tasteful, understated style. She had been admitted to Beijing Normal University, but, like me, she seemed to feel uncomfortable in her new surroundings.

I was impressed by Zhou Lin's brilliance: she hardly ever bothered to attend class, but in the two days before an exam she could prepare sufficiently to master all the material and get a good grade. In the late

1970s, when most students were meek and docile, this was a rare display of individualism.

We both came from the same small town in the northwest, and neither of us liked school—or perhaps I should say we both loathed it. I knew that Zhou Lin understood my attitude to formal education when she said she had once considered jumping out of a school window. When I was with her, there was no need to elaborate on what had made us miserable when we were young, no need to explain what we meant when we talked about spinelessness and hypocrisy. The unhappy memories that we shared fueled our rejection of everything around us, and our denial of reality in turn brought us closer together.

Zhou Lin and I would see each other every weekend. She shared her dorm room with five other girls, and rather than loll around under her mosquito net, we would go for walks by the wheat fields on the outskirts of town until the sky was dark. The roads were quiet, with just the occasional bus, and everything was seemingly at a standstill. Before long the cityscape would be transformed dramatically, and we ourselves would undergo a dynamic change.

The only real treat that the film academy offered me was that every week we were allowed to view two foreign films. At the time this counted as quite a privilege, because during the Cultural Revolution only people like Jiang Qing had been able to see foreign movies. As students, we were issued just one ticket, so I would make it my business to forge a second one. To guard against just such efforts, the tickets were printed on paper with different backgrounds and colors each time, but I would search everywhere for matching paper stock. To actually watch the movie was not so important to me as finding a way of smuggling Zhou Lin into the screening room. The line-drawing skills I had developed earlier in life enabled me to mimic the original tickets so precisely that it was impossible for others to tell the genuine one from the counterfeit. However, the ticket checker at the entrance always had his suspicions, and once he scrutinized my pair of tickets for a long time, after which he announced that the real ticket in my hand was fake.

During the Cultural Revolution, foreign culture had been abominated, so it was a disorienting experience to now be sitting in the dark watching European or American cinema, with a simultaneous interpreter giving a rendition of the lines spoken on the screen. There, in the film academy screening room, I felt even more tense than I would a few years later when I went to see a porn flick in Philadelphia. Fellini particularly struck a chord with me, because I felt the bizarre, sometimes poignant scenes in his movies conformed closely with my own experience.

During this period, Zhou Lin's two aunts in America made contact with her family again and visited Beijing for the first time since 1949. On leaving, when they asked Zhou Lin what they should send her, she responded instantly: an introduction to world art. And so I came to acquire a compendium of reproductions of artworks from all parts of the world. Later, in New York, however often I moved, I could never bring myself to leave this set of albums behind—I would sooner jettison my own pictures.

Zhou Lin's father was an orthopedic surgeon who often worked more than ten hours straight at the operating table, and her mother had been an English teacher whose siblings immigrated to America at a young age. Zhou Lin's parents were the only ones to stay behind and join the revolutionary ranks: they had gone to Xinjiang in an effort to support the development of the border areas.

SHE NEVER SAID SO, but I knew that Zhou Lin had been devoted to her mother, who in the early days of the Cultural Revolution had been taken away by Red Guards and had never come back. She was found hanged in the women's toilets, having been beaten viciously. The reason her mother had triggered such hostility was simply that she spoke English so flawlessly.

Zhou Lin was eager to study in America, and her relatives were only too happy to help her. It was clear to me that if she left, she

would not be coming back. I had made no secret of my distaste for the society we lived in, and she had made no secret of hers. Sooner than I expected, she left for America, and, while distressed by her departure, I was also happy for her—I felt as though a part of me was gaining its freedom as well.

She enrolled at the University of Pittsburgh, and before long I got a letter with a photo of her standing in front of one of Van Gogh's sunflower paintings. During our time together, she had often told me I was the best artist around. This was an extravagant claim to make, given how little art I had done, and she said it with a very straight face, like someone who is telling a lie, but she was convinced she was right. At any rate, her classmates had fully believed her—and they had no reason not to: as far as they knew, art was nothing more than a bunch of propaganda posters.

In late September 1979, we animation students were interning at the Shanghai Art Film Studio when a friend in Beijing passed on some exciting news. Some two dozen Beijing artists had taken the bold step of putting on an unauthorized exhibition of their work in a highly conspicuous location: more than 150 oil paintings, ink paintings, sketches, woodblock prints, and wood carvings had been hung on the iron fence that stretched for 130 feet outside the National Art Museum of China. They called it the *Stars Art Exhibition*. The following day, the public security bureau had sent a large squad of police to close it all down, removing all the pieces on display, on the grounds that the exhibition had not received official approval.

A few days later, on the morning of October 1, the banned artists staged a protest march down Chang'an Avenue. Calling for artistic freedom, they delivered impassioned speeches and attracted an audience of hundreds. After I got back to Beijing, I learned that the authorities had relented, giving the "Stars" permission to exhibit at Painted Boat Studio, in Beihai Park, and I was invited to show a sample of my work. On the last day of the show, as many as eight thousand tickets were sold. The following year, another Stars exhibition was mounted, this time in the National Art Museum of China—

Shanghai Sketch, 1979

partly through the support of my father's old friend Jiang Feng, who was now chair of the China Artists Association. "We are no longer children," the introduction to the exhibition declared. "We need to engage with the world in a new, more mature language." The crowds there were even thicker.

While the activities of the Stars showed that agitation for change in the art world could achieve some success, the government had zero tolerance for dissent that challenged political norms. On October 16, 1979, Wei Jingsheng was put on trial, and after proceedings that lasted only one day, he was sentenced to fifteen years' imprisonment, on trumped-up charges that included revealing military secrets, writing reactionary essays, and carrying out counterrevolutionary agitation. This inordinately harsh sentence had a profound effect on me, deepening my understanding of the cynical and brutal nature of the

Chinese state, and demonstrating the Communist Party's fundamental opposition to freedom of expression. The trial of Wei Jingsheng had ended Xidan Democracy Wall's brief heyday as a platform for political debate, and now the prospects ahead were bleak. I vowed to leave as soon as I got the chance.

Forest, 1977; used for the cover of *Selected Poems of Ai Qing*

———

"New York, New York"

I N 1981, I FILED AN APPLICATION TO PURSUE SELF-FUNDED STUDY abroad. Such an idea was practically unheard of, and the Film Academy promptly turned me down. I countered by threatening to drop out altogether. The school then sought guidance from the Ministry of Culture, which approved my application on the condition that before my departure the school would provide me with "patriotic education" and "training in keeping secrets."

In many people's eyes, electing to go to America for study was tantamount to defection. From 1949 onward, it had been virtually impossible for Chinese to undertake study abroad that was not state-sponsored. The country had been isolated from the West for more than thirty years, and from the Soviet bloc for more than twenty. Now, with the resumption of relations with the United States and Europe, I was in the first wave of students going abroad at their own expense.

Acquiring a passport was no easy matter. First one needed one's work unit to sign off, and then one took the work unit's letter of introduction to the public security bureau and submitted an applica-

tion, which was scrutinized even more closely than my forged movie tickets.

If getting a passport was hard, getting a visa was even more difficult. Only with visa in hand could I go to the local police station to cancel my household registration permit and identity card, after which I needed to return to the public security bureau to pick up an exit card—the prerequisite for purchasing an airline ticket for travel abroad.

The visa official at the U.S. embassy was a tall young African American man who spoke fluent Mandarin. When he learned I was studying animation, he said I must be sure to go to Disneyland. Then he issued me a visa.

China in 1981 had very limited foreign exchange reserves, and the Bank of China headquarters in Wangfujing was the only place in Beijing where one could convert Chinese currency into dollars. I handed over my passport, explaining that I needed dollars because I would be taking a bus from New York to Philadelphia—by now, Zhou Lin had transferred to the University of Pennsylvania. The teller took out a map of the United States and carefully measured the distance between the two cities, and on that basis she issued me thirty dollars in cash. When I went outside, I saw some farmers standing around with antique porcelain vases strapped to the backs of their bicycles, and a cluster of foreigners studying their wares and haggling over the prices. This scene would long linger in my mind.

By now, I couldn't wait to be on my way. My mother saw me off on the day of my departure, February 11, 1981. As we rode to the airport, I tried to reassure her, declaring nonchalantly that I was now "going home," and promising that in ten years' time her son would be a second Picasso.

I WASN'T GOING TO America because I hankered for a Western lifestyle—it was more that I couldn't stand living in Beijing anymore. Shortly before I left, Father had told me pointedly that in his day,

when people left China to study overseas, hardly anybody stayed on after their studies were completed. *Times are different now,* I said to myself.

In the final minutes of the flight, the plane circled around New York City on its descent into JFK. As I gazed down at the seething hallucinatory metropolis below, where traffic flowed like molten iron, all my motherland's teachings, earnestly imparted over so many years, drifted away like smoke.

It began to snow heavily on the bus journey to Philadelphia, and when I got off the Greyhound, there was Zhou Lin, standing in the snow. Now we were together again, on the other side of the world. I lived with her on the second floor of a townhouse a short walk from the University of Pennsylvania campus.

My plan was to first improve my English and then go to New York to study art. At Zhou Lin's prompting, even before I had gotten over my jet lag, I began to walk down the streets and ring doorbells. If someone opened their door, I would be ready with my dictionary in hand, to explain haltingly that I was a student from China—did they have a job for me? I could do any kind of work, I said. Soon I struck it lucky: one woman answered the bell and, after gaping for a moment in astonishment at this stranger on her doorstep, looked just as pleased as Mrs. Nixon on her introduction to the pandas in the Beijing Zoo.

Cleaning the woman's house and keeping the backyard in shape was a job right up my alley, since it required minimal communication skills and could be performed quickly and efficiently. The only real problem was how to make sense of the vast array of cleaning products, all so precise and varied in their applications. It was my very first paying job, and I was making in a day what would take several months to earn in Beijing. If the owner of the house didn't have change, she simply rounded up my pay, and the bonus was big enough for me to buy a whole carton of ice cream. When I'd finished my work, I placed the key under the doormat and left.

I enrolled in an English class where the students came from all corners of the globe and spoke a wide variety of languages. We

shared a yearning for a new life, but our clothes and our conversation exposed our haphazard efforts at cultural adaptation. One morning in late March, our lanky teacher entered the classroom with her usual brisk stride and announced slowly, so we could all understand, "President Reagan has been shot." It seemed at first as though she was cracking some kind of American-style joke, but it was a fact that Reagan had been the target of an assassination attempt after less than three months in office. The American fetish for guns served to broaden my understanding of justice: in China I had grown up thinking that only soldiers had firearms.

When I had free time, I went to the Philadelphia Museum of Art, which was as quiet as a church, often with just a few elegantly attired women lingering in front of the pieces. Back in our Xinjiang days, my father had kept an album with pictures of Rodin sculptures deep in a drawer, and whenever I snuck a peek, my face would flush and my heart would pound. Now, when I stood before *The Kiss,* the white marble flesh of the lovers was hard and cold, no longer imbued with the mysterious luster that I had once associated with it.

In one of the galleries, a bicycle wheel was mounted on a wooden stool; two large panels of glass, one above the other, each splintered and cracked, invited you to contemplate the relationship between the "Bride's Domain" above and the "Bachelor Machine" below. And *Étant donnés,* or *Given,* made by the artist secretly over a period of twenty years, offered the opportunity to look through a peephole in an old wooden door and see a naked woman lying in a heap of straw, her legs spread, holding a little oil lamp of the kind I knew all too well. I was so absorbed in viewing these pieces that the name of the artist failed to register, and it would be some time before I realized how important he would be to me.

BEFORE LONG, ZHOU LIN transferred to Berkeley to study computer science and I followed her there. West Coast life was laid-back, every-

Studies of Marcel Duchamp's *Bicycle Wheel* and
Chocolate Grinder with Ai Weiwei's *Bicycle*

Drawing of Marcel Duchamp's *Étant donnés*

one easygoing in the sunshine. Just outside the north end of the campus stood a former sorority house turned co-op, called Pax House, which was home to some two dozen students. I secured a housekeeper position there that covered the rent of a small room in the attic. Every week, apart from dishwashing, I also had the task of picking up groceries at the supermarket and filling a refrigerator that was taller than I was. Often, the next time I opened the fridge I would find, as if by magic, that there was absolutely nothing inside.

Zhou Lin handled her heavy course load with the precision of a tightly wound clock, and in her free time she would bike to the house of a lonely old man and attend to his needs. I kept myself busy as a handyman, clearing yards and doing home repairs. After muddling my way through a year, I felt that if I stayed on in Berkeley any longer, my brain would seize up completely in the unending sunshine. Luckily, I'd been admitted to Parsons School of Design with a scholarship. Zhou Lin was proud when she heard, but it was obvious we had different paths to follow, like fruit that ripen and fall off a tree in their own good time.

The day of my departure, I found a postcard on my desk: "One day, I'll see your name in the paper." It was signed by one of the Pax

House tenants, a crazy, soccer-loving girl—she seemed to have spotted something in me that others had not.

It was the Christmas holidays by the time I got to New York. Standing on the corner of Fourteenth Street, facing Union Square, I already felt part of this magical city.

I had always envied my father's command of language, which allowed him, even as a young man, to confidently map out his territory. My only regret now was that I lacked that ability to harness the power of words, to find focus and comfort in writing, however difficult my circumstances. That, perhaps, would have made my path simpler and more productive, and I would not have let time slip through my fingers in a welter of uncertainty.

At Parsons, painting was taught by an Irish artist, Sean Scully. In my first class, I laid on the floor a large sheet of rice paper—the size of a twin bed—and with a Chinese writing brush I effortlessly outlined a life-size human figure. My confidence and adroitness inspired my classmates to gather round and watch. I was fully concentrated on my work, and it was only when I finished that I realized Sean was standing right behind me. He said coldly that my picture was the worst he'd ever seen.

Sean's paintings displayed a control of inner emotions, and he would copy and distribute passages he considered important, often a mishmash of random verses and specious epigrams. One example I remember was a couplet by the Tang poet Wang Wei: "In the vast desert isolated smoke stands straight / Above the long river the setting sun is round." Sean quoted this to make the point that, from a distance, mountains don't look much like mountains and water doesn't look much like water, or something along those lines. Unlike education in China, his teaching took the form of a free exchange of views: we'd listen to Sean's comments on students' work and to classmates' critiques of one another's paintings. Disparaging remarks by one person tended to trigger defensive responses, and the atmosphere could get quite fraught.

The day we visited Sean's Tribeca studio, we were like a flock of

Figure drawings, 1982

lost fowl that had flown accidentally into another bird's nest. The wooden floors were littered with brushes and paint tubes, as though at the scene of some disaster, and leaning against the wall were some large oil paintings of Sean's that would eventually become classics. The art critic Arthur Danto has since described him as "an artist whose name belongs on the shortest of the short lists of major painters of our time." Sean always held a whiskey tumbler in front of his chest like a boxer ready to throw a hook. His sweeping brushstrokes and rich palette were exquisite, but, as novices, we focused only on the thickness of his colors and overlooked the key aesthetic points.

It would be thirty years before I saw Sean Scully again. Somehow I had never expected him to visit China, but one day, to my pleasant surprise, he came to see me at my studio in Beijing. He took a stroll around and pronounced it the equal of his own studio in Germany.

Parsons was like an expensive kindergarten, primly cajoling a bunch of wayward kids into behaving properly. But the time I spent

there was important. I felt myself standing on the waterfront of art, with a wide field of view in front of me and a tangle of ideas in my mind. I began to search for concepts and modes of expression that engaged me.

But just as I was beginning to get used to art school, I had to leave it, because of my performance on the final exam for an art history class. That day, the lecture hall was crammed full of students. I glanced over the questions, then placed my signature on the top right corner of the examination booklet and left the room. Outside in Washington Square, I realized there was nowhere in particular I wanted to go. The sky was high and the clouds were thin. This beautiful weather made me feel lost. New York's climate is much like Beijing's: although far apart, the two cities are at the same latitude.

I had submitted a blank paper not out of disrespect for art history per se, or because I thought there was something boring about Picasso and his lovers. I was simply ambivalent; I didn't know what I liked. I regret that I didn't have the chance to explain my actions properly to the professor. She felt that I hadn't tried, and if she'd thought I had she would have let me pass, as she was a patient, dedicated teacher. But I had felt that my English wasn't up to the task of answering the prompts to my satisfaction, and the simplest solution was to hand in a blank sheet. The price I paid was that I forfeited my scholarship.

After leaving Parsons, I moved to Williamsburg, Brooklyn, then a mixed community of Jews and Hispanics. But soon I had to move again, and one day I found myself waiting to pick up a key to an apartment in Alphabet City in Lower Manhattan, on the corner of East Third Street and Avenue A. Here, there was none of the rush and frenzy you saw in other neighborhoods—it was as dark and gloomy as a movie set in postwar Eastern Europe. When my elderly, petite landlady arrived, she peered up at me and spoke quickly in Yiddish. It was a studio apartment with a bathroom. The kitchenette had a small refrigerator; a single cockroach was there on the stove to greet me. A steady drizzle was falling outside, but some people without umbrellas

were hanging around the front stoop in the rain, showing no signs of leaving. Drug dealers or junkies, they were comfortable anywhere they were.

A futon and an old green bench that I had toted back from a park were the extent of my furnishings. I picked up a TV set that someone had abandoned on the curb, and once I had moved it into the room, I never turned it off. For a while I was glued to the black-and-white images of the Iran-Contra hearings, jarred by the scandals simmering below the surface of the democratic process.

A sense of belonging is as important to the poor as to the rich, and in Lower Manhattan I felt at home amid the dirt and decay and disorder. If, conversely, I'd been given an apartment on Park Avenue, I think I would have died of depression in no time. I learned to take my cues from seasoned New Yorkers, all so shrewd and alert. On the subway I would refrain from acknowledging others, and when walking I would never break my stride, like a mechanical device that would have trouble restarting if it were ever to stop. I would lock and bolt the door the moment I got back into my room, and I never once answered the bell. A part-time job might keep me busy for a while, but otherwise my time was completely unstructured and I was free to do whatever I felt like. Dressed in green army fatigues or a padded military coat, I would roam the streets at all hours.

Even if, on my home territory, people were as wild-eyed as vampires, leaving downtown Manhattan always got me a bit rattled. I registered for a class offered by the Art Students League of New York on West Fifty-seventh Street, although if I hadn't needed some formal affiliation to protect my immigration status, I would not have chosen to visit that part of town. This art school had a long and distinguished history, and—more to the point—it had a flexible fee structure, where you could pay as you went rather than commit to a whole year's tuition. Compared with Parsons, the school was shabby, but this didn't stop it from nurturing some major figures.

My teacher was Richard Pousette-Dart, a versatile artist then in his late sixties. One wouldn't have guessed that he had been part of Jack-

son Pollock's circle, but he was still an active member of that holy generation of New York School artists, and one of his early oil paintings was hanging in the Metropolitan Museum. I was energized to be in contact with a living, breathing part of history. Pousette-Dart always encouraged me to keep on doing what I was doing. But I knew I didn't have it in me to make a career out of painting. I was there simply because I hadn't found something more appropriate to do.

Sometimes I would shuttle into one gallery after another, and no matter how baffling the works on display might be, I learned to never rush and to give things their proper due—I was nurturing my patience and cultivation. At other moments, my head was full of impractical daydreams, and time, for me, had no better use, so I would leave home with no specific aim in mind, heading off in whichever direction the light was green.

I started working the night shift at a printing shop near the corner of West Thirteenth Street and Tenth Avenue. There, in the Meatpacking District, the slaughterhouses and packing plants had begun to close down, but the air still reeked of blood. Discarded wooden pallets would pile up on the sidewalks, and in the winter homeless people would collect the pallets, toss them into old oil barrels, and set them on fire. They stood there, drinking and yabbering, their faces reddened by the light of the flames. As evening fell on my way to work, I would stroll past these bonfires, a box of doughnuts in my hand, munching away contentedly.

Browsing at the far end of the basement of the Strand Book Store, on Broadway, one day I came upon a book entitled *The Philosophy of Andy Warhol: From A to B and Back Again*, with Warhol's signature on the flyleaf. It was the first book in English that I read devotedly from cover to cover, its language a lot like the terse pronouncements you see on Twitter today. My enjoyment of the book came partly from the pleasure of reading it and partly from imagining the pleasure that I would have once I could make sense of it. My attachment to the book was a bit like a Kenyan's bond with his cane, which never leaves him whether he's walking or dancing. I acquired multiple copies of

the book, in the same edition and with the same cover, and reading it—with only partial understanding—was like engaging in a religious ceremony. If I were ever to understand it fully, that knowledge would surely disappear to nothing in an instant.

In time I was kicked out of the Art Students League as well, and as a result I lost my student status and—like one out of seven New Yorkers—I became undocumented. Initially this was a blow, but soon I took a relaxed view of the matter, for I knew that something like this was bound to happen, given my willful tendency to let the dice fall where they may. I accepted my predicament as the price of my freedom—the mark of my freedom, even—and so long as there was still a carton of milk in the refrigerator, I felt secure.

For me, like a little ant on a big tree, survival was not an issue, and New York was more than a big tree—it was a whole forest, stretching as far as the eye could see. I could disappear inside it, unrecognized and unnoticed, and this was exactly what I liked about it. In those days, freedom for me meant simply being free of worries and responsibilities. When you are forgotten by the world, it's easy to adopt a devil-may-care attitude.

In the 1980s the East Village was swept up in a contemporary art craze, with the rebellious graffiti of Keith Haring and Jean-Michel Basquiat attracting much attention. At the International With Monument Gallery, not far from where I was living, a trio of fish tanks was put on display, with spotlights illuminating the basketballs floating inside. It was very impressive—but the value was several times my annual rent. Meanwhile, next to the windblown Cooper Union parking lot, you would see a tall, thin artist standing huddled in a wool overcoat, selling the snowballs laid out at his feet.

There were tens of thousands of artists in New York, but only a few dozen who were making money. For a certain subset, art had become a target of speculation and just part of the race to find the next new thing. Art had long been a consumption commodity, a decoration catering to the tastes of the rich, and under commercial pressures it was bound to degenerate. As artworks rise in monetary value,

Study of *Nude Descending a Staircase*

their spiritual dimension declines, and art is reduced to little more than an investment asset, a financial product.

At the Mary Boone Gallery, on West Broadway, one could view Eric Fischl's African women and boys playing on a beach, Barbara Kruger's slogan-like political commentary, and huge Julian Schnabel canvases, which served as fitting reflections of New York's financial heft. I admired the artistry of these works, and one day I got to meet Mary Boone herself, who was chic, petite, and driven. But like much of the art that was fashionable in New York in the 1980s, these works felt completely disconnected from my life experience.

Almost ten years later, amid the Beijing smog, my phone rang and the caller introduced herself as Mary Boone; she said she wanted to show my work. I didn't know quite what to say—except to agree right away.

ONCE MORE, IT WAS time to move. An art space in SoHo called the Kitchen, whose bulletin board was covered with housing ads, served as a clearinghouse for the countless pilgrims to this city. Whether filled with hope or racked with anxiety, we all needed a place where we could get some sleep. Clutching an address I found there, I made my way to 111 Hudson Street in Tribeca and pressed the bell. A short man of Asian ancestry answered the door. "Sam" had a Chinese name, Tehching Hsieh, and I soon learned that he was a performance artist from Taiwan. Several years earlier, he had assembled a wooden cage measuring eleven and a half by nine and standing eight feet high and imprisoned himself inside it for a year, during which time he neither spoke to other people nor read nor wrote. Every day a friend would bring him food and dispose of his waste, and that was all. When I met him, he had already completed three of these *One Year Performances*, and they weren't getting any easier.

Tehching Hsieh was now preparing another work. This time he and a performance artist from California named Linda Montano

were going to spend a year tied to each other with an eight-foot nylon rope. Given that this project would be taking up all his energies, Tehching wanted to sublet a portion of his workspace, and that was where I came in.

Tehching Hsieh was smart and decisive, with the self-possessed composure that's part of the New York character, but he also had the natural restraint of a Taiwan native. His place had once been a heavy machine workshop, and the wood floors were in poor condition; oil had seeped into them and they gave off a strong smell. When you opened or closed the windows, they resisted with a grating squeal. The bar across the door was a horizontal metal bolt like the kind of latch you see in the Forbidden City, and no force in the world could have broken it open.

The loft was huge and empty, and my footsteps sounded hollow. But that first night I was startled awake: below me was a discotheque, and the floor was shaking with the raucous chorus of "Girls Just Want to Have Fun." At first, I gave up trying to sleep at my regular time, and at night I would wander alone through the then largely deserted Tribeca warehouse district in a pair of cheap Chinese loafers. But it didn't take long before I got used to the din, and eventually the noise became, to my ears, a form of quiet. Later, when I moved to places where there was no noise, I found it hard to adjust.

Tehching's room had two single beds, placed parallel, three feet apart. Once he and Linda were tethered together, they went on living much as before, with Tehching doing design work and Linda giving interviews about the project and engaging in meditation. The difference was that now they kept each other company at all times. At moments when Linda entered a state of transcendental bliss, Tehching would simply gaze blankly at the clock on the wall. When either of them embarked on some activity—any kind of activity—it was a grim ordeal for the other. Every day they took a photograph, as a physical record of their time in bondage.

Tehching's art took up the whole of his life, and it frustrated him that he couldn't extend it further. But to bring to pass another "stage

in life," detailed and precise preparation was essential, and that may be why later he found it hard to continue with these performances. Art is always an event—no matter how you see it, it's bound to have a beginning and an end.

Tehching had a black Tibetan mastiff, small for its breed. I could never remember the dog's name, so I called it Tehching, too. It regularly paid visits to my room, because I hadn't installed a door. That winter, Tehching (the dog) peed copiously over a pile of sketches I had done, and his pee congealed into a layer of glistening crystal. I didn't get mad, feeling instead that the dog was dropping a not-so-subtle hint that the time had come for me to stop painting. Another day, I found a piece of paper on the floor, and on it was written "Weiwei, don't try to be perfect. Nothing in this world is perfect." It was signed with Linda's name. In a sense, I was part of their project, too.

At the end of the year, in front of a large crowd, Linda and Tehching (the man) picked up a pair of bolt cutters—the kind that bike thieves use—and as cameras flashed, they severed the rope that had fastened them together. While others celebrated the event, I just felt relieved, after seeing them suffer for their art for so long. Linda left soon after, and I never saw her again.

Linda and Tehching were models for me in terms of their unflinching commitment to an artistic vision, and in their company I never felt lonely. Tehching was like a character out of a Kafka novel: nobody understood what he was doing, and very few really took notice. He was like an exquisite plant specimen, immersed in an existence all its own. Now, when Tehching and I meet up, we always share our thoughts on the artist's life. He's like a boxer always ready to throw a punch, and I'm the punching bag.

As I saw it at the time, everything was just beginning, and I had no plan to leave this city that was so big it could be a world unto itself, or multiple worlds—I was going to spend my life here. If I encountered a situation that didn't allow me to make choices for myself, I would let life make a choice for me. My task was simply to stay on an even keel as I faced a fragmented and repetitive set of routines: regardless

of how I began the day, it would proceed from start to finish in a pre-dictable, mundane fashion.

Every aspect of my situation seemed impermanent—my immi-gration status, my ever-changing address, my unstable, odd-job in-come. But the conventional path of accumulating assets, getting a degree, securing an American passport—none of that interested me. What I wanted was for people to leave me alone, for I was in no mood to change my ways. At this point I was taking nihilism to extreme lengths, and it was the very confusion of my life that gave me a sense of my own existence. Still, I knew that possibilities are never com-pletely exhausted, and life itself is a great work of art, with room enough to encompass disillusionment and anomie.

In late December 1984, at a poetry gathering in St. Mark's Church, a heavily bearded Allen Ginsberg, dressed in a dark suit, read his po-etry on the rostrum while a crowd listened keenly below. He was talking about the trip he had just made to China:

> *I learned that the Great Leap Forward caused millions*
> *of families to starve, that the Anti-Rightist Campaign*
> *against bourgeois "Stinkers" sent revolutionary poets*
> *to shovel shit in Xinjiang Province a decade before*
> *the Cultural Revolution drove countless millions of readers*
> *to cold huts and starvation in the countryside Northwest.*

Ginsberg was a smoldering charcoal fire, warmly drawing people to him on this winter night. When he finished, I went up and told him that I was the son of the revolutionary poet he had just been talking about. His eyes grew big as he listened. Gazing at me intently, he said that his warmest memory of China was the hug that my father had given him. We left the church and went to the Kiev, a Ukrainian diner nearby. When I told him I didn't drink coffee, he ordered an egg cream for me instead.

Then in his late fifties, Allen lived on East Twelfth Street, in an apartment left to him by his mother. The shelves sagged under the

weight of his books, and in places the floor had been worn away. In the corner of his bedroom stood a little Buddhist altar table, above which hung a sacred word handwritten by his guru. All of a sudden, he turned to me and intoned a long, protracted "Aaaahh," his mantra of enlightenment.

Allen was never without his little Olympus camera, with which he would quietly record the passing moments in his day. No matter how dim the light, he never used a flash, and though the pictures could be grainy, there was a richness to their shadows. The back lot below his kitchen window was a subject he never tired of photographing.

On Christmas night in 1987, Allen recited his long poem "White Shroud" in my basement. He had written it for his mother. A radical and an activist, she had introduced Allen to politics at an early age, and at home she had often walked around in the nude. Allen reminded me of my father, for both were boys who never grew up. To them, the world was what found sanctuary in their consciousness, and when they died, that piece of the world perished, too.

One day, a woman with graying hair rushed over to greet Allen as we stood chatting outside Cooper Union. He introduced her as Susan Sontag, and me as a Chinese philosopher—despite the fact that I was clutching a sketchpad and was on my way to draw for tourists in Greenwich Village.

Allen was not always so flattering. Once, after examining a portfolio of mine, he said to me, "I really don't know who would be interested in a Chinese artist." I still remember this as though it were yesterday. I never thought of Allen as an American poet—even if his Americanness was utterly authentic—for others had an outlook that was entirely American, and Allen had a global perspective. The United States likes to think of itself as a melting pot, but it's more like a vat of sulfuric acid, dissolving variety without a qualm.

Another time, however, Allen listened raptly as I shared stories about my father and our life in exile. He looked at me through his thick lenses and said, "You need to write down your memories. The first thought is the best thought." I didn't understand what he said, for

I felt no attachment to my memories. My memories didn't belong to me; in the episodes that I recalled most clearly, my existence was nullified, and writing them down would be like tossing a handful of sand into the wind. It would be decades before I could give substance to those memories.

Once, in Allen's apartment, I saw a young man sound asleep on his bed. At this point in life he could not give, Allen told me ruefully, he could only take. But to my mind, Allen was always young, always giving of himself, selflessly. When I left New York, I didn't say goodbye to him. Later I learned that in his final days, when he was gravely ill, he had tried to get hold of my telephone number.

MARTIN WONG HAD BEEN born in San Francisco; his mother was Chinese and his father was half Chinese, half Mexican. Martin and I hit it off well, because we both enjoyed standing on the sidewalk, engaging in idle chitchat while people-watching. He would take up a position next to me, at the corner of Eighth Street and Second Avenue, just up the block from the Love Saves the Day sundry goods store and near a row of pay phones where kids from New Jersey would always be making calls. Though we were living in peaceful times, in this spot in the East Village there was so much chaos you might have thought the end of the world was nigh, with street peddlers hawking smuggled and stolen goods, punks asking for handouts, junkies sprawled across the sidewalk, and followers of Hare Krishna and skinhead louts rubbing shoulders with poets, vagabonds, rock musicians, and young Japanese admirers of the New York punk scene. Martin was a tall man with a slight stoop, a cowboy hat always perched on his head, the toes of his red leather boots perking up, wearing a fringed suede jacket over faded Levi's—the complete midnight cowboy.

Every time Martin opened his mouth, I already knew what he was going to ask me, because each question was the same: Had I really

been trained in socialist realism? That was a technique, promoted first in the Soviet Union and then in China, that enabled you to realistically depict some inspiring revolutionary scene. In order to make Martin happy, I gave him a short answer: I said it was a piece of cake to paint a portrait of Mao. I didn't want to disappoint him, but for a long time I had been in no mood to paint anything. I believed in the same god as he did, I said, it was just that I never went to church. He would lean against the wall, chuckling. For him to converse with someone from a Communist country was a cherished pleasure, because it allowed him to fantasize about the difficulties and miseries of our lives.

Martin's paintings were unconventional: his subject was the red brick walls in Chinatown. One of his pieces assembled the bricks in the shape of a heart, a warm, sad image with an honest solidity to its brushwork. I never had the chance to see the graffiti museum that he often talked of establishing—he would die a few years after I left New York. I am happy I still have one of his pieces, a small picture of a red brick wall.

Those were pretty much all the friends I had, and if I had died, it most likely would have been my landlady who'd discover my body. In a competitive atmosphere where people eyed each other suspiciously, you needed charm to win approval, to be thought of as cool. I relied on my imagination for other friends: on every street, in every window, among the scurrying pedestrians, there were friends of mine—it was just that I didn't know them. New York is nothing like a village, after all.

BY THE EARLY 1980S, young people in China who had been sent to the countryside during the Cultural Revolution had returned to the cities, and with rising unemployment, the social fabric was under a lot of strain. Deng Xiaoping, China's new paramount leader, downplayed the rights of the individual, defining humanitarianism as "protection of the majority of people's security." The government launched a

crackdown on crime that meted out swift and severe punishments, and between 1983 and 1987 no fewer than 1.7 million people received criminal sentences. Punishments were often grossly disproportionate to the gravity of the offenses committed, and there was a dramatic increase in the number of executions; in some cases the death penalty was imposed for misdemeanors as minor as sexual promiscuity. This "strike hard" policy harked back to the repression of "counter-revolutionaries" during the Mao era and demonstrated how little had changed.

In 1987, when the crackdown was still in full swing, Ai Dan came to join me in New York. A number of his friends had been jailed, so it was no surprise that he wanted to get out of China. It was six years since we'd last seen each other, and now he was twenty-five. His plan was to study photography.

Given that I didn't have much more in my refrigerator than a few rolls of film, Ai Dan needed to make some money. We posted ads on utility poles and scanned the want ads, and in the end he found a job delivering the local Chinese-language newspaper. First thing in the morning, he would go out with his trolley, and he'd spend the day shuttling back and forth between Manhattan and Queens, replenishing newspaper stands above ground and below. For a new arrival like him, this kind of demanding but tedious work was an unrelieved ordeal. When he got back in the evening, he would sit down and have a beer, but we found less and less to talk about. I felt ashamed that I wasn't able to look after him properly, the way an older brother should.

Ai Dan's presence made me realize how far my lifestyle deviated from the norm. The typical Chinese who arrives in the United States with less than a hundred dollars in his pocket is eager to regularize his position in society and achieve the American dream; he will start by getting a steady job in a restaurant or, perhaps, in a university laboratory. Almost everyone was seeking to get ahead, to live a more comfortable life, but I was not.

In response to a want ad, Ai Dan and I offered our services as extras for the Metropolitan Opera's production of *Turandot*. Franco

Zeffirelli, the director, glanced at us across the floor and—impressed by our classic Mongoloid features—immediately signaled his approval. For Ai Dan, a lover of classical music, to be on the same stage as Placido Domingo was a dream come true. We were assigned the role of executioner's assistants, which posed a conflict with Ai Dan's firm commitment to nonviolence, but it was just an opera, after all, so he set aside his scruples. Our roles put us center stage, where we brandished our axes so theatrically that Ai Dan sometimes couldn't help but chuckle. When James Levine's baton fell at the end of the final scene, we slipped out the back door and feasted on hot dogs and papaya juice at Gray's Papaya on the corner of Broadway and Seventy-second Street.

But Ai Dan never quite adjusted to our dissipated New York life, and within six months he was on a flight back to Beijing, where he shut himself in his room until he had finished writing a memoir, *New York Notes*. If you want to know more about my life at that time, you might have a look at that book. Writing it was Ai Dan's way of poking his finger in the eye of Chinese literary fashion, which he found insipid and shallow. Ai Dan never sought popular acceptance—for him it was enough to have just a few sympathetic readers, and he was happy to keep his distance from the mainstream.

In 1987, halfway through my time in New York, I put a few of my thoughts down on paper and published them in a Chinese poetry magazine, *Yixing*—here are some of them:

> Art has its own language. Its language may be unaesthetic and irrational, but it's the language of art all the same.
>
> Negative behavior has positive implications.
>
> When people talk about someone with talent, they say, "He did things of significance." In the future, people will say this of someone with talent: "He did nothing at all."

I had come to realize that art is simply an identity, and nothing else. To break free of constraints doesn't mean you have gained free-

dom, for freedom is an expression of courage and sustained risk-taking, and facing freedom is always difficult, whatever the time and place. I felt no need to explain my lifestyle any further, for it could not be categorized one way or another, and what lay ahead was a boundless expanse of aimless and unstructured life.

Andy Warhol died in 1987. Warhol was a product of self-manufacture and self-promotion; communication was the soul of his activities. He created a reality that defied conventional, elite values. Nobody has put it more clearly than Andy Warhol himself:

> I think everybody should be a machine, I think everybody
> should like everybody.
> I like boring things. I like things to be exactly the same over
> and over again.
> I never fall apart, because I never fall together.

A week before he died, Warhol wrote in his diary, "A really short day. Nothing much happened. I went shopping, did errands and came home, talked on the phone. . . . Yeah, that's all. Really. It was a really short day."

Although Warhol and I had had nothing to do with each other, his death deepened my sense of emptiness.

I WAS PAINTING LESS and less, fearing that if I got going and found it difficult to stop, I might end up like Van Gogh, a troubled artist with a room crammed full of pictures. Plus, I resented having to stretch a canvas over a frame, and I never liked the smell of oils and turpentine. I had lost patience with painting but had yet to find an appropriate visual language to replace it.

In the mid-1980s, the art world was still wallowing in German neo-expressionism—large paintings with raw, overdramatic brushwork—whereas I was drawn toward Dada's countercultural tendencies. I

fused a violin and a shovel, I inlaid a condom on a Chinese army-issue raincoat, and using a wire clothes hanger, I fashioned a profile portrait of Marcel Duchamp. It was Duchamp's work that had caught my eye at the Philadelphia Museum of Art when I first arrived in America, and it was his emphasis on art as an intellectual and not simply a visual experience that would be a lifelong inspiration to me. His interest in ordinary objects, in the "readymade," was already influencing my own artistic productions.

Hanging Man, 1985

It was at this point that I put on my first solo exhibition, *Old Shoes, Safe Sex,* at the Art Waves/Ethan Cohen gallery, in SoHo. This show, though obscure, was for me an epoch-making event. One solitary review in *Artspeak* described it as "such a neo-Dadaist knockout that we in the West, where rebelling against one's elders is something of a tradition unto itself, can only applaud its audacity, as well as its artistry."

"Undoubtedly," the reviewer went on, "Duchamp would have enjoyed these tributes and endorsed the irreverent talent of Ai Weiwei." I was very happy to have encountered such an appreciative critic—but not one of my works sold.

Around this same time, a couple of pictures of mine were part of a group exhibition in the East Village. When the show closed, rather than take the pictures home with me, I just chucked them into a

dumpster. Dumpsters are everywhere in the streets of New York City, and you could probably find a number of masterpieces in them. I must have moved about ten times during my years in New York, and artworks were the first things I threw away. I had pride in these works, of course, but once I'd finished them, my friendship with them had ended. I didn't owe them and they didn't owe me, and I would have been more embarrassed to see them again than I would have been to run into an old lover. If they were not going to be hanging on someone else's wall, they didn't count as anything at all.

I was now making money as a sidewalk artist, mainly near Christopher Street in Greenwich Village, sometimes in Times Square, sketching portraits with charcoal or chalk. Watching people surge out of the subway exits, I had no interest in who they were or where they were going—all that mattered was whether they would be able to spare fifteen minutes to have me sketch their portrait. Once I got going, a line would start forming behind me, and I wouldn't have a moment to grab a bite to eat or go to the toilet. American tourists, I found, were the most generous sitters; foreign tourists, particularly those from Israel or India, were the hardest to please.

No great powers of imagination were required to complete these sketches, and I would watch my subjects amble off with their portrait under one arm, carrying away my ideal. I knew that I was never going to be another Picasso, but this way, at least, I could take care of the next month's rent and the heating bill.

TOMPKINS SQUARE PARK LAY just two blocks from where I was living. Its benches served as beds for vagrants, and the abandoned houses nearby were inviting targets for squatters to occupy, rent-free. In the park, a few surviving Communists would distribute revolutionary manifestos, while during the weekends Hare Krishna devotees handed out sweetened rice balls to anybody who was interested. Neo-Nazis, skinheads, and ex-hippies got in on the action as well. The park

served as the community's holy land for everything from dog walk-
ing to drug scoring.

Art galleries began sprouting up as fast as bamboo shoots after
spring rain, the area began to be gentrified, and low-income residents
were gradually forced out. Protests against gentrification and police
violence were held every weekend, month after month, culminating
in a riot in and around the park in August 1988.

One steaming hot evening, when the authorities imposed a curfew
on the park, East Village residents responded angrily and all hell broke
loose. That was the first time I had witnessed police in full riot gear
inflicting violence on unarmed protesters. Rude, ferocious, and arro-
gant, the police must have felt threatened by the anarchists' bold defi-
ance, and once evening fell, they laid into them with brutal force.
Amid all the mayhem I took a lot of photos—mainly of the heads left
bleeding by policemen's clubs. This experience served as a crash
course in social activism, helping me understand the power of capital,
the conflicts of interest between institutionalized power and the indi-
vidual, and the necessity of upholding rights and freedoms in the face
of threats and violence.

One man I photographed was named Clayton Patterson. He was
an anarchist who videotaped several hours of violence at the hands of
the police. When the district attorney ordered him to hand over his
tapes, he flatly refused. He said he wasn't so stupid as to trust the
capitalist justice system with incriminating footage. On his way into
the city courthouse, he showed me his open palms, on which he had
written DUMP KOCH—Ed Koch being New York's mayor at the time.
Instantly, I pressed the shutter. I knew there was power in that image,
so from there I ran out into the street, clutching a copy of The New
York Times. From a pay phone I got through to an editor at the news-
paper, then hopped into a cab. The editor on duty took the film out
of my camera, and ten minutes later, with the easy assurance of a
shopper picking a tomato from a market stall, he selected one of the
developed exposures.

At three o'clock the following morning, I stood in front of a

twenty-four-hour convenience store on St. Mark's Place, waiting for the day's paper to be delivered. My photo appeared in the Metropolitan section, with a credit below in small print: "New York Times, Ai Weiwei." Seeing these words banished all thoughts of sleep. That photo was so ordinary as to be just one leaf out of the countless leaves that drop in autumn, but the feeling it gave me was special, for it was the first time I had established a true connection with my adopted city. I was no longer simply a spectator.

A real-life incident had been transformed into a media moment, and it took me some years to realize the full import of that. I was impressed by the journalistic commitment to independence and impartiality, and by the truth of the claim that in *The New York Times* one could read "All the News That's Fit to Print." It never occurred to me that one day I would have a chance to apply the experience I had now acquired. Twenty years later, in the face of brutality and censorship on the other side of the world, my photographic record would become all the more vital.

The confrontation between residents of the East Village and police was the last spasm of sustained violence I witnessed in New York City. But the photos I took of police beatings became part of the material record used by the New York Civil Liberties Union in its indictment of police brutality. One day in Washington Square, Norman Siegel, executive director of the NYCLU, gave me his card and told me that if the police knocked on my door I should call him, even if it was in the middle of the night.

After the Tompkins Square Park riot, I became interested in other protest movements. At a march in Manhattan demanding an increased budget for addressing AIDS-related issues, medical workers blocked traffic on a major street and resisted arrest so vigorously that it took four policemen to bundle a single protester into a squad car. That incident naturally triggered media attention. I remember seeing the artist Keith Haring, an active presence in the ACT UP movement, at the march that day. I photographed other events, too, including demonstrations against Operation Desert Storm, against police bru-

tality, and for gay rights and the rights of the homeless, although those protests failed to gain much traction.

THE BIG STORY IN the spring of 1989 was of turmoil elsewhere. In late May of that year, several of my telephone conversations with Ai Dan were drowned in the din of military helicopters flying low over downtown Beijing. Leaflets were scattered, demanding that protesters withdraw immediately from Tiananmen Square.

The sudden death by heart attack of Hu Yaobang, former general secretary of the Chinese Communist Party, on April 15, 1989, triggered a power struggle between top leaders who favored political reform and those who tolerated only economic reform. Marches to Tiananmen Square by university students mourning Hu Yaobang soon developed into demonstrations demanding that the government address inflation, unemployment, and corruption and uphold media freedoms, democratic processes, and freedom of assembly. In mid-May, a group of students began a hunger strike, attracting support from some four hundred other cities in China. It did not take long for the government to abandon dialogue with the students, and the hard-liners, led by Deng Xiaoping, chairman of the Central Military Commission, decided to crush the demonstrations by brute force. On May 20, martial law was declared in Beijing, and 300,000 troops were deployed.

In the early morning of June 4, soldiers armed with assault rifles and live ammunition, supported by armored vehicles and tanks, shot their way along Chang'an Avenue, the main approach road to the square, taking hundreds of innocent lives and leaving a trail of crushed bicycles and burned-out buses in their wake. Beijing residents had never imagined that the army would open fire on students peacefully petitioning for policy change. The legitimacy of the Chinese regime, undermined so often by one blunder after another, crumbled to dust in the slaughter. But state violence did not loosen the rulers'

hold on power. On the contrary, now they simply gripped their weapons all the more tightly.

"Regime change will cost a lot of people their heads" was the saying circulating in Beijing. Rumor had it that on the eve of the crackdown, Deng Xiaoping had said to his aides, "Creating our Communist state cost twenty million lives. If people want to take it from us now, they'd better be ready to lose just as many heads!" Other versions of this story attributed the remark to the veteran general Wang Zhen. This attitude of ownership and entitlement would determine China's developmental path in the decades that followed.

I watched the events in Beijing on CNN compulsively, day after day. What else could I do? Media had changed our way of knowing the world. It's not that people were closer to the news events, but rather that they had become a part of what was happening, part of a new reality. The world before us emerged as chaotic and unpredictable, while information unspooled endlessly, like life itself, in a disorganized blend of good and bad, right and wrong.

Some artist friends and I went on a hunger strike in front of the United Nations, organized a march, and submitted a letter of protest to the Chinese consulate. While the protests were still going on, we organized several charity auctions to benefit the students in Tianan-

men Square, and after the crackdown, in support of human rights organizations in China, we compiled an album of photographs of the protests taken by foreign journalists.

That September, at the Grand Hyatt Hotel on Forty-second Street, together with several activists who had fled China after June 4, I attended a talk given by the Dalai Lama. Thirty years earlier, the Dalai Lama had left Tibet as a twenty-three-year-old; he was now well into his fifties. Dressed in a maroon cassock, he was still a picture of robust good health. In a speech delivered in Tibetan, interspersed with the occasional English or Chinese phrase, he made the case for religious freedom and true self-government in Tibet, a position quite different from what Chinese propaganda attributed to him.

The popular view at the time was that the CCP regime would collapse in the economic downturn triggered by the international sanctions imposed after June 4. The Dalai Lama saw things differently, believing there were deep historical reasons for the CCP's ability to retain power all these years, and the regime would not collapse just because students were opposed to it. Those in exile needed self-discipline, he advised; it would be all too easy to become fragmented and corrupted. As we left, the hallway was crammed with admirers. Clearly there were two worlds, one inside the room and one outside, and, struck by the contrast between the richness of spiritual life and the coarseness of reality, I felt a numbing sense of helplessness as I walked toward Times Square. The pictures I took that day all came out blurry.

The days were slipping away, and I was increasingly weary of my situation. Freedom with no restraints and no concerns had lost its novelty, and, like an old soldier returned from battle, all that was left was a search for a reason to go on living. People said I would be the last person to go back to China, and I thought the same. But we were all wrong.

In the summer of 1991, my tenth year in America, something happened that made me further question my commitment to staying on in New York indefinitely.

It was common at the time to get mugged. An artist from Shanghai, for instance, was held up at knifepoint on the sidewalk beneath his apartment and robbed of everything he had on him. He was left standing naked in the street. Lin Lin, a talented artist who had studied at Hangzhou Art Academy, was not so lucky. Unlike many young Chinese who had come to New York, Lin Lin had an optimistic outlook and took every opportunity to engage with American society. He lived in a tenement in Harlem. One weekend evening he had gone to Times Square to do portraits, and there, in front of a Kentucky Fried Chicken, a young Black man got into an argument with him. Within minutes, the man pulled a pistol out of his pocket and shot Lin Lin in the chest. He fell to the ground, his eyes staring wide, and died within minutes, there on the noisy, tawdry sidewalk.

Lin Lin's murder made me more sensitive to the absurdity of this society. Violence, so deeply rooted in American life that you could never escape it, reflected the profound flaws built into the country's social fabric.

BY 1993, TWELVE YEARS had passed since I left Beijing. During my absence, China's economy had grown by leaps and bounds. I had no illusions about my native land, however: the things that really needed changing had not changed at all, and maybe they never would. But the fear and insecurity of my childhood years were far behind me now, and while my father was still alive, I wanted to spend time with him.

I had told myself that New York would be my final landing place, but now I was going back on my word. I left empty-handed, bearing no trophies. But some things had taken root in my heart, though they would take time to come to the surface. What I knew was that from now on I would always carry around with me some of the city's ethos. What lay ahead of me in Beijing were days with no clear goal, days of listlessness and anomie, days to which I could see no end.

CHAPTER TWELVE

Perspective

WHEN I RETURNED TO BEIJING IN 1993, MY PARENTS WERE now settled in a house in Dongsi Shisantiao. It seemed small compared with some of the living spaces I had encountered in America. My family was naturally overjoyed to see me and did not press me on what I had done during my time abroad—which was just as well, since I had no good answer. My mother didn't find me much altered, and to friends of hers who came over to play mah-jongg she would say, with some embarrassment, "This boy Weiwei is just the same as he was before he went to America."

My father, now eighty-three, was confined to a wheelchair and in and out of the hospital. He had suffered a series of mishaps: a cerebral hematoma, a broken arm, and then a compression fracture in his spine. At home, he liked to sit outside in the courtyard, counting the blossoms on the magnolia tree, listening as the doves wheeled in the air, the whistles on their legs whirring.

"This is your home," my father would say to me. "Don't hang back—feel free to do whatever you like." He could keenly sense my discomfort. And it *was* my home: here were my blood relations, close family who were understanding and tolerant of my foibles and who held me to no unrealistic standard. I had no particular worries or re-

grets, nor did I have any set vision for the future. But I felt no special attachment to this house, either: I was like a strand of duckweed floating on the water, no bonds tying it to any one place.

I needed some time to recharge and recover myself, to take advantage of these new days in order to take stock of the past. A familiar dilemma confronted me: I knew what I didn't want, but I was not quite sure what I did want. Born in the Year of the Rooster, I had gone to America in a year with that same birth sign; now, twelve years later, it was another Year of the Rooster and another cycle in my life was beginning. Ai Dan reminded me to be cautious.

Although family life remained the same, Beijing was different. It had grown much bigger, and at the same time felt smaller, because now a new subway line looped around the city, an expressway connected the airport to the city center, and a third ring road had been constructed, linking the suburbs. In the early 1980s, there had been no privately owned cars, and one rarely saw vehicles other than buses in the street.

Ai Dan had a car, and concerned that I might get bored at home, he hauled me off to the antique markets, of which there were many, piled high with artifacts from all over China and from all periods in history. The shopkeepers had a high regard for Ai Dan: he had established himself as an authority in identifying ancient relics, and if he vouched for the authenticity of a piece, its value immediately rocketed. If we came across something that I liked, my brother's bargaining skills far outshone mine. "You're like an American!" he would joke.

In the 1950s, when he first came to Beijing, Father had often browsed in the antique stores in Liulichang, and the shopkeepers would politely address him as Mr. Ai. The city had been an imperial capital for more than five hundred years, and for several decades following 1911, survivors of the old order were able to enjoy such genteel pastimes as raising songbirds and collecting antiques. But the revolution that followed the Communist takeover transferred private property to the state, and by the late 1950s it was rare for people to

show much interest in cultural relics. Then, in the upheavals of the Cultural Revolution, old things were seen as remnants of "feudal, bourgeois, revisionist" culture, to be smashed and thrown away without a second thought. But now, with the revival of the market economy, there was a spectacular surge in the antique trade. We were in a golden age for collectors: quality was high, prices were low, people who knew what to look for were few, and fakes had yet to appear.

Panjiayuan, on the outskirts of Beijing, was famous for its "ghost market," so called for its furtive trade in antiques in the hours just before dawn, when flashlight beams would flicker in the darkness as would-be purchasers inspected the merchandise. In Panjiayuan you could find Stone Age tools, Shang and Zhou ritual vessels, jade objects from the Warring States and the Han, and three-color earthenware figures from the Tang, not to mention countless collectibles from the Song, Yuan, Ming, and Qing dynasties. Very soon our courtyard filled up with a huge variety of jars and vases.

Immersing myself in traditional Chinese arts, I felt I had discovered a new continent. On my first expedition, I noticed a bundle of disassembled wooden parts in the corner of an inconspicuous little shop, and I bought them at a giveaway price. When I put them all together, a Ming-style square-seat wenge stool appeared before me, neatly proportioned, built with exquisite craftsmanship. Every day I would explore a new corner of this broad territory, finding an ethical order and a sense of beauty embedded in each piece I encountered. I acquired a four-thousand-year-old jade ax: it had been split halfway into two very thin blades, and I couldn't figure out how it had been so perfectly shaped, or why the artisan had chosen to make it in this way. I was also intrigued by an ivory talisman dating from the Shang dynasty (c. 1600–1046 B.C.E.), on the spine of which was a row of square holes: the work involved in crafting this piece was so demanding, it must have taken up much of the maker's working life. Every day I would spend hours with these curios, so enamored that my mother became jealous: "I wish *I* were one of those things!" she would say.

Observing these objects and imagining their history broadened

my perspective. In China, we were still living in a culturally impover-
ished era, but art had not abandoned us—its roots were deeply
planted in the weathered soil. The stubborn survival of this indige-
nous artistic tradition demonstrated that our narrow-minded author-
itarian state would never be able to remake our culture in its own
image. These things predated the current order, and they would out-
last it. From then on, when I wasn't spending time with my parents, I
was immersing myself in the world of antiques. The dealers found
me perplexing, for I followed no prevailing tastes or conventional wis-
dom. Instead I was taken with obscure objects, and made a point of
buying things that seemed to have little or no value; my hungry spirit
was nourished as I imagined the stories lurking behind each piece.
The observations and insights that came to me from the distant past
spurred me on to make art of my own.

As a way of introducing Ai Dan to the continuous capture func-
tion of one of my cameras, I had him record the last moments of a
Han dynasty earthenware urn as it fell from my hands. It would be
ten years before this set of photographs was shown in an exhibition.
This capricious, inane act was just one of my many outlandish do-
ings. Art lurks in the obscure parts of one's inner mind, and often I
find it where others do not look; to me it is as solid and authentic as
that litter of earthenware shards. After the photo was taken, I cleared
the shards away so that my mother wouldn't see them: I didn't want
her to view me differently. Luckily, there was no shortage of Han
urns at the market, and I had no worries as far as Ai Dan was con-
cerned, as he had long been witness to my pranks. When he wasn't
working on a novel, he accompanied me everywhere and tried to
steer me in the right direction, as if helping a lost bird find its way
back to the flock. Ai Dan wouldn't let me just coast along and get
nothing done; he wanted to see me make my mark.

Soon I found something else to do with a Han earthenware urn.
This one had classic proportions and was full and shapely in form, but
it seemed to lack a certain element, and after I painted the Coca-Cola
logo on its surface, it had a lot more pizzazz. Two years later, when a

Swiss art lover came to visit me and saw it tucked away in a corner, he couldn't believe what he was seeing.

These little acts of mischief in 1994 marked a starting point in my reengagement with the making of art. By simply taking a new attitude, I had recovered my sense of self. By alternately damaging the past and reconstructing it, I was able to make something different. Disdain is a chasm that no power can cross; it makes space for itself by subverting order.

All around I could see the wounds inflicted by the suppression of the 1989 democracy movement: they went much deeper than the cost in lives alone. Fear and numbness had seeped into the very marrow of people's bones. At intersections in downtown Beijing, armed military police would stop any vehicle they found suspicious and question the passengers. Household registration was strictly enforced, and people from other places had to show their identity card and residence permit; those who had no ID, no permit, and no regular income were labeled "three-noes" and packed off to perform manual labor outside the city until they had scraped together enough money to pay for a train ticket, at which point they would be sent back to where they came from.

At this time, the art scene in Beijing was quite desolate, as contemporary art was viewed with suspicion by the authorities. Young artists from far and wide had begun to settle near the ruins of the Old Sum-

mer Palace, in northwest Beijing, where they labored away unknown and unrecognized. Ai Dan and I often went to visit them.

The artists' work fell into two categories. The first presented gloomy, violent themes in dark, oppressive shades, while the second was quite the opposite: colorful and ribald, so-called political pop paintings, featuring pink, bald-headed men and seductive, preening women, with an overlay of Cultural Revolution imagery. Though they differed in their degree of self-mockery, decadence, absurdity, and cynicism, both idioms captured elements of our nonsensical, contrived reality. Once, we stepped inside the adobe cottage of a vagabond poet and found him stanching the flow of a bloody nose by holding his hand over his nose and then smearing the blood onto the wall, as though hard at work on a cave painting. But no artistic impulse lay behind this gesture: his life was full of hardship and he simply didn't have any tissues.

After being gripped in the stranglehold of radical politics for half a century, China now craved acceptance from the West: recognition by Westerners would surely be the key to improving one's life. Since my adventures in New York had become popular lore, young artists often came to me for counseling, and, like a traditional Chinese physician dispensing cures, I would feel their pulse and offer a prescription, my advice being the same in all cases: they should make no effort to please other people and just concentrate on preserving their vital energy. To conventional culture, I said, art should be a nail in the eye, a spike in the flesh, gravel in the shoe: the reason why art cannot be ignored is that it destabilizes what seems settled and secure. Change is an objective fact, and whether you like it or not, only by confronting challenges can you be sure you have enough kindling to keep the fire in your spirit burning. Don't try to dream other people's dreams, I told them; you have to face up to your own predicament honestly, on your own terms. There's a huge gulf between your aesthetic passions as an artist and the indifference of the real world.

These penniless artists often gave themselves new names and lived self-contained lives within their own small circle. Their personal aes-

thetics were all too often disconnected from contemporary Chinese realities, and their curiosity about the West was fueled by an eagerness to brand themselves successfully. With no exhibition space for contemporary art in Beijing, they could only hope that Hong Kong art dealers would show up occasionally and pick out a few of their pieces. But to define your identity in terms of how others see you can leave you permanently muddled. Strapped for cash but too aloof to get their hands dirty doing more profitable things, these young artists were unable to focus on their art, for every day they needed to think about where their next meal was coming from. In conversations with them, I was often reminded of my time in New York.

In those days there had been little urban development beyond Beijing's Third Ring Road, so some twenty-odd young artists and rock musicians took advantage of the low rents and settled in a run-down hamlet in the outskirts. They took to calling it Beijing's "East Village," and they gave me a similarly playful title—I was their "Godfather." Zhang Huan, an artist from Henan, asked me to curate a performance piece of his, titled 12 *Square Meters*. On a baking-hot summer afternoon, in a public toilet at the edge of "East Village," he stripped naked and smeared carp guts all over his body; within seconds he was covered in flies. His inspiration, he said, came from my father's exploits cleaning toilets in Xinjiang. Underground art like this enjoyed a relatively freer space, because it did not need an audience: its main component was simply the recording of it, though, precisely for that reason, it could not count as public art in any real sense. My photographs of the event found a place later in my first publication, *The Black Cover Book*.

My initial encounter with Lu Qing, an abstract artist, took place when riding a *miàndī*, one of the primitive minivan taxis that in those days were the most convenient form of transportation in the capital. As I squeezed my way into the little yellow van, steel springs poked up through the threadbare seat upholstery. Lu Qing and a friend of hers had invited me to a bar, then quite a novelty in Beijing. She and her friend were a little unsure how to plan their futures, for by this

time graduates of the Central Academy of Fine Arts like them were no longer assigned jobs by the state. Lu Qing asked me what to make of the work of Joseph Beuys, but I told her I knew little about him. It was clear that Lu Qing's mind was elsewhere, and she did not say another word for the rest of the evening.

The next time I met Lu Qing was at my parents' house. We talked until late in the night, and I had her stay over. From then on, we lived together as a couple, an arrangement that my mother regarded with some dismay. In her eyes, it meant there was now one more idler in the house.

Lu Qing spent much of a year covering an enormous scroll, more than thirty feet long, with a dense grid of tiny squares. Every day she would complete just 1 percent of the work, in a process as calm and unhurried as breathing. Scanning the scroll's wide, gray expanse was like watching a stream passing through the seasons. In her pictures one could see no explicit resistance to authority, no disruption or unease. Our experiences differed, but each of us in our own way fought back against brute force. No matter how strong a power, it can never suppress individuality, stifle freedom, or avert contempt for its ignorance.

Lu Qing's classmates had designed and built the statue of the Goddess of Liberty that had been installed in Tiananmen Square before the military crackdown in 1989. Soon after the tanks rolled into the square, she and her friends, holed up in the Central Academy of Fine Arts dormitory, could only drown their sorrows in cheap liquor. Having drunk a whole bowl of firewater, Lu Qing had given a despairing cry of "We've lost!" and then keeled over, completely blotto.

In an effort to erase the evidence of their atrocities, the authorities had installed new granite pavers on Chang'an Avenue and in Tiananmen Square. The bloodstains might have disappeared, but we would never forget the crimes they had committed. Again and again, as though drawn by some irresistible force, the two of us would return to Tiananmen Square. I needed to find a way to reassert our perspective on events, and emotion itself can be a rallying cry.

One day, at a spot not far from the flagpole in front of Tianan-men, Lu Qing lifted up her skirt, provocatively exposing her under-wear as I pressed my camera shutter. Her blank expression matched the bland innocence on the faces of the people around her, and the absurdity of the image underscored the real tragedy of the now pre-vailing narrative that nothing at all had happened here. It was June 4, 1994, the fifth anniversary of the suppression of the democracy move-ment, and the national flag was shrouded in smog.

A military sentry, no older than twenty, was standing stiffly at his post. From a distance, I photographed him with a telephoto lens, seven shots from head to toe, the last of them capturing the sentry's shoelaces, which had worked themselves loose. Every time I came to Tiananmen Square, I felt a mixture of helplessness and humiliation, but through such invisible acts of confrontation, I asserted my exis-tence. I realized I felt no regret for having left New York. On the con-trary, I had recovered lost sensations.

Finally, in the winter of 1995, on the west side of Tiananmen Square, in front of the Great Hall of the People, I took a photo of myself sticking the middle finger of my left hand at Tiananmen. That day, under a typically leaden, featureless sky, only a few scattered tour-ists were walking across the square. The ancient Gate of Heavenly Peace looked the same as always, Mao's portrait dimly visible in the murk. This unambiguously scornful gesture was my way of asserting the existence of self, and it left no room for misinterpretation. I had no other resources—all that I could deploy was an attitude. Through not forgetting, not forgiving, and not abandoning, I had come to real-ize my good fortune in returning to Beijing—at last, I had the feeling of coming back home. My photograph was not an artwork so much as a manifesto, offhand but hard-won.

Young people in China today have no knowledge at all of the stu-dent protests in Tiananmen Square in 1989, and if they knew they might not even care, for they learn submission before they have devel-oped an ability to raise doubts and challenge assumptions.

Bamboo Finger, 2015

———

I NOW FELT READY to take my place as an artist and critic, to set forth my understanding of art and construct a new kind of reality in my own language. So, in the summer of 1994, I decided to make a book. I wanted to create an underground living space for art, and pass on to future readers traces of people's thinking. In this respect I was following a trail blazed by my father, who at the age of twenty-six self-published his first poetry collection.

I reached out to the artists Xu Bing (in New York) and Zeng Xiao-jun (in Boston) for help in executing this idea. Xu Bing and I had spent time together in Manhattan, and after I left, he stayed on in the East Village basement I had rented. We agreed that Xu would gather some relevant Western writings, Zeng would come up with some funds, and Feng Boyi, then working at the China Artists Association in Bei-jing, would hustle up contributors.

The Black Cover Book brought together art that was being made in China and introductions to foreign art in the form of texts and photographs. I contributed an interview with Tehching Hsieh and Chinese

translations of writings by Marcel Duchamp and Andy Warhol. Among the pictures included were my photos of Zhang Huan covered in flies. The point I wanted to make was that concept is not method, but art practice in its own right.

Everything published in China was subject to state censorship and control, and if you photocopied even a single page, it had to be entered into police records. To ensure the security and quality of the project, I decided to do the editing and printing in Shenzhen—the special economic zone next to Hong Kong—where policies were more relaxed.

After checking into a hotel in Shenzhen, Feng Boyi, Lu Qing, and I laid out all the manuscripts on a bed, along with a ruler, a paper trimmer, and glue, and we set to work creating the layout of the book. I designed a cover that would register a silent protest against censorship: it was black and had no title, just a line of small characters noting the time and place of publication.

During a trial print run, I found that dust on the roller had left white streaks on the black-and-white photographs. I realized we had to get the printing done in Hong Kong instead, then smuggle the books back into China. The difficulty in making something happen, I have found, is often directly correlated to its importance: things that come easy aren't worth doing.

Even before *The Black Cover Book* made it back to Beijing, the China Artists Association received a visit from public security agents who said that Feng Boyi had gotten mixed up in "a political incident." This threatening accusation was tied to a work of performance art that was featured on the book's opening page—a photograph of Ma Liuming in the nude.

Ma Liuming, a slender young artist whose girlish appearance was accentuated by his long hair and earrings, had hosted a private gathering at which he stripped naked in his courtyard and cooked potatoes in a wok. Somehow the police got wind of the event and carted him off to jail on a charge of "obscene performance," despite the harmless

and innocent nature of his act. Later, when I asked him about his experience in prison, he said he had felt confined to a strange, meaningless limbo, where part of him was slowly leaving and another part slowly waking up. It was two months before he was released.

Xu Bing called me from America to ask that I hold back on distributing *The Black Cover Book;* he was worried that if the book started circulating, it would cause more trouble for Feng Boyi and would complicate his own life, too, because he planned to return to China and develop his career there. But I refused to pull the plug on the whole project when we were not yet truly in danger. And, in honesty, I was actually hoping there would be some kind of kerfuffle. It would give me the chance to experience government abuse firsthand, instead of just hearing about it. Plus I was duty bound to honor the commitment I had made to the featured artists, and to not distribute the books would have amounted to self-censorship. When I refused to budge, Xu Bing and Feng Boyi withdrew from the project.

Three thousand copies of *The Black Cover Book* were soon in circulation, and the project felt like a spring bubbling forth in a desert. In the years that followed, I went on to edit two sequels, *The White Cover Book* and *The Gray Cover Book*. This caught the attention of the police, but apart from delivering some verbal warnings, they did not directly interfere. In the foreword to *The Gray Cover Book* I wrote, "It's a painful fact that today, as we import science and technology and Western lifestyles, we are unable to introduce spiritual enlightenment, or the power of justice, or matters of the soul." Without consciously thinking about it, I had become politicized, doing the kind of thing my father had when he was young.

AT FOUR O'CLOCK ON the morning of May 5, 1996, my father's heart stopped beating, the curves on the monitor he was hooked up to flattening into a straight line. The doctors and nurses of the intensive

care unit took off their face masks and slipped out of his room; the emergency equipment was rolled away. Then, as a family, we accompanied the body down to the morgue.

When the stainless steel drawer closed and the body disappeared from view, I felt I had lost a part of me, but I also felt a certain release. Misfortune had dogged my father all his life, and now, amid countless regrets, he had been delivered from those trials. When we emerged from the hospital, the day had just broken and a light drizzle was falling.

The final farewell took place at the Babaoshan Revolutionary Cemetery. I took charge of the setup in the memorial hall, demanding that the generic recycled paper wreaths be removed and replacing them with fresh flowers. Father's body now lay on a plain white bed, surrounded by a sea of white blossoms.

But then events took an unpleasant turn. The Writers Association insisted that, given that my father was a party member, his body should be covered with the flag of the Chinese Communist Party. This cynical effort to confer a dying "glory" on him stirred a deep disgust in me: the government simply wanted to make a political ornament, a trophy, out of him. It was a moral outrage, and something my father would never have wanted. But despite my strenuous objections, they went ahead anyway. "Ai Qing doesn't belong to his family alone," I was told.

Things have to follow a set procedure in China, no matter how you argue your case. An individual has no right to challenge authority, and humiliation is often presented as an honor that you are fortunate to receive. Power erases individual thoughts and feelings, always. And thus, when mourners trooped in to pay final respects to my father, they found the Chinese Communist Party flag, with its giant yellow hammer and sickle, draped across his chest.

On the face of it, Father's impact on me was limited, for during his lifetime he had given me little direct guidance. But to a large extent, that simply reflected my unwillingness to seek his advice. Had I sought his counsel, I don't doubt that he would have responded. Al-

though he never tried to influence my decisions and never asked anything of me, like a star in the sky or a tree in a field he was always there as a compass point, and in a quiet and mysterious way he helped me to navigate in a direction all my own. By the very absence of explicit guidance, a spiritual connection was forged between us; Father, in his way, protected me.

IN THE MID-1990S, AS I worked on *The Black Cover Book* and its sequels, I came to know Hans van Dijk, a tall, rather frail-looking Dutchman. Hans often had a sly glint in his bashful eyes and was always a good friend to me. The anti-establishment nature of *The Black Cover Book* impressed him, but he himself identified with the Mondrian school, prizing balance and order. He devoted himself to the collection of art-related documents, and over time he organized several exhibitions. Every few months, he needed to leave the country to renew his visa, but he didn't mind this too much: it gave him the chance to enjoy a good ice cream in Hong Kong occasionally. Hans, his friend Frank, and I would launch an art space together called China Art Archives and Warehouse, the first professional alternative art space in China's capital.

In the summer of 1995, I met Uli Sigg, in a casual encounter that would alter my life. Sigg, then the Swiss ambassador to China, was a pioneer of joint ventures between China and the West. Thanks to him, international capital poured into this wasteland. He would chat confidently about a wide range of subjects and seemed to know practically everything, his interests and experience matching his exceptional energy. I always enjoyed talking with him, as often our conversation would head off effortlessly into uncharted territory, much like the sensation you had when he was behind the wheel of a car. He maintained such a steady speed on curves and headed so unfailingly in new directions that you felt the car and the road were simply an extension of him. Once when he was driving he pointed out a

deer on a hillside, but by the time I had turned to look it was gone, and I only heard the sound of pebbles tumbling into the valley below.

Sigg was fascinated by Chinese art and was just starting to put together a collection. He was sure China would realize belatedly that some of its best contemporary art had been lost, simply through neglect and lack of appreciation. I was not worried that China's future would turn out as he imagined, nor would I have minded if it did.

Sigg would tour the studios of artists who spoke practically no English—some could not even speak much Mandarin—and every one of them looked forward to his visits, because his recognition signified the success of their work. But it may be many years before his efforts to promote contemporary Chinese art are fully appreciated. At the time, certainly, his confidence seemed misplaced.

In 1997, when Sigg's term at the embassy was about to end, he set up a contemporary Chinese art prize—for which I was one of the judges during its first several years. He also invited to Beijing gatekeepers for influential art festivals, among them Harald Szeemann, Hans Ulrich Obrist, and Chris Dercon. Subsequently, Szeemann chose two works of mine for the Venice Biennale in 1999. I traveled to the exhibition site, where, in the exquisite heart of the historic city, the waterside breezes brought a pleasant, cooling touch. But tourist attractions always irritate me, and soon I was bored with it all. On the day of the opening, I stood in front of St. Mark's Basilica and took yet another middle-finger snapshot, then made my escape. I knew if I had stayed one more minute, I would no longer have been myself. Then, as now, I seemed to have, however childishly, an instinctive resistance toward cultural authority.

In the wake of my father's death, I returned to my experimentations with traditional Chinese artifacts. In the village of Longzhaoshu, on the southeast outskirts of Beijing, I rented an old printing factory as a space to house the China Art Archives and Warehouse. Outside, there was no cultural atmosphere whatsoever—the streets were strewn with garbage. But inside our compound we set things up very nicely, in a space bigger than that occupied by the National Art

Museum of China. A carpenter came to work for me, and we began a series of projects involving classical furniture. In one case I worked with a square beech table from the Qing dynasty. We placed one half at a ninety-degree angle to the other half and reattached it using traditional mortise-and-tenon joinery, while maintaining the other elements of the design and keeping the original patina throughout, so it looked as though the table had always been that way. We set it down with two legs on the floor and two leaning against the wall, where it stood insouciantly for several years, attracting no attention from the occasional visitor.

Bang, 2013

Changes to furniture's functionality bring changes to its identity, destabilizing the nature of the object, and I saw that multiple meanings can emerge through the process of fracture and reconstitution. I

had tapped into a lode that others hadn't found, and my understanding of tradition gave me the confidence to mine it deeply.

Often, my carpenters were not at all clear on what they were making or what purpose it would serve, but they were used to having me challenging their assumptions and didn't need me to explain why a piece had to be a particular way. They simply took my idea and ran with it. Eight years later, in 2004, when I had an opportunity to exhibit in Switzerland, deconstruction of classical order and ethics would become one of my themes.

In 2000, a friend asked me to curate an exhibition at a property he had rented in central Shanghai. The site was a relic of China's semi-colonial past: a former dockside warehouse on the banks of Suzhou Creek, dating back to the 1920s. At the height of globalization, by pandering to the power of capital, Shanghai had developed into a mindless, covetous, crazed metropolis that failed to appreciate culture's uniquely subversive character. Seventy years had passed since my father organized the Spring Earth Painting Club, but contemporary art was still seen as pernicious and now was confronted with an even more authoritarian regime. This exhibition would be my response.

Fuck Off (the Chinese title translated as "Uncooperative Attitude") was an extension of *The Black Cover Book* concept, and another collaboration with Feng Boyi. We invited more than forty artists to display their work, presenting a survey of underground photography, painting, installation, and performance art from the 1990s in China. After the show opened, on November 4, 2000, its provocative stance naturally antagonized the authorities: one top-ranking official in the central government was so livid, I was told, that he waved the exhibition catalog in the air for emphasis as he yelled, "Look what art has come to these days!" It's true that some of the works were hard to stomach; one photograph, for example, showed an artist chewing on the limbs of a human fetus. But these works confronted reality unflinchingly. China had, for twenty years, enforced a one-child policy, aborting at least a hundred million fetuses, so who could reasonably fault art for being too direct?

My inspiration and boldness came from disgust and exasperation, from the dogged resilience that New York had nurtured in me, as well as my impatience with the timidity of my father's generation. Now I had no intention of hanging back. I openly declared my opposition to the status quo, reaffirming, through the act of non-cooperation, my responsibility to take a critical stance.

Fuck Off articulated a kind of death wish, in that by the very act of showcasing its uniqueness it announced its own demise: soon after the opening, Shanghai Public Security closed it down. The exhibition attracted so much commentary that the Ministry of Culture soon felt compelled to issue a notice that stated, "Public performance or exhibition of bloody, brutal, or obscene images is prohibited; displays of human genitalia, erotic performances, or any other such exhibitions damaging to social mores are prohibited." By standing up to the state system as an equal, not an inferior, *Fuck Off* was, in effect, experimenting with treating politics itself as a "readymade."

IN SERGEI EISENSTEIN'S CLASSIC film *October: Ten Days That Shook the World,* a tribute to the 1917 Russian Revolution, a warship sails toward the Winter Palace through an ice-strewn river. As its cannons roar and the revolutionary forces mount their assault, a crystal chandelier in the palace shakes back and forth—an image of the old order on the brink of collapse. In a comparable setting, for the first Guangzhou Triennial, in November 2002, I designed a chandelier that was twenty-three feet tall. This huge geometric fixture hung low over the floor; an enormous scaffold mottled with rust supported its weight. The chandelier and the scaffold represented the coexistence of two separate worlds: power and poverty.

After time spent organizing exhibits and the work on various book projects, I was pleased to return to making art, but it was hard to shake the feeling that I was working with an empty mind. It would be some years before I found my ideal platform.

———

FAKE Design

H AD MY MOTHER NOT TAKEN A DIM VIEW OF OUR LIFESTYLE, LU QING and I might well have gone on living in her house indefinitely. But her patience had grown thin, and among other things she was tired of the bearded, long-haired artists who kept dropping by the house, most of whom had no more sense of direction than I did. I had always had a fantasy of finding a place where I could build a studio for myself, so I asked Ai Dan to help me make this happen. He had already written a couple of novels by this point—sardonic depictions of urban life—and now, when he wasn't drinking with his buddies, he was making himself an expert on ancient jade ornaments. I envied his collection of artifacts even more than I envied his writing talent.

Beijing has the Forbidden City as its core, with the modern city spreading around it in a square grid; on a map, the expressway that leads to the airport stands out conspicuously as a diagonal line heading northeast. The village of Caochangdi, some ten miles from downtown, lies close to this highway; north of the village is a railroad that runs all the way to Ulaanbaatar, the capital of Mongolia, and as trains rumble past they give a blast of their horn. Historically, this area had been a pasture for the imperial horses. There were no tall buildings anywhere near and no shopping streets, only the old road to

the airport, now so little used that you'd have a long wait if you were looking for a taxi. The village had caught my eye when I was out on a drive with Ai Dan: it looked tidy and clean, and its closeness to the expressway meant easy access to the city when I wanted to visit our mother.

The Caochangdi village party secretary, a man in his early fifties, took Ai Dan and me to inspect an untended vegetable plot at the edge of the village. The land was under his control, and there would be a steady revenue stream if he leased it out. The property was five *mou*—close to a full acre—and with a thirty-year lease he would be guaranteed an income of $6,000 a year. To disguise my studio's true purpose, the secretary recommended that we call it the Institute for Agricultural Development. He was a typical grassroots-level administrator—sly, unscrupulous, on the make. As we parted, he advised me to be bolder in my thinking. I was not all that clear what he meant by "bolder," recalling only that for decades there had been a popular slogan in China, "The bolder a man dares, the richer his land bears."

Until the 1980s, no property market existed in China. In its absence, the average per capita living space for urban residents was just seventy-five square feet, and most families lived in substandard housing. Under the economic reforms, property sales became the main source of income for city governments. Theoretically, the land belonged to all the people—including people like me—but the government simply appropriated it, monopolizing the market. In the twenty years of reforms starting in 1978, land-lease revenue rose more than a hundredfold, and in the seventeen years from 1999 to 2015, property revenue reached 27.29 trillion yuan.

The pillaging of wealth from land vastly outweighs other forms of capital accumulation in China. The way it works is this: Local governments first forcibly buy back land-use authority from farmers at a low price, then sell the land at a high price to developers. With property in hand, developers can easily get a bank loan, and before they have even broken ground they can begin to sell off houses that exist only in blueprints. This conjuring trick would make anyone wild with

joy: the money comes so readily, it's like passing wads of cash from your left hand to your right. Every pore of China's reforms is saturated with fraud and corruption, and this is just one of many abuses.

In the space of an afternoon I sketched a simple design for my studio. I visualized a sharp-edged box built in traditional-style gray brick, with a single large window in the south wall, a door at the corner of the east wall, and a gray brick pathway a hundred feet long leading to the main gate, which would be painted turquoise green. My sketch looked as artless as a child's picture.

258 Caochangdi

I had become an architect, the notion having been planted in my mind many years earlier when reading a book about the house in Vienna that Ludwig Wittgenstein designed for his sister. But I'd also had plenty of practical experience in making things: as a boy I had made a stove, a bed, a basket, and a wheelbarrow, so the concepts underlying architecture were not so foreign to me. And a challenge always gives me the motivation to move forward.

From my father I had inherited a plain style: he loved simplicity, and unconcealed emotion would fill him with delight. And to me, economy is effective: it makes perfect sense to leave out what you don't need, just like when I chiseled a hollow in the wall of our dugout to accommodate what was essential—a little oil lamp—and nothing more.

In late February, when the soil began to thaw, the builders broke ground and began to lay the foundation. Ai Dan and I visited the construction site daily to monitor progress. Building the studio would require 130,000 bricks, 80 tons of cement, 7.5 tons of rebar, and 60 cubic yards of sand. The walls rose three feet per day, and within a

Tiananmen Square, Beijing, 1995.

June 1994, black-and-white photograph.

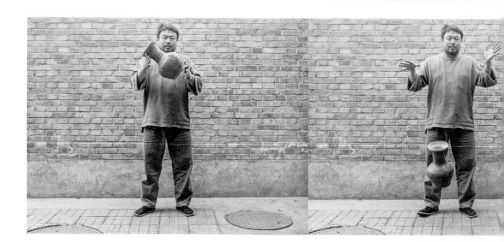

Dropping a Han Dynasty Urn, *1995, three black-and-white photographs.*

Ai Weiwei and Ai Qing in their home at
Dongsi Shisantiao, Beijing, 1995.

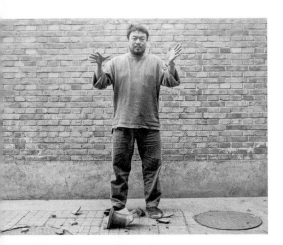

Han Dynasty Urn with Coca Cola Logo, *1993, Western Han Dynasty (206 BCE—24 CE) urn and paint, 25 x 28 x 28 cm.*

*Ai Weiwei's studio under construction
in Caochangdi, Beijing, 1999.*

*Jacques Herzog, Ai Weiwei, and Pierre de Meuron at the construction site
of the National Stadium, Beijing, 2007.*

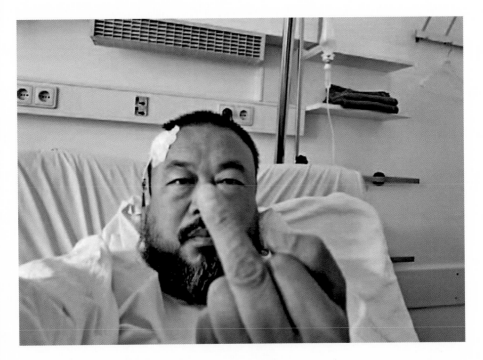

Ai Weiwei at the Munich University Hospital,
Munich, Germany, September 2009.

Ai Lao walking on Sunflower Seeds *at the Tate Modern, London, England, 2010.*

Straight, *2008–2012, rebar, 2500 x 600 cm and* Namelist, *2008–2011,*
black-and-white print of 5,196 names of student victims in the Sichuan earthquake.
Installation view at the Brooklyn Museum, New York, 2014.

Ai Weiwei with his
Circle of Animals—Dog,
2010, bronze,
302.3 x 134.6 x 172.7 cm.

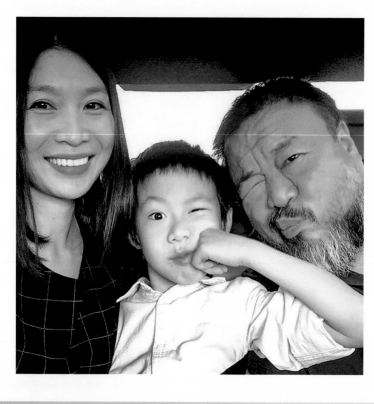

Wang Fen and Ai Lao reunited with Ai Weiwei, Munich, Germany July 30, 2015.

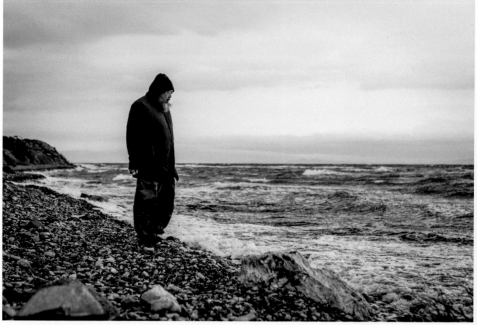

Ai Weiwei on the shore of Lesbos, Greece, 2016.

few weeks the whole thing was up and the roof was sealed before the arrival of the rainy season. The builders were farmers from the surrounding hills, and the quality of the work was crude. But my design was so simple that nothing much could go wrong.

When basic construction was completed, the interior of the house was completely bare, with exposed brick walls just like on the outside. At this point, in defiance of the prevailing custom of dolling houses up with all kinds of ersatz Western flavor, I decided to dispense with interior decoration.

"You mean we stop here?" the builders asked, in total disbelief.

So as to save myself the trouble of explaining, I told them the money had run out.

My design was unorthodox, deviating from standard practice in various respects: the brick walls were flush with the brick floors, obviating the need for eaves and a concrete apron, and these details helped to sustain a sense of unity, while also creating an unconventional appearance. The central space had no windows, but the skylights in the roof provided an even light to brighten the interior. There were no banisters on the stairway, and the toilet on the second floor was unenclosed, its fixtures exposed to view. Freedom and openness are no empty slogans: The house violated building codes right and left, and therein lay its greatest charm. The building was unplanned, unapproved, a law unto itself; to grow like a weed was the essence of its freedom.

One hundred days after breaking ground, I moved into the studio and was feeling perfectly at home. Now, finally, I had a space of my own and was in a position to get some work done. A Japanese architect who came to visit went away saying, "China has no other architects. Ai Weiwei is the best."

When we went to the Ministry of Commerce to register our new company, we offered three possible names in Chinese, and the clerk solemnly selected 发课 from among the three nominees. In written Chinese, these characters, placed together, are meaningless and innocuous, but in the Pinyin system they are romanized as FAKE, which

of course looks just like an English synonym for "phony." Even more appealingly, when pronounced in standard Chinese, the characters *fākè* (发课) also sound very much like the English word "fuck." One way or another, the name should warn you that it's a mistake to always take me seriously.

With the studio now in place, Caochangdi became a haven for contemporary art in Beijing. That November, Hans van Dijk and I, along with another European friend, Frank Uytterhaegen, moved our art space, China Art Archives and Warehouse, to Caochangdi, and there we mounted ten exhibitions a year, helping to launch the careers of many young artists.

Hans and I had prearranged that we would curate each exhibition

together. Later I saw how engaged he was and so let him take over. Our views on art were not entirely in step, so I was happy to let him go ahead with his plans, knowing full well that if I took the lead, the gallery was liable to be shut down within a few days.

Late one night in March 2002, my phone rang. It was Hans, and his voice was faint. Hans seemed to subsist mainly on a diet of cigarettes, beer, and coffee, and he would often sit quietly by himself in the courtyard sunshine. But now he had suffered a fall in his own home and could not get up. He died just a month later, much sooner than anyone expected. In Hans I lost a fine partner, a man with both determination and an excellent sense of humor. At his memorial service, I exhibited more than a hundred Polaroid photographs from among the things he left behind. Their subjects were mild and offbeat, like Hans himself, equally elusive and fleeting.

Now that I was so busy, my mother could at last stop worrying. In the years that followed, I took on close to sixty architectural projects, big and small—from design, planning, and renovation to landscaping—some commissioned by private individuals, others by government agencies. At this point in time, my relationship with the authorities had not yet become strained.

Among the commissions were several clusters of houses near my studio, all designed in the same manner, the only difference being whether they were built with gray brick or red. As time went on, I saw no need to visit the construction sites, because the houses were all in the same minimalist idiom and could be neither botched nor improved in the building process. Within China, my pragmatic attitude to architectural design sparked a discussion of architectural aesthetics, something that hitherto had been largely ignored. My basic point was that although architecture addresses a need in life and can be understood in various ways, ultimately it involves aesthetics and philosophical concerns. As time went on, it became all the more clear to me that politics obstructs creative work, and the preconditions for good architecture are a freer, more citizen-focused outlook and a science-oriented, democratic society.

For a while I invested all my energy in the often tedious real-world issues of design-and-build and the inevitable back-and-forth with developers and construction teams. The endless difficulties I encountered were symptomatic of the world in which we lived, and my experiences and reflections over many years, including during my early life with my father, had unconsciously prepared me for these challenges. But architecture is a part of public life, where the idea of expressing yourself fully is unthinkable. When authority determines meaning, independent thought does not exist, and everything is an extension of the discourse of power.

A NUMBER OF COMMEMORATIONS were held after my father's death. In 2002, Jinhua's city government invited me to design the Ai Qing Cultural Park not far from downtown Jinhua. At first, I doubted it would be possible to honor my father appropriately, but my mother ultimately convinced me to do it. If I didn't do the job, she argued, somebody else would, and I might not like the result.

My visit to Father's native district was a dispiriting experience. After the havoc and vandalism of the Cultural Revolution, the old order had disappeared without trace, and I found nothing that resembled the bucolic scenes in Father's poetry. I saw only shoddily built houses and abandoned building projects. Streams harboring freshwater pearl mussels were smothered in discarded plastic bottles, and the roads were crowded with construction vehicles and motor scooters, which made my father's early life seem all the more remote from mine.

When I visited my father's birthplace, Fantianjiang, I did find those two ancient camphor trees still standing. The village's party secretary guided me through the streets and alleys and explained that the Jiang mansion had undergone alterations since my father's time. We visited the former home of Big-Leaf Lotus, and I learned that her young-

est son was now a thin, wizened old man. My grandfather's grave was a little hump in one of the fields. Everything was foreign to me, and I felt no sense of homecoming.

A site on the bank of Yiwu River had been earmarked for the Ai Qing Cultural Park. But the river had been channeled into a concrete bed for flood prevention purposes, leaving no natural fields on either bank and no riverside path. When I emphasized the importance of accessibility for the success of the project, the city agreed to a design that encompassed both banks, not just one. The main site would extend a full mile along the south bank of the river. My design involved a dense cluster of thirty-six stone columns that created a labyrinthine space on top of a level plaza, along with banks of angled steps, also built with the local stone, leading down to the river. Through the juxtaposition of stone and water I wanted to evoke lines in one of my father's poems:

> A wave, and then another wave
> Unceasingly comes rolling in
> But the rock goes on standing there
> A smile on its face, watching the sea.

ONE DAY IN OCTOBER 2002, Uli Sigg called to tell me that a Swiss architectural firm had been invited to participate in the competition to design a stadium for the Beijing Olympic Games. The team of Herzog & de Meuron was looking for a collaborator on the Chinese side, and Sigg had recommended me. I knew little about the architects, but, convinced that nothing was impossible, I agreed at once.

By the Chinese New Year in early 2003, the SARS outbreak was nearing its peak in China and people were in panic mode. The day I left Beijing for my meeting with Jacques Herzog and Pierre de Meuron, travelers at Beijing's Capital Airport were few and far between,

and the cabin of my flight was practically empty. In Basel, Herzog was advised that to avoid possible exposure to viral material I might be carrying, I should perhaps be isolated inside a glass case.

The first case of SARS had been detected in south China in late 2002. Later, medical professionals were infected and the epidemic spread swiftly through the country, like something out of a horror movie. What happened next resembled every other disaster in China: The government suppressed accurate reporting, while officials from the Ministry of Health claimed on television that the epidemic had been effectively controlled, and the World Health Organization removed Beijing from the list of affected areas. Then, on April 8, 2003, a military doctor revealed to foreign media the full gravity of the epidemic: his hospital alone had sixty cases, and six people had died. For much of 2003, the mysterious power of the epidemic was pitted against China's opaque regime, freezing Beijing in near paralysis and deepening suspicion and hostility between people. The COVID-19 crisis in Wuhan seventeen years later would follow a similar pattern.

Foreign architectural firms need help coming to grips with China's unfamiliar culture and politics, just as experienced mountain climbers rely on a secure anchor point when approaching a difficult summit. "What do you think my role should be?" I asked Sigg as he drove me to the Herzog & de Meuron office in Basel. They had done some preparatory work, he told me, and were looking forward to hearing my opinions. That made things simple, for it is easy for me to have opinions and now I felt free to air them.

The firm's offices housed more than eighty architects. As we made our way through rooms big and small, drawings and scale models were everywhere. We joined Herzog, de Meuron, and several of their colleagues in a conference room, and soon we were engaged in a discussion that ranged across political and cultural issues and questions of function and environment, as well as structure and appearance and technical features like the mechanism for retracting the stadium roof.

The early stages of developing a concept are a bit like the hours

leading up to a baby's delivery: everyone careful but tense, eager to contribute but waiting for the right moment to intervene. But the more we talked, the more we were all agreed on a plan to unite structure and appearance in a bold and dramatic way. Soon we were sketching away with pencil and paper or putting together rough mock-ups with paper and scissors, and everyone completely forgot about SARS. Sigg simply sat in his seat and never said a word.

The stadium, as we began to imagine it, would have a height of 230 feet and a length of 1,080 feet—far longer than the Rhine River, flowing outside our window, was wide. Like a bird's nest, its exterior and its structure would function as a single unit, its open-meshed, netlike frame creating a light and airy feel, despite its enormous size and weight. After ten hours of intense discussion, the concept had acquired clarity and cohesion.

When we met again the next morning, Herzog turned to me. "Weiwei, do you know something?" he said. "With this design, we're going to win." The vast majority of competing designs, he predicted, would all be much the same, and we stood out, both conceptually and formally. That day, as my flight climbed through thick banks of cloud on the way up to cruising level, a feeling of elation accompanied me all the way back to Beijing. I felt proud that we had a solid, decisive design; the building would have integrity, and its balance and willingness to expose itself corresponded with the political forms that I wanted to see emerge in China. Beijing had gained an opportunity to show itself off to the world, and the Olympics would serve as an open inspection of a once mysterious and closed society. My hope was that the stadium would be an expression of universal values and would mark the beginning of a search for openness and understanding. Three months later, we were awarded the contract.

IN OCTOBER 2003, I was invited to teach a class in the architecture department of Tsinghua University. I rented a bus and taught my six-

teen students on the go, because I couldn't think of a better way of researching China's rapidly changing capital than to explore it. I installed a video camera in the front passenger seat, and during the sixteen days that we spent driving around Beijing, the camera recorded every road and every alley that we passed, and we ended up with 150 hours of footage that offered a visual record of Beijing as it was before the Olympics. This thousand-year-old city had already been largely destroyed in the first fifty years of the People's Republic, and fewer than a quarter of historical buildings still standing in 1949 had been preserved. Of the more than three thousand alleys that once crisscrossed the residential areas, only four hundred were left.

In the winter of 2004, my assistant Zhao Zhao helped me complete the filming of *Chang'an Boulevard,* a documentary record of the most important east–west axis in Beijing. Every fifty yards along its full twenty-seven-mile length, we filmed a one-minute video, and after putting all these clips together we ended up with a film that lasted ten hours and thirteen minutes. After that we made two companion films, *Beijing: The Second Ring* and *Beijing: The Third Ring,* forming a documentary trilogy monitoring urban change during the high tide of state capitalism.

Meanwhile, progress with the Bird's Nest was far from smooth, and opposition from conservative forces in Beijing almost put an end to the project. Several of China's architecture academicians submitted a letter to the central government denouncing the design as "colonialist architecture," claiming that China was becoming "a testing ground for foreign architecture," and warning that the building would "use excessive amounts of steel" and "pose a threat to safety." For a time, the stridency of the criticisms forced a halt in construction. A year later, when construction restarted, a retractable roof was no longer part of the design, and the notion of a "tech-savvy Olympics" had given way to a penny-pinching Olympics. Had it not been for the urgent need to complete construction in time for the Games, the project most likely would have been shelved.

My practice of architecture deepened my understanding of how

Fragments, 2005

cities work, but it also sharpened my awareness of what an untrust-worthy and aesthetically inept government we had. Ai Dan often advised me not to get drawn too deeply into things, and now, in the wake of the Bird's Nest project, I did not want to waste any more time on architecture.

Fairytale

THE INTERNET FIRST MADE ITS ENTRY INTO CHINA IN 1994, in the form of the Integrated Services Digital Network (ISDN) at a speed of 64 kilobits per second. Now, ten years later, there were 110 million internet users in China, more than 10 percent of the entire global population of "netizens." For a long time I had used the internet mainly for brief email communications and had not explored its other possibilities. But in late 2005 I composed my first blog post, slowly typing out the words "To express yourself needs a reason, but expressing yourself is the reason." At that moment, neither I nor China's internet censorship apparatus anticipated quite what a transformational act this would turn out to be for me. I entered the public's field of vision with the force of a bullet fired from a gun.

This was a kind of writing my father could not have imagined. It took time for his work to be published, and gatekeepers could limit his access to a Chinese readership whenever they chose. Online writing in China in the opening years of this century was not subject to the same constraints. It was intuitive, rapid, and thrilling. Writing online was different from writing novels, as Ai Dan had done, for there was no need to create a fully imagined physical and mental world.

Blogging appealed to me because it gave me an opportunity to address the ruptures and dislocations in the society around me. From

now on, the first thing I did when I got up in the morning was turn on my computer. The volume of traffic on my blog and the number of readers' posts increased so quickly, it felt as if the seeds I had sown one day had grown into a field of rich crops the next. The blog broadened my outlook enormously, for when I responded to one reader, another person whom I didn't know and would never meet could read what we had written and share their own perspective. Direct, sincere communication with others was no longer a fantasy—and it felt just as real as a declaration of love. I relished the endless possibilities of assuming multiple, separate online existences, and the fragmented, inconsequential, fleeting moments of emotion and engagement it gave me. Every character that I tapped on my keyboard was emblematic of a new kind of freedom. By enabling alternative voices, the internet weakened the power of autocracy, dispelling the obstacles it tried to put in the individual's way.

Freedom, of course, inspires expression, and soon my readers understood me even better than my family did. On the internet, social coercion is nullified and the individual acquires a kind of weightlessness, no longer subordinate to the power structure. Public opinion can take shape under the influence of shared aspirations and enthusiasms, and at times one could see signs of a revolution in the making as ordinary people's understanding of social realities altered fundamentally, transcending the limitations of time and space, encompassing everything we could see and everything we could not, as naturally as the air we breathed.

Civil society poses a challenge to autocracy, and therefore, in the eyes of our rulers, it is an object of fear. The Chinese government, accordingly, seeks to erase individual space, suppress free expression, and distort our memory. Already, in September 2003, China had launched the Golden Shield Project, a Ministry of Public Security information-gathering program with tools for internet monitoring that included speech recognition, automatic listening, remote monitoring, and facial recognition technology. As time went on, the program's internet monitoring expanded to include tracking, inter-

rupting, resetting, and censoring of individuals' internet activity, as well as the tapping of telephone calls, Bluetooth transmissions, and wireless internet communications. Filter software was also introduced, directly intruding into users' desktops and files, and software companies were required to make available records of social media communications and scanned documents.

There were plenty of restrictions, then, on internet expression, but they only made people more likely to resist control. Authority couldn't be everywhere at once, just as the sun cannot make every drop of water evaporate. I saw fear in the eyes of my adversaries, and on the horizon I glimpsed an alluring land of free expression.

Leg Gun, 2014

It is hard to fully measure the internet's impact on me—all I know is that I was like a jellyfish, and the internet had become my ocean. I began to see life no longer as an activity taking me in a single direction, but rather as a succession of countless instants and junctures, mine to reify—if I chose—in the posting of photos and videos, in this articulation of feeling or that sigh of dismay, in the lines of characters I wrote, in the pulses I sent along the optical fiber. Every instant could be presented as a complete world in itself, unpredictable and unrepeatable, dispelling classic meanings and goals. This was empowering rather than destabilizing, and, under a tyranny intent on cheating us out of history and memory, here was a new way of telling our stories.

I wasted no time testing my new medium, and soon I was spending eight or twelve or even twenty-four hours a day communicating online. In 2003, a college graduate named Sun Zhigang had been detained in Guangzhou because he wasn't carrying his identity card, and he later died in a detention center from injuries sustained in a beating. An extrajudicial detention system had existed in China for many years, and it was rife with abuses, often leading to fatal incidents like this one. Sun's death provoked such a torrent of criticism of detention practices that the government took steps to abolish the so-called custody and repatriation system.

Now, three years after Sun's death, another event triggered renewed online debate about social justice. In May 2006, a laptop belonging to Zhong Nanshan, a spokesperson for the medical profession in China, was stolen in Guangzhou. Zhong was so outraged that he appealed for a reinstatement of the detention system, arguing, "When designing the legal system, what kind of person should we prioritize? We should design the system so that it operates in the interests of good people and not bad people: leniency to enemies means cruelty to the people."

Seizing on this fallacious argument, I reopened the debate on the detention system. Intellectuals like Zhong were serving as defenders of this inhumane system, abandoning principles and standing on the side of power, as they so often did. On my blog I asked: "If a commu-

nity denies the facts and covers up mistakes, is there any chance it will improve itself? On what sort of foundation is today's political life built?" When these words were read and reposted hundreds of thousands of times, in a matter of hours, I knew I had touched a sensitive spot. At the time I had no idea that in 2020 Zhong Nanshan would become mired in controversy once again when he was accused of involvement in the cover-up of the COVID-19 outbreak in Wuhan.

I was also concerned about the human price of economic growth. The Pearl River Delta, in Guangdong, then had the world's biggest concentration of processing plants, and in its factories each year more than forty thousand workers would lose fingers in accidents; in the whole country, fifteen thousand people died annually in labor-related accidents. For thirty years China had dreamt of becoming rich, but increased wealth had come at a great cost in physical and mental health. Large numbers of migrant workers were hired to do simple, repetitive mechanical labor in the factories of Guangdong, and whenever there was a downturn in foreign trade and the business suffered losses, the workers would be tossed out on the street with no compensation for their sudden redundancy.

"In these last thirty years," I asked, "who has been frantically accumulating wealth? Where did their wealth come from? When will workers have unions and social welfare to protect their personal rights? When will the nation feel shame at having crippled so many? When will the government provide compensation for the irresponsibility of management? When will society stop celebrating extravagance and ostentation and promote fairness and justice instead?"

My blog became a virtual battleground, with arguments advanced vigorously on both sides. I sat there on my stool, blunt, uncompromising language glowing on the screen in front of me. It seemed that my blog had stirred people from their numbness and indifference, and the boundaries between life and individual expression were erased in this all-consuming digital existence.

At the same time, I was making the most of another favorite medium: photography. In those years I must have taken hundreds of

thousands of photos, recording what I saw in two dimensions. Then, with digital programming, these tiny scraps of information became credible fragments, forming a world of their own.

In the three years leading up to the 2008 Beijing Olympics, I recorded the construction of the Bird's Nest stadium and Beijing Capital International Airport's enormous Terminal 3 both on film and in still photographs. Every few days, my assistant Zhao Zhao would grab Ai Dan's car, a borrowed media permit taped to the windshield, and drive in and out of the construction sites to document the progress. My motivation was simple: if I did not make a record, nobody else would, and people would end up seeing only the finished product and not the labor that preceded it. A simple visual record becomes a part of human memory, enduring despite efforts to suppress it. I was determined to create a lasting testimony to the hardship of the migrant workers who toiled to build these landmarks.

I was also recording the demolitions, the perpetual upheavals and ruinations that accompanied the urbanization process. Beauty seemed powerless in the face of this ugly reality. Destruction of existing buildings had begun in the early 1950s, but the complete transformation of the old city didn't really get going until the 1990s, when the rapid growth of the economy was paired with a push for urbanization. Since the government's core profits stemmed from land transactions, soon the city was swallowing up agricultural land everywhere. I began to see these acts of documentation as essential to my life not only as an artist but as a citizen.

IN THE RUN-UP TO the Beijing Olympics, prominent Western visitors from the art world would typically want to work a visit to my studio into their China itineraries, to the point that it almost seemed I was as much of an attraction to them as the Great Wall or the Terra Cotta Warriors. Although I was usually willing to receive such guests,

I never initiated these get-togethers, because I was deeply conscious of the differences in experience and perspective that divided me from them.

The gap between us was never more apparent to me than on May 23, 2006, a lovely spring day, when two coaches pulled up in the street outside. An international team of consultants engaged by New York's Museum of Modern Art, made up of more than seventy collectors, museum trustees, and foundation trustees, had come to China to take measure of its contemporary art, and I had become a stop on their route. These visitors were smartly dressed and well spoken, strolling at ease on the lawn. Unbeknownst to them, in the corner of the courtyard, four sets of hidden cameras recorded their unsought visit from various angles. What this event told me was that China had now, in cultural terms, become part of the globalization spectacle, and its embrace of the Western powers would inevitably lead to an epidemic.

The head of the delegation stood in the sunlight and made some remarks to the effect that the bright day had a special significance, intimating that art in China was now entering the international field of vision. By coincidence, on this very same day sixty-four years earlier, my father and a hundred other writers and artists had gathered to hear Mao Zedong's closing remarks at the Yan'an Forum on Literature and Art, in which he emphasized that the primary task of literature and art was to serve peasants and soldiers, effectively announcing the tightening of party control over artistic production in Communist-held areas. Since then, literature and art had simply been reduced to cheap, utilitarian propaganda tools, and even now they had only the dimmest prospects. Here, in the twenty-first century, "foreign influences" were once more entering China with a swagger, no longer in the form of Marxism but as part of a new round of cultural imperialism and capitalist appropriation.

MoMA, founded in 1929, has a collection of more than 100,000 pieces and is the largest repository of modern art in the West; the ar-

rival of globalization and the information age would connect it to
Beijing on the eve of the Olympics. And now MoMA judged it was
the right time to lavish more attention on China. Before then, one
would never have seen tourists in Caochangdi; the only people you
saw going in and out of the village's simple houses were migrant la-
borers who had moved there in order to work in the city.

In New York I had once written, "If someone goes to MoMA and
doesn't feel overcome with shame, he's either got something wrong
with his artistic instincts or he's a complete scoundrel. All you'll find
there is prejudice, snobbishness, and vanity." I was young and full of
myself then, but twenty years later, with the visit of the MoMA del-
egation to Caochangdi, I continued to recoil against the museum's
complacent, elitist tendencies. Art should be recognized, yes, but not
in the form of expensive collectibles to be deposited in MoMA stor-
age to molder—that's simply a waste. My vision of contemporary art
took a very different form. To me, art is in a dynamic relationship
with reality, with our way of life and attitude to life, and it should not
be placed in a separate compartment. I have no interest in art that
tries to keep itself distinct from reality.

Online, the range of issues I addressed was steadily broadening,
for I viewed my blog as a way to help bring into being a more just and
humane society. Increasingly, I was seen as the first person to turn to
for support if some outrage or injustice was witnessed. In the early
morning of February 11, 2007, I received an urgent message from a
volunteer with Tianjin's Small Animal Protection Association. Her
group had managed to intercept a truck loaded with four to five hun-
dred cats at a highway tollbooth. ("Dragons and Tigers Tussle," a cat-
and-snake-meat stew, is a celebrated Cantonese dish.) I hurried over
to help these young people in their early twenties, in whom I saw a
compassion and decency too often lacking among their elders.

By the time I arrived, temporary shelter had been found for the
cats in a warehouse on the outskirts of Beijing. Outside, wire cages
were stacked, crammed with twenty cats per cage, and when I en-

tered the warehouse, I was shocked to see fearful cats clustered in every corner, on the rafters, and anywhere else they could shelter. Some had been injured in the course of their capture and transportation, and all were hungry and dehydrated.

In China's oppressive political environment, it's easy to lose the capacity for empathy and end up inflicting pain on others. With that in mind, I made a documentary, entitled *San Hua,* about the cat-meat-and-cat-trading industry and efforts to protect cats from abuse. I made the film available online, hoping to prompt frank discussion, the precondition for an effective response to ignorance and callousness.

I agreed to take forty of the stranded cats, hoping to make amends for the mistreatment they had suffered at human hands. In the Caochangdi studio, dozens of them found a home. Each cat had its own distinctive charm: San Hua would saunter across the lawn with great poise, while Lailai would sprawl on my desk, next to my keyboard, snoozing blissfully as interviewers peppered me with questions.

IN AUGUST 2006, I traveled to Kassel, a town in Germany that hosts Documenta, an exhibition that is a major event in the contemporary art world, occurring every five years. The twelfth such exhibition was ten months away, and I had been invited to participate. After viewing the venue, I traveled on to northern Switzerland, where Sigg and I went for a hike. The mountains there are not so very high, but every so often we needed to stop for a rest or take a bite out of one of the sausages or bananas that Sigg had brought. I kept toying with possible concepts for the exhibition, but my mind was empty and I wasn't quite sure what to do. All I knew was that I didn't want to fall back on clichés and let this opportunity slip through my fingers.

Blue wildflowers grew on either side of the trail, and as we paused to catch our breath, several families threaded their way past us—

Study of *Shanhaijing*

children perching on their fathers' shoulders, wives helping older folks along—their clothes and language revealing that they were not Swiss locals but visitors from Italy.

The appearance of this band of foreign hikers touched me deeply. In the early 1980s, Chinese people rarely had the opportunity to leave their native country. But when I was in New York, Chinese visitors passing through did drop by to see me, and their way of dressing and carrying themselves always identified them straightaway as Chinese. The average Chinese person is not adept at long-distance travel: if he ventures far from home, he's likely to feel as lonely as a clove of garlic that's been stripped from the bulb. When Chinese are abroad, they love nothing more than getting together with people they know— even being with people they don't like is better than being by themselves! This sense of insecurity when alone stems from the lack of basic guarantees in Chinese society: in China, kinship relations and bonds of affection are what you count on for protection. So when you leave your home, you tend to feel confused and ill at ease, and you look around everywhere for reassurance.

This is how the idea came to me of taking a bunch of anxiety-prone Chinese on an overseas tour. The more I thought about it, the clearer the concept became. I wanted to involve bold participants who could overcome the sense of insecurity instilled in them by political and cultural life in China and help them learn that they didn't always need to feel uncomfortable when far from home. Their stay in Germany would prompt them to scrutinize the world they found there, and scrutiny involves challenge, the challenge of detaching oneself from one's cultural system and governmental structure—it would be, I hoped, a scaled-down model of social action.

The work would combine two seemingly unrelated entities: the Kassel Documenta and 1,001 tourists from China. One thousand was a big enough number to evoke a crowd, while one, by contrast, would represent the individual. I shared this idea with Sigg, keen to get his reaction. He offered polite support, and I realized that however foolish my idea might be, he wouldn't dream of pouring cold water on it.

Perhaps it was no accident that the idea came to me at an altitude of seven thousand feet, where the air was thinner. My mind was in a whirl, and I was so energized that night that I couldn't sleep. My vision became grander: the project would be a physical enactment of China's relations with the world. But just what form that enactment would take could be learned only in the process of executing it.

My concept won the approval of the husband-and-wife curatorial team Roger M. Buergel and Ruth Noack, and a friend put me in touch with two private Swiss foundations that agreed to provide funding. The project was to be called *Fairytale*—a name that seemed all the more appropriate because of Kassel's historical association as the longtime home of the Brothers Grimm.

What was more difficult than getting money was figuring out how to get German visas for 1,001 Chinese citizens. To be on the safe side, Sigg accompanied me on my visit to Ambassador Volker Stanzel at the German embassy in Beijing. The ambassador listened intently as I outlined my vision and explained the challenge before me. To my relief, he promised his full support: his goal would be to see that every applicant received a visa. I remained a little uncertain about just how things would play out, knowing that under normal circumstances a lot of the prospective visitors would be viewed as lacking the financial wherewithal to be eligible for a visa, and if any of them were to overstay, it could amount to a diplomatic incident. Still, as we left the embassy, I felt fortunate, and my thoughts were already turning to the journey ahead.

On February 26, 2007, I formally introduced the *Fairytale* venture on my blog, in part to solicit participants. I needed to make clear to my future fellow travelers that they would, in effect, be vehicles for a work of mine. And above all, I needed them to know that this was a serious enterprise and not some internet scam. I was not fully confident that I could win their trust, for I had difficulty explaining the purpose of the enterprise—the purpose would become apparent only in the act of traveling, of going to a place one had never been. Here is the text that I ended up posting:

FAIRYTALE 2007:

A JOURNEY TO KASSEL

BY 1,001 CHINESE

Fairytale is a work by artist Ai Weiwei, to be presented at the 12th Kassel Documenta Exhibition. Ai Weiwei will travel with 1,001 Chinese to the city of Kassel in central Germany; this trip to Kassel by 1,001 Chinese is the basic element in the work.

The dates of the activity are June 12, 2007, through July 14, 2007.

The organizer will be responsible for organizing the participants' group departure and group return.

Procedure: the organizer will circulate application materials prior to March 1, 2007, and prior to April 1, 2007, will review the applications and select participants. After receiving their notifications, the participants will before April 1 mail to the organizer their passports and copies of their identity cards. The organizer by May 1 will initiate visa processing, and all participants will gather at a prearranged time and place to proceed to Germany.

Within three days I received more than three thousand applications, and soon, in order to keep the numbers manageable, I had to announce that no more online applications would be accepted. I had carefully designed a questionnaire for the volunteers, with a total of ninety-nine questions, including such queries as "Have you ever been to Germany?," "What would you like to tell the West?," "What is a fairytale?," "Can art change the world?," and "Do you believe in evolution?" I wanted to understand who the applicants were and at the same time make sure they knew I was being serious, and so the questions probed their expectations for the future, their reflections on their own circumstances, and their attitude toward their native culture.

In 2007, internet use in China was largely confined to the big cities, so I asked friends with family roots in rural areas to spread the word

to people they knew who might want to participate but would otherwise not hear about the opportunity. This served to diversify the group beyond the tech-savvy urbanites of Beijing and Shanghai who were flooding me with applications. One farmer in northwest China gave the same answer to all my questions: "I don't know." But he signed his name at the end of the form all the same, to confirm his interest in joining the group.

Reading the applicants' prompt, orderly responses, I gained a clear sense of the passion and energy that surged through virtual space. When I sent out the invitation, I had added a comment: "Your very act of writing to me will mean that you have already experienced a miracle, in that you are now looking at the world with a new set of eyes and have acquired a new way of thinking." For people to face the unfamiliar and enter into the unknown would become an organic part of this project. Coming from all of China's provinces and major cities and autonomous regions (apart from Taiwan and Tibet), the applicants touched me with their fervor. Another northwestern farmer told me that practically everyone in his little village of twenty-odd households wanted to go to Germany; the only one who decided against applying couldn't bear to leave his pigs and ox for such a long period.

In an even more remote village in China's southwest, journalist and singer Wu Hongfei shared the news of the project with her relatives: women of the Dong ethnicity who had never in their lives left the Guangxi mountains where they were born and where a farmer's annual income was a mere hundred U.S. dollars. In their native language, there were no such words as "artist" or "fairytale," and to them, traveling to Germany was as far-fetched an idea as traveling to the moon. Wu Hongfei told me she didn't know how to describe the place they would be going; all she could say was "Germany is as wonderful as Tiananmen." They had heard of Tiananmen at least.

To get passport photos and apply for passports, the women had to make two trips to the county town, and the bureaucratic procedures brought dizzying complications to their tranquil lives. These women

had lived well into their fifties without names of their own—when they married, they had adopted their husbands' surnames, and in their residence booklets they were identified simply as "so-and-so's mother." Now they were required to supply precise personal details, and to get passports they had to quickly improvise names for themselves. One resorted to calling herself Wunai Baozheng, Wu being her husband's surname, Baozheng being her eldest son's personal name, and *nai* meaning "mother" in the language of the Dong.

The applicants included people from a variety of professions, including bar owners, poets, painters, teachers, students, singers, authors, tea merchants, safety inspectors, unemployed migrants, and farmers fresh from mountain hamlets. After sorting through all the applications and collecting more information through follow-up questions, we selected more than a thousand volunteers, their ages ranging from two to seventy.

Fairytale wasn't the kind of work one could hang up on a wall or display on a pedestal. Though anchored in my life and my thinking, it was a living entity, still in process, lodging individual desire in the practice of social ideals, and as a social movement in miniature it would have a lasting influence on the life of each participant. For me, *Fairytale* found a medium and a form in sociological terms: sourced from the Chinese masses, seemingly unrelated to contemporary art, individual awareness would become the work itself. When asked what it was I wanted to show the viewer, I said that was not my purpose: my goal was to not show anything at all.

As we prepared to apply for visas, on my desk lay a huge pile of passports. I assembled a team of students and volunteers, and we divided the 1,001 participants into five groups of roughly two hundred individuals, purchasing tickets and travel insurance for them all. At staggered intervals between June 10 and July 11, 2007, each group traveled to Germany, flying on Lufthansa or Air China from Beijing or Shanghai to Frankfurt or Munich, where they transferred to buses that would take them to Kassel for a weeklong stay.

On the campus of the University of Kassel, I had found a vacant

warehouse. There we erected a series of attractive temporary tents for the visitors, and built a kitchen and toilets. To stock the facility, we had shipped in ten forty-foot-long containers full of woks, bowls, ladles, plates, cookers, steamers, and other kitchenware, along with camp beds, sheets, and quilts. So that people wouldn't suffer too much from culture shock, our four cooks prepared a Chinese menu for breakfast, lunch, and dinner each day—if Chinese bellies encounter just a single meal that's not to their liking, their owners will miss home. At the same time, we also made a point of offering some German specialties, like sausages or pork knuckle.

The huge amount of organizational work involved—passports, visas, health insurance, plane tickets—practically drove me crazy, and I almost forgot I was working on an art exhibition. My role in this production was akin to that of a manager or tour guide, handling logistics, public relations, media, safety precautions, and all other administrative services. At the same time, I tried to minimize my role as an aesthetic decision-maker, which I hoped would maximize the work's potential to move in multiple directions and help the fairytale avoid becoming too artsy and recycling stale clichés.

One thousand and one antique Qing dynasty chairs became another element of *Fairytale,* a stationary but equally culturally shaped and memory-laden counterpart to the 1,001 human arrivals. Chairs are familiar to us all, not just as furniture but as accessories woven into the traditional, normative fabric of family and society. The chairs—a part of the Chinese participants' memories—were not exhibits, but served rather as convenient places for rest for visitors.

Elements highlighted by *Fairytale* would later find resonance in such developments as the explosion in global tourism and then the convulsions of the refugee crisis in the years that followed Documenta 12. A German newspaper carried an article entitled "The Chinese Are Here," which read in part, "To their hosts, these 1,001 Chinese may be a potent metaphor for the world's dramatic population growth, and they can also symbolize the loss of culture and the impermanence of material possessions."

When I saw the Chinese arrivals slowly emerge from customs at Frankfurt Airport, I was deeply touched. These people knew little about contemporary art, and most of them would probably never really understand what I was up to, but the internet had ushered us all into a new reality, and now, as they stepped off the plane in a foreign country, they were about to widen their experience. To me, interaction with the lives of others was no ordinary thing: to explore the world is a right that you acquire when you are born, and these travelers were exercising this right for the very first time.

Fairytale's temporary home—or, as the German media described it, the "field hospital"—was on two floors, one for men and one for women, each floor divided into ten rooms with white cotton curtains and ten beds in each room. Each person was issued a T-shirt printed with the F1001 logo, and a USB bracelet that allowed free access to the exhibition hall. The bulletin board at the entrance to the dormitory featured all manner of announcements: the schedule for the day, insurance details, instructions on use of the internet and telephone, and activity sign-up sheets. Kassel residents had donated dozens of bicycles for the visitors to use during their stay, and the USB bracelets guaranteed free travel on the city trams and buses, serving, in effect, as access passes for "Weiwei's Chinese."

China differs from the West in many fundamental ways, functioning at a different level and in a different context, sometimes even moving in an opposite direction. As 1,001 Chinese explored Kassel, the mutual imaginings and mutual confusions of East and West rippled through the streets and alleys of this German town and came together as I'd hoped—like a fairytale in this foreign land. Before and during the event, a large crew shot more than a thousand hours of film, painstakingly recording scenes in the lives of *Fairytale* participants, including the humdrum routine of their native places, their worries, their dreams, and their challenges. After editing, we had a documentary that chronicled the concept and implementation of *Fairytale*.

On a stretch of green lawn in front of the eighteenth-century palace in Karlsaue Park, I installed another work, *Template*, made from

more than a thousand wooden doors and windows salvaged from old buildings in Shanxi that were earmarked for demolition. I had placed these fragments into a modern environment, constructing a blended, disruptive, contradictory context, like a temple both from the past and from the future. I did not care how, specifically, *Template* was defined—in an interview I even remarked that I wouldn't mind if it was struck by lightning. I had found true delight in the spontaneous, ephemeral sense of fulfillment enabled by virtual reality, and inherent ideas and frameworks left me dissatisfied. By now I had no desire to meet the media's—or MoMA's—expectations of what contemporary art should be.

Then, on June 21, just two days after the opening of Documenta 12, *Template* was toppled in a sudden thunderstorm. The news came as an enormous shock: it seemed to me like a grim portent of doom. But the sun broke through as I inspected the crumpled wreckage, and I couldn't help but marvel at its new appearance: this huge installation that we had expended so much effort to construct had twisted itself around in a circle, but it was not completely flattened. The structure had stubbornly resisted the forces that were bent on destroying it, and now it had even more vitality than before, when it had

Template, 2007

been standing erect. Its power projected itself out of the ruins. Art never ends, it was telling us—art is always just a beginning.

Fairytale provoked much debate, and it turned out to have more complex ramifications than I had expected. One observer would later write, *"Fairytale* was a turning point in Ai Weiwei's artistic career; from then on, he increasingly employed radical forms to examine social issues." I am no admirer of order—whether order appears in Eastern or Western guise, it always triggers suspicion in me. I dislike the constraints on human nature and the restrictions on choice that order imposes. When you break away from mandated meaning, you enter a state of tension with your surroundings, and it is then, when you are uncomfortable, that you are at your most alert.

Often I find myself confused, but it is precisely such confusion that leads me forward. *Fairytale,* in terms of its social engagement, was a sign of things to come, and from this time on my art was increasingly preoccupied with the tangled connections between politics and reality. A newly born art was growing inside me, its roots spreading everywhere.

It was during this fertile artistic period that I came to know Wang Fen, a young film editor working on the *Fairytale* documentary, and we became involved. While visiting New York in 1998, Lu Qing and I had gotten married, and now, ten years later, we both still lived in Caochangdi, but we slept in different rooms. Once, in much distress, Lu Qing told me that the only thing keeping her in Caochangdi was our cats and dogs. She rarely expressed her emotions so directly, and it left me quietly tearful. What you like in life is almost always more real than what you love, and more accessible. Lu Qing was gentle and kind by nature, and her tolerance had allowed me enormous space to do as I saw fit. In all these years together, she had not changed a bit—it was I who had.

It is tempting to see fairytale elements in the development of a new relationship, but reality is never a fairytale. Life had taught me to relinquish other emotional ties I had once had, and there was no way to predict how durable this new bond would be.

—

Citizens' Investigation

O N A LONE FLAGPOLE, CHINA'S FLAG WAS FLUTTERING. I STOOD
in the ruins, dazed and trembling, overwhelmed by the smell
of death. Beneath my feet lay scattered clothes, rain-soaked text-
books, rulers, tiny mirrors, and backpacks. Soldiers in white chemical
protection suits, laden with black body bags, made their way past a
now silent mechanical digger. Two weeks earlier, 740 children had
perished here when their school collapsed.

On May 12, 2008, an 8.0-magnitude earthquake struck the south-
west province of Sichuan, its epicenter in the town of Wenchuan. It
was so powerful that within minutes the tremor could be felt in Bei-
jing, 950 miles away. As news of the disaster spread, the whole nation
was plunged into mourning.

I was in no mood to just keep on blogging. Accompanied by my
assistant Zhao Zhao, I arrived in Sichuan's capital, Chengdu, on May
29, and we immediately headed out to Dujiangyan, a town near the
epicenter that had suffered severe damage. There we saw the ruins of
Juyuan Middle School, now a heap of bricks, splintered concrete, and
exposed rebar. On just this campus alone, 284 children had died. We
stopped our car and got out.

Amid the rubble we met a couple in their forties. The man was a

taxi driver; his wife held in her hands a pink pencil box, with her daughter's little glasses and one of her baby teeth inside. Their daughter had been everything to them, she said. Why had they put up such a flimsy building, she asked, and who was going to take responsibility for the shoddy construction? These were questions that would never get answers. In all, more than seventy thousand people had perished, many of them young children like her daughter, buried under collapsed schools.

Later, when I began to commemorate the deceased children on my blog, the mother of a schoolgirl who died in Beichuan would post a comment: "I found my daughter's name on your list: 'Yang Xiaowan, 7, first-grade pupil at Qushan Primary School.'" She added, "All I want is that more people know about my daughter Yang Xiaowan. She lived happily in this world for seven years. I hope everyone will remember her name, and remember the names of all those who died."

Even if there had been no earthquake at all, 2008 would have been no ordinary year. The looming Olympics shared space in the public consciousness with disasters both natural and man-made, each exacerbated by Beijing's fumbling for control of the narrative. In late January and early February, a series of unusually severe snowstorms paralyzed transportation routes for days on end. Then a protest movement launched in February by the Tibetan government-in-exile was followed in March by demonstrations against Chinese rule in Lhasa and other places, leading to a crackdown by the Chinese authorities. In my blogging I could not undo such tragedies, but I could at least remind my readers what had triggered these protests. Soon I would do even more.

JUST SIX WEEKS BEFORE the 2008 Olympics were due to begin, a gruesome series of murders was committed at a police station in the northern Shanghai suburb of Zhabei. According to the official ac-

count, a masked intruder burst into the building and managed to stab a guard and some ten police officers before he could be subdued; six of the policemen died of their wounds. Given the gravity of this assault on an organ of the state, the case against Yang Jia, the man accused of perpetrating the attack, was shrouded from the start in suspense and speculation, and I resolved to make a documentary about the episode.

In October 2007, Yang Jia, who lived in Beijing with his working-class mother, had gone to Shanghai for the National Day holiday. After renting a bike, he was stopped in the street and questioned by police, who suspected that the bike was stolen. When he argued with them, they took him in for questioning. He was released at two the following morning, after which Yang called 110—the police emergency number—and also had a long telephone conversation with his mother; he said he had been beaten up inside the police station.

After that, Yang Jia filed a complaint against the police, and as time went on the rights and wrongs of the matter became all the more difficult to establish. Upon his arrest, Yang Jia's first words were "If I have to put up with this mistreatment all my life, then I'd rather be an outlaw. Whatever you do, you need to give me a proper accounting. If you don't, then I'll give you an accounting of mine."

The trial was riddled with procedural irregularities. Yang's state-appointed defense lawyer declined to call key witnesses and failed to inquire into the causes of the incident, forfeiting any possibility of a new development in the case. In the courtroom, Yang Jia asked his lawyer simply to be candid and straightforward, and to speak clearly. Again and again, in an effort to prompt a discussion of the events that triggered his act of revenge, Yang Jia pressed for an answer to the question "Did the police beat me, or not?" After Yang Jia was sentenced to death, the Shanghai authorities still refused to conduct a psychological evaluation, thereby precluding a plea of insanity and dooming Yang to execution.

When administrative power is unlimited, when the judiciary is subject to no scrutiny, when information is shielded from public view,

society is bound to operate in the absence of justice and morality. Corruption of the judiciary is the public face of a morally bankrupt body politic, a scar disfiguring the era in which we live.

The appeals court upheld the death sentence, and, having written extensively about the case on my blog, I could think of nothing more to say. Just one month later, Yang Jia was executed. His mother, Wang Jingmei, was notified only after the fact. She had been consistently denied the right to speak up in his defense. On the day of his arrest, she had been detained by the Beijing police, and she was then confined to a mental hospital under an assumed name and forced to undergo "medical treatment."

China executes more people than any other country—it accounts for more than half the executions in the world—and in this unjust society the dead are not the only victims. The day after Yang's execution, I posted a video of a burning candle, and later I uploaded my documentary. It raised doubts about the case, examining Yang Jia's motive for attacking the police and questioning the legitimacy of the judicial process. I entitled the film *One Recluse*.

THE EYES OF THE WORLD, meanwhile, were elsewhere. On August 8, 2008, the XXIX Olympiad opened in Beijing. For the next two weeks the world became smaller, with plenty of room, still, for power and capital, but not so much space for others, particularly not for those citizens deemed by Chinese media outlets to be "not very important." Migrant workers had been expelled from Beijing, and many shops had been shuttered: the everyday pleasures of normal people were suspended in order to satisfy the whims of the authorities.

The design of the Bird's Nest aimed to convey the message that freedom was possible: the integration of its external appearance with its exposed structure encapsulated something essential about democracy, transparency, and equity. In defense of those principles, I now resolved to put a distance between myself and the Olympics, which

were simply serving as nationalistic, self-congratulatory propaganda. Freedom is the precondition for fairness, and without freedom, competition is a sham.

Wang Fen was now several weeks pregnant, and after a prenatal checkup on August 8, the day of the Olympic opening ceremony, we sat ourselves down in a coffee shop not far from her apartment. I was going to become a father—a big event in life and, like other key changes in my life, one that announced itself suddenly and brooked no dissent. There is nothing more abrupt than a pregnancy, and nothing more disorienting than the prospect of being a father. But one thing was certain: the child would guarantee a permanent connection between Wang Fen and me.

As the opening ceremony began and fireworks exploded on the TV screen on the wall, I scribbled some reactions on the back of Wang Fen's visit report: "In this world where everything has a political dimension, we are now told we mustn't politicize things: this is simply a sporting event, detached from history and ideas and values— detached from human nature, even. Politics always reminds us who has built two different worlds and two totally different dreams. There are many things we need to repudiate, but let's first say goodbye to autocracy, no matter what form it takes and no matter how it's justified, because the result is always the same: denial of equality, perversion of justice, warping of happiness."

ONE HUNDRED DAYS AFTER the Wenchuan earthquake, China's haul of gold medals at the Olympics had surpassed the U.S. team's total by a wide margin, and the nation presented a false smile to the world. The Olympics were intended to be the capper on thirty years of growth and reform—a national coming-out party, showing the rest of the world how much China had changed. But for me it was proof positive that nothing essential had changed at all. Belief and ideology were no longer the real battlefield. The real battlefield was profit—

naked profit—spanning across regions, conglomerates, and nations, inspired by the globalizing dream of capitalist powers. The Chinese regime sought to gloss over the ideological gap that separated it from the world's democracies, and by openly criticizing this phenomenon I had become a maverick, a political opponent, and a potential threat.

In the summer of 2008, melamine—a chemical that can cause kidney stones and trigger the failure of kidney function—was discovered in infant formula and other milk products sold in China. But the government deliberately quashed reports that huge amounts of melamine-tainted infant formula had entered the marketplace, and the facts didn't emerge until after the Olympics were over. By that time, thirty million infants had already been adversely affected by the adulterated milk powder.

On the last day of 2008, I affixed my signature to a bag of the notorious "Sanlu milk powder" that had wrought so much damage and put it up for auction online. The reserve price for the bag was just 20 yuan, but it sold in the end for 1,600. With the proceeds I purchased some warm winter clothes, which I distributed among petitioners from the countryside who were sleeping under bridges in Beijing as they waited for their cases to be handled.

That year, I had been following current events with keener attention than ever: from the apocalyptic snowfall at the beginning of the year, when so many working people were hopelessly stranded, to the muffled reports of riots in Tibet, the grotesque jamboree that was the Beijing Olympics, and all the toxic cocktails in Chinese society even more insidious than the melamine in infant formula. I saw what an absurd and heartbreaking road China had followed since 1978 and what bitter fruit it had yielded.

By late 2008, the authorities were making strenuous efforts to shut down my blog. One day I found that its comment function had been disabled, and I knew it would be only a matter of time before the blog itself was suspended. I felt powerless. "Don't harbor illusions about me" was my last public statement of 2008.

As the year drew to a close, I arranged for members of my team

to collect footage of the recovery efforts in Sichuan for a documentary on the earthquake. I had not forgotten the plea of the Beichuan parents for a full investigation of the school collapses and for a tribute to their children's lives, and I planned to make myself personally responsible for assembling a list of the child casualties. In Wenchuan we interviewed the parents of more than a hundred of the children and listened to their accounts of the disaster, the relief efforts, and the ensuing "stability maintenance" measures—the government's push to silence those who were pressing for an inquiry into the shoddy construction of all those schools. Simply put, the government never carried through on its commitment to investigate building quality, and the names of the schoolchildren who had died had still not been released.

In March 2009, from my studio in Caochangdi, I placed more than one hundred telephone calls to schools and government agencies in Sichuan. I spoke to provincial, municipal, and county-level administrators in the education, civil affairs, and public security bureaus, as well as all the affected schools, and asked them to supply the names of the children who had died. The responses were uncannily similar.

First they claimed they had no such list. Then they admitted that there was a list but said they could not share it: all the details fit for public consumption had already been released, and what hadn't been made public was a state secret. Such an explanation was laughable, of course, and when I pointed this out, the person at the other end would ask me who I was, convinced I had to be some hostile element bankrolled by a foreign, anti-China power—some even asked me outright if I was a spy or with the CIA. "All you're doing is pouring salt on the parents' wounds," they fumed. "If you'd just kept quiet, they would have already forgotten about it." But every day I would receive messages from parents whose one hope was that their children would not be forgotten. The construction quality of the schools was a taboo topic: media coverage of the earthquake focused exclusively on how successfully the party was leading the people in triumph over the disaster.

Taifeng, 2015

I announced the start of an inquiry into the names of the children killed in the earthquake, calling it a "Citizens' Investigation." Here is how I presented it to my readers:

CITIZENS' INVESTIGATION:
TRUTH. RESPONSIBILITY. RIGHTS.

Ten months ago, I visited the areas in Sichuan most severely affected by the earthquake, and saw unthinkable pain and fear. Today we still don't know the names of the children who left us when the earthquake struck, nor do we understand why they had to leave us.

We're told by the authorities that the children's deaths had nothing to do with them: the deaths were inevitable, unavoidable—experts have said so. Corruption is not to be discussed, "tofu-dregs construction" [a metaphor for shoddy work, using flimsy materials] is off limits, unpleasant evidence is suppressed. In the name of "stability maintenance," they threaten, detain, and abuse parents who press for an inquiry, violating the constitution and fundamental human rights.

Rejecting amnesia, rejecting lies, we are launching a "Citi-

zens' Investigation," to remember the dead and show concern for the living, to shoulder the responsibility for finding out every child's name and placing it on record. Remember, please: every day that we do not leave, these children will not leave. This is part of our reason for living, and we will not abandon this task.

Those willing to take part in the Citizens' Investigation, please leave your contact information. Your actions are your world.

Close to one hundred people volunteered to take part. We organized them into small teams of two or three, who visited the quake-affected areas. The thirty-one volunteers in the first phase of the investigation spent four months in Sichuan and visited forty-five towns and eighty-seven schools in seventeen heavily damaged counties. Eleven volunteers in the second phase resolved further questions, visiting thirty-one towns and fifty-four schools over a forty-day period. Through text messages, telephone calls, and email they sent names back to my Beijing studio. I stayed close to my computer, organizing the data and posting it online.

In the cemeteries, freshly covered graves had no names, only numbers. Local governments imposed a strict clampdown on sharing information, banned interviews, forbade parents from having contact with outsiders, and above all prohibited the release of names. All the parents suffered harassment of one kind or another; they were detained or threatened or even beaten, and ultimately were bullied into signing an agreement that they would inquire no further into questions of negligence, and if they did they would forfeit compensation for the death of their loved one and lose housing benefits. Thus, they often did not divulge even the most basic information.

Our volunteers, for their part, were regularly detained, questioned, and abused by the police. On one occasion, two young colleagues were seized in western Sichuan. The policemen opened the trunk of their taxi, video camera running, and they pulled a pistol out

from underneath a rug that was lying there. The two volunteers, see-
ing the gun for the first time, had no clue whether it belonged to the
driver or had been planted by the police. They were paralyzed with
fear, for in China gun possession is a serious crime. They were forced
to squat on the ground and put their hands on their heads, facing a
wall. "Who is this Ai Weiwei?" the police wanted to know. What was
he trying to do? Why were they collecting names? What organization
was behind this?

After six months of sustained effort by our team, which had suf-
fered multiple arrests, confiscation of records, and deletion of tapes
and videos, we completed our investigation. In the ruins of the
schools we collected samples of concrete and rebar, we examined the
original design plans of some of the buildings, and we found proof of
gross deficiencies in construction. The Citizens' Investigation com-
piled data on seventeen districts, cities, counties, towns, and villages
affected by the earthquake, and identified and confirmed the names
of 5,196 schoolchildren who died, along with their age, sex, school,
and class, as well as their parents' information. Aided by hundreds of
interviews with bereaved parents, we completed a documentary, en-
titled *Little Girl's Cheeks*.

After our investigation, we sent out 183 appeals to the central gov-
ernment and to the Sichuan provincial government, requesting the
release of information regarding earthquake relief policies, verifica-
tion of the earthquake damage, circumstances surrounding the
deaths, assessment of buildings, details of how donated relief funds
were being spent, and post-earthquake recovery efforts. We sent
thousands of questions in all, and we have never received a direct an-
swer to any of them. Ultimately, what shocked me most, apart from

the tragic deaths of so many children, was people's increasing indif-ference to it all—how they deserted the cause, forgot about it, fell silent—as though the disaster had nothing to do with them.

I had changed, it seemed, from being an artist to being a social activist. It is not at all difficult to become a social activist: as soon as you start expressing concern about the nation's future, you're already on a path that could take you straight to jail. But in a certain sense, I was facing a fragile regime, and I realized that this called for action on my part, to expose its wickedness. I see what is in front of me as a "readymade," just like Duchamp's urinal. Reality creates greater pos-sibilities for my art, and this realization is the source of my confi-dence.

The internet made it possible for me to align personal expression with collective interests, to make people aware that, even if they think they don't care about politics, once they see what's being done, they, too, will say, "Hey, things can't go on like this!" Such opportunities to shape opinion, however, were much briefer than I would have liked—sometimes just a few seconds—for every scrap of information that I sent out could last only as long as it took for the censor to delete it. At the same time, if I didn't fully utilize the opportunities that came my way, all that would be left on the internet in China would be loath-some clichés and hypocrisies—all insults to people's intelligence.

Any discussion of human rights inevitably becomes a political topic, and so I naturally became a political figure. There's nothing wrong with that: living in this era, you need to confront its reality. If art cannot engage with life, it has no future.

———

Disturbing the Peace

THE YEAR 2009 WAS A TUMULTUOUS ONE, AND I WAS LUCKY to get through it alive. When the moon rose in Beijing on the evening of February 9, the night of the Lantern Festival, it looked especially large and round. A little after 8 P.M., just north of the East Third Ring Road, a fire broke out in the satellite building next to China Central Television's new headquarters. As it raged out of control, the fire illuminated the sky; one spectator took a picture and uploaded it to his blog, and within a few hours his site received more than 370,000 visitors. For a while, the rare spectacle of this mouthpiece of dictatorship burning became the most popular image on the internet in China. As I watched the flames consuming this showcase building, I kept wishing that the whole thing would go crashing to the ground and take with it the propaganda machine that it represented.

While our Citizens' Investigation rolled steadily on that year, I grappled with both new opportunities and new obstacles. I grew surer of my role in overlapping communities that included my internet followers, the art world, and the Chinese public—even as my enemies in the Chinese state grew surer that I was a threat. That fire under a full moon was a fitting prelude to all of it: a combination of chance, danger, and drama.

Two weeks later, late at night, the television in the obstetrics department at Beijing Amcare Women's and Children's Hospital was broadcasting scenes from the 81st Academy Awards, and up on the screen we could see Robert De Niro presenting Sean Penn with the gold statuette for Best Actor. "We have a little prize of our own," Wang Fen said to me. The delivery had gone very smoothly—in a mere twelve minutes. The nurse had held the infant upside down and slapped him twice on the soles of his feet, eliciting a healthy wail. Wang Fen now lay in bed, calm and composed, weary but relaxed.

I gave our son the name Ai Lao. People used to call my father that, since Lao ("old") is a respectful way of addressing someone of advanced age, and Ai Lao and his granddad were born almost a hundred years apart. Bringing posterity into the world had never been a particular goal of mine, and the idea of a settled family life was new to me, so when I thought of how this tiny baby would grow, slowly but surely, into an adult like me and like his mother, I was prey at first to a deep unease.

Fathers have a limited role to play in the first few weeks of a newborn's life, and in that same month, a media uproar surrounding the auction of two eighteenth-century bronze animal heads drew some of my attention away from my son and his mother and ultimately became the inspiration for a new artwork of mine.

The bronze heads were originally part of a set of twelve zodiac symbols that had been designed by an Italian Jesuit, Giuseppe Castiglione, to decorate a fountain in Yuanmingyuan, the Old Summer Palace on the outskirts of Beijing. In 1860, when an Anglo-French expeditionary force broke into the palace grounds and started looting, this set of heads disappeared, and some of them later made their way into the hands of Western collectors. Now, at an auction in Paris of artworks from the collection of the late Yves Saint Laurent, Christie's had offered the heads of the rat and the rabbit for sale.

In the months leading up to the Beijing Olympics, many people in China had been seized with a nationalistic fervor, which was still in

full swing. The Chinese authorities bitterly denounced the auction of
the two heads and threatened retaliation against Christie's, and in an
attempt to highlight his patriotism, a Chinese bidder had appealed for
the repatriation of the sculptures, hailing them as "national trea-
sures." The whole affair was hyped up to an absurd degree; ironically,
the bronze heads had been designed in the first place as playthings for
China's Manchu rulers, who had conquered China in the seventeenth
century and treated Han Chinese as a subject people. On my blog I
asked, "What kind of slave would love the whip that once flogged
him?" As a student, I had spent a lot of time in and around the Old
Summer Palace, and I smelled hypocrisy in the indignation about its
looting by the British and French. "The Old Summer Palace is in ruins
not merely because of the Western invaders," I pointed out. "Until
the 1980s, marble from the palace was carted off by farmers and used
to build pigpens."

I decided to make a new, complete set of zodiac heads, on a larger
scale than the originals. The seven surviving heads offered potential
models on which to base my designs, but I made a number of
adjustments—the original tiger head, for example, looked more like
a bear (perhaps Castiglione had never seen a real tiger)—and in the
case of the five animals whose heads have been lost I relied entirely
on my imagination. As one critic would later note, the project would
come to complicate discussions of repatriation, shared cultural heri-
tage, and contemporary understandings of art.

I aimed to display my set of bronze heads in a public space in New
York City, so that a wide variety of people would get to see them.
These sculptures were long in the making, but with the support of
my friend Larry Warsh, the sculptor Li Zhanyang and I ultimately
were able to complete *Circle of Animals/Zodiac Heads*. On the pond in
front of the Plaza Hotel, on the corner of Fifty-ninth Street and Fifth
Avenue, the twelve animal heads were set out in an arc. At the open-
ing, on May 2, 2011, Mayor Michael Bloomberg made a moving speech
in the rain, and several artists read extracts from my blog and ap-

Study of *Circle of Animals/Zodiac Heads*

pealed for my release from detention—because at that point I had been held in a secret location in Beijing for almost a month.

ONCE MY CITIZENS' INVESTIGATION commenced, in March 2009, surveillance cameras sprouted up everywhere around the perimeter of my studio. During the day, plainclothes officers would take turns standing watch outside, and at night they would huddle up inside an unmarked white sedan. As I saw it, they posed no more of a threat to me than buzzards circling in the sky above, and I soon got used to being monitored. Having nothing to hide, I had nothing to fear, and I was comfortable with everything I did being out in the open—transparency would work in my favor. But they didn't stop there. Soon they would seek direct contact.

On Dongfang East Road, in Beijing's Chaoyang district, stood a cluster of buildings designed in a crude functionalist style, like a business enterprise, high security all around: this was the U.S. embassy. When Nancy Pelosi, Speaker of the House of Representatives, visited Beijing in late May 2009, the embassy invited a number of people to a reception in her honor, and I was on their guest list.

Pelosi, in her remarks, sounded very relaxed. The embassy's design, she joked, had successfully captured elements of the Chinese tradition. We were just a week away from the twentieth anniversary

of the suppression of the 1989 student protests, but she made no mention of human rights or Tibet and spoke only of the environment and the climate. In the wake of the market collapse and Obama's inauguration as president, visiting Western politicians, eager for China's help in resolving the financial crisis, conspicuously avoided sensitive subjects. Human rights were downplayed in the interests of globalization and economic growth, confirming that, East or West, it's money that talks. I could see that this was not going to turn out well: the difficulties that the United States and Europe were encountering would not disappear if they tried to make an ally out of China; on the contrary, their real troubles were just beginning.

I left the party early, regretting that I had come, and made my way out through the embassy's multiple security cordons. Picking up my phone once I was back in the car, I saw that my mother had tried to reach me, so I called her back. Whispering, she told me that several people from public security were waiting for me at her home in Dongsi Shisantiao. "I'll come right over," I said.

Mentally, I had already prepared myself for something like this, but I hadn't bargained on authorities showing up at my mother's house. What happened next was like a scene out of a poorly written absurdist novel. In my mother's courtyard I encountered three strangers: two in police uniforms and one in plain clothes, with a Beijing-style buzz cut, who wore a bag diagonally over his shoulder. Without offering any explanation, he asked me where I lived.

I politely but firmly asked to see his ID. This wasn't the response he expected, and it threw him off balance. "I don't have it here," he said, then offered various excuses. I had no interest in bickering with him, and when he refused to leave, I picked up my phone and called the police to report his intrusion. Police have a duty to carry identification and be ready to show it—though most Chinese would not think to ask.

Mother, standing apprehensively at my side, urged me to be more cooperative. "Talk nicely," she urged. "Be reasonable." But I felt that if they were going to hunt me down at home, they damn well ought

to follow proper procedure; I wasn't prepared to meekly surrender with my mother looking on. The plainclothes man was at his wits' end, anxiously conferring on the phone with his superiors.

Soon the bell rang and in came two more policemen—local cops responding to my emergency call. When I asked these new arrivals to show me *their* identification, they, too, claimed to have left them behind, and at my insistence they had no choice but to drive back to the station to collect their ID. Later we all went together to the police station, and I lodged a written protest. By then, Buzz Cut was practically climbing up the wall in frustration. Things clearly hadn't worked out at all as planned, although in the end the police had been able to clarify my residential status, a basic informational detail that—I realized later—would have a bearing on issues of legal jurisdiction if they were to press charges against me in the future. Night had fallen, and as I left the station my parting words were "Next time you have business with me, don't forget to bring handcuffs."

Later, I posted an account of this saga on my blog.

"Careful, now!" concerned readers counseled. "Are you really prepared to get arrested?"

"I'm prepared," I responded, "or rather, there are no preparations I need to make. I'm just a single individual, after all, and Ai Weiwei is the full extent of what I can offer and what they can get."

My online activity, in the end, had made me a target, but it was too late to pull back. While I had more at stake now that I was a father, I also had all the more reason to fight for a better future, one that would keep China's children safe from harm.

"Reject cynicism, reject cooperation, refuse to be intimidated, refuse to 'drink tea' "—such were the lines I hurriedly wrote on May 28. I sensed that this might be my last chance to state my position clearly. Inviting a dissident to "drink tea" is the secret police's way of issuing a warning, their way of intimidating you and weakening your resistance. But self-censorship amounts to self-abasement, and timidity is the road to despair.

People asked me, *How do you dare say those things on your blog?* My

answer was: *If I don't say them, it will put me in an even more dangerous situation. But if I say them, change might occur.* To speak is better than not to speak: if everyone spoke, this society would have transformed itself long ago. Change happens when every citizen says what he or she wants to say; one person's silence exposes another to danger.

Soon I got a call from a Communist Party official at the Writers Association who exhorted me to keep quiet during the days to come—the period leading up to the twentieth anniversary of the massacre in Beijing on June 4, 1989. I told him I could give no such assurance. No sooner had the call ended than I discovered I had disappeared from Chinese cyberspace. I was unable to log in to my blog; the three thousand posts I had written and the ten thousand photographs I had uploaded over the course of three years and seven months were gone; and even an online search for "Ai Weiwei" drew a blank—my name was now taboo.

I had attracted the attention of society not because of my reputation as an artist but because of my online presence. After starting out as a computer illiterate who typed with one finger, I had become a veteran blogger who posted up to five essays a day, and in the eyes of others I was waging a Sisyphean struggle, posting content that was constantly being deleted. At the moment my blog disappeared, I felt as though my body was being torn apart; I knew that this spelled the end of our Citizens' Investigation. There was a simple reason why the government refused to let an alternative voice be heard and why it wanted the owner of that voice to disappear from view: the people in power know that once there is a free exchange of ideas, their days are numbered.

On May 29, the day after my blogs were shut down, I set up a microblog on a Chinese platform called Fanfou, and I also signed up for a Twitter account to reach readers outside of China. The Fanfou microblog afforded a marvelous space for offhand commentary: its terse format lightened the weight of serious topics, allowing it—for a time—to avoid the government's attention. There was freedom to post, comment, chat, or talk utter nonsense, just so long as you kept

it all brief. When I posted playfully, "Since no problem of state security is involved, artist Ai Weiwei was not today taken away for questioning by the police," within moments there were dozens of equally facetious responses that jumbled my words into various combinations, such as "Since security is involved, Ai Weiwei took away the state for questioning today," "Since the state is involved with Ai Weiwei's security, the problem has been taken away by the police," "Because Ai Weiwei is involved in protecting state security, security has been taken away for questioning by the state."

As I sat there on my stool, the screen in front of me seemed like a fantastic octopus, its countless tentacles connecting with any corner of the internet world. As I tapped away on the keyboard with my two middle fingers, imagining how this action could put an end to this stale and decadent world, I experienced a sense of weightlessness. On the microblog, all posts were brief; it wasn't like facing an ocean so much as a babbling brook, leading me forward on its unending flow, incessantly updating and broadening my space.

A day had passed between my blog being shut down and the microblog account going up—a day in which my despondency quickly gave way to eager anticipation. In due course, the internet censors shut down my microblog, too, but fans then set up multiple new accounts for me, using such aliases as "Weiweiwei," "Weiwei Ai," "Wei Aiai," and "Ai Weilai," and for a while things were so confused as to completely befuddle the censorship system, rendering it unable to determine whether one or all of the microblogs represented the true me. I became all the more emotional, urging my readers to assert themselves—to give the authorities the finger before the finger got cut off. Power lay precisely in such spontaneous, fragile interactions. Those heady days did not last long, however.

By 2009, internet use in China had grown enormously, and public protests anywhere in the country attracted intense attention online. The government, arguing that "stability has priority over everything else," responded accordingly. Its budget for "stability maintenance" began to exceed the national defense budget, and internet controls

continued to tighten. It was not just my microblog that was being shut down—after barely a month, Fanfou itself was shut down. That left me with Twitter, but Twitter was on the other side of China's firewall and I needed a VPN to "jump the wall." Once I did have Twitter at my fingertips, I stayed on it until the early hours, meaning I now got significantly less sleep. In my struggles to maintain an online presence, my art, for a time, played second fiddle. I needed to find an arena where it, too, could reach an audience.

THE MORI ART MUSEUM, perched at the top of the Mori Tower, in Roppongi Hills, is Tokyo's loveliest art space. Here, in July 2009, was held the largest solo exhibition of my work up to that point. Curated by Mami Kataoka, *According to What?* presented twenty-six of my works in three galleries, under the headings "Fundamental Forms and Masses," "Structure and Craft," and "Reform and Inheritance." In the foyer, I hung a giant chandelier whose contours altered dramatically as you rode the escalator up or down, and the entrance was covered with more than a hundred large photographs of the Bird's

Nest stadium at various stages of its construction, the exposed ribs of its skeleton resembling dinosaur remains.

Another new installation was a sculpture, *Kippe*, which worked two very different materials into tight-knit unity. The first element was parallel bars reclaimed from an abandoned factory: in the socialist motherland that I remembered from my youth, every work unit's exercise field had a similar set of parallel bars, probably influenced by the Soviet Union's prowess in gymnastics. The second element was hundreds of pieces of ironwood, a very heavy tropical timber, stacked so neatly that they formed a solid wall of wood—reminiscent of the stacks of firewood I once assembled in Xinjiang. The wood had been salvaged from a Qing temple in south China, and I had used it for the first time several years earlier in my *Map of China,* which at first glance looked like one single, enormous piece of timber but was painstakingly constructed from multiple pieces of ironwood.

The exhibition received poor reviews from Chinese critics, reflecting my paradoxical situation within my own country. As an activist, I had reached a point where my standing in China was universally recognized, but my art was regularly denigrated. When I commented on current affairs, on the other hand, people were often equally dismissive: "He's just an artist—what does he know?" Now, in Tokyo, critics went the other way: "He's all politics." One Beijing curator wrote, "Ai Weiwei's works lack any kind of originality—it's just the large scale of his installations, the expensive materials employed, and his impact in Europe that serve to boost his reputation in Japan." Another chimed in, with equal condescension, "Because Ai Weiwei's work is simple and lacks deep thought, it easily finds acceptance." But these put-downs didn't discourage me. I never expect to please everyone, particularly when two competing worldviews are involved.

According to What? didn't attract much attention in Japan. In Asia at the time, contemporary art was often seen as irrelevant. My works are sometimes like salmon that swim back from the ocean to their native rivers: they need to complete a full life cycle before they can achieve their mission. Later, when the exhibition toured the United

States, Canada, and other countries, it received a very warm recep-
tion. But by then I was being held in one of China's secret prisons.

AT THREE O'CLOCK ON the morning of August 12, a loud, urgent
banging woke me up. In the darkness I heard shouts and the sound of
a door being kicked open, and through the peephole I glimpsed the
glare of flashlights at the far end of the hotel corridor. I instinctively
turned on the audio recorder in my computer bag and at the same
time called 110, the police emergency number.

I was in Sichuan once more, this time to testify in the trial of a
human rights activist for whom I felt a strong sympathy. Tan Zuoren,
an author based in Chengdu, working independently of my efforts,
had been the first ordinary citizen to set up a database of earthquake
victims and investigate the construction quality of the schools where
so many children had died in 2008. Tan had been arrested in March
2009, but it wasn't until that summer that I learned from his lawyer,
Pu Zhiqiang, that he had been accused of "inciting subversion of
state power"—a grave crime in China.

Pu Zhiqiang was hoping that I could serve as a defense witness,
and I agreed. I believed that the results of my own investigation of the
Wenchuan earthquake could clearly establish Tan Zuoren's inno-
cence, since the evidence I had collected suggested overwhelmingly
that the schools' tofu-dregs construction had been a direct cause of
the children's deaths.

On the evening of August 11, accompanied by my rock musician
friend Zuoxiao Zuzhou and ten studio assistants, I had arrived in
Chengdu and checked into the Anyi Hotel, not far from the Chengdu
Intermediate People's Court. A local author came to welcome us and
led us right away to a restaurant next to People's Park famous for its
"Old Mama's Trotters," a local delicacy of pigs' feet in broth.

After dinner I headed back to the hotel. By this time, it was late at
night and the street was quiet, but I noticed that a white sedan had

stopped in front of the hotel, with two men sitting in the front seats, the windows rolled down. Intuition told me they were up to something, so I walked briskly over and hailed them through the open window: "You're waiting for me, aren't you?" The pair looked at each other in alarm. The driver turned on the ignition and they drove off slowly, obviously not knowing quite what to do.

I woke up to bangs and shouts.

Soon several policemen knocked open my door and barged in. As I tried to fight them off, my T-shirt was torn and I felt a stinging blow on my head. I turned around to find a short, stocky policeman with an expandable steel baton in his hand; the extension would not retract properly after doing its work, and he was struggling to get it back in place. My recording of our exchange went like this:

AI: Why did you beat me?

POLICE: Who beat you? Who saw it?

AI: Is this the way you police behave?

POLICE: What's your evidence? Who beat you?
Which one was it? And where did you get hit?
Where's the injury? You can't just make
wild claims.

AI: You're wasting my time.

POLICE: Who beat you? I'm asking you.

AI: Who beat me? If you hadn't beaten me,
how would my shirt get ripped?

POLICE: You ripped it yourself!

AI: Oh, so I ripped it. And I beat myself up, too,
I suppose.

POLICE: That's right!

My face was burning and I found it almost impossible to close my mouth; I felt waves of dizziness and my ears were ringing. Amid all the wrangling that followed, as most of Chengdu's ten million residents were still asleep in their beds, I made sure to send updates to my

Twitter feed so that the news could reach my followers as soon as possible, wherever they were.

My first tweet went out at 4:35 A.M.: "Dozens of police broke into my room early this morning, and beat me when I demanded to see their ID. Some volunteers have been taken away. Police say we'll be held until noon today."

About an hour later, the police agreed to get my injuries looked at. Escorted by policemen, Zuoxiao and I boarded the elevator to go downstairs. Still wearing my torn red T-shirt, facing the elevator door and with my back to a stainless-steel-framed mirror, I raised my Nokia mobile phone and pressed the photo button. In the confined space, the flash was blinding, and the policeman beside me was stunned into silence. I seized the opportunity to put the photo online, and the satisfaction that gave me outweighed the fear, pain, and stress of the incident. Though I'd been savagely beaten by the police and was deprived of freedom of movement, I felt a sense of triumph, and my caption for the photo was "This is the best shot of all." Soon the photo was all over the internet, and the news that we had been detained in Chengdu was circulating in real time.

After seeing a doctor, I was confined to my hotel room for the next few hours, and several members of my team were taken away for questioning. The police refused to explain why we were being held—they simply kept repeating, in their heavy Sichuan accents, "We're just doing our jobs—please be understanding." We weren't allowed to leave the hotel until 2 P.M., by which time Tan Zuoren's trial was over. That evening I flew back to Beijing, and when I boarded the plane in Chengdu, it might have seemed that I had nothing to show for my efforts, apart from the big bruise on my head.

On my return to Beijing, I shot off a series of tweets. "I'm back," I wrote at 9:52 P.M. "Chengdu is definitely not the worst, but it really is the most hopeless: from top to bottom completely lacking in goodwill, utterly unreasonable, without a shred of morality." At 11:22 P.M. I added, "It's not too sore—a small thing only. I experienced the stu-

pidity, shamelessness, and meanness of the police, but compared to the system, they're dwarfs." "What makes one despair," I tweeted at 11:54, "is that they reject any discussion, for they've already formed their own view on life: 'There's nothing I can do.' And so they are capable of anything."

I was far from finished with Chengdu Public Security. The next morning, I flew straight back to the lions' den, accompanied by my lawyer Liu Xiaoyuan. I had two goals. First, I wanted to file a complaint about the attack and my forced confinement in the hotel; second, I wanted to find out why one of my assistants, Liu Yanping, had not yet been released from custody. Pu Zhiqiang and Liu Yanping's husband joined us, and so did my cameraman, Zhao Zhao. Much of Zhao Zhao's footage that day would soon make its way into our documentary *Disturbing the Peace* (the Chinese title was *Laoma tihua*— Old Mama's trotters).

These days, you would never be allowed to film inside a police station in China. But until that afternoon, nobody had ever thought to film their encounters with the police, and so there was no firm policy against it. In the absence of clear directives from above—and since they could never have imagined we would be so quick to make use of the footage—they let the filming proceed.

Initially, we were advised to direct our concerns to a certain Xu Jie, section chief of the legal affairs office in the Jinniu District Public Security Bureau. On arrival at that building, there was no sign of him, and we were received instead by a woman commissar, Xu Hui, who listened to our complaints but professed ignorance of the issues we raised. She clearly wanted us out of there, and we were just as determined to stay, suspecting that if we left we would never get back in again.

Xu Hui, visibly wilting after her unsuccessful efforts at persuasion, finally passed us on to Section Chief Xu Jie. In *Disturbing the Peace,* he unwittingly plays a starring role, showcasing the mealymouthed equivocation and indifference to malfeasance characteristic of some-

one deeply invested in the system. For Section Chief Xu, our protest was nothing of consequence, and if he could pull the wool over your eyes, he would; if he could stall, he would do that, too. He didn't say a single honest word and never directly answered a question, but instead acted as though this business had nothing to do with him. He was like everyone in the government, who, no matter what their position, is betting on the whole system backing them up. They know you can't outlast them—you don't have the resources to do that. It's they who will exhaust you. When we argue and reason with them as if they are accountable to the people, we just reveal that we haven't yet cottoned on.

If you don't have the right to raise questions, you have no real freedom, and I refused to accept the idea that the state's authority can't be opposed, challenged, or interrogated. In the face of power, I would always be at a disadvantage, I knew, but I was a born contrarian, and there's no other way for me to live except by taking an oppositional stance. I wasn't at all prudent and politic that day, but I was curious to know how far this attitude could take me. And, in the end, my intervention had one positive effect: later that night, Liu Yanping was released, and we were all able to return safely to Beijing.

In Chengdu, we had filmed every moment we possibly could. To make a documentary is as natural and instinctive as opening an umbrella on a rainy day, and in Chengdu we could see that the rain was not going to let up anytime during our stay—it just kept pelting down—and so we kept our umbrella open and made a record of everything we experienced.

Sometimes friends ask me how to make a documentary. There are three cardinal rules, I tell them: start filming, keep filming, and never stop filming. So long as the camera is running, then you have footage, and there's no footage that can't be properly edited. Recording what is happening is more important than pushing any particular point of view, and that's all the more true when information is suppressed.

In this case, people were desperate to know what had happened in Chengdu. They had been frantically circulating the snippets of news

that I had been sending, and now they wanted to hear the full story. As soon as I got back to Beijing, I set about editing the material we had filmed, and within a week we were able to put *Disturbing the Peace* online, where it instantly became a sensation. Its scenes of us reprimanding the police, putting them on the defensive, and rendering them helpless left a deep impression on Chinese viewers—they had never seen anything like it before. On YouTube, the film has been viewed more than 400,000 times. Later on, we produced forty thousand DVD versions of the documentary, and friends created subtitles in English, French, German, and Japanese.

In Chengdu I had for the first time encountered physical violence— until that point the authorities had only been spying on me from a distance. In Beijing they continued to monitor me, with a dozen cameras installed around the perimeter of the studio and always a few guys keeping watch outside the gate. "If you're not going to put me in jail," I told them, "then stop bugging me." But they were just biding their time. As I became more outspoken in my resistance, their tendency toward violence had become all the more obvious, and my experience in Chengdu altered my view of the situation. I didn't want my uncompromising stance to jeopardize my family's safety, and of course I was mindful of my father's wretched life as an outcast. At the same time, I was determined to see how far I could go. Other like-minded activists had similar concerns and were taking a wait-and-see attitude. As for Tan Zuoren, he was sentenced to five years' imprisonment for inciting subversion of state power.

As it turned out, I had not escaped Chengdu unscathed. In September, as I flew to Munich to set up a large solo exhibition at the Haus der Kunst museum, the headache that had already persisted for a month since the beating became even more excruciating. On the night of my arrival in Munich, I was in so much pain I couldn't speak, let alone think properly. The next day, Chris Dercon, director of the Haus der Kunst, packed me off to the hospital right away. The initial examination at Ludwig Maximilians University Hospital identified bleeding on the surface of the brain tissue and a blood clot on the

right side of the cerebral dura mater; the right hemisphere was out of position. I was immediately admitted to the hospital for observation.

Brain surgeon Jörg-Christian Tonn, who had examined me, was at his home at eight that evening when he remembered he'd left a file in his office and went back to fetch it. While in the hospital, he examined me once more and found that my condition had rapidly deteriorated: I was falling into a coma. He decided to operate at once. Several hours later, I came out of anesthesia to find that two holes had been drilled into the right side of my skull and twenty milligrams of fluid from under the brain tissue had been drawn out—and my headache was gone.

On the night before my surgery, when my headache was at its worst, I had fantasized about floating out through the window and melting into the sky, so that I could be delivered from the unbearable pain. Now that I was recovering from this near-death experience, I returned to my art—and to the Munich show—with a sense of release. The events in Chengdu had convinced me that there was no further space for negotiation with the Chinese government. For years I had been physically and emotionally involved in the worlds of social media and political struggle, and art now offered me a safe haven, a language that was less confrontational, a comfort zone in which I could move freely.

The title of the Munich exhibition, *So Sorry,* had been suggested by Chris Dercon, alluding to the insincere apologies that come in useful when an individual—or a government—wants to gloss over some misdeed and sweep it under the rug. To fulfill the promise I had made to Yang Xiaowan's mother when visiting Sichuan, I covered the facade of the Haus der Kunst with more than nine thousand backpacks that formed a single sentence in colored Chinese characters: "She lived happily in this world for seven years." There are all kinds of tragedy in the world, but the biggest tragedy is when you ignore the lives of others. Yang Xiaowan would be remembered, just as all children who die so tragically deserve to be commemorated.

The Haus der Kunst, at the south end of Munich's largest park, was built in the mid-1930s and for a time served as a monument to the Third Reich, hailed as "the German people's gift to the Führer." During the reign of Adolf Hitler, every year it mounted a Great German Art Exhibition, designed to showcase Nazi-friendly "authentic" German art, as opposed to the "degenerate art" that was stigmatized and purged from German collections. For the Nazis, just like the Communists, art was a tool to promote an ideological agenda.

Over the years, the Haus der Kunst had not been well maintained, and the stone floor in the main gallery was cracked and stained. I photographed every one of the floor tiles and had a wool carpet woven that not only had the exact same dimensions as the floor but precisely reproduced the color and appearance of each tile, matching even the lines and creases in the original flooring, thereby evoking the layers of history, one on top of another, that underlie modern Europe. On top of this soft carpet I placed a hundred large, desiccated tree trunks, all more than a hundred years old, harvested from the mountains of southern China.

This work, *Rooted Upon*, reflected my renewed interest in the forms and shapes of the natural world and my engagement with the Chinese love of rocks, bamboo, and tree roots, an age-old tradition that conveys an inner understanding of the human relationship to the environment. Finally, on the four walls of the gallery I hung portraits of the 1,001 participants in *Fairytale*, embodying the spirit of openness and adventure that informed the cultural encounters of those Chinese visitors to Kassel.

Unlike the *According to What?* exhibition in Tokyo earlier in the year, which got only limited notice, *So Sorry*—opening shortly after my widely reported hospitalization—attracted intense interest and received overwhelmingly positive reviews. To win this kind of acclaim in Munich, a major art center in the heart of Europe, reinforced my spiritual connection with my father, whose love of art had been nourished by the museums and galleries of Paris eighty years earlier.

——

AS THE YEAR ENDED, I was beginning to mull over the possibilities offered by a new invitation, this time from the Tate Modern, in London. As part of its series of Unilever commissions, the museum asked me to make a work of art for its Turbine Hall, a huge space that is 500 feet long and 75 feet wide and rises to a height of 115 feet. To exhibit a solitary, stand-alone work is a rather daunting task, a bit like being asked to convey a whole lifetime's experience in a single word. But one idea soon caught my imagination.

During the preceding years I had developed relationships with ceramic workers in the town of Jingdezhen, in northeastern Jiangxi Province. These potters are celebrated for their long history of shaping, carving, painting, and firing ceramics; during Ming and Qing times, Jingdezhen produced ceramics for the commercial marketplace and supplied highest-quality porcelain to the imperial court. I had long been fascinated by traditional Chinese crafts that pursued representative art on a miniature scale, and as early as the 1970s I had experimented with making pottery. Together with the Jingdezhen ceramists, I had been exploring ways of creating tiny, realistic ceramic pieces that would evoke the material world around us.

Historically, in China, miniature art served a purely decorative function and was appreciated in an intimate, personal context, but in the Tate Modern commission I saw a chance to put it to work on a gigantic, conceptual scale. I wanted to try something involving a material object that had close associations with culture and history, memory and identity, a subject that would be instantly recognizable but at the same time open to a variety of interpretations.

Sunflower seeds, I decided, would fit the bill perfectly. These little seeds had always been part of the fabric of my life. In one of my early photographs, you can see a profile image of Marcel Duchamp that I made by bending a clothes hanger into the shape of a human head. The hanger lies on the table of my New York apartment, and Du-

champ's face is highlighted with the scattered husks of sunflower seeds—as a penniless artist, I had been eating a lot of them.

When I was growing up in China, we had few possessions apart from a bed, a stove, and a table. But even in our darkest days, we might well have had a little handful of sunflower seeds in our pockets. They offered spiritual comfort as well as a modest answer to our hunger, and people were always cracking seeds between their teeth.

In Mao's China, sunflowers also had a special, symbolic status as stand-ins for the people, the nominal rulers of China who, as the propaganda posters of the day constantly reminded us, owed unqualified allegiance—owed life itself—to the great leader, Mao Zedong. In countless pictures, with captions reading "Beloved Chairman Mao, we will always be faithful to you!" or "Chairman Mao Is the Reddest, Reddest Red Sun in Our Hearts," Mao, smiling smugly, dominated the center of the picture, a huge red sun rising like a halo behind his head, while below a sea of sunflowers turned their enraptured faces toward him, basking in the sunshine of his infallible thought.

By March 2010, when I submitted my proposal to the Tate Modern, the concept was clear in my mind: to fill the immense space in the Turbine Hall not with a large, imposing structure but with its opposite. Across the huge floor I would lay a bed of tiny, humble objects: sunflower seeds, one hundred million of them. All yet to be made.

River Crab Feast

A T THE BANK OF CHINA IN BEIJING, TWO AGENTS FROM STATE security were scrutinizing my account for signs of "economic fraud." One of the bank staff—a reader of my blog—alerted me to this development, and straightaway I posted the news online. Danger was edging its way steadily closer, but I continued to press forward.

One day in February 2010, when I was out buying some supplies, my assistant Xu Ye called from Caochangdi to say that several artists had come to the studio looking for me. They lived in an art district not far from Caochangdi, and when I returned, they were gathered in a circle. One artist's head was swathed in bandages, his face and hair stained with blood. The night before, they told me, scores of thugs armed with clubs and knives had descended on their district, demanding that they immediately vacate their homes; anyone who refused to comply was beaten. Local governments in China, depending so much on land sales for their revenue, frequently enforce eviction notices under cover of darkness. The artists had no choice but to evacuate, and heavy equipment was now demolishing their compound.

If you want to uphold your rights, I told them, you can't protest in a confined space. If your mother beats you, to make a fuss inside the

house is not going to get you anywhere—you need to be out in the street where the neighbors can see.

"Let's try for Chang'an Avenue," I suggested, an ambitious-sounding goal, since that is the high-profile boulevard leading to Tiananmen Square. Actually, I didn't expect that the police would let us get anywhere close, particularly since two major political meetings were due to be held, which meant security in Beijing was at its tightest. But I liked the idea of moving the issue of forced demolitions out of internet space and into the streets.

We encountered only light traffic on the road from Caochangdi to Jianguomen, east of central Beijing. Getting out of our cars on East Chang'an Avenue, we unfurled three white cloth banners on which we had written protest slogans in black ink. One of the artists pushed his injured brother-in-arms along in his wheelchair while the rest of us marched westward toward Tiananmen. I took photos all the way and posted the news on Twitter.

Chang'an Avenue, the longest and broadest boulevard in Beijing, divides the city into north and south, and it runs perfectly straight: no matter where you stand, it seems to go on forever. It was along this road that the democracy protesters had marched during the Tiananmen incident of 1989, and where the army had advanced on its blood-soaked entry into the city center in the early-morning hours of June 4.

As we pushed forward, our shouts went unnoticed by drivers and pedestrians, and strangely there was no sign of the police. Only as we got closer to Tiananmen did we start attracting a crowd, and it was then that armed and plainclothes policemen quickly appeared on the scene. They blocked our way but otherwise acted with restraint and made no arrests. Once I got home, I gave an interview to foreign media to explain the purpose of the demonstration, but I didn't rule out the possibility that the authorities would retaliate against us. A year later, when I was being questioned, I would learn that my participation in this protest was one of the reasons for my detention.

———

IN MARCH 2010, THERE were two occasions on which I spoke publicly about my resistance to government censorship. First, at the international literary festival lit.COLOGNE, I engaged in a discussion with the Romanian-born Nobel literature laureate Herta Müller. Backstage before the event, she asked me if I was nervous, noting that she always felt on edge when she was about to make a presentation. But Herta proved to be an excellent speaker, and her diminutive figure only served to emphasize the acuity of her observations. During Romania's years as a Communist state, she had been harassed by the country's security services, which were keen to groom her as an informer. But she refused to spy on others. If she were ever to do that, she told the police, she would no longer be herself. Rather, Herta devoted her life to resisting totalitarianism and to speaking and writing for the people who had died at its hand. She refused to forget the past or to compromise her principles.

Herta had a question for me: Could it be that I was overestimating the internet's power to change things? She herself doubted that it would have such a great impact: it's easy for young people to get themselves excited with internet activity, she acknowledged, and they may get the feeling they can change society in a big way, but dictators are full of arrogance and will arrest or kill whomever they want. She may well be right, I agreed: simply denouncing totalitarianism does not achieve a transformation of society as a whole; true change requires all kinds of favorable conditions. But nonetheless, I still made a case for resistance. "If in a pitch-dark room I find a single candle," I said, "I will light that candle. I have no choice." No matter how the government tried to shut me down, I would always seek to make my voice heard.

A few days later, at the Paley Center for Media in New York, I videoconferenced with Jack Dorsey, creator of Twitter, and Richard MacManus, founder of the technology blog *ReadWriteWeb*. I was interested in knowing why there was no Chinese-language edition of

Twitter, and Dorsey's answer was that this was a technical issue that would need some time to resolve. He had only recently realized that Twitter was blocked inside China. I talked about social media and digital activism in China, tweeting in Chinese, and Google's exit from the Chinese market—how even the words "Ai Weiwei" were not allowed to appear on the Web. In China, I explained, the internet was subject to stringent censorship, and YouTube, Facebook, and Twitter were all inaccessible to ordinary internet users. Copycat clones of Facebook and Twitter existed, but they served the regime's ideological agenda, and their contents were strictly controlled.

I pointed out the advantage of using Chinese characters rather than English letters when tweeting, with Chinese packing three times as much information into the same space. When I circulated a piece of news on Twitter, it would reach a substantial audience in China, for there were plenty of tech-savvy users who were adept at "jumping the wall." When Fanfou was shut down in 2009, its users had migrated to Twitter. Although Twitter, in turn, had been blocked, the censors hadn't been able to completely extinguish it, and many journalists, lawyers, and activists still used it. In early 2011, however, Twitter's Chinese user base suffered grave damage when dozens of active users were detained, placed under house arrest, or "invited to tea." Many never returned to Twitter.

For months I had been tweeting about one controversial incident after another and managing to maintain an online presence despite being such an outspoken critic of the Chinese government. In the Q&A session, I was asked whether being the son of a famous poet had helped me get attention. I answered with a joke: "If Twitter had appeared sooner, by now my reputation would be a lot greater than my father's." This might have sounded arrogant, but it reflected a truth about the attention that my tweets commanded.

At the same time, I added, I hoped that one day I wouldn't need to tweet. I had begun to feel disappointed with online activity. Tweeting, in particular, had become too easy, and once I have mastered a skill I reach a point where I feel sated and don't want to keep doing the

same thing over and over again. And in due course, I did stop tweet-ing altogether for a time.

Between my frenetic tweeting and the slow development of my offline art projects, documentary filmmaking occupied a middle ground. By now I had almost lost count of the number of documen-taries we had made; as soon as one was finished, we uploaded it to the internet. In China, where freedom of expression has never been the norm, it's no easy matter to make your work accessible to others. But I had found a way of communicating.

The films we made were nearly all about politically sensitive sub-jects, and there were no channels for distribution other than putting them on the Web or sending people DVDs; public showings were impossible. At the end of 2009 I had begun to give away physical cop-ies of my documentaries: twenty thousand copies of *Fairytale* in disc form, twenty-five thousand copies of *Disturbing the Peace,* five thou-sand copies of *Little Girl's Cheeks,* twenty thousand copies of *One Re-cluse,* and thousands more of other titles. Each disc had an attractive design, almost like a fashionable gift. In 2010 and early 2011 we made *Hua Hao Yue Yuan* (about two young activists abused by the authori-ties), *So Sorry* (a sequel to *Disturbing the Peace*), *Ordos 100* (on the in-volvement of a hundred international architects in a development project near a new city in Inner Mongolia), *The Mala Desert* (about a confrontation between a freethinking netizen and a pro-government internet troll), and *Ping'an Yueqing* (about the suspected murder of a village head).

Wang Fen and I were not living together, but we saw each other every day and would take Ai Lao, now more than a year old, on out-ings to the local park, the best place for him to play. But the air quality in Beijing was very poor, and he often came down with a cold and ran a fever, so we were continually taking him to see a doctor. When she wasn't taking care of Ai Lao, Wang Fen focused on editing the documentaries—her area of expertise, although she was less politi-cally engaged than me. Since the time of the Citizens' Investigation, Caochangdi, galvanized by our studio team, had become a center of

freedom and resistance. That said, I was never sure just how many people there were on the team, just as I didn't know how many cats were roaming around the compound.

In late April 2010, as we approached the second anniversary of the tragic Sichuan earthquake, I launched a crowdsourced commemorative activity designed to "respect life, refuse to forget." I asked netizens to record themselves reading out loud the name of one among the thousands of schoolchildren we had identified as having died, and then send to us the audio file. Some 3,444 people answered the call, often submitting multiple readings, and after completing the audio mixing of more than two thousand such recordings, I put *Remembrance* online, in tribute and in protest.

AFTER MANY MONTHS and the painstaking paintwork of sixteen hundred pairs of hands, a hundred million sunflower seeds were now ready to be shipped to London for the Tate Modern installation. The work involved in making a single ceramic sunflower seed was no less complicated than the making of other ceramics, with more than twenty steps in the production process. Surely a project can be done on such a large scale only in today's China, where it's possible to hire sixteen hundred skilled artisans to work on a project with their own hands, all at the same time. It was through their meticulous, patient

Sunflower Seeds, 2010

labor that the seeds steadily accumulated until the required volume
was reached.

For these workers, making crafts by hand was a familiar activity.
They would pick up a batch of seeds from the kiln, take them home,
and get some painting done in any free moment when their child was
playing or their parents were preparing a meal. You could see sun-
flower seeds piled high under the eaves of house after house in Jing-
dezhen.

This process reminded me of something that happened once in
New York in the 1980s, when I made a surrealist object. I took a pair
of shoes, cut them both crosswise into two pieces, discarded the
heels, and then sewed the two vamps together. I felt that a fresh coat
of polish would add the finishing touch, so I strolled down the street
to the neighborhood cobbler and handed my customized shoe to the
elderly Pole behind the counter. As he studied my creation, his face
darkened. He turned and called his wife, who had been working in
the small room behind. Together they peered at my unwearable foot-
wear. "We don't have any black polish," he said.

"That's okay," I said. "Brown will work just as well."

Now he looked all the grimmer. "The buffer's broken."

They were offended, I realized. Their life's work was not some-
thing to be trifled with, and they didn't care for this weird shoe of
mine. When you are the master of a craft, you have a firm bond with
society—something I sorely lacked at the time. I carried this knowl-
edge with me in creating the sunflower project.

One Man Shoe, 1987

Each seed was an independent entity, but there was no significant
difference between one seed and the next, and when a certain num-

ber of sunflower seeds were gathered together, they became something else. You could see each seed, but at the same time you couldn't, for each was drowned in an enormous flood of countless similar seeds. If you wanted something to express my understanding of China—and something that every Chinese person knows—that thing has to be the sunflower seed.

Sunflower seeds now floated like an ocean in the Turbine Hall at the Tate Modern. On the day that the exhibition opened, Ai Lao, now eighteen months old, teetered over to me and said one word: *"Pò"* (broke). A broken seed lay in the palm of his little hand. This was his first trip abroad, and I was looking forward to taking him to even more far-off places in the future, places that I myself had never been.

Here in London, my hope was that when people walked on the seeds it would be as though they were walking on water, feeling the traction and friction under their feet. Sure enough, in the first few days of the exhibition, Londoners crunched their way across the carpet of seeds with great enthusiasm.

The sad thing was that tests indicated an excess of silica in the dust thrown up when people walked on the seeds, and concern about the effects of repeated inhalation meant that the floor of the hall had to be closed to visitors. At first, this news was no less shocking to me than the collapse of that pavilion in the thunderstorm in Kassel a couple of years earlier. But I never see my art as being in a fixed condition but rather in a state of flux, always operating within the constraints imposed by reality. Although the decision to close off access to the seeds represented a major change, the basic conceptual elements of the installation were untouched. If anything, I came to feel that the ban on walking on the seeds made the concept even stronger. And in the few days when visitors were free to walk on the sunflower seeds, there must have been close to a million seeds that disappeared into pockets or purses, and if the installation had stayed accessible for the whole duration of the show, there might not have been many left at all by the end.

Regarding this huge expanse of sunflower seeds, visitors to the

Tate wondered, "Where do they all come from? Why so many? Who made them?" The show elicited positive reviews, even in quarters where I had received only faint praise in the past. The Chinese critic Fu Xiaodong described the exhibition as "an emblematic event in the art world, one that nobody can ignore." As he put it, "With one hundred million handmade sunflower seeds, Ai Weiwei has, in the most patient and extreme way possible, asserted the independence of each individual. Just as every one of these seeds is different, complete in itself, every life is valuable: none deserves to be drowned in the swirling red dust of worldly strivings."

The museum set up a video feed in the exhibition gallery, enabling visitors to ask me questions so that after I got back to Beijing I could respond to them online. A number of people told me they thought of the sunflower seeds as "seeds of freedom" and asked if they could have one to keep; one correspondent said he fantasized that someday the seed in his hand would give off light in the darkness, and that would be the moment that freedom would come. In the following two years, we mailed off more than forty thousand seeds to my supporters.

The *Sunflower Seeds* installation marked the end of a period when I might have been accused of having "no proper job." Now I significantly reduced my online activities and unfurled my sails on a navigational course toward unknown parts—knowing I might encounter all kinds of adverse weather.

AS MY REPUTATION GREW around the world, in China the screws were being tightened even further. On Christmas Day 2009, a Beijing court sentenced the writer and activist Liu Xiaobo to an eleven-year prison term on charges of "inciting subversion of state power." When Liu was awarded the Nobel Peace Prize in October 2010, the Chinese government protested vehemently, claiming it was a travesty to give the Peace Prize to a criminal. In an effort to stop Liu's family and friends from attending the award ceremony in Oslo, public security

assembled a list of a hundred Chinese citizens prohibited from leaving the country.

On December 2, I was due to fly from Beijing to Seoul, on the first leg of my journey to the Gwangju Biennale, for which I was a curator. I had made it through passport control and was at the boarding gate when a female police officer approached me. "Are you Mr. Ai?" she asked. There had been a computer malfunction when I was in the immigration line, she said—could she have a look at my passport?

I had to laugh. "You're not letting me leave the country, are you?"

She showed me a handwritten note that read, "Since your departure may pose a threat to national security, to fulfill its legal duty Beijing Public Security Bureau prohibits your departure." She would not let me keep the note, nor would she say how long the prohibition would last. All I could do was register my disgust online. "When a state restricts a citizen's movements," I wrote, "this means it has become a prison . . . Never love a person or a country that you don't have the freedom to leave."

At this time, I had just completed the building of a new studio near the village of Malu in rural Jiading, northwest of Shanghai—a red brick building at the end of a quiet road bordered by vineyards. I had designed this studio at the invitation of a local official to complement other new projects in the vicinity that were planned or under construction: the studio of my artist friend Ding Yi, a museum designed by Tadao Ando, and a contemporary art gallery to be founded by an Indonesian collector. Before long, it was expected, the vineyards would give way to an art colony.

The exterior of my studio was a traditional courtyard house, with water on three sides and a road on the fourth, where the entrance was. Hugging the outer wall was a path laid with gray square pavers that extended into the inner courtyard. The residence was on the south side, with the gallery to the east, the studio to the west, and a guest room to the north, each unit independent but connected by the inner courtyard.

The project took two full years to execute, and more than any-

thing I took it on because the space would allow me the freedom to invest my energies in creative art. I had no fixed plan for how much time I would spend in the studio or what I would use it for—what was vital to me was the simple yet exacting task of designing and building the structure, of constructing a studio that pleased both eye and mind.

In October 2010, we were just about to move in when my assistant Lü Hengzhong received notice that the building was slated for demolition, on the grounds that our land use and construction activities violated local codes. I was no stranger to the Chinese government's arbitrary ways, but I was still taken aback that a huge city like Shanghai would reverse itself like this, especially when the much vaunted 2010 Shanghai Expo was still in full swing. The official who had invited me to build the studio said he could do nothing to stop it. Because of "political factors," he said, the "high-level leadership" would not let me come to Shanghai. His hands were tied. "Lao Ai," he told me, "you must know how much of a thorn in their side you are politically."

But my so-called thorniness stemmed simply from my concern for disempowered Chinese.

My Twitter followers were keen to see this new studio that was now about to vanish; within a few days, more than a thousand people asked to visit. It happened to be the season when mitten crabs, a Shanghai delicacy, were coming onto the market, so I proposed that we hold a "River Crab Feast" to give the studio a formal send-off. In Chinese, the two characters for "river crab" sound just the same as the characters that mean "harmony," an overriding political objective of the current government. So the event would be my way of registering a protest against the infringement of individual rights that is central to the authorities' notion of "harmony."

Soon after I tweeted the invitation from my home in Caochangdi, several plainclothes policemen came out to see me: the authorities had let it be known that they did not want me to go to Shanghai for the dinner.

"But the guests have all been invited," I objected. "How can the host not appear?"

He Xie, 2010

"Just tell them you're under house arrest," the police said.

"I'm not going to do that," I said. "Not unless you really and truly put me under house arrest."

The following morning, as I was about to leave for the airport, a dozen policemen arrived at the studio in Caochangdi and announced that, yes, they were now putting me under house arrest. "Please don't attempt to go to Shanghai," one of them said. "Prior to midnight on the seventh, you are not to leave this house. Thank you for your co-operation."

The choice of words was wrong, I remarked. "It's not that I'm cooperating—it's that you're compelling me."

Within days, state security agents sought out thirty-two sympathizers who planned to attend the River Crab Feast. A Shanghai-based Twitter user posted, "Just now the old lady from the neighborhood committee came to see me and told me not to attend the River Crab gathering on Sunday. I wonder how was she able to track me down? All I had said on Twitter was: 'I'm in Shanghai.'"

One student talked about his experience "drinking tea": "When I sent a text message signing up for the feast, this caught their attention, and state security agents came to my school; I was called in by the politics teacher. He told me not to mention Liu Xiaobo's Nobel Peace Prize. 'Study hard, so you can get a good job in the future—don't get involved in other activities.' He pressed me particularly on

where I got my news and whether I had contacts with other people. He closed with an injunction to write an account of my doings and ordered me to stay on campus for the next several days."

While I was a prisoner in my own home, eight hundred other people managed to attend the River Crab Feast, hosted by my assistants. There they consumed some three thousand crabs, played guitar, sang, and chatted—all the while posting their photos and videos online, in celebration of these little acts of defiance.

Two months later, early on the morning of January 11, 2011, Lü Hengzhong got a call from a Malu villager saying that a number of construction vehicles had arrived outside the new studio, and a backhoe had already knocked a gaping hole in the southwest wall. The official in charge confirmed that they planned to demolish the whole place in the course of that day.

Since the travel restrictions placed on me were no longer in effect, I got on a plane to Shanghai, and by late that afternoon I had arrived in Malu. Under the setting sun, four wrecking machines were still waving their huge arms, and all that was left of my studio was a section of wall in the northeast corner. Some workers were stripping rebar from the shattered concrete, while others loaded broken bricks and concrete into trucks for carting off. It was all very methodical. They wanted to clear away the ruins as soon as possible, leaving no trace of what had once been. In the pictures we took a week later, all you could see was a barren plot of land. It looked as though it might have been recently plowed but otherwise showed no sign of human activity. A line of duck tracks stretched across the snow-coated ground.

How to describe the loss I felt then? If we think of art in terms of a finished product, then this was a moment when I saw the calculated destruction of my work. But I think of art as a beginning: it is when we push ahead, regardless of the consequences, that we give meaning to our lives. The demolition of my studio accurately summed up my predicament at this point in time: even if I put all my effort into a project, it might well end up getting nowhere.

At the time, David Cameron, the British prime minister, was visiting Beijing, which prompted me to write a piece for *The Guardian* calling on Cameron to continue to pressure China on human rights, asking him not to abandon core values for some short-term advantage. There is no country in the world that can prosper if it does not allow a diversity of opinion, and China, I argued, did not yet count as a civilized country. In its business deals with China, the West always avoids issues of freedom of speech and citizens' rights—one of the most glaring moral failures of our time. The West has an obligation to reaffirm human rights, for otherwise its conduct is tantamount to a neocolonialist exploitation of developing nations.

ON THE OTHER SIDE of the world on December 17, 2010, in Sidi Bouzid, northern Tunisia, a twenty-six-year-old street vendor set himself on fire to protest the mistreatment he had suffered at the hands of the police. This led to demonstrations demanding the ouster of President Zine el-Abidine Ben Ali, which soon evolved into sustained rioting. Dubbed the "Jasmine Revolution," it was the first time that a regime in the Arab world had been overthrown because of popular resistance. The events in Tunis evoked a chain reaction, and crowds took to the streets in many North African and Middle Eastern countries to protest dictatorship and corruption and demand democracy and reform, in what would come to be known as the Arab Spring.

People had another name for this sudden and dramatic upheaval: the "Twitter Revolution," because the use of social media networks and digital technology enabled the rapid spread of information and weakened governments' power to control things. "Insurrection" and "revolution" became buzzwords of the day.

At four o'clock on the afternoon of February 17, 2011, a Chinese Twitter user with the handle @mimitreeo (*mimi* meaning "secret" in Chinese) posted an announcement of an upcoming "Chinese Jasmine Revolution Rally." After that, word spread online of the location of

simultaneous "Jasmine Revolution" rallies in China's major cities at
2 P.M. on February 20. The initiators called themselves "the instigators
of China's Jasmine Revolution," obscuring their true identities.

No sooner had the news begun to spread than the characters for
"jasmine" were blocked on the internet in China, and even the char-
acter for "flower" became a sensitive word. On Chinese-language
websites it was impossible to input sentences that included the words
"tomorrow" or "today." Florists were not allowed to sell jasmine blos-
soms, and one young Beijinger was arrested for displaying a bouquet
of white flowers on the downtown shopping street of Wangfujing.

February 20 fell on a weekend, and the uniformed and plainclothes
police who descended on Wangfujing vastly outnumbered the people
who had come to attend the scheduled rally. There were not many
protesters at all; those who did show up were mostly college students.
Arrests began just as the U.S. ambassador, Jon Huntsman Jr., appeared
on the scene, wearing sunglasses, with the Stars and Stripes promi-
nently displayed on the left sleeve of his jacket. Asked why he was
there, he said with a smile, "I've just come to have a look."

I followed with rapt attention the progress of the Arab Spring in
Tunisia, Egypt, and Iran. But resistance to authority didn't just stop at
online discussion, and the clamor in streets and squares eventually
gave way to bloodletting and arrests. The promise of internet activ-
ism ended up building a trap from which there was no escape. Like a
tsunami, it swept away deadwood and for a time was unstoppable,
but when the wave subsided, the rocks and cliffs remained just as
powerful as before. The thrilling online revolution led to a fragmen-
tation of society, with long-lasting repercussions and a collapse into
resentment, conflict, and despair—such was the pattern wherever the
unrest had surged.

WITHIN THE COURTYARD OF 258 Caochangdi, things were calm. At
the far end of the gray brick pathway stood my gray brick house,

with its straight lines, right angles, and block surfaces, the white door open a crack to let the cats wander in and out, while magpies hopped around on the branches of the willow trees. Outside, on the opposite side of the street, the white sedan parked there might have seemed quite unexceptional, except that this one was stationed there permanently, day and night, with somebody sitting in the front seat, jotting things down in his notebook.

One day, as I approached the car, I noticed that the young plainclothesman had fallen asleep in the driver's seat. The window had been partly rolled down, so I reached out a hand to extract the brown-cover notebook that was lying on his lap. By the time the young man woke up, rubbing his eyes and squinting at me in confusion as the warm sunshine beat down, the book was safely in my possession.

In it were recorded, in squiggly, uneven lines, the precise days and times of my departures and returns, along with the license plate number of every car that visited my studio. I thought of my father, and began to understand what protracted suffering he must have endured, for in a Communist system, to be constantly under observation is the normal state of existence. To someone with an independent streak, this incessant surveillance means that life itself is like a term of penal servitude. In my case, as time went on, the intrusions afflicted me with a nameless exhaustion, as though some unidentifiable foreign body had been planted inside me, controlling my judgments of myself and the people around me. I didn't know when this shadowy presence might flex its muscles or whether it would ever go away. I felt as though I were climbing a steep cliff and needed to keep a tight grip every second, so I would not slip from that lofty and exposed height.

In January my Shanghai studio had been demolished, and in February more than a hundred people were detained for political reasons, including scholars, lawyers, and university students. The government was alarmed by so many people's thirst for change. To reduce the pressure, I set about establishing a studio in Berlin. But I had no plans to move abroad for good—in my mind, China's alien regime was the one that needed to get up and leave.

Eighty-one Days

AMONG THE CATS IN THE CAOCHANGDI COMPOUND WERE a long-haired one we called Tiantian and a short-haired one we called Daidai. One day, Tiantian figured out how to open the door, crouching down on the floor, then leaping up onto the handle and clinging tightly as the door swung open. Daidai, observing this feat, took the chance to slip out, too.

Around this same time, a dozen or so police came to the studio to check people's residence permits on three separate occasions, including once at night, on the pretext of inspecting fire safety. The village official who had once urged me to "be bolder" had a quiet word with a friend of mine, saying, "Better give Ai Weiwei a heads-up: he's in a lot of trouble now. Tell him to stop doing all that stuff that makes foreigners happy but hurts the feelings of the Chinese people." Soon after that, a car pulled up next to Zhao Zhao. The driver rolled down his window and told him there were now eighteen people stationed in the village to shadow me.

I was conscious of the threat, of course, because I lived with it every day. My defense of my basic rights, my mood, my sense of self, and my worldview—all were shaped by the awareness of that threat.

Whether it was a matter of eighteen or eighteen hundred people watching me, this didn't stop me from doing what I had to do.

On the morning of April 3, 2011, the compound was as quiet as ever. Xiao Pang, my driver, took my black travel bag and put it in the trunk of the car. We were leaving for the airport, which was twenty minutes away. I was booked on a flight to Taipei, with a stopover in Hong Kong. My solo exhibition at the Taipei Fine Arts Museum was due to open that autumn.

In my bag I had packed six T-shirts, six pairs of underwear, six pairs of socks, a laptop, and a camera. Since the birth of Ai Lao, Wang Fen and I had been spending the days together, and in the evenings I would go back to Caochangdi. Lu Qing and I were both living there, but without conflict, leading separate lives with different agendas. Normally, Lu Qing would prepare a ten-day supply of medications for my high blood pressure and diabetes, but on this occasion—I'm not quite sure why—she had packed two months' worth of medications into a plastic bag, along with the directions for taking them. Although we were no longer close, she walked me to the gate as usual.

Sitting in the back seat of the car was my new assistant, Jennifer Ng, a young Canadian I had come to know several months earlier on Twitter, and this was to be her first trip abroad with me. At around eight that morning, we checked in and proceeded toward immigration, passports and boarding passes in hand. The departure hall was fairly empty; we each picked a line and waited. Jennifer was seen first. The officer picked up his phone and placed a call as he studied her passport, and soon another policeman walked over and took her aside. Something was up.

It was now my turn. The officer opened my passport, then raised his head and looked at me intently. I knew right away what was going to happen next. Other policemen, scattered around the hall, were beginning to move toward me, and an inspector ushered me over to a room on the left. "Why are you doing this?" I asked. I was deemed a

risk to national security, the man told me. By now Jennifer was no-where in sight.

Several state security officers and I were packed into a small room. "Let's find a place to chat," the most senior one said to me, and he asked me to hand over my mobile phone. I responded by taking the battery out of my Nokia. An elevator took us down to the first floor and we walked toward a white van parked on the opposite side of the road. I recognized a man who had visited the studio a couple of days earlier, on the pretext of conducting a census. "Lao Ai, sorry about this," he said as he opened the door.

I sat down in the back with a plainclothes cop on each side. The senior man, in the front seat, turned around and pulled out a black hood stamped with the word SUSPECT, which he told me to put over my head. It was made of a material so thick it didn't let air in. When I complained, he took it back and tried to poke a few holes in it with a key. He got nowhere with the heavy fabric and handed it back, say-ing, "You'll just have to get used to it." After that, with the hood on, I couldn't see anything at all.

THE FULL NAME FOR state security is Domestic Security Protection; its operations are veiled in secrecy. Because "state security" (*guóbǎo*, 国保) in Chinese sounds just the same as "national treasure" (国宝), online you'll see its agents referred to as "pandas." State security's

Panda to Panda, 2015

targets include political dissidents, nongovernmental organizations, and human rights activists.

The agents sitting on either side of me gripped my arms as we drove along. Where were we going? And then what would happen? I had no idea. All I could do was try to relax and breathe normally. But soon I felt stifled, and sweat trickled down my face. While I had anticipated that something like this was bound to happen sooner or later, now that it was happening, it seemed unreal. Kidnapping scenes in movies came to mind, and it was as though I were observing an incident involving someone else.

I had a sense that the car was traveling north, which made me wonder if we were heading for Qincheng Prison, in the far north suburbs of Beijing, famous for housing political prisoners. Just three days earlier, I had been up in that area picking strawberries with Wang Fen and Ai Lao and had pointed out the prison, looming behind a row of poplar trees. *It's good if they know where that place is,* I had thought to myself.

I tried to take note of every turn the car made, but the effort made me sleepy. Well over an hour had passed by the time the car slowed down noticeably and, after going through several checkpoints, came to a halt. The agents silently pulled me out of the car and we went indoors, where they led me up a curved staircase. It was too narrow for us to ascend shoulder to shoulder, so one led the way and we went up the stairs sideways. Halfway up, they changed their minds and we returned to the first floor. I felt carpet under my feet as we entered a room, and they had me sit down in a round-backed wooden armchair.

After forty minutes or so of complete silence, I was told to stand up, and my hood was lifted off. Facing me was a tall, muscular figure, the kind of character you would expect in this kind of scene in a movie. I sensed that he was relishing the occasion. A shorter man patted me down and took away my belt, phone, and wallet, then handcuffed my right hand to the arm of the chair. The handcuff was heavy, and cold as ice.

A young man in a Nike tracksuit—he looked a bit like an athlete—
was sitting in a chair three feet from me, and he watched me unblink-
ingly, his hands flat on his thighs. Fresh-faced, through his narrow,
hooded eyes he gazed at me blankly. This expressionless gaze was one
I would encounter often in the days ahead, like the stare of a stone
effigy.

Looking down, I noticed that much of the paint on the arms of
my chair had worn away from the friction of handcuffs. To my right
I saw marks indicating that two twin beds had once stood there and a
picture had once hung on the wall, while to the left there was a closet
and a bathroom. Through the cracks between the window blinds I
could make out an electrified fence and surveillance cameras on the
slope outside.

After dinner, two men came in; they looked to be around forty
years old. The older of the two, dressed in a well-cut beige jacket,
greeted me civilly enough. He said that he and his partner, who would
take notes on our conversation, were from the interrogation team of
the criminal investigation section of Beijing Public Security. He casu-
ally tossed a file onto the table and sat down.

"I gather you're a celebrity," he said. "Excuse me for not knowing
about you sooner. Before coming in I made a point of going online
and reading up about you."

I listened carefully, trying to figure things out: I lived here in Bei-
jing and could have been arrested anytime, so why wait till I was at
the airport to take me into custody? It seemed the order had come
down so suddenly that he'd had no time to prepare.

He said that the sanction they were imposing was "residential sur-
veillance," one of four coercive measures specified in criminal law,
the other three being interrogation, detention, and arrest.

I wanted to call my family and engage a lawyer, but he told me
these things were impossible. This came as no surprise, because what
one would take for granted outside had here become absurd. The full
name for my form of detention was "residential surveillance at a des-
ignated location." This allowed the authorities to hold me for up to

six months in a facility outside the regular prison system and not subject to any formal constraints. It was a measure harsher than formal arrest, since I was denied legal representation and visitation rights.

In other words, I had been kidnapped by the state, which was flouting its own rules in wrenching me away from my home and placing me in complete isolation. I felt like a miner trapped by an underground collapse, where people aboveground don't know if there's anybody alive beneath the rubble and the man below doesn't know whether a rescue effort has begun or whether it has already been abandoned. But I drew comfort from the knowledge that my father had been imprisoned eighty years earlier: being accused of much the same crimes as he was would only serve to raise my spirits.

The pretrial investigator was puffing on one cigarette after another, and the wreaths of smoke he was blowing my way seemed to widen the gulf between us.

"You're going to asphyxiate me," I told him.

"You are free to not smoke," he responded. "But," he went on, slowly and with emphasis, "I am equally free to smoke. When I'm working, I have to smoke."

He wasn't enjoying this, I could see. He asked me my name, age, and address. In this small room, his voice was loud, as though he were reciting lines on a theater stage.

"Surely you couldn't have me brought here," I said, "without knowing who I am."

This stung him. He needed to confirm my identity, he said. "It's not unknown for the wrong person to be booked." He tried to sound reasonable. Then he asked for details about my family.

I asked him a question instead: "What's your name?"

He hesitated. I didn't need to know it, he said, for he was simply a representative of the state's authority. But he did mention that he shared the name of a famous engineer in Chinese history, one who had designed an arched stone bridge fifteen hundred years ago, a man with a flawless grasp of proportion and mechanics. He went on to say, with a touch of pride, that the only difference between their

names was that his personal name was written with four more brush-strokes. From these clues I was able to deduce that his name was Li Chun. Investigator Li, I soon learned, was fond of displaying his knowledge of history, and his cultural literacy gave me a faint sense that we shared some common ground.

When asked my profession, I answered, "Artist."

"Artist?" he said. "What makes you so sure you can call yourself that? Is it because anybody can think of himself as an '-ist' in some-thing or other?" He added, derisively, "At most you can call yourself an 'art worker.'"

I did not object, although these days nobody calls himself an art worker—it must have been decades since that label was used in China.

Over the next several hours we sparred back and forth, me trying to pin him down on exactly why I was in custody, him cycling through indictments as though trying them on for size. I was suspected of economic crimes and art fraud, he said: "Your works cost next to nothing to make, but their asking prices are astronomical." "You're always cursing the Communist Party." "You're a tax dodger and a con man."

At one point during the questioning, a tall man who said he was the division chief entered the room and looked at me with satisfac-tion, like a hunter who has finally captured his prey. "You've been doing one thing under cover of another," he said, adding that their investigators abroad deserved a lot of credit.

As he left, he said I would be allowed to sleep that night, and later the guards dragged out a mattress and set it in the corner of the room. The handcuffs were unlocked and I was finally able to lie down, while the guards began to play with their phones. I tried to avoid thinking about my family, and in particular Ai Lao, who had just turned two and was becoming ever more delightful company, with a big square head full of ideas. The night I left, Ai Lao had toddled out into the hallway and reached up to press the elevator button for me. Just so long as I could manage not to think of things like this, I was confident I wouldn't buckle.

In the days that followed, I needed to be on my toes as Investigator Li continued his questioning. Before we got going, I would sometimes ask myself whether I should refuse to cooperate and simply say nothing, or persist with my standard procedure: speaking my mind and holding nothing back, even if that led to some fruitless exchanges. I opted for the latter, out of curiosity about where it would all lead.

The following day, Investigator Li raised the possibility that I might be charged with inciting the subversion of state power. Three people in Beijing had already been charged with the crime, he told me: Liu Xiaobo, Hu Jia, and Gao Zhisheng. Liu Xiaobo, at the time, was two years into his eleven-year prison term. (In 2017, having contracted liver cancer in prison, Liu would die at the age of sixty-one.) Hu Jia, long a social activist, was serving a three-and-a-half-year prison term, while Gao Zhisheng, a human rights lawyer, was serving a three-year term. All three were classic political prisoners, and now he was saying that I could be the fourth.

This is the scenario he predicted for me: I would stay in the current location for six months, and if charged I would then be transferred to a detention center as my case was reviewed. If the prosecutors wanted more information, I would be sent back to answer further inquiries. That could be done three times, for up to ninety days each time. The whole process might take up to a year or so, and then judicial procedures would kick in: arrest, sentence, prison.

On the fourth day—April 7—at my insistence, Investigator Li showed me the residential surveillance notification issued by Chaoyang District Public Security. The "designated location" was given as 44 Reservoir Road.

"Where's this?" I asked.

"How many reservoirs are there in Beijing?" the investigator responded brusquely.

Unintentionally he had let a secret slip, and now it gave me a clear sense of my whereabouts. I realized it had to be Miyun Reservoir, nestled attractively among the mountains northeast of Beijing.

———

EVERY DAY, THE QUESTIONING began at ten in the morning and fol-
lowed this pattern: the investigator asked, I answered, the scribe re-
corded. After a week, Investigator Li told me this case made him feel
like he had a thorn in his back, or a bone in his throat. He said he
hoped to wrap up the case quickly and aimed to find a way for me to
avoid jail time. This made little sense to me; surely it would not be
that simple.

During the interrogation, he said, he had to be stern. But no mat-
ter how relentless he was in his questioning, if I didn't know some-
thing, I should say I didn't know, and if I couldn't remember
something, I should say I didn't remember, and if I didn't want to say,
I could just not say. He must have seen that I was getting worked up,
and so he felt a need to tell me these things. I began to wonder: *He
couldn't be on my side, could he?*

"Ai Weiwei, do you realize the situation you're in?" he asked, with
seeming concern. "Do you remember the Xi'an Incident?" Talking
about history visibly cheered him. He was referring to the episode in
1936 when Chiang Kai-shek was pressed by two of his generals to
team up with the Communists to resist Japan. Later, Song Meiling,
Chiang's wife, and the Soviet Communists brokered a settlement,
and Chiang Kai-shek signed the six-point agreement the generals had
proposed, thereby winning back his freedom.

"Ai Weiwei, do you understand?" he asked. "You're in the same
predicament that Chiang was in then. You have been cursing the
Communist Party, and that's enough to get you a lengthy prison sen-
tence. You need to admit your guilt in order to win lenient treatment;
if you don't, you stand no chance. Should you lose, there is no wiggle
room—you've lost everything. In 1936, Chiang Kai-shek hated having
to sign that agreement: after trying to exterminate the Communists,
how could he team up with them to fight Japan? But he was a tough
character—he bit the bullet and signed the six-point agreement, oth-
erwise he would have been a goner.

"You're in the same situation," he said. "If you don't admit you're in the wrong, you're playing with fire."

He was contradicting his earlier advice, and I didn't understand why he was saying all this. An investigator should be sorting out the facts and not drawing conclusions. But he seemed intent on leveling all kinds of charges against me, putting me under such pressure that I would be forced to admit guilt. I continued to answer all his questions. If he really wanted to understand who I was and what I was thinking, I was perfectly ready to tell him.

His wife was several months pregnant, he said, but he was too busy to go home and see how she was doing, much as he would have liked to. According to him, his greatest wish was to be with his family. I found it rather depressing that he rarely spent time with his wife and never went online. He was on call twenty-four hours a day—and he had to pay his own phone bill.

Each day, I was wakened by a shout, and each day Li continued his inquisition into my life. We both had jobs to do.

On this day, Li went on to accuse me of bigamy.

I laid things out as clearly as I could, saying that Lu Qing and I had gotten married in New York, informing no one—neither friends nor family, needing neither permission nor blessings for a matter that was ours alone. That day, Lu Qing and I had been walking the streets near the World Trade Center in downtown Manhattan, and she said she wanted to go up to the top of the Twin Towers. I had lived not far away for a full ten years but had never had the slightest inclination to do that. From the observation deck on the North Tower we could see the jagged skyline of the Midtown high-rises, evoking so powerfully the frenzy of capital and the smallness of the individual.

It was then that Lu Qing had raised the issue of marriage: if we were not going to marry, she would opt to stay in America rather than return to Beijing. By then we had been together for more than a year, and Lu Qing was a purehearted, endearing companion. I could not justify continuing to stay uncommitted, so I agreed to her suggestion. We registered our marriage at City Hall, with an old friend act-

ing as witness. That evening we went to Atlantic City and spent the night at the blackjack table in the Trump Taj Mahal. But Lu Qing and I had never registered our marriage in Beijing, I told the investigator, so divorce was not an option.

Although Wang Fen and I did not live together, we made no secret of our relationship, I noted: on Ai Lao's birth certificate, I was recorded as his father and Wang Fen as his mother.

"For all intents and purposes this is a marriage," the investigator said, "and it constitutes the crime of bigamy. In China you have to respect Chinese law."

"If this breaks the law," I said, "then there are countless lawbreakers."

"That's true," he countered, "but those other people don't curse the government, they don't make a ruckus like you do. You're constantly stirring up trouble, so high and mighty, so full of yourself. And you have all those followers." He made no effort to conceal how selectively they were applying legal sanctions.

"Supposing I did break the law," I said, "then of course I would admit it. But at least you ought to let me see an attorney and familiarize myself with the law."

Again the investigator refused to listen to my arguments. To him, there was no point in talking about law, because law was his specialty, not mine. And anyway, he was just a cog in the machine of state. He asked what I was planning to say in my statement in court.

I thought for a moment. "I am standing here to defend human dignity, and I will continue on that path with dignity."

He smirked at the stiffness of this declaration. "This is what you should say: 'I admit my guilt and submit to punishment.'"

Now he tried a different tactic, turning instead to purported tax evasion and disrupting the economic order. But if taxes were a concern, then all they had to do was audit our accounts. Even if the charge could be made to stick, I argued, I would simply be asked to pay the arrears and any penalties, without being held criminally responsible.

Later I would learn that financial issues were not what had prompted my detention at all. After I was disappeared, the police raided my studio and confiscated computers and disks, leaving the company's account books untouched.

The other accusation, that I had disrupted the economic order, was equally dubious, involving payments made to foreign architects who had come to China to do design work. According to the investigator, these payments constituted illegal trading in foreign currency and thus disrupted the economic order. If he was to be believed, it meant I'd been intercepted at the airport because of a foreign exchange transaction. This sounded altogether too far-fetched.

Given my unwillingness to own up to tax and currency misdeeds, the investigator turned to my art projects instead. Where did my money come from? Were "anti-China forces" purchasing my work, in order to fund my activities and support my agenda?

"If anti-China forces do exist," I said, "I'm sure they have no money—and certainly no money to buy artworks."

Facing a suspect who had nothing to hide, who was ready to discuss any topic, he found my answers frustrating. He would, perhaps, have preferred to be dealing with a thief or a swindler or a murderer, where things would be simpler; my mind seemed to work differently from that of a crook.

Eventually, like a punctured balloon, he softened. He was no longer belligerent and overbearing, and we maintained an unchanging distance, like parallel tracks going around a bend. But not before circling back to my art projects once more. "What were you trying to accomplish by taking so many people to Germany?" he asked, referring to *Fairytale*.

"My goal was to take them there and then bring them back again," I replied. But such a seemingly nonsensical answer left him dissatisfied. If I couldn't give a good explanation, it must mean it was all part of some nefarious scheme that I was desperate to conceal. To relieve his fears, I elaborated on what art is and why I did what I did, how I simply helped some people get visas and plane tickets and resolved

their daily needs when in Kassel. My art cannot be fully explained in words, I told him, for the works are always developing—just like my interrogation, they didn't necessarily lead to a sudden revelation. All art is a conspiracy of some kind, I said. I continued in that vein for quite some time, until he signaled me to be quiet.

"So weird!" the investigator said. "How come you can talk at such great length when art is the topic, and you get so excited that you can't stop? If we talk about other things, you can never give a clear account of yourself, or you don't remember, or you've forgotten. Can it really be that there's nothing worth remembering apart from stuff connected to art?"

He had another question, which he posed rather cautiously. "Someone online says that every sunflower seed represents a child who died in the Sichuan earthquake. Is that true?"

Up to a point, there was some truth in that, for *Sunflower Seeds* drew inspiration from that tragic event. But it's tiresome to have to explain a work of art in any kind of detail, so I answered him offhandedly: "That's absurd." My "absurd" later made it onto the interrogation transcript, but the next thing I said to him was omitted: "There were 5,335 schoolchildren who died in the earthquake, but the sunflower seeds numbered 102.5 million." (I know this because at the end of each interrogation session, the scribe would ask me to confirm that the transcript was accurate by affixing my signature and fingerprint on the last page.)

Li's art critique grew more pointed when he accused me of "spreading pornography." This charge seemed ridiculous, and I wasn't sure if it was a diversionary tactic or a reflection of his personal interest. In the summer of 2010, a sex worker who had defended the rights of AIDS patients came to visit me at the Caochangdi studio. That day, three other female visitors happened to be present, and when I proposed taking a picture of us all naked, they blithely took off their clothes. We posted the photo online, and it caused quite a stir.

That photograph was free of any unsavory content, I told the investigator: we did not know one another, nobody touched anybody

else, and there was no sexual motive. But he got quite agitated. "How come you don't take a picture of you and your mother naked and post *it* online?" he demanded. And indeed, if my mother had seen this picture, she certainly would have considered it in very poor taste. But that was the whole point of the exercise: to be vulgar and offensive, just like my middle-finger photographs, or the shot of Lu Qing lifting her skirt. And everybody willingly participated. But in his view, it would have been appropriate for me to receive up to a five-year sentence for this offense, even if what we did had nothing to do with pornography.

The next day, the investigator told me he'd watched my documentary *One Recluse* online the previous evening, and now he really lost it. "Yang Jia was a lunatic, an absolute lunatic!" he yelled, repeating this several times for good measure. "Those six policemen were innocent, but he murdered them all so brutally, and now their families are living in misery." He spoke with such vehemence and at such a volume that it seemed he wasn't addressing me as much as everyone in the building. I agreed with him, but only up to a point: Yang Jia may very well have been insane, but there is no way of knowing that, for it was the justice system that refused to conduct a psychological examination; it was they who refused to bring things out into the open.

"You criticize the government," he said, "and your attacks make the country look bad. Look at this desk here. It's a fine desk, with a level surface and four strong legs. But you seize on some little point and won't let it go, constantly insisting that there's a problem with it. This causes confusion in public opinion and makes people think there really is something wrong."

The desk in question was a cheap office desk, and on one side it was wreathed with cobwebs and covered with a layer of dust. I pointed this out to him, and he leaned over to take a look. "Oh, it *is* dirty. It needs a wipe," he had to admit.

The interrogation was like a car that veers off the road and charges wildly over desolate fields and wild hillsides, far from the intended

route, before clawing its way back to the main road. Now, after many twists and turns, the questioning turned to the pro-democracy protests known as the Chinese Jasmine Revolution, which was what ultimately concerned them the most. This issue would decide whether they could successfully pin the crime of inciting the subversion of state power on me. In the months preceding my incarceration, the authorities had taken many people into custody who had published online essays about politics or who had discussed the Jasmine Revolution in interviews.

In fact, during the period in question, I had been online a good deal less than before, as I was taking my son to the park every day. Ai Lao had learned to speak and was already playing with words. When he told us, "Mom and Dad, you both count [*suàn,* 算] as friends of mine," he said he was using the *suàn* (蒜) that means "garlic." At that stage, he was not used to expressing his attachment to us so frankly, and this was his way of making a joke out of it. He also said that between Tom and Jerry, he liked Tom better, because Tom kept getting tricked and he felt sorry for him.

The investigator said that someone had testified that I was involved with the Jasmine agitation. "In that case," I said, "feel free to believe him." My Twitter posts were available for their inspection, I noted, and my tweets covered all my activities.

Another day, out of the blue, the investigator said, "Your mother is very distressed about your current situation. People who really care about you all want to help you, they all want to guide you in the right direction. It's those anti-China forces in Germany, the U.S., France, and Switzerland that are hoping we'll shoot you." This was the first time he had divulged news of life outside. His tone was mild and unconfrontational, and I wondered if he just wanted to put me at my ease.

In the days that followed, he seemed unable to find new topics to discuss, and there was no real progress in his investigation. He seemed to know he couldn't get any further with me. "Let's just have a casual chat," he would say, signaling that the scribe didn't need to keep a

record, and the conversations came to lack any central focus. It was as though they were waiting for something.

One evening, the investigator visited me on his own and handed me a couple of bananas, their skin already black, saying this was all they had. He opened up to me a little, telling me how much he loved criminal law. Once, his teacher had asked the whole class, "If someone shoots the moon out of the sky, does that count as a crime?" "Of course that's a crime," everyone said, "because the moon is for everyone." "No, that's no crime," the teacher said, "because there's nothing in criminal law to say you can't shoot down the moon." Actions that the law hasn't determined are illegal are never criminal, even if some people think they are. As someone who got paid a meager salary of two thousand yuan a month (about $300), he saw himself as having no grudge against anybody else and no need to get anyone into trouble or out of trouble.

Just before leaving that night, he said to me, "In this case of yours, I am going to try to make it that we do not charge you, for once a charge is filed, a guilty sentence is all but certain, and you would have to serve time. But we need to wait for the right moment. You know that our party is sensitive to its image and sometimes it acts in an extreme way, so it's hard to know how things will play out. There's a process involved, and it may be a while before we see the whole picture. Things take time to fall to earth." With his hand he made the motion of a long downward arc.

"You could be here a long time," he added, "or they might move you around a bit. But no matter where you are or however long it takes, you need to stick it out, you need to hang in there." I'll always remember those words.

"Are there cameras in this room?" I asked.

"Of course," he said.

Even in the grimmest of circumstances, individuals can retain the power to be human, and society is shaped by the actions of countless individuals. People have their own sense of right and wrong, one that cannot be entirely replaced by authoritarian principles.

He opened the door a crack and stood there smoking. We chatted about different ways of preparing *zhajiangmian:* the proper ratio of fermented soybean paste and sweet flour paste when you're making the sauce, and whether to add scrambled egg or diced pork. Beijingers set a lot of store by their noodles. Given what Li had been saying, I was now pretty sure I was going to be moved.

THE THIRTEENTH DAY OF my incarceration came, and Li did not appear. Instead, several young men wearing black suits and white shirts entered the room. They surrounded me and told me to stand up, then put handcuffs on my wrists and a hood over my head and took me outside. Once we were in the car, no one spoke, and it almost felt as if I was the only passenger.

When the hood came off at our destination, I saw two young men in trim uniforms standing as stiffly as statues in front of me, the words BEIJING ARMED POLICE sewn onto their chest patches. The Chinese People's Armed Police (PAP for short) is responsible for upholding political security and social stability. Sixteen years ago, I had taken a set of photos of a soldier standing guard in Tiananmen Square, and now this pair of armed police struck exactly the same pose.

I was told to take all my clothes off and submit to a body search. A chief—in the army, anybody above the rank of platoon leader is called "chief"—entered the room to observe. As he entered, the soldiers stood at attention and cried, "Chief."

The officer told me the protocol here: When sitting I must maintain a formal position, neither stretching nor folding my legs, with both hands lying flat on my thighs, looking straight ahead. I wasn't to look directly at the guards or talk to anyone. If there was any issue, I was to raise my hand and open my mouth only when the guard allowed me to. All movements on my part required the guards' permission, and I must obey orders at all times. Finally, he said, "If you make things easy for us, we'll make things easy for you." Like many sol-

diers, he had a distinct accent—in his case, that of Henan, a poor inland province where joining the army is practically the only way to make a living.

I was assigned a north-facing room on the second floor. The windows were sealed shut and the ventilator made a grating noise. There was a small bathroom, a single bed, and a table where interrogations were conducted, with two armchairs covered in camel-colored slipcovers placed next to each other on one side of the table. That was all. The chair in which I sat was tightly covered with black foam wrap, while the walls were covered in sheets of white foam wrap that had been fixed in place by bands of transparent sticky tape; through the cracks I could faintly make out dark green wallpaper. Everything in the room was coated with white foam wrap, including the toilet, the washbasin, and the faucets.

My room number was 1035, and the sentries knew me by that number rather than by my name. The room was some 280 square feet, and the floor was laid with brown ceramic tiles meant to look like wood, each two feet by two feet, six tiles across and twelve tiles down. I could exercise only on the six squares in the middle of the room: after walking seven steps, I had to turn around and go back in the other direction. My total daily walking time was set at five hours, which according to the guards was half the time that other prisoners were required to exercise. I was expected to fold my quilt into a neat, straight-edged stack each morning.

On the day after my transfer, to my surprise, Investigator Li appeared. After coming in, he looked around and said, "What an interesting place! It's good the guards keep you company as you walk. They're here to protect you, and if you walk fast or walk slow, they have to do exactly the same. The regulations make things clear and easy."

I had to agree with him. Here, practically everything apart from breathing was prohibited, and living didn't seem much different from being dead.

Li came with a second investigator, a man named Xu, whom he

introduced as their group leader and who he said would be taking over the questioning now. On the way out, Li casually put his paper cup in my hand, his way of saying goodbye.

Investigator Xu had a very different style. He was a careful, circumspect man, and he did not say a whole lot. Every day he would arrive on time, smartly dressed, and when time was up, he rose and left without further ado. In his mid-fifties, robust and resolute, he was the kind of person who in China is deemed "politically reliable." Every move he made told you that his job was to keep the government machine running smoothly.

The topics for this new round of questioning began with a photograph I took. Xu held up a sheet of A4 paper on which was printed in black-and-white a photo of my middle finger with Tiananmen in the background.

"Explain to me," he said, "what was the meaning of that?"

"This artwork is entitled *Study of Perspective*," I said. "It was a selfie I took in front of Tiananmen in 1994, one of a series with the same compositional design."

"What a load of bullshit!" he said. "You call that art? It is a blatant attack on the state."

I had taken similar pictures in front of the White House and the Eiffel Tower, I pointed out.

"Well, that's not my concern," he said. "I'm with China's police—let the American police worry about the White House."

He pressed on. "What does the middle finger mean?"

"In America it means 'fuck,'" I said.

"How about Tiananmen?"

"It's a city gate."

Now he was riled. "Over 90 percent of the world's population knows that Tiananmen is the symbol of the People's Republic of China! Every Chinese knows how to sing 'I Love Beijing Tiananmen.'"

What he said was true. I had learned as a young child the lyrics of

"I Love Beijing Tiananmen," a Cultural Revolution hymn of praise for Mao Zedong. This nauseating ditty might actually have been the underlying reason why I gave Tiananmen the finger.

"That opening line, 'The sun rises right above Tiananmen,' is totally unscientific," I said. For good measure I added, "Tiananmen is just a symbol of feudal power."

"What power are you talking about? Why don't you just come out and say it? You mean the Chinese Communist Party, don't you? What are you so afraid of?"

I wasn't going to flat out deny there was any substance to his accusations, nor was I afraid of taking responsibility for my actions. What I objected to was the crude political interpretation that he was applying to my work. If I were to agree to his reading, my art would have no reason to exist. But he had asked what I meant by the "power" of Tiananmen, so I answered him. "Its power lies in having an overwhelmingly superior command of discourse, and it uses that advantage to limit personal freedom."

"What a load of crap!" he said.

The back-and-forth left us both fuming. He kept raising his voice, and I asked him why he had to shout. That was just the way he talked, he said. Later I regretted challenging him, for when he lowered his

voice and spoke softly, I found it even more disconcerting. His change of tone reflected a selective deployment of courtesy, emblematic of the system's self-confidence.

"You actually are quite spineless," he added. "You don't have the courage to admit your own purpose."

He wasn't about to stop prodding. He held printouts of a dozen or so essays I had published on my blog, one of which he asked me to read out loud. As I did, he interrupted me to ask, "Who did you mean when you said 'government'?"

"I wrote this essay in standard Chinese," I said. "So when I wrote 'government' I meant 'government.' I reject your insinuation that what I wrote was not what I meant. To be frank, I can't be sure who the 'government' is, for obviously it's neither a person nor a tangible object."

"So timid? You just don't dare say, do you? What are you afraid of?"

I answered him straight. "I'm not afraid. If I say that in these places I mean the Chinese Communist Party, do you want me to rewrite the piece and republish it with that all clearly spelled out?"

He read out a line from another of my posts: "As long as there are muddled rulers in this world, there are going to be people who throw stones—unless the people lose their arms, or unless they run out of stones." He wanted to know what I meant here, too—who were these "muddled rulers"?

Again I took the same tack: "Would you only be happy if I said 'the Politburo Standing Committee'?"

"That kind of talk of yours—isn't it subversive? You're not just vicious, you're deranged." He was so indignant that for a moment he couldn't find the word he wanted and resorted to saying, "I think you're absolutely mad." Clearly he wasn't just putting on an act—he needed to persuade himself he was right. He leaned forward, reverting to his loud, abrasive manner. He wanted me to genuinely believe that my action amounted to inciting the subversion of state power. He wanted me to admit my crime. "I think you're mad," he repeated. "What is it they say?"

I guessed he had in mind something like Longfellow's "Whom the gods would destroy they first make mad."

"That's right," he said. "That's it."

Though at loggerheads, we had read some of the same books.

Another proof of my having "incited subversion" came from remarks I made at the Chinese University of Hong Kong. On that occasion there were more than a hundred students in attendance, and I had not given a speech but, as I did so often, simply answered questions. "Ask anything you like," I told them. The Hong Kong students were following the situation in China more closely than I had imagined, and from the questions they asked I could see how disturbed they were by the prospect of Hong Kong becoming part of China. One thing I told the students was that there has never been a totalitarian government that willingly perished. "It's pointless to expect it to reform itself," I said, "and we can't wait for it to die a natural death."

"So what is the unnatural death that you are hoping for?" Xu asked.

That question, of course, was hard to answer precisely: as I told Xu, unnatural death takes many forms, and if a government is chosen by the people, then it will die whatever way the people want it to.

During the questioning he did not bring up the Sichuan earthquake, the Citizens' Investigation, the River Crab Feast at the Malu Studio, or the demonstration on Chang'an Avenue. He seemed to avoid asking anything connected to the real reasons for holding me in isolation. The authorities were embarrassed to mention events that reflected poorly on them and that might provoke my "intolerable insolence."

"For every word you've said," Investigator Xu declared, "there'll be a price to pay. If you'd said those things during the Cultural Revolution, you could have been shot a hundred times over." He stood up abruptly, saying, "That'll do for today," and left at once. So ended my second day at the new location.

That night, as the hours stretched out ahead of me, I thought of my father, and I realized just how incomplete my understanding of

him was. Xu's remark about the Cultural Revolution was no exaggeration, and I certainly appreciated the relative tolerance of this current era. My father had endured a harsher one, when so many people paid with their lives for the words they uttered. I had never asked him what he was thinking, never wondered what the world was like for him as he looked at it through his one good eye. I felt a deep pang of regret at the unbridgeable gap between him and me. Then and there, the idea of writing this book came to me, for I did not want Ai Lao to suffer the same regret.

ALTHOUGH LONELY, I WAS never alone. In the early mornings, a shaft of light would slip through the ventilator opening and shine on the wall, moving like the hand of a clock to a spot that told me it was now 6:30. The two guards standing by the bed would take a step forward, checking their watches, and instruct me to get up. During the night, one would have been standing next to the bed while the other paced back and forth robotically, to avoid dozing off.

The twenty minutes from 6:30 to 6:50 were allotted to washing and attending to bodily functions. Once I was on my feet, I would report to the team leader and ask to wash my face. I would squeeze into the bathroom with the guards, one in front and one behind, and ask permission to urinate; after receiving clearance to flush the toilet, I would ask to brush my teeth. This activity involved standing in front of the washbasin at a forty-five-degree angle, for the toothbrush was tied to the faucet with a shoelace and I had to bend very low to reach it. On either side, the guards would likewise lean forward, their eyes fixed on me as the toothbrush moved around in my mouth.

From 6:50 to 7:40 was reserved for exercise, which consisted of walking back and forth on the six permitted tiles. The guards accompanied me on either side, walking and turning just as I did, maintaining their position and adjusting their distance as necessary, to make sure I didn't suffer some mishap—however unlikely that might be.

Together we made up the world's smallest drill team, but in time we reached a high level of wordless coordination, sensitive to the slightest changes in rhythm.

A doctor would come in before breakfast to take my pulse, test my blood pressure, and measure my blood sugar level. Then he would drop into the palm of my hand a set of pills—not my original medications—two for blood pressure, one for blood sugar, and three others said to be vitamins. Because I was suffering from insomnia and a ringing in my ears, he added two white pills that he said would steady my nerves.

Breakfast was served at 7:40. It came thirteen hours after dinner the previous evening, and by this time I would be faint with hunger. The meal was always brought in five minutes early, and I had exactly eight minutes to consume it. Every step in the process followed a routine, beginning with the moment I requested to move my chair over to the table. A plastic spoon was my one eating implement.

Breakfast consisted of an unshelled hard-boiled egg, milk, one steamed bun, and small side dishes such as long beans with minced pork or greens in pepper oil. For a while there was cabbage tossed with seaweed shreds, but after I had several bouts of diarrhea it was taken off the menu. Otherwise I would have ended up wasting a lot of toilet paper, and paper was limited, as my allotment came out of the guards' supplies. Every time I defecated, the guard would watch attentively as I wiped my ass.

There was something suspicious about the breakfasts, for each day the eggs were missing a little corner—about the size of a pea—and it was the same with the buns. I puzzled over this until one day a guard confided that they were keeping those bits as samples for possible lab tests, should anything happen to me.

The three and a half hours from 8:10 to 11:40 were nominally earmarked for "reflecting on issues," but in fact most of this time was set aside for interrogation, which commonly began at 9:10 A.M.

Lunchtime was from 11:40 to 12:10. I was given four cooked dishes and a soup, usually braised pork with seaweed, celery with lily bulb,

shredded pork in spicy sauce, bean curd with greens, and egg soup. Within eight minutes I could finish every dish, leaving five minutes to wash the food box and hand it back to the guard, who would take it with him when he went off duty, after the door guard had inspected it. Sometimes the doctor would visit during the lunch break; if not, I was required to simply sit in my chair for the remaining time.

The change of guard always took place precisely at the appointed hour. The door could be opened only from the outside, and as one team entered, the other left, completing the rotation within two minutes. Once, a guard suddenly had an upset stomach and needed desperately to use the toilet. He was not permitted to use mine, so all he could do was grip his aching belly with one hand while waving frantically at the closed-circuit camera with the other. Seconds passed, but his efforts failed to elicit the slightest reaction from the hidden observers. By now he was doubled over, and I had no choice but to "order" him to use my toilet. He practically dashed inside; when he came out, all my toilet paper was gone.

Then, from 12:10 to 1:00 P.M., I had fifty minutes to walk.

Nap time was 1:00 to 2:30.

From 2:30 to 5:40 there was more questioning.

Dinner was 5:40 to 6:10. Before the meal, the doctor would come in to dispense medication. First he had the guard check the dosage, and the doctor left only after watching me put the pills in my mouth. The guard would make me stick out my tongue to verify the pills had been swallowed; with that, I was permitted to eat.

After dinner, I did my final fifty minutes of walking for the day.

Next, 7:10 to 9:00 was set aside for writing "self-examination materials."

Shower time followed at 9:30, and bedtime at 9:45. I would spend five minutes washing my underwear, T-shirt, and socks, one minute brushing my teeth, the other nine showering, with two guards standing so close to me that water always sprinkled their uniforms and shoes. After that I would ask to dry myself, at the same time hanging my clothes up to dry. The guards would eye their watches carefully as

I got ready for bed: I had to lie down at 9:45, and if I washed too quickly, I had to stand naked next to the bed and wait. After 9:45, those monitoring the CCTV feed were to see no further sign of movement in my room.

Lying down didn't make me relax. My exhaustion actually prevented me from getting the sleep I so desperately wanted. It kept me on edge the whole night through as the high-pitched growl of the ventilation outlet exacerbated my unease. Night after sleepless night, I would lie flat on my back in bed, my arms by my sides, the fluorescent bulb's white light shining on my face. The events of the day would fade, and all I could do was use memories to fill the time, looking back at people and events, like gazing at a kite on a long string flying farther and farther, until it cannot be seen at all. Thinking about the past was like taking items out of a bag one by one, until you give it a shake and it's completely empty, leaving you bereft. Amid the stillness I would start thinking about Ai Lao, and soon I would find tears were coursing down my cheeks.

Two guards stood at my bedside and watched me the whole night through. At first they seemed like wooden statues, motionless in the shadows, but soon I realized that night duty gave them a chance to unwind, and their exchanges served to ease my isolation. Through some remarkable knack, they could maintain a faint conversation without moving their lips, in a sound softer than an electric fan, so that the microphone hidden in the wall could not pick it up at all. Thus began their nightly outpourings, regarding parents and wives back in their home districts, episodes from their childhood, and anxieties about the future. Listening to them, I lay there like a corpse slowly sinking into the sea, drifting down through the algae blooms and the dark waters to the black depths where no light shone.

The guards gradually became fully, noisily human to me. They were always taken aback by my wakefulness, for I would continue to lie awake until the next team took over. At midnight they had a meal. For these young fellows from the countryside, this late-night feast of egg fried rice was the most enjoyable moment in the day, and they

wolfed it down with gusto. But their digestive systems would register protest, and they could never stop burping. The reek of garlic would linger in the room until dawn.

The soldiers would regularly crack their joints—a crisp snapping sound like a turnip being broken into two pieces. Whether clenching their fists, waving their arms, squatting down, or bending and twisting their waists and necks, every part of their bodies seemed to make a sound. They would stand very still and straight, then suddenly swivel their heads, and their necks would give a loud pop. In their elasticity they reminded me of performing acrobats, because from a standing position they could stretch backward and touch their heels with their hands. Or from a crouch they would turn rapidly left and right, executing a set of bizarre, repetitive movements. Whether this was to assert their existence or vent frustration, I had no idea.

I began to sympathize with them. They were like me, in a way, confined and constricted, their present ruptured from the past, and lacking anticipation of their future. Sooner or later the prisoners would move elsewhere, but these men would have to continue standing guard—the one skill they possessed—until the day that a whistle would blow and suddenly they'd have to leave and return to the place they came from.

Every one of the soldiers felt there was something freakish about his life. Born into poverty, they had handed over their youth in exchange for an army uniform. Like fish deposited in a bowl, they had no control over their fate, to be used or discarded as their masters pleased.

We began to talk, outside of my requests to use the toilet or walk my squares. In their loneliness, the guards felt an urge to spill their feelings, whatever the consequences. They told me about their parents, their hometowns, their formative years, why they had enlisted, and what they did when they weren't watching me. All I needed to do was close my eyes and I could picture their home counties and their families, step into their childhoods, and imagine their futures.

Big Feet—that's how I thought of him—was a lucky survivor of

the one-child policy. Unbeknownst to the village family-planning officials, his mother had managed to get pregnant with her second child, and before they were able to force her to have an abortion, she had slipped out of a toilet, clambered over a wall, and made her escape. She had given birth to him while hiding in a relative's home; when this was discovered, the family received a huge fine and their house was demolished. Now he was a solid soldier. His body was as strong as a dumbbell, and for him to do five hundred push-ups was a piece of cake. His big feet were a drawback, though, because he would keep stubbing his toes on my bed frame as he walked next to me. He had grown used to living on a base and wearing a uniform, and now he could eat his fill at every meal—before he had always been hungry. He didn't like the idea of having to leave the ranks and return to his impoverished Henan village.

Once, when Big Feet was on duty, a nurse came in to take a routine blood sample. No sooner had she given the tube of my freshly drawn blood a couple of shakes than he keeled over and fainted. She came to his aid immediately, pressing the hollow between his lips and his nose, and he revived quickly enough. With a casual remark to me that "many of our soldiers faint at the sight of blood," the nurse left the room. I am still trying to decide whether that counts as divulging military secrets. For the next few days, Big Feet was the envy of all his fellow recruits, because—according to the popular version of what happened—he'd had the chance to lie in the nurse's arms and cushion his head against her breasts.

There were two surveillance cameras in the room and another in the bathroom, and the footage was monitored, I was told, in two control rooms in the prison, one operated by the military police, the other by public security. These young guards were spending a lot of time with a man unlikely to rat on them, and this spurred their curiosity and their willingness to take risks.

"It's a dark empire," they told me, forbidding in its hierarchy, riddled with corruption and filth. Their company commander acted like an overlord: He would amble around, taking off pieces of his uniform

and chucking them on the ground. They would have to pick them up, wash them till they were squeaky clean, and fold them neatly and put them on his bed. The worst thing was his thunderous snoring every night.

The soldiers were in their twenties, from provinces that produce lots of army men, such as Shandong, Henan, Anhui, and Fujian: taken together, the populations of these four provinces exceed that of the entire United States. Their monthly pay in the first two years of service was 360 yuan (about fifty dollars), and with all their training exercises and guard duties they got only four or five hours of sleep a night. "See, when you lie down, we stand," one of them said to me. "When you eat, we still have to stand, and when you shower, there we are again, still standing. When you walk, we walk, too, but when you sit down we keep on standing. Who did we offend, to have to suffer this?"

After they first arrived at the base, they were seldom allowed to take even a step outside, and none of them knew precisely where they were stationed. The May 1 International Workers' Day holiday was their only day off during the course of my imprisonment, and actually that was just a half day, when they were taken to a sightseeing spot for a couple of hours. On that hill, they saw a girl whose outfit opened wide enough to reveal a little lace—a sight that fueled their fantasies for days to follow. Sometimes they would inquire tentatively whether I had ever had a relationship with a woman of some other ethnicity, and if I supplied one or two unexpected details they would be over the moon. They began to preface their inquiries with an appreciative "Dear Sex Uncle," and when I was filling in some of the many gaps in their sex education, time would fly by.

As the weeks stretched on, they began to tell me of other high-profile suspects they had handled: A business executive had offered 500,000 yuan ($75,000) for every carton of cigarettes they could smuggle in for him. And the boss of a life insurance company would fold and refold his quilt dozens of times a day, until it had as straight an

edge as if it had been cut with a knife. Every day, he would lie down on the floor and scrub every crack and crevice, and he'd even put his hand into the toilet bowl to scour it clean.

I lost track of time, for one day was much like any other, rigidly structured with its set routines. By now the guards and I were pacing back and forth with even more seamless coordination, and seeing my hangdog look, they would try to find ways of cheering me up. "How about you sing a song? Singing can lessen your worries. Or tell a joke? You're old enough to know a joke or two, surely."

But I couldn't think of anything funny. I knew my mother must be worrying about me and wondering when Ai Lao would see his father again. The guards' concern for me relieved some of the pressure I felt. But my nights were still sleepless, haunted by thoughts of all those I'd left on the outside. I kept up my stubborn performance in my daily sparring with Investigator Xu, and bantered with his foot soldiers to pass the time. But doubts crept in as I lay awake in the late hours— about how this all would end, and about the path that had led me here.

On May 2, the guard I called Burper was wearing a disconsolate expression when he arrived for the morning shift. His idol, he said dolefully, was no more. My curiosity was aroused: Who could be an idol for this orphan, whose only passion seemed to be playing video games day and night? The answer would have startled anybody. Osama bin Laden had been zapped, he said, a look of misery on his face—the U.S. Special Forces had gotten him. Together we paced back and forth in our regular exercise routine, and I didn't know what to think. This news flash, with its report of sudden, violent death, deepened my sense of foreboding.

Cut off now from past experiences, my memory withered and crumbled, but my dreams grew rich and lush. One night I dreamed I was wandering through some rolling landscape when I found myself in an ancient village, home to a secret society. Corpses were floating on a lake, the bodies lacking heads or limbs, while bystanders stood

and watched. I had my video camera running, but the more I filmed, the more danger I seemed to be in. Soon I realized that no matter what I did, it would be impossible to leave this place, because I knew too much. What distressed me most was that the spectators weren't bothered at all—I was the only one who sensed there was a plot afoot that needed to be exposed to the world. When I woke up, I felt deeply unsettled, for just a few days before I was taken into custody I'd had much the same dream.

In mid-May, on the forty-third day of my secret incarceration, Investigator Xu informed me that Lu Qing wanted to see me. It was one of the few times he had acknowledged that the world outside still existed.

I did not want to see her, I told him flatly. This was not at all the reaction he expected, but I had no wish to be part of some demeaning charade. I knew I wouldn't be able to talk freely about my imprisonment, and my problems involved me alone. I didn't need sympathy—what I needed was justice. But justice was nowhere to be seen, and offering family ties as a substitute was a cynical ploy. I wanted no part of it.

Since the first day that my rights were denied, I'd had no illusions about the process: in the face of the state's accusations, I told myself to prepare for the worst. It was the investigators who had said I would not be able to see anyone for six months, but now, on the forty-third day, the authorities must have come under pressure, and so they needed to prove to the outside world that I was still alive. In the end, Investigator Xu told me categorically that I had to see Lu Qing, arguing variously that they were making a remarkable exception in my case, that this was part of the procedures, and that I could not say no.

There were four points I must communicate to Lu Qing, he told me. First, I was suspected of economic crimes, but I was not to mention the investigations or the lines of questioning, and by no means was I to mention political issues. Second, I had been treated fairly and had not been tortured. Third, I was cooperating willingly with the

investigation and believed the government would reach a reasonable conclusion. Fourth, the family was to avoid foreign media and ignore all rumors and provocations.

The next day, the guards had me shower and put on a white shirt. I was again hooded and driven into the city. I was led into a meeting room in a large building; on the back of a chair I saw the words CHAO-YANG DISTRICT PUBLIC SECURITY BUREAU. I knew then we were not far from my mother's house.

In the middle of the meeting room, two tables had been put together and covered with a scarlet velvet tablecloth. The guards sat me down on the left, with Investigator Xu and his assistant sitting like umpires on the other side; on the wall behind them, a camera was installed. Once again they stressed the ground rules and had me recite my spiel.

When Lu Qing entered, she was looking very summery in a pair of red floral culottes. The air of freedom about her, so striking to me, seemed to underscore all that I had lost. She was carefully taking me in but said nothing, perhaps not quite believing what she was seeing; it was as though we were separated by a sheet of glass.

I had to make clear through my manner the absence of the *real* me—a difficult task, but one that I had to attempt. My speech was slow and stumbling, not revealing my emotions. I delivered my pre-packaged lines, and she listened intently to what I was saying, hoping to discern the real me beneath the mask I wore. But she would never be able to imagine just where I had come from and what I'd had to go through. She might well think I was being held close by—otherwise why would they choose to have us meet here? In this very brief exchange, everything I said to her was a lie. Her function was to serve as the mouthpiece of a regime, to paint a false picture for the world.

Lu Qing, for her part, said she had seen Wang Fen and Ai Lao. They were both well and I was not to worry. She had no doubt been coached by state security, just like me. By the time we had finished reciting our lines, our fifteen minutes were up. Lu Qing rose to her

feet and gave me a quick hug. An hour later, I was back in the detention center, but after this, my mood was calmer. At the very least, people on the outside now knew I was still alive.

ON THE NIGHT OF June 3, thunder roared and lightning flashed amid bouts of wind and rain. I sank into a reverie, imagining the army's crackdown at Tiananmen Square twenty-two years earlier. Every time the weather turned bad, I felt a deep craving for the company of my loved ones. Without them, I was an empty shell, like the cicada skins one sees clinging to the trees in the courtyard of Caochangdi after the first spring rains, transparent and hollow.

Once my incarceration had passed the fifty-day mark, Investigator Xu grew increasingly glum; he had run out of things to say. He demanded that I take stock of my situation, asking how long I deserved to be put away for, given the crimes I had committed. I said I had no idea. I didn't believe I had broken the law, and I had even less understanding how a sentence would be determined.

Investigator Xu put it to me bluntly: I could expect a sentence of at least ten years. "Don't have any illusions," he told me repeatedly. "You'll get out one day, but Ai Lao will have grown up by then, and your mother may well have passed away." This plunged me into misery. I was disgusted that he was speaking of my family in this way, in an effort to break me down. According to him, I was an "enemy of the state," and I could not just go on stonewalling. According to his logic, I had to repent my crimes; only then could he come to my rescue and lighten the punishment.

Now, as a public enemy, I could stand as an equal with my father. After an eighty-year gap, in this same land, similar offenses enabled us to meet.

"You're wrong," Xu said. "He and you are in different eras."

He had no more pressing questions, just more words of warning. "Nobody who comes in here leaves without surrendering. A mur-

derer is bound to know that a guilty plea won't save him from a death sentence, but still in the end he'll confess."

"Why's that?" I asked.

"All it takes is patience and determination on our part," he said, his eyes distant.

The next day, Xu asked me to trust him; if I didn't, I would lose my last chance. After saying his piece, he went quiet, deflated like a leaky ball.

He understood that I wasn't an evil person, he said—just a troublemaker. To my surprise, at this late stage he seemed suddenly to have reached a higher understanding: everything I did was basically a form of Dadaism, he declared—cultural subversion was my specialty. Duchamp had been a destructive fellow, too, he added.

In the end, he said, in light of what he knew of me, even if I was given a ten-year sentence, I would still be the same after I was released. "Am I right?" he asked.

"Yes," I answered. "Even if you threaten to drag me out now and shoot me, my position won't change."

CHAPTER NINETEEN

———

Living the Best Life
We Can

SEVERAL DAYS PASSED WITHOUT QUESTIONING, AND THE GUARDS
said this meant there were two possibilities: either I was going
home or I would be putting on a yellow jacket—the mandatory uni-
form in a detention center.

On June 22, 2011, Investigator Xu came into the room but didn't
bother to sit down. "Collect your things," he said. "You're going
home." He handed me a black plastic bag, and after I had put my
clothes and other effects inside, he told me to check and sign for a list
of items I had been allowed to purchase during my detention and
could now take with me: toothbrush, toothpaste, soap, laundry de-
tergent, a basin, six hangers, and a pair of plastic sandals. The cost of
these items had been deducted from the sum in my wallet. They
were going to keep my passport for the time being, he said.

My eyes were covered for the last time and I was ushered into a
vehicle by one of my regular guards—the one who had once told me,
"Here, everything they say is false. There's not one word that's true."
He said that by the end of his first day in the army he had already re-
gretted joining.

When my blindfold was removed after the drive, I found myself in
a large conference room. The guard stood very straight by my side,

gazing dully ahead with a grim and weary expression. The prize he had been guarding for eighty-one days was about to slip away.

I was allowed to visit the toilet at the far end of the hallway, where, in the dim light by the washbasin, I saw myself in a mirror for the first time in many weeks: an unkempt, shaggy-bearded old man, holding up his pants with one hand.

A little after eight o'clock that evening, I heard footsteps in the corridor. Investigator Xu entered, followed by my mother and Lu Qing. My mother looked haggard, with stress written all over her face. She sat down next to me, and Xu then read out a decision by Beijing Municipal Public Security that said I was to be released on bail; my mother, as guarantor, signed the papers. The reason for my release was just as opaque as the reason for my detention.

I was surprised to see my mother. She clasped my hand tightly, as though reunited with a lost child and determined not to lose him again. Her hands were soft and warm, but under the skin I could feel the bones and veins.

We sat together in the back of a car as it quietly made its way along familiar streets, among pedestrians and bicycles, a light rain falling. At the wheel was the plainclothes cop who had driven me away from the airport eighty-one days earlier. I had run afoul of a "crooked, perverse" regime, my mother lamented. Yesterday was now in the past, and when I rolled down the window, damp air wafted over me. I was looking forward to seeing Wang Fen and Ai Lao.

The terms of my release on bail stipulated that I was not to leave Beijing, not to go online, and not to communicate with the media. I was also required to attend a weekly interview with the police. After all the talk of being sent directly to prison, I felt like a ball that had jumped out of a spinning roulette wheel.

Once back in the studio, I was able to hear the accounts of Jennifer Ng, who had managed to fly to Hong Kong after I was detained at the Beijing airport, and my driver Xiao Pang, who was taken to Nangao Police Station for questioning that same day. Caochangdi itself was in uproar on the day that I was seized, with scores of police descending

on the village, using bullhorns to order my staff to come out. The police put ladders up against the perimeter wall, ready to storm the compound if there was any resistance, and once they were inside, they pried open doors with a metal bar as they went from room to room. A dozen or more people from the studio were taken away to the police station, and the questioning lasted until three o'clock the following morning.

My assistant Liu Yanping told me she had been interrogated by a tall, burly plainclothes cop. He had hardly sat down before he was wagging his finger at her and shouting angrily, "You fucking idiots, what did you think you were doing, putting together a list of kids' names? Did you ever give a penny to the earthquake relief? Did you ever donate a drop of blood? When the houses collapsed, did you save anybody? What's the fucking point of releasing casualty figures? Did you think there wasn't enough damage done already? All you assholes do is make things more difficult for the government."

Liu Yanping asked him to clean up his language and reminded him that every word of his tirade would shortly be appearing online.

"If you're going to put that online," the officer said, "don't complain if I respond in my own way. I won't beat you up in the police station, but there's nothing to stop me from beating you up outside. You fucking loser, are you sure you'd like a taste of my fists? I just don't know if I want to get my hands dirty."

The police had tried to persuade my assistants to spy. They told Xu Ye that if he stayed on at the studio, they would guarantee him an extra income, and all he needed to do was "see us now and again."

The day after I was seized at the Beijing airport had been the day of the Qingming Festival. Xiaowei, an honest, reliable man who had long been doing odd jobs around the studio, had traveled back to his family home in Anhui to pay respects at his father's grave. As he made his way through the empty, misty countryside, he saw a police car blocking the road in the distance. Two officers got out of the car and asked if he had come from Beijing. Xiaowei was taken back to the county public security office, where he was subjected to questions

about our company, FAKE, by four police officers who had just flown
in from Beijing. Xiaowei, a guileless country man, explained that his
job was simply to answer the phone and buy groceries and he didn't
know anything else.

After three hours of cross-examination, the policemen asked, "Do
you know about Jasmine?"

Hearing a familiar word at last, after so many pointless inquiries,
Xiaowei nodded his head like a horse and said confidently, "Yes, I
know."

The policemen pricked up their ears and watched him intently as
he continued. "The jasmine flower is very fragrant," Xiaowei said,
"and native to south China."

Although sorely disappointed by this unhelpful answer, the police-
men insisted on taking him back to Beijing for further questioning.
That night Xiaowei slept soundly, enjoying a hotel stay for the first
time in his life. The policemen had him sleep on the bed while they
slept on the floor, next to the door, for fear of his escaping. The next
morning he was treated to another first-ever experience—air travel to
Beijing.

Others were detained as well, including my collaborator Liu
Zhenggang, my accountant, and another colleague—and nobody
knew where they'd been taken. Wang Fen's apartment was searched
by a dozen police officers, who made an inventory of her possessions
and took photographs. Twice she was summoned to the police sta-
tion, where Ai Lao, standing staunchly by her side, kept saying good-
bye to the policemen, in an effort to cut short the questioning.

The day after I was seized, material appeared on the internet at-
tacking me. According to the Xinhua News Agency, I was suspected
of tax evasion and taking money from foreigners: "Ai Weiwei, though
an artist in name, is in practice a political opportunist." Online com-
menters hired by the government concocted stories, impugning my
integrity and insulting my mother, Wang Fen, and even my sister
Lingling, who actually had little contact with me.

On April 5, my Twitter followers launched an online campaign

entitled "Free Ai Weiwei," which soon gathered more than seventeen hundred signatures. Ai Xiaoming, a scholar and filmmaker based in Guangzhou, published an open letter that began, "Today, every one of us could become an Ai Weiwei." In it she wrote, "Ai Weiwei has been taken away. Perhaps he will be back in a few days, or perhaps it will be many years before he is out. But he has an audience in the hundreds of thousands—young people, mostly. Ai Weiwei will retain this audience, and countless people will carry on Ai Weiwei's ideals and practice. In this sense, Ai Weiwei wins, whatever happens."

There were many appeals for my release. A large number of sympathizers posted my picture on their webpages, while overseas artists and art organizations signed protest letters, and in London the Tate Modern wrote RELEASE AI WEIWEI in giant letters on its facade. In Hong Kong, my image was sprayed on pedestrian crossings and in the subway, and projected at night on the walls of the barracks that housed Chinese troops. U.S. secretary of state Hillary Clinton publicly expressed concern, and the leaders of Germany, Britain, and France jointly sent a letter to the Beijing authorities, while the European Union issued a number of statements. The police later told me that if it hadn't been for all this "noise," I might well have been released sooner.

My disappearance reawakened in my mother memories of the injustices inflicted on my father. Ignoring the advice of friends and family, she posted a "missing persons" notice on the internet, as she had become adept—at age seventy-eight—at "jumping the wall" as a way of staying informed about my situation.

My release caused just as big a stir as my seizure. On the morning of June 22, tweets regarding my impending release began to appear, and by the time I got back to my studio in Caochangdi, foreign reporters were waiting in the street to confirm my return. Xinhua News Agency issued a dispatch reporting that FAKE, under the control of Ai Weiwei, had committed offenses including tax evasion and destruction of evidence, but because I showed a positive attitude and suffered from health problems I had been released on bail.

For a time, everything seemed to return to normal. When I visited

my workshop in the Zuoyou Arts District, I heard an incessant clang of metal hitting metal, the sound rising and falling in a steady rhythm. A year earlier, I had bought more than two hundred tons of twisted rebar salvaged from the collapsed schools in Wenchuan and shipped it back to Beijing. A dozen workers were now hammering every one of these pieces of steel back into shape, making them so straight you might have thought they had just emerged from the mill. Hearing all this noise, I felt a surge of gratitude that even during my detention the work had continued. This sculptural installation, *Straight*, would go on to be exhibited at the Venice Biennale in 2013.

Around the studio, additional surveillance cameras had been added, and to make their job easier the police had built a small two-story building right next to the compound, its window directly facing my front gate, so that they could observe what was going on inside. Every morning, two men entered the building carrying black briefcases, and they stayed there the whole day. Each time I went in or out, I first had to register with the police, and I needed their permission to leave.

The days after my release were a jumble of emotions—love and hate, craziness, happiness, and sadness. Every day seemed to be imbued with a mythical, symbolic significance, for stupidity and falsehood had come to frame my life, and my daily struggle was only part of a much larger picture. I was constantly aware of my enemies' presence just outside the gate, and even the smallest incident would put me on edge. I didn't indulge in imagining the future, nor did I have any particular expectations. I simply lived for the moment.

On the forty-fourth day after my release, deciding I could be silent no longer, I sent out greetings on Twitter to my supporters, and also noted the physical and mental ordeal that my associates had suffered during their detention. By defying the restraints placed on me, I risked being taken into custody once more, but to me the loss of the freedom to express myself was itself tantamount to captivity. Those who followed me on Twitter had reached 100,000 strong, and when I tweeted again for the first time in months, it felt for a moment like old times. But of course everything had changed.

As before, Wang Fen and I took Ai Lao to the park nearby for a walk each day. They had suffered a great deal in my absence. To account for my disappearance from their lives, Wang Fen had resorted to the pretext that work on a major project was keeping me in Britain, and on my release Ai Lao had told me firmly, "Dad, no more working in London, please." By now he knew the whole story, and I vowed not to leave him, no matter what.

LYING BY MY SIDE one day not long after my release, Ai Lao studied my face. "Ai Weiwei," he said, "if you just open your eyebrows more, you'll be happy." Ai Lao always calls me by my full name.

"You're a good dad," he went on. "And so, I am going to have a son too, and that son will have a son, and that son will have a son."

"What do you think about Ai Weiwei being taken away?" I asked.

His answer took me aback. "That was no big deal," he said. "They were doing a commercial for you, to make you more famous."

Another time, he said to Wang Fen, "Fools have their own rhythm. What I mean is, even if someone's a fool, you should let him do his thing. Bad guys have their own rhythm, I've noticed."

Always curious, he once asked me, "Dad, how long has it been? Is it a hundred days?"

"What do you mean 'how long'? How long since when?"

"Since we were monkeys."

He also had a message for my online supporters: "Shoes are crooked, you are good." According to him, this was from a poem about spring.

"Do you think love is useful?" his mom asked.

"Love can give us feelings," he answered.

"So what do you think love is, exactly?"

"Love?" He pondered for a moment. "Love is a water bottle that's easily broken, but if you drop it on the floor it doesn't break."

Ai Lao made many discoveries. "Everybody who manages to escape will pretend to be dead."

"What's wrong, Ai Lao?" I asked. "Are you not happy?"

"Dad, do you know why I'm not happy? Because I feel that time in this world passes too quickly."

"So think of a way to make time pass more slowly. You're such a resourceful entomologist."

"The only way is to be sad. Being sad makes time pass slower."

One day in my studio, Ai Lao turned to me and said, very seriously, "I don't just do whatever I feel like doing—first I do something, and then I look at what it is."

He had developed a special interest in words, a flair for language. On August 13, he wrote a poem to his grandma. "Fire, why do you burn so fiercely? Mars does not answer, and just keeps burning. Mercury and Mars are so far away they never need to bump into each other, and a desert lies between them, a desert with a pagoda."

Once, in the car, I was telling him stories and asked, "What should we write on a hero's tombstone?"

"Dad, write this," he said. " 'I hope a breeze that likes him blows over his tombstone.' "

I loved that line. *Keep it for me,* I thought.

GIVEN THAT MY PASSPORT remained in the hands of public security, I was unable to attend the opening of my solo exhibition *Absent* at the Taipei Fine Arts Museum in October 2011, nor could I attend the openings of my other shows in the next four years. My absences presented a challenge both for me and for the curators of these exhibitions, but at the same time they demonstrated the necessity of standing up for freedom of speech, whatever the sacrifices might be.

Although I had been released on bail, I knew the authorities had more in store for me. During my secret detention, and again in the weekly meetings that followed my release, I often heard public secu-

rity officers make this kind of comment: "Ai Weiwei, we're fed up with you attacking the state and the government. We're going to make you die an ugly death: we're going to tell everyone what a disreputable life you lead, what a big tax dodger you've been, how untrustworthy you are." They were preparing to deal with me in the same way as they dealt with any political opponent: by pinning a fabricated crime on me. My answer was always the same: "Do you think young people will believe what you say?"

"Well," they said, "90 percent of the people will."

On November 1, 2011, after I'd been out on bail for several months, the government accused FAKE of tax evasion, and two days later enforcement officers from the Beijing Local Taxation Bureau delivered to the studio in Caochangdi a tax bill of 15.22 million yuan (about $2.4 million). They demanded that within fifteen days FAKE pay the entire sum, comprising tax arrears, late fee, and fine. "Unless you're fined, you'll never shut up!" was the way the police put it to me.

The fine was unprecedented, an exorbitant sum, larger than the annual net income of a huge enterprise such as the China Railway Group. There was a balance of only two thousand yuan in FAKE's account. If I couldn't pay the full amount, they said I could pay in installments— or simply shut down the company. That was their ultimate goal.

I was not prepared to accept a cooked-up charge of tax evasion, so I appealed the ruling, even though I knew full well what the outcome would be. According to the law, one who appeals must first pay the outstanding tax, but such an inflated tax bill would normally deter anyone from lodging an appeal. In my case, I welcomed the opportunity to clarify the facts and seek justice, so I asked Pu Zhiqiang, the lawyer who had defended the Chengdu activist Tan Zuoren, to act as legal representative for FAKE, and at the same time I engaged a tax lawyer, setting in motion an appeal against the Beijing Local Taxation Bureau's demand.

It was a gamble that we couldn't possibly win. Undeterred, I did everything I could to bring things out into the open and litigate the case. But the court refused to let my lawyer read and copy the original

documents on which the tax ruling was based, and it also rejected our request for an open hearing. There could be no change in the decision, we were told, because the order had come from above: "If the state says you haven't paid your taxes, don't argue. Are you a complete idiot? Would the state ever change its position? If it wants you dead, then there's no way you're going to get out alive—forget about it!"

But miracles do happen. To the surprise and dismay of public security and the tax bureau, I went ahead and posted online the news of what was happening and announced that I planned to take legal measures to defend my rights. Evil must be exposed, I told my readers. Only when it is exposed does justice have a chance to emerge.

My declaration immediately had the internet buzzing with excitement, and I launched an appeal for funds to support my legal costs. This triggered an enormous reaction as netizens began to donate money in a movement even larger in scale than our Citizens' Investigation or the River Crab Feast. The spontaneous outpouring of sympathy and the tangible expressions of solidarity showed the extent of popular outrage at the abuses inherent in my secret detention and the under-the-table manipulations of the judiciary.

On that first day after I posted, more than five thousand infusions of cash were sent to my account, totaling 1.1 million yuan. And in the morning, we found the lawn in the studio courtyard littered with little pink paper planes, made of folded one-hundred-yuan bills that had been tossed over the wall.

After ten days, I had received 28,479 deposits, totaling close to nine million yuan. Messages were attached to each donation—optimistic, determined, passionate notes. I was not alone, people told me, and through their donations I felt the towering strength of their support. Messages noting incoming online donations would appear on my phone, lighting it up continually, late into the night. In the eyes of the donors, these monetary contributions served as votes of confidence in me.

The author Wang Xiaoshan and his wife came to see me, bringing a duffel bag full of cash—money they had been saving to buy a car.

"Weiwei, you take it all," his wife said. Everyone rallied round, as though shielding a flame to stop it from being blown out by the wind. On the street or in a park, every day I would run into young people who came up and said, "We're on your side."

I was deeply touched by a message from an internet follower in Shenzhen whom I had never met:

> Hello, Auntie, I know you're busy, so I'm not going to try to call you on the phone. I'm simply writing to request an IOU.
>
> Yesterday I transferred to you one million yuan. I'm no business executive, but simply somebody who has worked for almost twenty years in the finance industry. I don't count myself rich, and the money I have sent you is close to half of this middle-aged woman's savings. But I want to lend it to you in your hour of need.
>
> Although this may well get me into trouble, I still want to do this. Is this really dumb? Maybe it is, but I've been dumb for forty years already, and I may as well continue.
>
> Given that I'm your biggest creditor, could I trouble you to write me an IOU? Go ahead and write my real name, just in case they try claiming that this is an "illicit loan."
>
> My name is Sun Weibing. November 9, 2011.

"Auntie" was one of many nicknames I had acquired, the word being a homophone for the Chinese word for "god," another popu-

lar way of referring to me. (When I asked the Chengdu police why they had beaten me that night in the hotel, one of them had said, "Hah! That's just you playing God"—"playing God" being slang for "making things up." From then on, online supporters took to calling me "God Ai.") This correspondent's courage showed me the power of people, just as in my actions she saw a possible future for our society.

Almost overnight, I had acquired a host of "creditors" thirty thousand strong, making me the most envied debtor in China. Every day I would spend hours at my desk, writing IOUs. Each IOU was an exquisitely designed creation, with the names of the borrower and lender and the amount of the loan carefully recorded in traditional script in neat, handwritten vertical columns, and my signature and seal affixed, with a couple of grass-mud horse or sunflower seed stamps in the top right corner, further certifying the agreement. (The grass-mud horse is an imaginary alpaca-like creature that symbolizes resistance to internet censorship; its name in Chinese sounds a lot like an insult.) Then the IOU, together with a couple of my ceramic sunflower seeds—the seeds of freedom—and one of my documentaries would be mailed off to the lender. Once again, my art was part and parcel of a citizens' movement.

On November 16, 2011, by submitting the paperwork for the tax payment guarantee, I gained the right to press ahead with my case for administrative review. On the final day of the year, public security called me to their office to discuss the actions I was taking. The officer in charge had not anticipated that the tax case would get so complicated. He knew me well enough to know that I wasn't going to back down, and in some ways he'd developed a grudging respect for my point of view. On this occasion, he said to me, very earnestly, "Ai Weiwei, you're just a pawn in the game, you know—a very special pawn, perhaps, but a pawn just the same. You were born here, in a true-bred socialist family, but now, with your good English and your high profile, you've ended up serving as a pawn for Westerners to attack China. Pawns sooner or later all get sacrificed, don't you realize?

You're actually quite pathetic." It was obvious that he wasn't speaking for himself but serving as a mouthpiece for his superiors.

"Do you really think it's because of Western backing that I make an impact in China?" I couldn't help asking.

"Compared with a population of 1.3 billion, your thirty thousand donors don't count for much at all," he retorted.

"In the last six months," he went on, "you have violated every one of the commitments you made. You've tweeted, you've pleaded causes, you've given interviews and made solicitations online and broadcast live video." He also claimed I was taking advantage of Pu Zhiqiang and my other lawyer and friend Liu Xiaoyuan, who had been the first person to loan me money online. "I may not be able to shut you up, but I can certainly shut them up," he added. "I am going to get rid of every single pawn that's protecting you, and in the end I will put *you* out of business, too."

I appreciated his frankness.

"Why is public security so concerned about a tax case?" I asked. "And what's the problem with our going public about it?"

He began to speak more slowly. "We could have handled this peaceably, do you understand? No matter what you do, the verdict in the tax case is settled." His basic point was this: if I would simply shut up, they would let bygones be bygones. Finally, he noted, if in the future I was jailed again, I couldn't say I hadn't been warned. I had to admit, he had certainly issued plenty of such warnings.

The case would not be resolved for nearly another eighteen months. In June 2013, the Chaoyang District People's Court of Beijing issued a verdict that the Beijing Local Taxation Bureau's actions and procedures were within the law and the measures taken were appropriate, and it rejected my appeal. On August 4, after a second appeal, the Beijing Second Intermediate People's Court issued its verdict, upholding the original ruling, and the tax case ended with the failure of my appeal.

Liu Xiaoyuan and I went to hear the announcement of the verdict—the first time I had been allowed to enter a courtroom. The

judge read the verdict aloud twice. When I asked if he was a Communist Party member, he simply sat there in silence, eyes down. I couldn't stop myself from shouting, "Shame on you! This won't be forgotten!" But the outcome had come as no surprise. The authorities held on to the large cash deposit I had made when lodging my appeal, and during the course of the next two years I gradually repaid all the loans to my creditors.

EVER SINCE MY DISAPPEARANCE, friends had been closely following my news, and after my release, of course, the police surveillance had been all the tighter. As a gift to public security, I decided to let them observe everything I was doing, who I was meeting, and even how I sat in front of my computer or lay asleep in bed, by voluntarily re-creating the state of surveillance during my confinement. "Since

you're so very interested in my private affairs, I'm going to provide you with access to my entire life" was how I explained it.

To mark this new development, I hung a traditional red lantern under every surveillance camera that the authorities had placed around the perimeter of 258 Caochangdi, introducing a festive note to that somber, gray street. On April 2, 2012, the day before the first anniversary of my disappearance, I installed webcams in front of my desk and above my bed, and began a live feed on weiweicam. com that displayed every second of my daily activities. During the forty-seven hours and nine minutes that followed, the webpage received 5.2 million hits, with my more ridiculous sleeping poses providing much entertainment for my online audience, who took screenshots, then pasted and posted them. But late in the evening of April 4 the video stream suddenly cut out—clearly not at my prompting. Difficulties are hard to express, but it is precisely when daily experiences present a barrier to exercising logic that art begins to show its power.

At that time, Wang Fen, Ai Lao, and I would often brave the smog and go for walks in Chaoyang Park. By the park's west gate stood a bookshop, and we soon noticed that on days we visited the park, two men who clearly had absolutely no interest in books would spend the afternoon on the bookshop balcony, drinking tea, chain-smoking, and taking pictures of the parking lot below.

One day in the spring of 2012, we were walking in the park with our friend Xia Xing. Ai Lao was dozing off on his mother's back, his

arms wrapped around her shoulders. Suddenly Xiao Pang hurried over and said, "You see those two men over there? They've been tailing us the whole afternoon." I had reached the end of my tether with this incessant harassment, so I took chase, with Xia Xing close on my heels, and soon I caught up with one of the spooks, a middle-aged man in a blue T-shirt, a camera bag slung over his shoulder.

"Hey, you dropped something!" I cried, but he quickened his pace without looking back. I grabbed his camera bag, and as we scuffled, a small Olympus camera fell to the ground. Xia Xing swiftly picked it up and removed its memory card before returning it to its owner.

It was dusk by the time we got back to the studio, and my staff had left for the day. When I inserted the memory card into my computer, the pictures that came up on the screen left me dumbfounded. In one series of photos, our driver Xiao Pang sat on a bench in the park; there were close-ups of his back and his legs. I saw the Din Tai Fung restaurant, where we had eaten the day before, with photos of its exterior, its hallway, its private rooms, and its cash register. What I found most chilling was the pictures of the stroller in which I pushed Ai Lao around. What father would not recoil at the thought that he cannot protect his own child? I could practically feel a lurking assail-

ant breathing down my neck. The memory card gave me a peek into the mindset of my adversaries, the details that they so compulsively monitored, the digitization of living human subjects, now flattened and formatted into data that could be accessed as needed.

Power, spreading its tentacles everywhere, revealed my vulnerability, but it was not directed solely at me—its attention was directed at every individual, for everyone has soft, hidden places that they don't want others to touch.

Despite the ever-present threat of government intervention, I was now more than ready to resume my role as a provocateur. My war with power was a bit like an online game: each time I died, I came to life again. Power might use all kinds of tactics to attack me or monitor me, but I could turn those tactics into an advantage, through public activity and through creative ripostes, maintaining the role that they least wanted me to play—that of a mass-oriented activist and artist. Freedom of expression became a central meaning of my art, for personal freedom is the highest value that we can know.

In some ways I was pessimistic, because I was living in an era when it was enormously difficult to effect even the smallest change. In other ways, I was optimistic, for the individual's yearning for freedom can never be repressed—it always finds expression in one form or another.

IN LATE 2012, I accepted an invitation to attend Elton John's first-ever performance in Beijing. Before the show, Wang Fen and I took Ai Lao backstage to meet the British singer. He was all by himself in the dressing room, his performance outfits lined up on hangers and a whole row of spectacles, in every style you can imagine, laid out on the table. Elton greeted us warmly and gave Ai Lao a hug, then posed for a picture with him and gave him a pair of glasses with bright red rims.

Five thousand high-spirited fans had come to watch the show, and after the first batch of songs Elton John turned away from the piano

and stood up to address the crowd. He was dedicating this performance, he announced, to someone he admired for his courage and inspiration. Then he said my name. His next few words were drowned out by applause.

Out in the audience, I was overcome with embarrassment. But it boosted my morale to hear another artist emphasize his commitment to the freedom of artistic expression, whatever the consequences. Elton's generous act reminded me of the bond between my father and Pablo Neruda, a friendship that transcended the enormous physical distance between them and the obstacles put in their way. Later I heard that after the show, Elton's dressing room was sealed off by the police. He will not be able to come back and sing again for his adoring Chinese fans.

In May 2013, with the help of my rock singer friend Zuoxiao Zuzhou, I recorded a song entitled "Dumbass," along with a music video re-creating scenes from my incarceration—something that people were eager to know more about. On YouTube I circulated *The Divine Comedy,* the first rock 'n' roll record that Zuoxiao and I had made together. Around this same time, I completed a set of large sculptures called *S.A.C.R.E.D.* Inside six iron boxes, we realistically re-created the cell space in which I had been confined, like a diorama illustrating the life of primitive man. When this work was exhibited in Venice, my mother—now in her eighties and on her last trip overseas—was able to peer through a small window in one metal box after another and get a glimpse of how I spent those eighty-one days.

As a subtler form of protest, outside the studio gate, I leaned a bicycle up against a young ginkgo tree, and at nine o'clock every morning I would place a bunch of fresh flowers in the bicycle basket, take a picture, and post it on Instagram. I had begun to use Instagram on August 7, 2011, a month and a half after my release from detention, sharing things that happened in my life and selfies taken with people I met. Now I planned to maintain this ritual of photographing fresh flowers each day until I had recovered my passport and regained my freedom to travel. The flowers would serve as a living symbol of the

loss of liberty, and they made for a benign, lyrical form of resistance, silent but beautiful, refreshed daily, no matter how inhospitable the weather. Art always engages with the uncertainty of life, and empathy and trust are prerequisites for any fruitful discussion. The act of putting flowers in the basket established just that kind of connection. I could be disappeared, but art could not, just as my father's poetry continued to live on in people's minds even when he was in exile.

In April 2014, my *According to What?* solo exhibition opened at the Brooklyn Museum, its last stop on a multicity tour. At the same time, I was busily preparing new work that would be exhibited that autumn on Alcatraz Island, the former U.S. federal penitentiary in San Francisco Bay that was once used to incarcerate the "worst of the worst." I saw this project as a precious opportunity to connect my predicament with the struggle of political prisoners all around the world. I designed a series of installations, including, laid out on the floor like ancient Roman mosaics, large portraits made with Lego bricks of 176 political prisoners then under confinement in many different countries. I wanted to show solidarity with them and affirm respect for their struggle.

I recalled how deeply my father was stirred when, during his long banishment in Xinjiang, he received a postcard from one fearless, ad-

miring reader telling him that his poetry was not forgotten. What captives yearn for most is confirmation that the outside world exists. Accordingly, in a section of the exhibition entitled "Yours Truly," visitors could, as they chose, write messages on postcards pre-addressed to innumerable prisoners of conscience. Many did so.

Although the struggles that I faced involved me as an individual, I didn't feel alone. I was forbidden to travel, but this forced immobility didn't adversely affect my work; instead it gave me sustenance. For me, inspiration comes from resistance—without that, my efforts would be fruitless. Having a real—and powerful—adversary was my good fortune, making freedom all the more tangible—freedom comes from all the sacrifices you make to achieve it. Limitations come only from a fear inside the heart, and art is the antidote to fear. I did not need sympathy, for courage itself is an aesthetic feeling, and it's only when true feeling is transformed into something broadly understood that art can avoid drying up.

Also in 2014, while preparing a large solo exhibition in Berlin, I contributed work to the *Don't Follow the Wind* exhibition, in the exclusion zone of Fukushima, Japan, evacuated after the earthquake-triggered nuclear disaster there in 2011. Along with twelve other artists, I created work to commemorate the incident and reflect on its impact on the lives of tens of thousands of displaced residents. In one of my pieces, *A Ray of Hope,* I installed solar-powered lights in one of the abandoned houses to provide illumination for the house's future inhabitants, placing snapshots of Ai Lao and me on a cabinet and bookshelf. Every evening, in this empty house in this ghost town, the lights go on, unnoticed. One day far in the future, when the radiation fully dissipates and people can safely return, my work will finally be seen.

BACK IN FEBRUARY 2011, shortly before my solo show at the Ullens Center for Contemporary Art (UCCA) in Beijing was due to open,

the curator had told me that the show had been canceled. He had given no detailed explanation, telling me only that it was for "reasons that you know." For years UCCA had served to promote Chinese society's newfound openness, but it was business profits (contingent on harmonious relations with the authorities) that were the ultimate concern. Two months later, on the very day that I was pulled aside at the Beijing airport and led off to secret detention, Sotheby's in Hong Kong auctioned off a portion of Guy Ullens's collection of contemporary Chinese art at a price of 427 million Hong Kong dollars (almost US$55 million).

Now, in April 2014, something similar happened when Shanghai's Power Station of Art's *15 Years Chinese Contemporary Art Award (CCAA)* exhibition opened. Twenty minutes before the opening, several special visitors arrived at the gallery. They were officials from the Shanghai Cultural Affairs Bureau, and at their insistence my name was removed from the list of artists on the wall of the exhibition hall. When Uli Sigg, one of the guests of honor, entered the gallery, he saw workers using a hair dryer to dry the wall where my name had just been painted over. My Swiss friend was so puzzled by this, he photographed the absurd scene with his phone and sent it to me. In his speech at the opening ceremony, Sigg tactfully expressed his dismay at this interference: "I very much regret that suddenly, just before the opening, one of our major artists cannot be exhibited here." The interpreter made sure to leave this out of the Chinese translation.

I had been awarded the CCAA Lifetime Achievement Award in 2008 and had been on the selection committee for the previous three prizes. Some forty Chinese artists' work was on display at this exhibition, and they all knew me and my work, but not one of them stood up to object. It was as though the censorship had never happened, as though airbrushing me out of the picture was perfectly normal.

Tolerating the distortion of history is the first step toward tolerating humiliation in real life. To register my protest, on Instagram I posted a photograph of the boxes of my ceramic sunflower seeds that

had been moved out of the exhibition hall and were now locked away in an office.

The following month, the exhibition *Hans van Dijk: 5000 Names* opened at UCCA. This retrospective showcased Hans's contributions to Chinese contemporary art in the 1990s, demonstrating the special significance of that period. Three of my works were featured, but I soon found that my name had been omitted from the list of participating artists on the press release: the list began with the letter C and ended with the letter Z, with no sign of me anywhere. And in the exhibition's account of Hans's career, there was mention only of him collaborating with "other people" to set up the China Art Archives and Warehouse, thus erasing his collaboration with me from history.

I immediately called the museum director and told him I could not accept this way of doing things and was withdrawing my work from the exhibition. As Hans's friend and collaborator, I wished to remain true to the memory of our association. Later, when I asked the police why my name and my works had been suppressed, their answer was "You know we don't get involved with foreign galleries. This is their doing—sue them if you like."

By now, numerous foreign galleries were trying to squeeze their way into the Chinese scene, eager to serve up another dish in the great banquet of globalization. Just days after I was disappeared in April 2011, a Sino-German blockbuster show, *The Art of the Enlightenment,* mounted at great expense, had opened in the National Museum of China, in Tiananmen Square. This is said to be the largest museum in the world, but for much of the time the exhibition halls were largely empty. A few Chinese officials may have paid a formal visit, but it's highly unlikely that this would have led to any enlightenment on their part.

You have to wonder why these organizations insist on traveling so far to seek their own humiliation. But in a perverse way, dictatorship in China has served as a perfect partner for the free world, doing things that the West cannot do, and the occasional humiliation is seen

as an acceptable price to pay if it enables continued glory and prosperity for the Western partner. Sadly, the freedom that Westerners so enjoy loses its meaning if the West does not fight for freedom elsewhere.

My blacklisting stemmed directly from my understanding of art as a form of social intervention, promoting the values of justice and equality. When people blur right and wrong, what takes over is pragmatism and a preoccupation with what is expedient. UCCA's director told a *New York Times* reporter that the reason I had launched a protest was that I don't like quiet openings—a glib comment that completely failed to excuse the act of self-censorship.

Real choice is difficult, because the meaning of choice emerges only in difficulty itself. To know a period of history is equally difficult, for so-called history is a part of self-knowledge. In the face of authoritarianism, most curators and artists lose the power of speech, nullifying aesthetics and ethics with their moral compromises. I myself do not have it within me to compromise. But in this echo chamber, to give a hoarse battle cry elicits nothing but a hollow reverberation. Today's censorship touches on all aspects of life—from the internet and newspapers to books, concerts, and art exhibitions. It nullifies the individual's sense of self and experience of life: ideas give way to compliance, speech becomes flattery, and existence is reduced to servility.

In this environment, censorship bestows on willing collaborators many practical advantages. All they need do is accommodate themselves to the demands of power, knowing that if their masters were ever made to feel uncomfortable, they would have no way to survive, because the order in which they prosper was never the result of free competition. To lead a prosperous life under censorship requires savvy and a cooperative spirit; the rules of play are primitive and simple, but impossible to ignore. If you're not prepared to make a name for yourself through resistance, the only way to win distinction is through bowing and scraping.

Any inquiry into freedom of expression is bound to raise ques-

tions about the legitimacy of state power. That explains why nobody was willing to talk about freedom of speech, why my name was everywhere blocked, why I was reduced to a virtual existence. Authoritarianism fears art that operates on multiple levels, with multiple meanings.

If my protest at the *5000 Names* exhibition had been limited to the removal of my pieces, this would not have excited much controversy. What disturbed many in the art world was that I had asked others to take a stand, too. According to one view, I was denying the "negative freedom" of the other artists—in other words, their freedom to enjoy the right to not do anything at all.

In a state that does not guarantee citizens' political rights, freedom of expression, or freedom of association, where does "negative freedom" come into the picture? In this slyly evasive China, "negative freedom" is just another term for cynicism and cowardice.

In the end I realized that what I was facing was not simply a huge, arbitrary political system but an expanse of barren territory where freedom was mocked, betrayal was encouraged, and deception was praised.

ONE MORNING IN MARCH 2014, the doorbell rang. Xiaowei opened the door to the compound and two strangers entered, one holding such a huge bouquet of carnations that I could hardly see his face. The older of the two visitors, a section chief from public security, spoke first. "Today is March 27, a very significant day."

At first, I didn't know what he was talking about. Then he explained: it was the 104th anniversary of Ai Qing's birth, and his superiors had told him to deliver flowers in my father's honor. He asked where they should put the bouquet and whether there was a bust of my father in the house.

There was no bust, and I had not even registered that this was Father's birthday.

My father had been a first-generation revolutionary, the visitor noted. "What we are doing now has to stand up to history's scrutiny." My situation would improve, he promised, and he even named a date when I could expect the return of my passport. "Believe me, I wouldn't try to mislead you," he promised.

But I didn't recover my passport on the date that he mentioned. Instead, on that day a state security agent opened the trunk of his black sedan and presented me with a pack of beef jerky, a carton of tea, and a live giant salamander—a rare creature that I had never seen before in my life—along with a set of tips on how to cook it. (I remember only the first line of the instructions: that you need to nail it to a chopping board and then cut it into pieces. We did not do this, and kept the salamander as a pet.)

The agent and I chatted in the street for a good half hour. "Don't meet with the Canadian foreign minister when he visits China next week," he warned, making no effort to conceal how closely they were monitoring my social engagements; the only people who I thought knew of this event were the political attaché in the Canadian embassy and the ambassador himself. As the policeman left, he told me that the "higher-ups" were anxious to avert any further publicity and hinted that they would not be able to return my passport for a while yet. But it would just be a matter of time, he assured me, and I would need to be patient. "You have such influence, and with Hong Kong already in an uproar over the Occupy Central movement, there's concern that you could cause more trouble."

"Wasn't it you people who made me so influential?" I said.

Before dinner that evening, I received a phone call from another security agent, the one who had driven me home after my secret detention. He asked if I could look after two turtles that he had bought for his father, who had turned out to be too old to care for them. That evening, Xiao Pang met the man at the entrance to a park and took possession of the turtles.

The two turtles, which were from Brazil and had unusual markings on their shells, lay motionless in a wooden crate. The man gave Xiao Pang feeding instructions and a note specifying that at one o'clock every afternoon they needed a warm-water wash that would help promote a regular defecation schedule. The consistency of their excrement also required observation: if white lumps were not visible in the discharge, this meant they were ill and would need to visit a pet hospital. Xiao Pang was none too thrilled about adopting this pair of turtles, but I felt we ought to respond kindly to the agent's appeal for help. He trusted us, and he had nobody else to turn to.

Although the authorities took no further steps against me, things got bleaker in the summer of 2014, when the police arrested a number of my acquaintances. The lawyer Pu Zhiqiang was detained simply because he had attended a small gathering on the twenty-fifth anniversary of the 1989 democracy movement; other human rights lawyers were also arrested.

In the middle of June, a man about my age appeared one day at the entrance to the compound in Caochangdi. It emerged that Ai Xiaoming, the filmmaker who had gathered signatures in support of me, had asked him to deliver something. He handed me a beat-up old suitcase, declining my invitation to come inside. As he made to leave, he asked if he could have a few sunflower seeds, to pass on to a rightist he knew. "Might that be your father?" I asked. He nodded, and as I watched him walk away down the street, I saw myself in him.

When I opened the suitcase, inside I found a number of whitened bones wrapped inside old newspapers. Human bones—part of a skull, an assortment of ribs and vertebrae, part of a pelvis, some toes—they all came from Jiabiangou, in Gansu Province. In the late

Remains, 2015

1950s, thousands of rightists were exiled to the desert there for reform through labor; the vast majority of them died of hunger and disease, their bones scattered in the sands. Ai Xiaoming had come across these remains when she was making a film about this episode. Recalling my works commemorating the children who died in the Wenchuan earthquake, she had collected these physical vestiges of another appalling human tragedy.

I laid the bones down one by one on my table. They had passed more than fifty springs and summers in those barren wastelands, illuminated only by sun and moon and stars. Like dead trees, they had lost color and breath and every trace of life, although strands of desiccated tissue, like a knot of fraying cords, still clung to one of the bones. There was no way to restore any real order to these fragments of a human skeleton.

Holding them in my hands, I was reminded of one of my father's early poems:

> *Several millennia from now,*
> *On a deserted seashore*
> *In the ruins of a once thriving place*
> *When they pick up a bleached bone*

—A bleached bone of mine
They will never know
It was burned in the flames of the twentieth century
Who could ever find among those layers of soil
The tears of those pitiful victims?
Their tears had been sealed away
Behind endless rows of iron fencing
And there was only one key
That could open the gate
The countless stalwarts who tried to seize the key
All fell beneath the warders' weapons
If ever one could retrieve such a tear
And keep it by one's pillow
It would shine more brilliantly
Than a pearl from the deepest ocean
And illuminate eternity!

Have we not all
In our own era
Been nailed to a cross?
And that cross was
No less painful
Than the cross to which the Nazarene was nailed.
The enemy's hands
Have placed on us a crown of thorns
The dark red drops of blood that flow down
From our gashed and pallid foreheads
Never fully expressed
All the grief and rage in our hearts.
Of course, we should have no great illusions
But we do hope one day people will think of us
The same way they think of those remote ancestors
Who wrestled with huge wild beasts
And on their faces will appear an easy, open smile

Perhaps a little too serene
But I am perfectly willing
To die for such a smile.

<div align="center">("SMILE," 1937)</div>

In August 2014, I watched as Wang Fen took the hand of Ai Lao, now four years old, and they walked off slowly together toward the departure lounge at the Beijing airport. They were going to fly to Berlin, where the studio I had been setting up during the previous three years was now complete. Like me, Ai Lao was following in the footsteps of my father and leaving the country of his birth. Years from now, he would understand why that was necessary. In my mind, this was a brave step for them to take.

Before they left, Ai Lao said to me, "Here's a poem that I want you to have when I am eight. I am giving it to you ahead of time—it's about the five-year-old me."

The wind blows westward
The water flows eastward
I stand here
Remembering this lovely scene

Three years ago
When I was still a little kid
I was already smart

Goodbye, nation.

As Wang Fen and Ai Lao passed out of sight, I felt a weight had been lifted. I no longer needed to worry whether they were somewhere safe. In the previous five years—except when I was disappeared—I had watched Ai Lao grow up day by day, at the same time hoping he would never grow up, wishing he would always be able to ride on my shoulders as we strolled by the pond, catching dragonflies above the

Ai Lao's Frozen Hammer, 2015

lotus leaves or katydids on the lawn. But at this moment, it was not at all certain I would be able to see them again.

Later, in one of our video chats, Ai Lao told me he had put a hammer in the freezer. "It's a present for you," he said. "The hammer represents Ai Weiwei. No matter how much hassle he gets from the police, Ai Weiwei is always Ai Weiwei—he's not going to change. When the ice thaws, the hammer is still the hammer."

ONCE, WHEN WE WERE talking on the phone, he told me to stop saying I missed him. "As time goes on, you'll get used to it," he said, very matter-of-factly.

When our conversation was over, he told Wang Fen, "Do you remember that time a few months ago when I cried after talking to him? I was thinking Ai Weiwei wouldn't be able to leave, that they would never let him leave."

Another time he asked me suddenly, "Ai Weiwei, was it the police who detained you, or was it the Communist Party?"

I was stumped for an answer. If I had been able to respond to that question clearly, other problems surely would have also unraveled,

like garments whose stitching had come loose. Ai Lao's question was one that had vexed me for a long time—it touched on issues of political legitimacy, and also on my identity.

On December 16, 2014, Ai Lao wrote for me, in Chinese characters, "Heart calm and good." It was an aphorism of his own invention: If the heart is calm, you'll do things well.

"I find that bad people are all strong," Ai Lao said. "They need to be strong to do bad things. And so, if you want to be stronger, you need to do some bad things—but not too many, otherwise you'll become a bad person yourself."

Wang Fen told him, "Your dad says there's nothing perfect in the world. What do you think?"

"Yes, there is," Ai Lao said. "Life is perfect."

"Don't always keep thinking about things being fair or unfair," he added. "Sometimes, what's unfair is fair. For example, if you get something that someone else doesn't have—that's not necessarily unfair, because maybe he already has more stuff than you."

JUNE 21, 2015, WAS the day before the fourth anniversary of my release. The skies over Beijing had been clear for more than a month, and it was sheer delight to feel a soft breeze wafting over my face and to breathe the clear air. I had been writing steadily for quite some time, and it was as though my consciousness had detached itself completely from everyday routine, steeped as it was in imaginings of the past. But on this day I felt an urge to find the place where I had been incarcerated: it had gnawed at me, lurking in my mind as a symbol of a hidden power so strong it disrupted my internal coordinates and challenged my sense of self. I wanted to see the place once more, this time with fresh eyes. So Xiao Pang and I got in the car.

During my detention I had been unable to pick up any information about the prison's location; the guards were equally in the dark about where exactly they were. But after my release, one of them,

having completed his service, came to see me, and he showed me a selfie he had taken in his sleeping quarters. I noticed that there was a window behind him, and through it one could faintly make out an apartment building. On one occasion, the guard recalled, the company commander had let slip mention of a place called "Vineyard." Later, Google Maps helped me track it down.

That day, as though aided by some uncanny power, our car threaded its way through a large swath of Beijing, never taking a wrong turn, and led us like a magnet to the place I was seeking. We pulled up next to a residential compound. To its right was a small park.

Beneath a high-rise apartment building, a middle-aged woman was chatting with someone walking a dog. At the end of a path, close to the perimeter wall, I glimpsed the two-story building where I had been detained. It was on the other side of the wall, flanked by an electrified fence and surveillance cameras. The building's appearance conformed exactly with the image of it in my mind: they were like two parts of a broken jade disk that, placed together, leave not the slightest gap. I climbed up to the top of the adjacent apartment block, gazed down at the building where I had been held, and took a picture. Then, elated, I called Wang Fen to report my find.

BY THE SUMMER OF 2015, the authorities seemed no longer to be anxious that I would make a nuisance of myself in Hong Kong. My four years of house arrest had ended; the bicycle basket outside my studio had been decorated with fresh flowers every day for exactly six hundred days. On July 18, state security agent Zhao quietly handed me my passport as we sat in his car. I took a selfie with my passport in hand and posted it on Instagram. Now, at last, I could go to Berlin.

Where I would go in the future was a matter of no little concern to public security. They did not like the idea of my going to the United States, even if that was the Western country where I had spent the most time. Germany, in their view, was a preferable option—indeed,

they asked me to submit a formal application to travel to Germany for a follow-up examination of my head injury.

China and Germany, during this period, enjoyed close economic ties. Xi Jinping had visited Germany in March 2014, and in July of that year Chancellor Angela Merkel visited China for the sixth time since taking office. From January to August 2014, the total volume of Chinese-German trade came to $117.3 billion, a 12 percent increase over the same period in the previous year. More than two thousand Chinese-investment enterprises were operating in Germany, and soon China would become Germany's largest trading partner. In just a few days, through an expedited process, Germany approved my visa application.

I also had plans to visit Britain, where I was due to hold an exhibition that autumn at London's Royal Academy of Arts. My application for a six-month visa to the UK ran into difficulties, however, when the British embassy in Beijing claimed that I had failed to come clean about a criminal conviction—a reference to the accusation of tax fraud. I did what I could to clarify things, pointing out that I had been framed and kidnapped because of my opposition to the Chinese government, and I had never been officially prosecuted, but this explanation cut no ice with the consular officers. In the end, the UK home secretary, Theresa May, had to intervene.

American diplomats in Beijing, for their part, did invite me to visit the embassy and meet with the ambassador, but the first thing I was asked when I got there was "Why aren't you coming to America?" I could only sigh: I had just managed to drag one foot out of the mud, and I still had a long way to go.

Shortly before my departure for Germany, the authorities tried to retrieve listening devices they had planted in the walls of my studio, which I had uncovered. (I had celebrated my discovery by setting off firecrackers right next to their transmitter.) But I preferred to keep the devices as a memento. "These things are secret," I told the police. "They don't exist. How can I return to you something that is not supposed to be?" To this day, they are still in my possession.

A listening device discovered at 258 Caochangdi

On July 30, my friend Xia Xing and I went to the airport under the "protective escort" of public security, and we were taken to a special waiting area that was decorated in exactly the same style as the reception rooms in the Great Hall of the People, with comfortable armchairs, a large carpet, and pictures on the wall. I was given my boarding pass and led to the gate where the flight to Munich was waiting.

If there was one person in the world I was now eager to see, it was Ai Lao. I wanted us now to always be together. The flight landed in Munich at five o'clock in the afternoon. I got through customs quickly, before Wang Fen and Ai Lao had arrived, and I spied them in the distance as they made their way toward me. Although I knew how happy they were to see me, they made no dramatic show of emotion, and it was as though we had never been apart. But Ai Lao said that Wang Fen and I were his only two jigsaw pieces, and now he could put the pieces together.

Ai Lao's bond with me reminds me of the bond I had with my father, for Ai Lao grew up early, just as I did. I endeavor always to do right by him. No matter whether he is nonchalant or indifferent, he is my final arbiter, and his approval will be the ultimate measure of whether

my efforts have paid off. When I remember my father, the regret that I feel stems from my lack of curiosity about the difficulties he endured, and from the lack of empathy and understanding I showed when I was younger. During those long weeks in secret detention, my fear was not that I might not be able to see my son again, but that I might not have the chance to let him really know me. So the idea came to me that if I was released, to bridge the gap between us, I should write down what I knew of my father and tell my son honestly who I am, what life means to me, why freedom is so precious, and why autocracy fears art. I hoped that my convictions could become something he could see and feel in his heart and mind. That way, if one day Ai Lao wanted to know more, it would be there—my own story, and his grandfather's.

MY PAST AND MY present have become disconnected, like the skeleton of a dead animal whose bones have long lost connective tissue, and despite my best efforts I still find it hard to present the entirety of my experience. This same puzzle is found in my art. Though I am unsure to what extent my environment has influenced me, this never weakens my sense of responsibility to reality. As with someone trekking at night through the rain, every step I take brings me closer to the place I want to go, but where is it I want to go?

Because art reveals the truth that lies deep in the heart, it has the capacity to impart a mighty message. As I see it, any advocacy of freedom is inseparable from an effort to attain it, for freedom is not a goal but a direction, and it comes into being through the very act of resistance. As an artist, I have a responsibility to turn that belief into something fascinating and breathtaking. Even if my art at times seems insubstantial in comparison with all that I am up against, it will endure as a part of the tangible record. I continue to press for equity, for equity offers the fullest possible realization of the individual's interests in a group context. Or as Ai Lao has put it, "Fairness means making everyone happy."

Despite all the difficulties I encounter, I hold steadfastly to my chosen path, consciously engaged in my mission, unperturbed even if I find myself standing at the edge of a chasm, grateful for the possibilities offered by the unknown.

I am not concerned about how far I can go in my journey or where the journey will take me; no matter what happens in the future, I undoubtedly will be part of that future. For me, the worst thing would be to lose the capacity for free expression, for that would mean losing the motivation to recognize the value of life and make choices accordingly. For me, there is no other road I can take.

The rights that I have strived to defend should be for all to enjoy, but any adverse consequences are for me alone to bear. Awareness of this point gives me mental strength. I am reminded of lines my father wrote after visiting the ruins of an ancient Silk Road city in Xinjiang:

Of a thousand years of joys and sorrows
Not a trace can be found

You who are living, live the best life you can
Don't count on the earth to preserve memory

The efforts we make, the mishaps we encounter—all count as repayment for living.

At this point, what more can I add? I need to stop here, for in these memories there is little that is wholly mine. I stumbled on those parts that never belonged to me, like a spider that cannot make a proper web and whose every struggle only destroys the silk it has already spun.

I have lived through a remarkable era whose blessings and misfortunes alike testify to its glory, and together they fashion a kind of truth. But at the same time, the illusions of life continue to shape my existence. So let me put it this way: In those months before I was able to rejoin Ai Lao, I wrote down what I would have preferred not to remember, for it is these recollections that help me forget.

Afterword

IN LATE DECEMBER OF 2015, WANG FEN AND I TOOK AI LAO TO the Greek island of Lesbos. It would be our first time traveling together since I recovered my passport. In the months leading up to our trip, a dozen or more boats had been arriving daily on Lesbos and disgorging refugees from Syria, Iraq, and Afghanistan. When I arrived there and saw the ever-worsening refugee crisis firsthand, I had to completely rethink what had been my plans.

That day, the Aegean Sea lay before me under an azure sky. In the far distance, I saw what looked like an orange raft making its way slowly across the water, toward shore. As it came closer, I could see it was a rubber dinghy, crammed full of refugees wearing orange life jackets. My first real-life encounter with a group of migrants fleeing their war-torn homeland, it broke apart all preconceived notions and confronted me with a world of suffering and desperation. Seeing that boat stirred me so deeply, it had the force of a sacred revelation.

As the boat approached the beach, I could hear the wails of the babies on board, mingling with the cries of adults. Then, one after another, women in long dresses and bearded men clambered out of the dinghy and stumbled their way onto dry land. Some were so weak they had to be carried ashore, only to collapse on the beach in exhaustion.

Even though I witnessed this scene with my own eyes, it took some time for me to fully understand what I had seen. I wanted to know who these people were, and what had brought them to this foreign shore. Amid their anxious yells and sobs, I could see that there was a silence deep in their hearts, for this was not their home and they were not looking for assistance and sympathy. I sensed how alien and unwelcoming this new land must be to them. Seeing their misery, I felt a part of myself dying.

In the months that followed, I filmed a documentary on the crisis, and to better understand its causes and consequences, I began to travel widely: to the refugee camps in eastern Turkey, adjoining the war-torn areas of northern Syria; to the Palestinian refugee settlements in Lebanon, now more than sixty years old; to Jordan's huge Syrian refugee camps and the no-man's-land on its northern border. I went to Jerusalem and the blockaded Gaza Strip, and, later, to the U.S. border with Mexico.

I visited a newly established refugee shelter at Tempelhof, formerly one of Berlin's main airports. But I couldn't find anyone who was willing to admit that it was now simply a refugee camp, because ever since the Second World War, Europeans have resisted the idea of such tragedies taking place on the continent. I traveled to Idomeni, on the border between Greece and Macedonia, where more than ten thousand refugees from Syria, Afghanistan, Iraq, and Pakistan were stranded: the road leading northward to Europe had been closed suddenly, shattering the hopes and dreams of countless displaced families. And after several months of filming and interviews, I came to more fully understand the scale and severity of this dire humanitarian crisis.

During this time, there were constant reports of refugees drowning as they attempted the sea crossing; in 2015 two children drowned daily in the Aegean Sea, and eventually people grew weary of hearing such stories. In most European countries, migrants received no assistance, and discrimination against the survivors of armed conflict was often no less vicious than the wars many were fleeing. Most poi-

gnantly, the dangers of the journey and the struggle facing the refu-
gees on the other shore did not weaken their resolve to make the
passage. They continued to surge forth like a flood, preferring that
their children survive amid prejudice rather than see their lives imper-
iled in the war-torn ruins of their homeland.

I think back to my father and the dilemmas he faced and the
choices he made. When a man meets adversity, he yearns for the next
generation to be spared the same hardships: children represent the
exile's ultimate hope, for if one loses one's child, one's exodus is fu-
tile. My father, my son, and I have all ended up on the same path,
leaving the land where we were born. A sense of belonging is central
to one's identity, for only with it can one find a spiritual refuge: as the
Chinese saying has it, "It's once you're settled that you can get on
with life." Without a sense of belonging, my language lost, I feel on
edge and unsure about things, facing an equally anxious world.

Lesbos helped me realize how I came to be incomplete, and it
helped me see how the life of exile that afflicted my father is also
coming to shape my own child, just as shadow follows form. Since
2011, when the Syrian conflict began, close to ten million refugees
have been driven from their homes, leaving the places where their
memories are lodged and losing touch with their language and emo-
tions. When an individual's memory or a people's memory cannot
endure, the sadness that remains is a bottomless black hole.

Refusing to forget endows life with a new reality, and that act of
resistance has become my mission. In 2016, I decided to wrap the clas-
sical pillars of the Konzerthaus Berlin with several thousand life jack-
ets, and for my *Law of the Journey* exhibition, in Prague's National
Gallery, I designed a two-hundred-foot-long rubber boat filled with
260 rubber human figures. In 2017, in the course of putting together
the documentary *Human Flow*, I collected clothing worn by refugees
as they were herded from place to place in Europe. Often they would
jettison items that they had brought from home and that for a while
had furnished some warmth and comfort on their endless journey. In
evacuated refugee camps we picked up abandoned children's shoes,

women's scarves, and men's jackets, and I shipped all the discards back to my Berlin studio, where they were cleaned and cataloged. With this project I hoped to signal to those who enjoy secure lives that we all share a similar physical form, and it is only our circumstances and memories and views that differ. If we think along these lines, could this not help put an end to rejection, estrangement, and hostility?

My works relating to migrants are consistent in form with the projects that have interested me in the past. Whether my status is seen as that of an artist, an activist, or a citizen, I always seek to integrate these various roles and create an effective interplay between form and language in my explorations, documentary recordings, and exhibitions. My focus on the refugee crisis gave me the opportunity to move beyond the arena of resistance to China's authoritarian government and engage in more universal observations about human nature, and to more fully express my understanding of human rights.

Artistic creation, being so personalized, commonly stands in stark opposition to a state's agenda, and my work typically has an antagonistic dependence on the will of the group and the will of the state. No one can rid themselves of the imprint of their era's language and culture, and art serves simply as a pioneer for collective reflection: it offers a chance for a group, or a nation, to become alert to an issue, and to enhance its awareness of things.

My understanding of freedom puts me, as a political exile, at odds with the authoritarianism practiced by my native country. By choosing to leave China, I have lost a sense of belonging and a secure foundation, drifting like duckweed on the current. But now my country is in much the same predicament, because it rejects memory and refuses to honestly address the task of building a healthy society and establishing a legitimate polity. Although China grows more powerful, its moral decay simply spreads anxiety and uncertainty in the world.

Today, more and more people are being forced to leave their ancestral homes, for all kinds of reasons—war, religious discrimination,

political persecution, environmental degradation, hunger, poverty. Will we ever be able to eliminate these scourges? Can a civilization that is built on the misfortune of others carry on forever? And who can be sure that they themselves will not one day be torn from their homes and cast onto a foreign shore, only to encounter discrimination and be forced to beg for sympathy?

The fates of our three generations—my father's, my son's, and my own—are tightly linked to the fates of countless people we have never met and will never know. This gives me all the more reason to say what's in my heart, to share with others, and to make myself heard. Self-expression is central to human existence. Without the sound of human voices, without warmth and color in our lives, without attentive glances, Earth is just an insensate rock suspended in space.

ACKNOWLEDGMENTS

THE IDEA OF WRITING THIS BOOK CAME TO ME AFTER I WAS taken into police custody in 2011. During that period of enforced isolation, I felt a need to think through my relationship with my father, Ai Qing. Although he and I were not emotionally close, our connection has undoubtedly played a role in determining the road I have taken and the position in which I find myself. I have experienced some of the personal struggles and larger political difficulties that he encountered, and like him I have been labeled an enemy of the state. Thus I resolved to write an account of his life and mine, and to share this memoir with my son, Ai Lao, who at the time of my arrest had just turned two. When I was released, after eighty-one days in detention, the first thing I did was to start recording my story on tape, beginning with what happened during my disappearance, to preserve a detailed account while the events were still fresh in my mind.

I want first of all to thank Peter and Amy Bernstein, through whose good offices I was able to sign a publication agreement with Penguin Random House. For this I am enormously grateful.

It is almost ten years since the day of my arrest, and I rejoice at the completion of this project, not least because I am conscious of how ill-equipped I was when I began to take on the task of addressing the

events and historical realities with which my book grapples. In this connection I wish to thank the following authors of earlier accounts of my father's life: Cheng Guangwei, Luo Hanchao, Ye Jin, and Zhou Hongxing. I often made use of the materials and detailed timelines that they included in their studies. I also gratefully acknowledge the selfless contributions of the members of my studio team who fact-checked myriad details of both family history and national history—history often complicated by ambiguity and imprecision in the written record. I particularly want to recognize the unstinting efforts of Xu Ye, who was engaged in this work from start to finish. Among my other studio colleagues, Jennifer Ng and Sun Mo also assisted me in fact-checking and proofreading, while Kimberly Sung, Chin-Chin Yap, and Li Dongxu helped with editing the illustrations and photographs. I wish to also thank Margarita Fjodorova and Pierpaolo Pregnolato from Damocle Edizioni, who arranged the cover fonts for the book.

I want to extend my sincere thanks to the editors at Crown who placed their trust in me and shepherded the manuscript along. In the first round of editing, the invaluable advice I received from Rachel Klayman and Meghan Houser gave me a clear sense of direction as I began to revise. I also profited from the guidance of the second team of editors, Gillian Blake and Libby Burton, who suggested significant structural changes; their expertise and helpful advice on how to enhance the book's readability enabled it to reach its final form. I also thank David Drake and Molly Stern, whose suggestions and encouragement were crucial.

I would like to extend a special thanks to my translator, Allan Barr. I feel very fortunate to have been able to collaborate with him. A deep understanding of Chinese history and culture informs Allan's rendering of my Chinese text, and his natural, straightforward language has done much to compensate for the deficiencies of my own writing. By maintaining a clarity and suppleness in the narrative, his translation has done a great service to English readers.

Finally, I want to thank my mother, Gao Ying, and my sister, Ling-

ling, who helped to locate materials and verify details, and my brother, Ai Dan, who cheered me on and provided writing advice. I also thank my partner, Wang Fen, and our son, Ai Lao; without their support and understanding during these past ten years, it would have been very difficult to finish this book.

Ai Weiwei

MARCH 4, 2021

ART CREDITS

Cover design by Ai Weiwei

Late-1800s Venetian wooden type font,
selected for the cover
by Margarita Fjodorova and
Pierpaolo Pregnolato (Damocle Edizioni)

Page 27: Cup of the liner *André Lebon*
M. M.–CCI Aix Marseille Provence Collection,
photography copyright © Marie Caroll. Reprinted by
permission of Marseille Cultural Review.

Page 42: Courtesy of Jiang Feng.

All illustrations are original drawings by Ai Weiwei
unless otherwise noted.

All photographs in the inserts are
courtesy of the author.

ARTWORK DESCRIPTIONS

Ruyi, 2006

39 *Ruyi* is a traditional Chinese ceremonial scepter that symbolizes fortune and immortality. Ai's porcelain sculpture *Ruyi* uses the forms of human organs.

Shanghai Sketch, 1979

163 A drawing of the cityscape in Shanghai. During his first year at Beijing Film Academy, Ai went there for an internship; it was his first time in Shanghai.

Forest, 1977

164 This drawing was used for the cover of Ai Qing's poetry anthology *Selected Poems of Ai Qing*, published in China in 1979.

Figure drawings, 1982

172 Drawings that Ai did in a class at the University of California, Berkeley, during his first year in the United States.

Hanging Man, 1985

188 Ai's homage to Marcel Duchamp depicts the French artist's profile made of a wire hanger.

Breaking Blue-and-White Dragon Bowls, 1996

200 A drawing of a broken antique porcelain bowl.

Bamboo Finger, 2015

205 This drawing is in relation to Ai's *Study of Perspective* series (1995–present).

Bang, 2013

211 A drawing of an installation of wooden stools. *Bang* was exhibited in the German pavilion at the 2013 Venice Biennale.

Fragments, 2005

225 A drawing of an installation made from the pillars and beams of dismantled temples from the Qing dynasty (1644–1912).

Shanhaijing, 2015

236 Drawings of a series of bamboo works using traditional kite-making techniques. *Shanhaijing (The Classic of Mountains and Seas)* is a Chinese text of mythology and geography (fourth century B.C.E.).

Template, 2007

244 One thousand and one Ming dynasty (1368–1644) and Qing dynasty (1644–1912) wooden doors and windows salvaged from demolished houses. *Template* was exhibited at Documenta 12 in Kassel. After the work collapsed in a storm, Ai declared that it had acquired a new identity.

Rebar, 2012

255 A drawing of a twisted piece of rebar salvaged from the Sichuan earthquake of May 12, 2008. Among the earthquake's eighty thousand victims were more than five thousand stu-

dents buried in collapsed schools. Ai collected twisted rebar from the schools' rubble and used it in his work.

Circle of Animals / Zodiac Heads, 2011

260 Drawings for a set of sculptures of twelve animal heads.

Sunflower Seeds, 2010

283 Ai carpeted the Tate Modern's Turbine Hall with one hundred million porcelain seeds.

He Xie, 2010

289 A drawing of Ai's porcelain sculptures of river crabs. *He xie* is a Chinese homonym for "harmonizing," a euphemism for the state's suppression.

Panda to Panda, 2015

296 A drawing of a souvenir. The work is stuffed with shredded copies of the NSA documents leaked by Edward Snowden and a card reader with a micro-SD memory card.

Ashtray, 2011

342 A drawing of an ashtray filled with cigarette butts.

Marble Stroller, 2014

343 A drawing of the work *Marble Stroller,* a marble sculpture of Ai's son's baby stroller.

Remains, 2015

354 A drawing of *Remains,* a porcelain sculpture of a set of human remains. The bones were collected from a desert where thousands of intellectuals were exiled to a labor camp; many perished from disease and hunger.

Bugs, 2015

361 A drawing of a listening device concealed in the electrical sockets of Ai's studio.

Odyssey, 2016

364 A wallpaper design of journeying refugees.

AI WEIWEI was born in 1957 in Beijing, China. He lived in the United States in the early 1980s, returned to Beijing in 1993, and has been residing in Europe since 2015.

Ai Weiwei is an artist who advocates for human rights and freedom of speech. He is active on social media, and his work has been widely exposed to the public. His art exhibitions include *Fairytale* at Documenta 12, Kassel (2007); *Sunflower Seeds* at the Tate Modern, London (2010); *Evidence* at Martin Gropius Bau, Berlin (2014); *Ai Weiwei* at the Royal Academy of Art, London (2015); *Maybe, Maybe Not* at the Israel Museum, Jerusalem (2017); *Ai Weiwei on Porcelain* at the Sakip Sabanci Museum, Istanbul (2017); *Good Fences Make Good Neighbors* in New York (2017–2018); *Raiz* at OCA São Paulo (2018); and *Circa 20:20* in London (2020). His feature-length documentary films include *Human Flow* (2017) and *Coronation* (2020).

Ai Weiwei has received several awards, including the Václav Havel Prize for Creative Dissent from the Human Rights Foundation (2012) and the Ambassador of Conscience Award from Amnesty International (2015).

ALLAN H. BARR is the author of a study in Chinese of a literary inquisition in the early Qing dynasty, *Jiangnan yi jie: Qingren bixia de Zhuangshi shi'an* (江南一劫: 清人笔下的庄氏史案), and the translator of several books by contemporary Chinese authors, including Yu Hua's *China in Ten Words* and Han Han's *This Generation*. He teaches Chinese at Pomona College in California.

ABOUT THE TYPE

This book was set in Dante, a typeface designed by Giovanni Mardersteig (1892–1977). Conceived as a private type for the Officina Bodoni in Verona, Italy, Dante was originally cut only for hand composition by Charles Malin, the famous Parisian punch cutter, between 1946 and 1952. Its first use was in an edition of Boccaccio's *Trattatello in laude di Dante* that appeared in 1954. The Monotype Corporation's version of Dante followed in 1957. Though modeled on the Aldine type used for Pietro Cardinal Bembo's treatise *De Aetna* in 1495, Dante is a thoroughly modern interpretation of that venerable face.